ARTS OF ENGAGEMENT

MW00824942

Indigenous Studies Series

The Indigenous Studies Series builds on the successes of the past and is inspired by recent critical conversations about Indigenous epistemological frameworks. Recognizing the need to encourage burgeoning scholarship, the series welcomes manuscripts drawing upon Indigenous intellectual traditions and philosophies, particularly in discussions situated within the Humanities.

Series Editor:
Dr. Deanna Reder (Métis), Assistant Professor, First Nations Studies and English, Simon Fraser University

Advisory Board:
Dr. Jo-ann Archibald (Sto:lo), Associate Dean, Indigenous Education, University of British Columbia

Dr. Kristina Bidwell (Labrador-Métis), Associate Professor, English, University of Saskatchewan

Dr. Daniel Heath Justice (Cherokee), Associate Professor, English, Canada Research Chair in Indigenous Literature and Expressive Culture, University of British Columbia

Dr. Eldon Yellowhorn (Piikani), Associate Professor, Archaeology, Director of First Nations Studies, Simon Fraser University

ARTS OF ENGAGEMENT

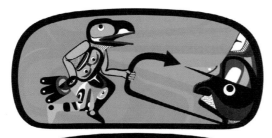

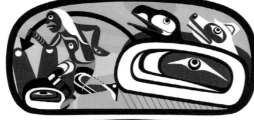

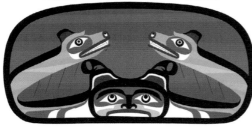

*Taking Aesthetic
Action In and
Beyond
the Truth and
Reconciliation
Commission
of Canada*

DYLAN ROBINSON and **KEAVY MARTIN**, editors

WILFRID LAURIER
UNIVERSITY PRESS

Wilfrid Laurier University Press acknowledges the financial support of the Government of Canada through the Canada Book Fund for its publishing activities. This work was supported by the Research Support Fund.

Library and Archives Canada Cataloguing in Publication

 Arts of engagement : taking aesthetic action in and beyond the Truth and Reconciliation Commission of Canada / Dylan Robinson and Keavy Martin, editors. (Indigenous studies series)

(Indigenous studies series)
Includes bibliographical references and index.
Issued in print and electronic formats.
ISBN 978-1-77112-169-9 (paperback).—ISBN 978-1-77112-171-2 (epub).—
ISBN 978-1-77112-170-5 (pdf)

 1. Indian arts—Political aspects—Canada. 2. Indian arts—Social aspects—Canada. 3. Aesthetics—Political aspects—Canada. 4. Aesthetics—Social aspects—Canada. 5. Truth and Reconciliation Commission of Canada. I. Robinson, Dylan, [date], author, editor II. Martin, Keavy, 1982–, author, editor III. Garneau, David, 1962– . Imaginary spaces of conciliation and reconciliation. IV. Series: Indigenous studies series

| E98.A73A78 2016 | 700.89'97071 | C2015-907847-4 |
| | | C2015-907848-2 |

Cover design by hwtstudio.com. Front-cover image: *Giants Among Us*, by Bracken Hanuse Corlett. Text design by Janet Zanette.

© 2016 Wilfrid Laurier University Press
Waterloo, Ontario, Canada
www.wlupress.wlu.ca

This book is printed on FSC® certified paper and is certified Ecologo. It contains post-consumer fibre, is processed chlorine free, and is manufactured using biogas energy.

Printed in Canada

Every reasonable effort has been made to acquire permission for copyright material used in this text, and to acknowledge all such indebtedness accurately. Any errors and omissions called to the publisher's attention will be corrected in future printings.

No part of this publication may be reproduced, stored in a retrieval system, or transmitted, in any form or by any means, without the prior written consent of the publisher or a licence from the Canadian Copyright Licensing Agency (Access Copyright). For an Access Copyright licence, visit http://www.accesscopyright.ca or call toll free to 1-800-893-5777.

CONTENTS

ACKNOWLEDGEMENTS

First and foremost, our thanks go to the thousands of Indian resi-
dential school survivors and their families whose stories we had the
privilege of listening to at the Truth and Reconciliation Commission
national events. We also want to acknowledge the TRC commissioners
and organizers who carried out the momentous task of implement-
ing their part of the Settlement Agreement—and who provided us
with the opportunity to think much more deeply about the possibili-
ties and problems of reconciliation. The TRC's hard-hitting summary
report and in particular the ninety-four calls to action are deserving of
our utmost attention.

We would like to thank the Social Sciences and Humanities
Research Council of Canada for the funding that allowed us to form
a research collective and to attend several of the TRC national events.
We also acknowledge the support of the European Research Council
for their funding of the Indigeneity in the Contemporary World proj-
ect at Royal Holloway, University of London. We are also grateful to
Petah Inukpuk, to Avataq Cultural Institute, to the Provincial Archives
of Saskatchewan, and to the Truth and Reconciliation Commission
of Canada for allowing us to use the various images included in this
collection.

To all of our co-researchers and contributors, we thank you for the
privilege of our many conversations and for the important and chal-
lenging work that you are carrying out. Our thinking was enriched
by several people whose work is not represented in this collection,
but whose presence at our gatherings was integral to the evolution of
this book: Helen Gilbert, Rob Innes, Niigaanwewidam Sinclair, Chris-
topher Teuton, and Jocelyn Thorpe. To the artists who have shared
their time and discussed their work with us—in particular, Bracken
Hanuse Corlett, Georgina Lightning, Luke Marston, Peter Morin, Lisa
Ravensbergen, Armand Garnett Ruffo, Susan Aglukark, and Andrea

Menard—thank you for demonstrating for us the potential of aesthetic action. We are particularly grateful to Bracken Hanuse Corlett for the beautiful and inspiring work *Giants Among Us*, which graces the cover of this volume.

There have been numerous academic and artistic colleagues who have deepened our understandings of the role of artistic practice in processes of conciliation. To the members of the REwork(s) in Progress project—Ashok Mathur, Sophie McCall, Trina Bolam, Jonathan Dewar, Steve Loft, Ayumi Goto, Gabrielle L'Hirondelle Hill—your cutting-edge work continues to set the bar high for us. To the staff at Shingwauk Residential School Centre, we extend our gratitude for hosting us there from September 27 to October 3 during the REwork(s) in Progress gathering. Thank you also to Len Findlay and to the attendees at the University of Saskatchewan's Cultures of Reconciliation: Academic, Artistic, Activist. Daniel Heath Justice has been a constant mentor throughout the development of the project and collection. Similarly, Dylan thanks Lumlamelut Laura Wee Lay Laq for her continuing mentorship—éy kw'el sqwá:lewel kw'as íwest. We are also indebted to Kristina Bidwell for providing space for our meeting at the University of Saskatchewan and to Helen Marzolf for hosting our meeting at the Open Space artist-run centre in Victoria.

We are hugely thankful for the support of our editors, Lisa Quinn and Rob Kohlmeier, and their team at Wilfrid Laurier University Press—and to our two peer reviewers for their insightful suggestions. Thank you also to the research assistants—Aaron Franks and Patrick Nickleson—who have carried this project along at various stages. And to our families—in particular, Keren Zaiontz (for Dylan) and Richard Van Camp and Edzazii (for Keavy)—we are, as always, thankful for the unconditional support and love you have shared with us during the project.

Finally, it is with great sadness that we note the passing of Naomi Angel, who was a core member of our research team during the two and a half years of the project. Naomi, your radiance remains with us even today, and we hold tightly to the recollection of our numerous conversations, many walks, and much laughter. We are grateful that we have your words—so evocative of your wisdom, thoughtfulness, and compassion—to continue to guide us, and we hope that this collection honours your memory. Our heartfelt thanks go to Naomi's husband, Mitchell Praw, and to Pauline Wakeham for helping to carry Naomi's work to these pages.

INTRODUCTION
"The Body Is a Resonant Chamber"

Dylan Robinson and Keavy Martin

At the 2013 Québec National Event hosted by the Truth and Reconciliation Commission (TRC) on Indian residential schools, a Kanien'ke-há:ka audience member summed up neatly the problem with the national project of reconciliation: "If you come and break the windows to my house," he said, "you're going to have to fix those windows before I'll entertain your apology."[1] This statement begs the question of whether any of the actions that have been undertaken in the name of reconciliation—such as the 2008 federal apology, or any of the elements of the 2007 Indian Residential Schools Settlement Agreement (IRSSA)—have "fixed the windows" broken not only by the Indian residential school system, but also by the longer and still-ongoing process of colonization. As Maria Campbell states with reference to a commemoration ceremony held at Batoche, "there's a plaque, but the people still have no land."[2] Even for Indigenous nations who have negotiated treaties and land claims, their rights to their lands and resources continue to be subservient to Canada's own economic development priorities.[3] Meanwhile, little federal funding is directed toward outstanding issues resulting from a century of Canadian Indian policy, such as the high number of missing and murdered Indigenous women, overrepresentation of Indigenous populations in the foster care system and correctional facilities, high rates of addiction and suicide, and the endangered status of most Indigenous languages. Placing Campbell's poignant critique alongside the continuing injustices and challenges faced by Indigenous peoples brings into sharp relief the fact that Canada's efforts to address the atrocities of the Indian residential school system are only one of innumerable actions necessary to begin to repair the damages wreaked by colonization and contemporary government policy.

As scholars committed to processes of decolonization,[4] we struggle with the reality that almost nothing we can do will lead immediately or directly to the return of land or to the unsettling or dissolution

1

of Canada's claim over Indigenous territories. Of the various courses of action available to us, it is difficult to know which one to take that might permanently prevent pipelines from being built through the territories of Indigenous nations in British Columbia, or that would restore the abilities of northern Alberta Indigenous nations to practise their treaty right to harvest, hunt, fish, and trap in lands now dominated by the oil sands industries. In order to achieve outcomes like these, we need a wide range of diverse actions; each can play a part in the broader project of achieving justice. For that reason, we maintain a belief that even small, symbolic, and everyday actions are significant and therefore need to be thought through carefully. While focusing on small actions puts us in danger of feeling that we have "done enough" (thereby avoiding the larger decolonizing actions that need to take place), discounting them not only risks creating a sense of powerlessness and despair, but also misses the potential of micro-actions to ripple, to erode, and to subtly shift.[5]

At its core, this collection focuses on various forms of what we have called "aesthetic action." Aesthetic action is here conceived quite broadly to describe how a range of sensory stimuli—image, sound, and movement—have social and political effects through our affective engagements with them. In other words, we are concerned with the ways in which the TRC proceedings and artworks related to the Indian residential school system have impacts that are *felt*—whether this is through emotion or sensory experience—and to what degree these impacts result in change. We believe this to be important because of the potential for embodied experiences to go unrecognized or unconsidered, even as they have enormous influence on our understanding of the world. At the TRC events, a huge range of sensory provocations and aesthetic choices—from the ambiance of the rooms selected to host the gatherings, to the presence of massive projection screens in the commissioners' sharing panels, to the music and art included in the proceedings, to the arrangement of chairs (to name only a handful of affective elements)—worked together to create particular experiences and responses in the bodies moving through these spaces. The resulting connection, interest, empathy, relief, confusion, alienation, apathy, and/or shock (again, to name only a few possible responses) worked powerfully to shape participants' engagement with the history of Indian residential schools and with ideas of reconciliation. These aesthetic experiences, therefore, were a crucial component of how the issues surrounding the TRC are taken up by both survivors and varied members of the public. By considering the aesthetic—the realm of the

senses—we focus on some of the most tangible results of the TRC: the way that it has affected different bodies. As Tahltan artist and scholar Peter Morin writes in this volume, "I carry the voices of the residential school survivors, / I carry their testimony with me / I put them on a shelf inside my body / you should too" (89).

In order to consider the TRC and its impacts in this deeply embodied sense, we ask, what kinds of feelings do the events of the TRC provoke in its participants, and what is the significance of these provocations? How do participants respond, and what kinds of changes result from this? "Aesthetic action" here also refers to the way in which the structure and form of events are mobilized toward particular political sensory experiences. These included calls to empathize (such as via the TRC's media image of mothers with their children),[6] invitations to join together (for instance, through participation in round dances or talent shows), or refusals that enforce distance (such as the spatial arrangement of survivors' sharing circles, which kept witnesses on the outside, and the testimony of survivors who purposely refused to "confess" their trauma). These actions perform a similar political function as artistic practice: they unsettle us, provoke us, and make us reconsider our assumptions. Such was the case with survivors' and family members' annotations on photographs observed by Naomi Angel and Pauline Wakeham at the Northern National Event in Inuvik; such was the case with Peter Morin's requirement at his performance (held in close proximity to the Québec National Event) that audience members come forward to dance; and such was the case when the Halifax sharing circle facilitator (Patrick Etherington Sr.) informed listeners that we were "witnesses"—and that we should come forward to embrace each of the young speakers and to "tell them what we needed to tell them." Actions like these have the potential to assist us in viewing the structures that we are embedded in more clearly—perhaps revealing the ways in which public spaces and national discourses privilege certain bodies and contribute to the ongoing oppression of others—and also suggest to us possibilities for different kinds of engagements and understandings.

* * *

The impetus for this collection first came about when Dylan Robinson, a Stó:lō scholar of Indigenous art and music, and Keavy Martin, a settler scholar of Indigenous literatures, brought together a team of scholars and artists to provide an interdisciplinary arts perspective in comparing the social and political impacts of aesthetics at the

then-upcoming TRC events. We felt that it was crucial for the academic community to engage with the work of the TRC in a way that was supportive and respectful of the decision of residential school survivors to share their testimony but which also maintained a critical perspective on the national discourse of reconciliation. We were not alone in this endeavour; across the country, academics were paying very close attention to the national process of reconciliation, and we would benefit tremendously from their work, as we did from the testimony and interventions of the thousands of residential school survivors who attended the TRC's regional and national events.[7]

While all members of our own research team had experience working in fields related to Indigenous cultural production, we found that the context of the TRC provided enormous challenges to our own practice as academics and as artists. What did it mean to attend the TRC as researchers, particularly in light of Linda Tuhiwai Smith's famous assertion that "'research' is probably one of the dirtiest words in the indigenous world's vocabulary"? (1). Despite the reality that many scholars working with Indigenous peoples and communities have since reconsidered and radically altered their methods, we struggled with the persistent connotations of "research" as being a minimally invested pursuit of "interesting" data. To transform the TRC—and the experiences of residential school survivors—into mere data serving the interests of the academy would be to perpetuate an intellectual resource extraction that mirrors the exploitative practices of current colonial regimes. We strongly felt the need to engage with the events at the TRC in ways that would not perpetuate this exploitation but that would bring different forms of Indigenous engagement, including resistance, to the fore. As Sam McKegney reflects in his contribution to this collection,

> the position of academic onlooker can be characterized by voyeurism, consumption, and lack of accountability—tensions amplified by my status as a settler scholar. I am aware, therefore, that the safest position ethically is to avoid discussing this testimony altogether.... [Yet] as an anonymous survivor declares in *Breaking the Silence*, "My story is a gift. If I give you a gift and you accept that gift, then you don't go and throw that gift in the waste basket. You do something with it" (Assembly of First Nations 161). This paper is part of my effort to "do something" with this gift. (196–97)

In an interview with Jonathan Dewar, Maria Campbell speaks to the responsibilities of both artists and scholars: "Reciprocity is a big teaching in our community: that what you take, you have to give back. And there are responsibilities to taking people's power to heal yourself, whether it's their stories or their friendship, or just making a place in the community. There's a responsibility; you can't just go and take that power. You'll get sick. It'll make you sick" (qtd. in Dewar et al. 15). When Dewar asks, "Can one give back with a study?" Campbell responds, "Of course you can. Anything that opens people's minds—that allows our people to be critical thinkers.... [I]f we can teach our people to be critical thinkers—to be able to ask those questions, to have curious minds—then you're giving back" (qtd. in Dewar et al. 15–16). While these words give us hope for the relevance of academic work, they are also a reminder that reciprocity must remain at the top of our priorities, particularly considering all that we have gained personally and professionally from attending the TRC events and from listening to the stories of survivors. While we offer this volume as one kind of reciprocal action, we continue to seek other means to honour our individual and collective responsibilities to give back to the people and communities who have taught us so much.

A Brief Overview of the Truth and Reconciliation Commission on Indian Residential Schools

The TRC was initiated in 2007 as a cornerstone of the Indian Residential Schools Settlement Agreement. Its stated priorities include the provision of a "holistic, culturally appropriate and safe setting for former students, their families and communities as they come forward to the Commission" and the promotion of "awareness and public education of Canadians about the IRS system and its impacts" ("Our Mandate"). While the commission suffered a rocky beginning due to the early resignation of its original three commissioners, it was reinvigorated by the appointment of a new team of commissioners: the Honourable Justice Murray Sinclair, Chief Wilton Littlechild, and Dr. Marie Wilson. In June of 2010, the first national event was held in Winnipeg, and since that time, the TRC has heard over 6750 testimonies from former students and their families, as well as from other individuals connected to the schools, both in major urban centres and in smaller communities across the country.[8] The TRC has also made efforts to engage the public

by including at its national events artwork and performance events, "It Matters to Me" town hall sessions, educational displays, and lectures; by appointing honorary witnesses; and by streaming its proceedings online. Following its conclusion in the summer of 2015, the TRC submitted to the Parties of the Settlement Agreement a lengthy summary of its final report and a series of ninety-four calls to action, and it is archiving its findings at the National Research Centre for Truth and Reconciliation, now housed at the University of Manitoba.

Almost from its inception, the TRC—along with the other elements of the national process of reconciliation, including the IRSSA and the 2008 federal apology to residential school survivors—has faced criticism. Indeed, most scholars agree that the national discourse of "reconciliation," as appealing as it may be to a settler-colonial state hoping to put its genocidal past behind it, is a virtual minefield of assimilative dangers. Pauline Wakeham and Jennifer Henderson have noted in the context of the 2008 federal government apology that "the absence of the word 'colonialism' … enables a strategic isolation and containment of residential schools as a discrete historical problem of educational malpractice rather than one devastating prong of an overarching and multifaceted system of colonial oppression that persists in the present" ("Colonial Reckoning" 2). The TRC has likewise been limited by its mandated focus on the history of *recognized* residential schools, a restriction that—while imposing some useful limits on the work of the commission—allows the multiple and *ongoing* tactics of settler-colonialism to go largely unnoticed by Canadian society.[9] As Taiaiake Alfred (Kanien'kehá:ka) states, "without massive restitution, including land, financial transfers and other forms of assistance to compensate for past harms and continuing injustices committed against our peoples, reconciliation would permanently enshrine colonial injustices and is itself a further injustice" (*Wasáse,* 152). While many individual speakers at the TRC do raise these issues—thereby refusing the compartmentalization of residential schools into a firmly historical "sad chapter" ("Statement of Apology")—non-Indigenous participants and commentators continue to fall back upon the language of "healing," "forgiveness," and "moving on"—notions that place the burden of restoring relations squarely on the shoulders of survivors.[10]

Jeff Corntassel (Cherokee Nation), Chaw-win-is (Nuu-chah-nulth), and T'lakwadzi (Kwakwaka'wakw) observe, furthermore, that "[a]t its core, reconciliation is a Western concept with religious connotations of restoring one's relationship to God. Given that reconciliation is not an Indigenous concept, our overarching goal as Indigenous peoples

should not be to restore an asymmetrical relationship with the state but to restore our communities toward justice" (145). In his contribution to this volume, David Garneau elaborates on the Catholic underpinnings of reconciliation, noting also that

> [t]he system requires the spectacle of individual accounts (confessions) and healing narratives (forgiveness and penance). It prefers to lay blame on its individual (mostly dead and certainly absent) members, and even then does not willingly present them for public confession and atonement. While it acknowledges that the abuses were the result of (past) systemic policy, Canada does not do anything that would risk the integrity of current dominant structures.... How do we prevent Reconciliation from being primarily a spectacle of individual pain for settler consumption and Aboriginal shame? (33–34)

This consumption of Indigenous trauma often leads to what Roger Simon refers to as "idealizations of empathy, identification, and facile notions of solidarity that simply promote settler state citizenship" ("Towards a Hopeful Practice" 136). Confident in the fact that the churches and federal government are paying compensation to Indigenous survivors, Canadians may absolve themselves of any personal and ongoing responsibility. Meanwhile, the related issues of Indigenous land rights—as seen in the rise of the Idle No More movement in 2013—provoke widespread frustration in the mainstream population; as Eva Mackey notes, "financial reparations for residential schooling can be individualized and contained in a way that land claims cannot" (50).

Yet despite—or perhaps because of—these very real concerns, the TRC remained throughout its life a venue of possibility. Rather than being solely an expression of the state's desires for the conclusion of Indigenous grievances, it was also a space animated by the agency of the thousands of survivors who both guided and participated in its proceedings. Commissioner Justice Murray Sinclair consistently reminded audiences (a) that the majority of survivors are not especially interested in reconciling with Canada, but rather with members of their own families, and (b) that the work of creating a better relationship between Indigenous peoples and settler Canadians will continue long—likely for generations—after the TRC's 2015 conclusion. In the meantime, the question remains as to how audiences should engage with and respond to the testimony shared by survivors. Paulette Regan refers to these stories as "gifts" for which listeners must learn how to responsibly reciprocate. She asks,

> [H]ow do we listen and respond authentically and ethically
> to testimonies—stories of colonial violence, not with colonial
> empathy but as a testimonial practice of shared truth telling
> that requires us to risk being vulnerable, to question openly
> our accepted world views and cherished assumptions about
> our colonial history and identity? How do we learn to listen
> differently, taking on our responsibility to decolonize our-
> selves, making space for Indigenous history and experience?
> (*Unsettling the Settler Within*, 190)

Faced with these challenges, audience members may indeed withdraw
or rest within the easy space of empathy—but they may also be trans-
formed, leaving with a desire to learn more and to find meaningful
ways of pursuing justice.

The Challenge of "Aesthetics"

Our original project title, "The Aesthetics of Reconciliation in Can-
ada," invoked the language of aesthetics in order to provide a lens
for considering the artistic, medium-specific ways by which different
art forms and sensory experiences located at the TRC engendered
particular affective relationships with their audiences, and how each
enabled (or, in some cases, elided) certain kinds of work: cultural
affirmation, healing, political mobilization, or even the packaging of
residential school experience in "safe" forms for public consumption.
In choosing the term "aesthetics," we sought to signal our interest
in how the structural, stylistic, and generic choices made by artists
enabled different kinds of social and political engagements. How, for
instance, did generic choices for the music performed at TRC events
foster a sense of belonging or distance for diverse audience mem-
bers? How was the language and rhetoric of testimony narrating the
history of residential schools in different ways than the language and
rhetoric of formal TRC "expressions of reconciliation"? Our focus on
aesthetics, moreover, had an equal concern with the ways in which
TRC events were staged and produced: the form and structure of
the TRC itself. Although many of our collaborators analyze specific
artistic works, songs, and literary contributions within and beyond
the TRC, their consideration of aesthetics was not limited to works of
art. Our understanding of aesthetics was thus also connected to an
earlier, pre-Kantian understanding of aesthetics as *sensory engage-*

ment. We were interested in the actions of telling, making, talking, walking, sharing, giving, and receiving. Equally, we were interested in different kinds of reception—the ways in which such actions were read, witnessed, and understood by the multiple audiences that experienced them. We sought to examine how residential school experience was conveyed and received through speaking and hearing testimony, through sharing dialogue, or through a formal process of giving objects to the bentwood box as "Gestures of Reconciliation" (Kalbfleisch, this volume).

Whereas traditional art historical models follow a Kantian definition of aesthetics premised upon the distanced judgment of the sublime and beautiful aspects of the fine arts, more recent work in aesthetics instead takes Alexander Baumgarten's 1735 definition of *aesthesis* as a starting point.[11] Aesthesis, according to Baumgarten, is "primarily concerned with material experiences, with the way the sensual world greets the sensate body, and with the affective forces that are generated in such meetings" (qtd. in Highmore, "Bitter" 121). Processes of redress and reconciliation are themselves bound up in a merging of different affective forces that occurs in the many meetings, greetings, negotiations, repellences, and reunions that take place both upon the ground of artistic encounter and at TRC events more broadly.

Our starting point of "aesthetic action" also makes connections with contemporary perspectives on what has been called "everyday aesthetics."[12] Such perspectives move away from the use of "aesthetics" as exclusive domain of artistic practice, and instead explore the structures of daily experience—how forms determine the ways in which we move through and understand the world. Examples include how we experience architecture in a state of "tactile distraction"[13] and how community-making is alternately fostered and foreclosed upon by the ways in which built and natural landscapes direct our movement.[14] In relation to the TRC, we may note how the visual and aurally produced rhetorics of TRC promotional media inflected empathetic connection, seeking to catch the attention of the general public and compel them to take part as witnesses. Viewing the TRC as a space of aesthetic relations requires an engagement with the structures and form of those things that constitute TRC gatherings, and how these in turn constitute experiences of reconciliation and resistance. However, as Jacques Rancière makes clear, just as the politics of aesthetics does not reside within the political messages, or content, of works, neither is it located within deep structures of a work hidden within the semiotic codes of artistic form to be deciphered by experts. Rather, aesthetic

politics lives within the immediate sensory experience and impact of artistic forms. It is the non-representational and affective aspects of these works that enact politics through displacement of normative and hegemonic structures, or what Rancière calls the "(re-)distribution of the sensible."

And yet, for all the ways in which the recuperation of the term "aesthetics" holds great potential, the word also has its own affective force. As with any term, "aesthetics" carries the weight of its history, a weight that may in certain cases obstruct dialogue. No matter how we might seek to recuperate or reform certain understandings of aesthetics, it cannot conceal its Western lineage as a concept that has come to be known and associated with "proper judgment" of artworks. For many Indigenous people, the word announces a separate trajectory from pressing issues of land claims negotiation, community health, and resource extraction. "Aesthetics'" affective charge can elicit wariness, distrust, and outright confusion (we may similarly consider in this category the affective force conveyed by the term "postcolonial" in Indigenous contexts).[15] Using the term can quickly shut down rather than open up conversations, particularly in relation to the Indigenous communities to which we belong and the Indigenous peoples with whom we interact. This is to say that the term "aesthetics" carries with it such a strong charge that it can also intimidate or repel people from wanting to take part in dialogue.

Even in academic contexts, the term "aesthetics" quickly affiliates its speaker with those questions of artistic judgment it has come to be strongly associated with from the Kantian formulation of disinterested artistic evaluation. In this modern(ist) construction of aesthetics, as David Howes notes, "it is only the uncommon viewer, or connoisseur, [who] is capable of training his or her gaze on the windowpane itself, who is capable of enjoying a pure aesthetic experience, and of exercising the proper form of judgment" (75). There is thus an elitism of aesthetics that precludes those who "merely" perceive or experience. From this perspective, the term "aesthetics" habitually distinguishes itself from the common, from those base experiences of boredom, frustration, shame, and anger. The work that the term "aesthetics" carries out through these affiliations can often result in situating the speaker outside of those concerns of Indigenous communities with whom she or he engages in processes of redress and reconciliation. Yet, for all these challenges, contemporary engagements with aesthetics provide tools and strategies with which to understand the role the arts and sensory experience play in the TRC. Just as Indigenous

scholars have sought to examine the potential of certain forms of post-colonial thought, it is similarly important to assess the usefulness of aesthetics for critical Indigenous theory.[16] Otherwise, we risk ignoring some of the most powerful and integral ways in which knowledge is produced, conveyed, and understood: through the body. As Morin writes in this volume, "[t]he body is a resonant chamber"—a place where experiences echo, sinking deep into the bones before reverberating back out into the world.

Being Together and Remaining Apart: Aesthetic Proximity and Distance

Etymologically, the word "reconcile" refers to the act of bringing back together. There is no doubt that the TRC events were, in their most general sense, about engendering different forms of coming together: the coming together of Indigenous communities to support one another alongside the coming together of members of the Indigenous and non-Indigenous public.[17] The result of this latter encounter at the TRC was evidenced both in the often awkward and forced moments where institutions came to present "expressions of reconciliation," and in early "It Matters to Me" town hall forums where the non-Indigenous audience expressed their sadness at learning of residential school history for the first time. Entering the same room or public space is the first step in the potential negotiation of different perspectives and sharing of experience. However, the act of physically coming together in the same space is more easily accomplished than the negotiations of being together in ways that result in transformation and change—both on the individual level and in social and political realms. The success or failure of this "togethering" relies upon the quality of presence and felicitousness of those who come together. For many Indigenous people, the success of a gathering is contingent upon whether this coming together and the relations between participants follow protocols of welcome and acknowledgement. The aesthetics of space also guides and facilitates the various interactions that take place between the settler public and Indigenous people at the TRC.

From the architecture of the spaces used for the TRC events to the spatial orientations of audiences and set-up of places for learning around and within which interaction takes place, the aesthetic choices implemented by the TRC spatialize connection. In the ease of navigation and informality of outdoor space, new relationships are fostered more

easily by chance encounters (as in the Saskatoon TRC's outdoor gathering spaces and at The Forks in Winnipeg). This sits in contrast with the formality of the commissioners' sharing panels, with their raised platform stages, dual large-screen projections, and seating for hundreds of audience members. The aesthetics of space here has an explicit relationship to the kinds of togethering that are possible.

In addition, artistic presentations also play a role in engendering proximity and distance, through their emotional tenor drawing us near (or, alternatively, alienating us) to the topics and issues they address. As is clear in many of the musical examples considered by Diamond, Robinson, and Dueck, music allows for a great deal of public intimacy and empathy. Whether the physical and emotional proximities afforded by music provide opportunities for alliance building (Diamond), affirming Indigenous social relationships (Dueck), or allowing settler audiences to feel positively transformed in spite of the need for further political redress and restitution (Robinson), music at the TRC offers a wide array of possibilities for togethering. The challenge here, as identified by scholars such as Dominic LaCapra, is that the arts may in fact draw us so close to such experience that we over-identify with the other.[18] Through emotional identification with the violent dispossession of Indigenous children by church and state—as if this dispossession were their own—settler audience members may collapse the distance that might otherwise unsettle their understandings and challenge their complicity in ongoing colonialism. In contrast, Garneau emphasizes that what is currently required in these processes of reconciliation and redress is at times a cultivation of distance and spaces of non-Indigenous inaccessibility, what he calls "irreconcilable spaces of Aboriginality" (this volume, 26).

Taken together, the chapters in this collection contribute to a composite rendering of the role that aesthetics played in the Truth and Reconciliation Commission, as well as a summary of the arts' roles in reconciliation—or, to use David Garneau's term, *conciliation*—outside the framework of the TRC. Confronting the scopophilic desire to access Indigenous knowledge, Garneau's chapter, "Imaginary Spaces of Conciliation and Reconciliation: Art, Curation, and Healing," proposes a way forward by asserting the need for spaces of visual and sensorial *in*accessibility. His essay details why many Indian residential school survivors do not participate in the TRC process, which he understands as enacting a Western religious ideology of reconciliation that places the burden of confession on survivors while requiring nothing of the kind from the impenetrable state. As an alternative to this framework,

Garneau asserts the need to cultivate "irreconcilable spaces of Aboriginality," "sovereign display territories," and "collaborations beyond the project currently known as Reconciliation" (23).

With this critical framework in mind, Dylan Robinson's essay, "Intergenerational Sense, Intergenerational Responsibility," forwards an aesthetic understanding of the TRC by considering the ways in which the history of residential schools has been expressed through survivors' sensory memories, both in their written accounts and in testimony given at TRC events. Robinson emphasizes two sites of sensory experience: (1) face-to-face interaction in the space of listening to/ giving testimony, or in witnessing/giving "expressions of reconciliation" by institutional officials, whether church, government, RCMP, or universities, and (2) sensory interaction occupying the space between artistic works and spectators, and in particular a performance of "O Siem" by the Gettin' Higher Choir at the TRC regional event in Victoria, British Columbia. Robinson questions the need for different models of sensory interaction, in particular through the impact that certain forms of language and naming can have in calling on settler Canadians to engage in a greater level of "intergenerational responsibility."

As a detailed and powerful example of aesthetic action, we turn to Peter Morin's essay, "this is what happens when we perform the memory of the land," which brings a Tahltan-specific model of witnessing and healing into being. Morin here documents his experience of both the TRC and his own performative counter-monument, staged immediately following the 2012 Québec National Event in Montreal. In response to what he felt were highly restrictive formats for participation at TRC events, Morin called upon a network of other artists and witnesses to assist him in staging a two-part performance-art piece that created a space of respectful difference—while still ultimately supporting the work underway by TRC survivors, attendees, and organizers (the commissioners in particular). Morin's narrative eschews the restrictions of academic style and even of punctuation much in the same way that it resists the constraints of the official Truth and Reconciliation process, replacing these with a more embodied and relational means of engaging with colonial history.

Building upon Morin's accentuation of the potential and immense challenge of witnessing, Naomi Angel and Pauline Wakeham's "Witnessing *In Camera*: Photographic Reflections on Truth and Reconciliation" considers the manifold roles of photography at the TRC (and at the 2011 Northern National Event in Inuvik in particular). As Angel and Wakeham point out,

> The ubiquitous scenes of classroom instruction and posed stu-
> dent portraits that pervade the [Indian residential schools']
> historical record seek to approximate the normalcy of educa-
> tional experiences in schools across Canada, enabling some
> viewers to see what they want to see—the signs of "progress,"
> of a benevolent church and state performing social and moral
> uplift—rather than the disturbing traces of the assimilationist
> project's assault on Indigenous peoples. (96)

Challenging this normalization, the authors read the absences and
interventions surrounding the more iconic residential school photo-
graphs currently circulated by media and the TRC, while also provid-
ing a reflexive account of lenses they and other settler scholars bring
to witnessing. Through their detailed analyses of these layers of visual
representation, Angel and Wakeham provide us with a comprehen-
sive understanding of the way in which the medium of photography
makes visible different histories and contemporary memorializations
of residential schools.

David Gaertner's chapter then examines the way in which the act of
witnessing testimony is situated by the TRC—in particular, he unpacks
the ambiguity surrounding the commission's invocation of an "Aborig-
inal principle of witnessing." Although Northwest Coast traditions of
witnessing are often referenced by the TRC, the extension of these
geographically specific practices to pan-Canadian contexts, Gaertner
argues, risks "making it difficult for communities who view witnessing
in unique ways to make their designations heard—particularly if they
are counter to the 'official' definition" (142). In answer to this, Gaert-
ner considers an alternative principle of witnessing via Anishinaabe
artist Rebecca Belmore's video-art piece *Apparition* (which appeared
as part of the exhibition *Witnesses: Art and Canada's Indian Residen-
tial Schools* at UBC's Belkin Gallery during the B.C. National Event).
Gaertner argues that Belmore's piece complicates the TRC definition
of witnessing by *refusing* to "bare witness"—to expose itself to the
scopophilic desire and consumption of mainstream audience.

Likewise considering the need for geographically specific
approaches, Jill Scott and Alana Fletcher's chapter, "Polishing the
Chain: Haudenosaunee Peacebuilding and Nation-Specific Frame-
works of Redress," considers the way in which acts of apology are
linguistically constituted and reflective of the worldviews embedded
within language. Noting the absence of specific Indigenous-centred
models for redress at TRC events and also the ways in which the 2008
federal apology to Indian residential school survivors was constrained

by its own cultural inheritances, Scott and Fletcher turn to Haudeno-saunee traditions of condolence and atonement, thereby seeking to locate conciliatory frameworks that are specific to the lands on which they live and work—and which are less dependent on colonial and imported paradigms that ultimately limit the possibilities for achieving just and respectful relationships on this land.

We move then to the problems and possibilities of conciliatory relationships as they are staged within Indigenous theatre, here explored in a conversation between Dylan Robinson and Vancouver-based Indigenous theatre practitioner Lisa Ravensbergen. Considering the representation of colonial history in Kevin Loring's *Where the Blood Mixes*, Drew Hayden Taylor's *God and the Indian*, and Ravensbergen's own *The Place Between* and *The World Is The World,* Ravensbergen and Robinson comment on the dangers of making a history palatable for a non-Indigenous theatre audience who may come to the topic reluctantly—or who may feel entitled to be entertained and/or educated. As Ravensbergen says, though, "Aboriginal theatre … becomes a tool for decolonizing the performer–audience relationship" (187), thereby creating the possibility of conversation, reciprocal action, and the adoption of responsibility by the audience. All in all, this discussion suggests, Indigenous theatre and other forms of aesthetic action have tremendous power; as Ravensbergen concludes, "it *is* power."

The truth of this assertion can be seen clearly in Sam McKegney's chapter, "'pain, pleasure, shame. Shame': Masculine Embodiment, Kinship, and Indigenous Reterritorialization," which argues that purposeful alienations enforced upon Indian residential school students—such as gender segregation and shaming—were a calculated tactic of deterritorialization. Building upon an analysis of survivor testimony and residential school literature, McKegney asks,

> If the coordinated assaults on Indigenous bodies and on Indigenous cosmologies of gender are not just two among several interchangeable tools of colonial dispossession but are in fact integral to the Canadian colonial project, can embodied actions that self-consciously reintegrate gender complementarity be mobilized to pursue not simply "healing" but the radical reterritorialization and sovereignty that will make meaningful reconciliation possible? (194–95)

To answer this question, McKegney turns to the action undertaken by the Residential School Walkers, a group of predominantly young Cree men who walked 2200 kilometres from Cochrane, Ontario, to

the Atlantic TRC event in Halifax, Nova Scotia, in support of residential school survivors. Their walk, argues McKegney, is "a testament to embodied relations with the landscape; it is an assertion of ongoing Indigenous presence, an expression of resilience, and an affirmation of belonging. In short, this journey constitutes an act of radical reterritorialization that honours and reclaims the land through embodied discursive actions that simultaneously honour and reclaim the body" (210).

We move then to the work of renowned Anishinaabe poet, scholar, and filmmaker Armand Garnet Ruffo, here in conversation with Shingwauk Residential School Centre Director Jonathan Dewar. Like McKegney, Ruffo and Dewar assert the potential of Indigenous artistic practice to educate audiences about the contemporary impacts of Indian residential schools—but also to act as a vessel of cultural reclamation and rebuilding for the generations to come. Ruffo recalls the burgeoning of Indigenous literatures in Canada—a movement that largely coincided with the push for redress for the Indian residential school system—and discusses the origins of his film *A Windigo Tale*, which draws upon Anishinaabe oral traditions as a framework for grappling with intergenerational trauma resulting from residential schooling. While the film focuses on the possibilities of healing within one family, Ruffo also urges us to consider the broader and *ongoing* tactics of colonialism: "When you have a people whose values are at odds with the fundamental structure of the society, a society built on the exploitation of people and the land," he says, "then that society can only do two things to accommodate those people: eliminate them—incarcerate them, for example—or assimilate them, pay them off" (225). And it is up to the artists to draw upon the deep roots of Indigenous intellectual and spiritual traditions in order to help ensure a vibrant Indigenous future.

This commitment to using art as a means of resisting assimilation and of rebuilding healthy Indigenous communities likewise inspires Cree filmmaker Georgina Lightning, who speaks here with Keavy Martin about her award-winning film *Older Than America*—and about her new trilogy of documentary films funded in part by a grant from the TRC. The first film, *Fantasies of Flying*, shines a spotlight on trauma-induced depression and suicide; the second, *Path to Freedom*, addresses stereotypes and misconceptions about Indigenous people; and the third, *Grandmother's Medicine*, aims to reassert the traditional, empowered place of Indigenous women in the face of systemic violence. Lightning draws upon her experiences of the TRC event, of Idle No More, and of her own experience of working to heal from

trauma through a holistic and indigenized process of transformation. Within the larger context of global epidemics of depression, addiction, and suicide—epidemics that are overwhelmingly visible in Indigenous communities—Lightning calls for immediate, large-scale action by policymakers and community leaders.

We move then from the interventions of filmmaking to the possibilities presented by music at the TRC events. Both Beverley Diamond's and Byron Dueck's essays point to the ways in which song and musical performance allow for a greater degree of agency in how survivors share their experiences of the residential school system and its legacy. Diamond's "Resisting Containment: The Long Reach of Song at the Truth and Reconciliation Commission on Indian Residential Schools" focuses on performances by Susan Aglukark at the Winnipeg event, by Andrea Menard at the Saskatoon event, and by a number of performers at the Atlantic TRC event in Halifax. Having conducted interviews with the performers, Diamond examines how song provides a space for survivors to assert what she calls "performative moments of micro-sovereignty." Music making, in Diamond's examples, provides an alternative strategy to the TRC's focus on "reconciliation" through the facilitation of both interpersonal and intercultural interaction. Music, in other words, asserts sovereign protocols. Dueck's chapter, "Song, Participation, and Intimacy at Truth and Reconciliation Gatherings," in turn, focuses primarily on the ways in which TRC participants take part in Indigenous forms of public intimacy through music making at the TRC talent show evenings. As Dueck describes, "the work of song, like that of testimony, was in many instances an affective labour that sought to move an *intimate public* through narratives that appealed to presumed fellow-feeling in its hearers" (279). His essay emphasizes the significant role "amateur" music making plays in negotiating relationships, and connecting people and other-than-human intimates.

Elizabeth Kalbfleisch further examines the ways in which TRC attendees are called to engage, as she examines the aesthetic and material significance of one of the most iconographic objects used at the TRC, the *Medicine Box*. Carved by Coast Salish artist Luke Marston, the *Medicine Box* is a bentwood box that figured centrally in TRC event proceedings, functioning as an archival receptacle for "Gestures of Reconciliation," including both written statements and material objects, or gifts. Paying particular attention to the *Medicine Box*'s numinous qualities, or its "thing-ness," Kalbfleisch asks how the object's four panels speak to the various Indigenous and non-Indigenous constituencies who view it. Additionally, Kalbfleisch examines

the *Medicine Box* as a mnemonic device: "a prompt for the *act* of sharing truths and receiving truths by residential school survivors, intergenerational survivors, and others implicated in IRS history and reconciliation" (299). Despite the specificity of its Coast Salish design, Kalbfleisch foregrounds how the bentwood box was used at the TRC events not for traditional purposes of holding sacred regalia, but as "a pan-Indian tool of reconciliation" (286).

We end with a conversation between Dylan Robinson and Wuikinuxv / Klahoose / Gwa'sala-'Nakwaxda'xw artist Bracken Hanuse Corlett, whose piece *Giants Among Us* we are hugely honoured to have on the cover of this book. Hanuse Corlett describes the way in which his artistic practice has functioned in part as a mechanism to address the history of residential schools within his own family—and also the contemporary discourse of reconciliation, particularly in Vancouver. "I didn't accept the residential school apology," he reminds us; instead, he continues to challenge the premise of reconciliation, noting both its Catholic connotations and also the reality that "[i]t is hard to reconcile when one side is still exerting control over you" (312). Drawing on Northwest Coast traditions in powerfully contemporary and political ways—for instance, painting Dzunuk̓wa, the wild woman, beheading Stephen Harper as part of the show *Offical Denial: The Art of the Apology*, Hanuse Corlett reminds us that the effects of residential schools are ongoing, that the concept and practice of "reconciliation" must be continually interrogated and reimagined, and that art—aesthetic action—is the ideal mechanism through which this can occur.

When considered as a whole, these essays demonstrate how the idea of "broken windows" invoked at the Québec National Event hardly refers to an isolated incident of vandalism; instead, it signals a larger *systemic and ongoing* problem requiring a variety of actions for repair—though, in truth, that possibility may remain distant while Canada continues its efforts, both insidious and overt, to demolish the houses of Indigenous nationhood. As the TRC's summary report asserts, "The way we govern ourselves must change. Laws must change.... Thinking must change. The way that we talk to, and about, each other must change" (*Honouring the Truth* 364). The aesthetic actions discussed within this volume will, we hope, contribute to this transformation by compelling readers to engage in thinking through and beyond official practices of reconciliation—not only in the mind, but in the body, that "resonant chamber" (Morin, this volume 71). We

remain hopeful that, from this place of deepened understanding, those on either side of the glass might one day be able to envision remedial actions that constitute more than window dressing.

Notes

1 This is a paraphrase.
2 Quoted from an unpublished interview by Jonathan Dewar.
3 For example, the landmark 2014 Supreme Court of Canada decision *Tsilquot'in Nation v. British Columbia* delineates the mechanism whereby Canada may "justify overriding the Aboriginal title-holding group's wishes on the basis of the broader public good" (*Tsilquot'in* para. 77).
4 Decolonization, note Eve Tuck and K. Wayne Yang, needs to be literal rather than only metaphorical: "When metaphor invades decolonization," they note, "it kills the very possibility of decolonization; it recenters whiteness, it resettles theory, it extends innocence to the settler, it entertains a settler future" (3).
5 Brian Massumi calls such small aesthetic shocks "micropolitics." In a similar vein, Diamond in this collection points toward song performance as acts of as "micro-sovereignty."
6 See Dylan Robinson's discussion of one example in this volume (58–59).
7 We are particularly indebted to Jennifer Henderson and Pauline Wakeham's special issue of *English Studies in Canada (Aboriginal Redress)* and their meticulous volume *Reconciling Canada: Critical Perspectives on the Culture of Redress*, as well as to the Re:Works in Progress project coordinated by Sophie McCall, Jonathan Dewar, Ashok Mathur, Trina Bollam, and Steve Loft, with its resultant stunning collection *The Land We Are: Artists and Writers Unsettle the Politics of Reconciliation* (edited by Gabrielle L'Hirondelle Hill and Sophie McCall).
8 These data are drawn from *The Survivors Speak: A Report of the Truth and Reconciliation Commission of Canada* (2015).
9 Despite the restrictions of the IRSSA, the TRC's summary report and ninety-four calls to action have boldly and importantly situated the schools and the task of reconciliation within a broader context of historic and contemporary colonial transgressions. As the summary report states, "Canada's [current] child-welfare system has simply continued the assimilation that the residential school system started" (*Honouring the Truth* 186). The calls to action therefore demand that Canada attend to this problem, as well as to other contemporary injustices facing Indigenous people, such as systemic violence against Indigenous women. It also acknowledges that "[n]ot all Survivors of residential school abuse were included in the Settlement Agreement. For example, day school students, many Métis students, and pupils from schools in Newfoundland and Labrador have been excluded, as have students who attended

government-funded schools that were not identified as residential schools. These exclusions have led to new civil lawsuits against the government" (216–17), such as the class-action lawsuit of residential day-school students now underway ("Tk'emlups"). Meanwhile, activists continue to identify and seek redress for other assimilative initiatives—including the Sixties Scoop, "Indian hospitals," and the criminal justice and corrections system ("Aboriginal Sixties Scoop"; "Former Patients"; Jacobs 1–8).

10 See, for instance, the video recording held at the National Reserch Centre "It Matters to Me" town hall sessions, in which non-Indigenous audiences exhibit interest in significant support for the "healing" of survivors, but markedly less interest in taking responsibility for challenging contemporary colonial and assimilative initiatives. For a critical reading of the "It Matters to Me" forum in the context of friendship, see Robinson, "Feeling Reconciliation, Remaining Settled."

11 Such contemporary perspectives include "social aesthetics" (Highmore), the "politics of aesthetics" (Panagia, Rancière), and "practical aesthetics" (Bennett).

12 See, for example, the work of Kupfer, Tuan, Katya, and Saito.

13 See Latham.

14 See Berleant.

15 See Leggat, who traces the critiques of the term "postcolonial" by authors including Thomas King and Lee Maracle.

16 See in particular Jodi Byrd and Michael Rothberg's introduction "Between Subalternity and Indigeneity: Critical Categories for Postcolonial Studies"; Robert Warrior's "The Subaltern Can Dance, and So, Sometimes, Can the Intellectual"; and Glen Coulthard's engagement with Fanon and Nietzsche in *Red Skin, White Masks*.

17 As Naomi Angel noted in one of our meetings, the term "reunion" was often used by survivors gathering for the Inuvik event.

18 See Dominic LaCapra's *Writing History, Writing Trauma*.

CHAPTER 1
Imaginary Spaces of Conciliation and Reconciliation: Art, Curation, and Healing

David Garneau

The oil painting *Aboriginal Curatorial Collective Meeting* (2011) is an attempt to picture my memory of an event without violating the privacy of those who were there. The canvas is composed like a comic-book page. However, the panels do not show people or scenes and do not follow a conventional narrative sequence. They are arranged circularly, without a clear beginning or end, and are populated only by empty speech bubbles and the coloured spaces between them. The bubbles have varying flesh tones and are meant to stand in for specific Indigenous persons. Knowing the conventions of comics and meetings, I hope viewers will read argument, agreement, frostiness, overlapping dialogue, shared and evolving ideas, and innumerable other things into these shapes and thereby get a sense of the scene. I also imagine that many will feel frustrated that their comprehension is restricted.

The painting is a mnemonic device. It reminds me of the relationships, exchanges, and affect of a moment. Most importantly, it allows me to show what happened without giving anything away. I wanted to memorialize the fact that this event occurred, but I did not want to betray its full content. What I will now[1] explain is that the picture describes a crisis. During an Aboriginal Curatorial Collective symposium at the National Gallery in Ottawa in 2011, a non-Indigenous academic championed the art of an Indian residential school survivor, Mohawk artist R.G. Miller-Lahiaaks. Some in the audience were uncomfortable from the start. Was it because the presenter was white and the artist absent? Perhaps, but it could also be that the crowd was sensitive to his lack of sensitivity. The talk peaked with a comparison of the effects of Indian residential schools to flesh-eating disease, complete with photographs. It was offensive, particularly to the survivors present. Oblivious and confused, the man was ushered from the building. The event gathered Indigenous and non-Indigenous folks, but following this incident a group of Indigenous people removed

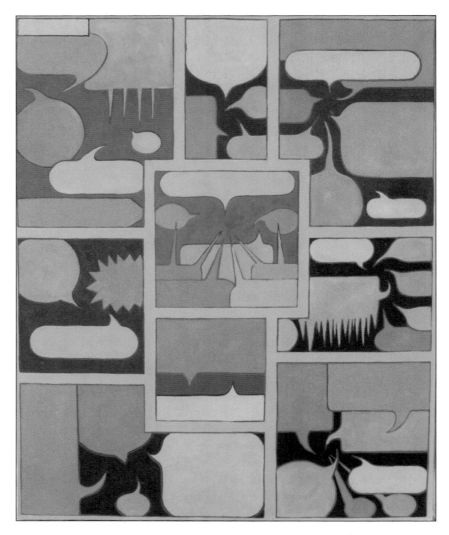

Figure 1.1: *Aboriginal Curatorial Collective Meeting*, David Garneau (oil on canvas, 5' x 4', 2012).

themselves to a separate room to comfort a senior artist and survivor and to figure out what had happened and what should happen next. Later, the main room was cleansed with smudge and song and the symposium resumed.

There is no need to detail this incident further. It is only one example that hints at the challenges of conciliation in the curatorial and academic arena.

One lesson: while decolonization and Indigenization is collective work, it sometimes requires occasions of separation—moments where Indigenous people take space and time to work things out among themselves, and parallel moments when allies ought to do the same.

A second lesson: the professor in question, Neal Keating, is not a curator but an anthropologist who, perhaps out of a sense of justice, felt the need to play the part of a curator. Presumably, he determined that his need and interest, his compassion, were enough to qualify him to stride into this complex discourse. That he played a curator before an international gathering of Indigenous curators was audacious and symptomatic of larger concerns about white, colonial, professional privilege.

The colonial attitude is characterized not only by scopophilia, a drive to look, but also by an urge to penetrate, to traverse, to know, to translate, to own and exploit. The attitude assumes that everything should be accessible to those with the means and will to access them; everything is ultimately comprehensible, a potential commodity, resource, or salvage. The academic branch of the enterprise collects and analyzes the experiences and things of others; it transforms story into text and objects-in-relation into artifacts to be catalogued and stored or displayed. The primary sites of Indigenous resistance, then, are not the rare open battles between the colonized and the dominant but the everyday active refusals of complete engagement with agents of assimilation. This includes speaking with one's own in one's own way, refusing translation and full explanations, creating trade goods that imitate core culture without violating it, and refusing to be a Native informant.

This chapter examines Indigenous refusal, particularly why many Indian residential school survivors do not participate in "Canada's Truth and Reconciliation Journey," and how this non-compliance signals the need for forms of representation outside of the current Reconciliation narrative. I will outline how Indigenous resistance to the reconciliatory gaze can inform the development of sovereign display territories. But this essay also looks to possibilities other than separatism, to the development of non-colonial, Indigenous/non-Indigenous curatorial projects and academic and artistic collaborations beyond the project currently known as Reconciliation.[2]

The sanctioned performance of Reconciliation is foundationally distorted. Testimony produced for the Truth and Reconciliation Commission (TRC) is constrained by non-Indigenous narratives of healing and closure;[3] by Western religious ideology (the Catholic rite of

reconciliation and Christian concepts of forgiveness); by an emphasis on individuals over communities; by the public display of victims but not perpetrators; and by the degrading and corrupting influence of cash-for-testimony. As a result, not all stories are welcome in these official sites and not everyone is interested in engaging in this often humiliating theatre. If artistic and curatorial practices that are critical of this structure or that emerge out of experiences and ways of working and being that cannot be accommodated or contained within the TRC's display mechanisms are to find room for expression, those spaces must be articulated outside of an assimilationist frame of mind.

For reasons I will soon explain, we can begin by reframing the contemporary dialogue between Indigenous and non-Indigenous people as one of *conciliation* rather than reconciliation. Thinking, making, collaborating, and exhibiting within sites of perpetual conciliation has the potential to transform rather than contain. A goal of non-colonial curatorial and art practices is to make room for the production and reception of Indigenous experience and expression apart from the dominant discourse. De-, anti-, and post-colonial practices are reactive; they directly challenge colonization and racism. Non-colonial practices seek to recover and perpetuate pre-contact culture. Other forms of non-colonial practice struggle to describe or perform new ways of being that are cognizant that a return to pre-contact conditions is impossible and that total assimilation into the dominant ideology is unacceptable (cultural genocide). Recently, there are performative dialogues—for example, among First Nations artists and "new" Canadian artists—that shift emphasis from themes of oppression and resistance to the production of generous moments of empathy and agreement beyond conventional Native/settler binaries.[4] In each case, the goal is to resist and transform colonial ideology and behaviour. This change is not for the Indigenous alone. In environments of perpetual conciliation, non-Indigenous people struggle with their inheritance of privilege, unlearn the colonial attitude, and work toward non-colonial practices.

Sacred/Things

In "Altars of Sacrifice: Re-membering Basquiat," bell hooks explains that the young African-American artist Jean-Michel Basquiat's (1960–1988) paintings are like "a wall between him and the established art world." His works are "a barrier," "designed to be a closed door," and "like a secret chamber that can only be opened and entered by those

who can decipher hidden codes." His art is closed to the "Eurocentric perspective" (hooks 36) and is fully available only to those who share like experiences with the works' creator. The codes are not just signifiers that can be read into denotative signs by a competent reader, though that is an important aspect. They also have empathetic undertones in tune with the felt relationships and wordless understandings shared by members of a culture.

Every culture circulates around a set of objects and spaces that are beyond property and trade. They are the national treasures, sacred sites and texts, symbols that are a community's gravitational centre. The objects and their protection define the culture; they hold its many parts in orbit. The colonial attitude, the state of mind required to assume control over the space, bodies, objects, trade, and imaginaries of others, begins by refusing the living, relational value of these entities.

This is done in one of two ways. Either the colonist refuses the sacred character of the object or site because it derives from a metaphysical system that it rejects in favour of its own cosmology, or, in a recent and more sensitive version, materialist scholars recon the *semiotic* value of sacred objects but fail to experience their *symbolic* value. That is, they recognize the object's value *for believers* but not for themselves. Because of their objectivist creed and position as outsiders, materialist scholars do not *know* the essential, sacred qualities of these entities from within the believers' lived experience. You can, for instance, read many wonderful books about Aboriginal art by non-Indigenous writers and receive anthropological insights, learning about the history, sociology, economics, political meanings, and occasionally the aesthetics of these works, but it is rare for such texts to include, for example, subjective engagement with an Indigenous object. Narratives about how one feels with these things, how one "was moved, touched, taken to another place, momentarily born again" (hooks 35), are either not included because they are not experienced or, more likely, excluded because such confessions lie outside of the objectivist discourse of these disciplined texts. Such writings keep the first person (author) at a distance from the First Nations artwork. hooks argues that if critics (in her Basquiat example) are "unmoved, they are unable to speak meaningfully about the work." The "meanings" she alludes to are those felt values, communal affects, and metaphysical knowing that lies beyond measure.

If the metaphysical qualities of these things are not recognized as essential properties, as facts, then they suddenly become available for appropriation. Desacralized, the medicine bundle, mask, song, story,

territory, et cetera, become mere real things that have ascertainable market value or academic worth. However, this reconceptualization works only if in the background lurks an authority backed by the threat of force. Through the alchemy of the colonial imagination, combined with brute power, sacred and cultural objects are transmogrified into commodities, melted for their gold value or collected for their artifact or art value. (By "art" I mean the recent, modernist, Western sense of objects having "universal," and therefore no longer local, value—creations that are expressions of humans and therefore belong to all of humankind, though collected and administered only by those who are properly trained in the correct, humanist tradition.) The desire of the colonist is directed not just at appropriating these material things, but to displacing their local symbolic value. This decontexualization erodes the culture by removing the gravitational centre. The same operation happens when Indigenous lands are converted by colonists from a sacred and eternal relationship with the people into property separable from the people.[5]

In response to voracious traders, Indigenous cultures have since contact devised ingenious ways to protect their sacred things from appropriation through the use of screen objects. In Freudian psychoanalysis, screen memories are seemingly insignificant and incomplete memories that both suggest and conceal meaningful but repressed content. In order to satiate settler cravings for their sacred objects, Maori, Haida, indeed all Indigenous people, produced—and continue to produce—trade goods. Screen objects resemble the sacred things they imitate but do not include their animation. These sculptures, masks, and garments have the patina of the originals but none of the meaning, ritual, or context. They are cultural artifakes—reasonable facsimiles designed for others and to give nothing essential away. The hope is that colonizers might settle for the appearance and leave the essential undisturbed. My favourite example comes from the Haida who carved argillite to look like authentic ceremonial pipes, only the holes in the bowl and stem did not meet. Visitors bought signifiers of Haida culture but could not enjoy full use.[6]

Irreconcilable Spaces of Aboriginality

Aboriginal Curatorial Collective Meeting is part of a series of paintings that visualize Indigenous intellectual spaces that exist apart from a non-Indigenous gaze and interlocution. The idea is to signal to non-Indigenous spectators the fact that intellectual activity is occurring with-

out their knowledge; that is, "without their knowledge," as in without their being aware, and "without their knowledge" in the sense of intellectual activities based on Native rather than Western epistemologies. I think of these as irreconcilable spaces of Aboriginality.

Irreconcilable spaces of Aboriginality are gatherings, ceremony, nêhiyawak (Cree)–only discussions, kitchen-table conversations, email exchanges, et cetera, in which Blackfootness, Métisness, and so on, are performed without settler attendance. It is not a show for others but a site where people simply are, where they express and celebrate their continuity and figure themselves to, for, and with one another without the sense that they are being witnessed by people who are not equal participants. When Indigenous folks (anyone, really) know they are being surveyed by non-members, the nature of their ways of being and becoming alters. Whether the onlookers are conscious agents of colonization or not, their shaping gaze can trigger a Reserve-response, an inhibition or a conformation to settler expectations.

Anthropologist Audra Simpson argues that racialization attempts to turn Indigenous people into knowable subjects for white settlers who themselves are less knowable. Individual Mohawks, however, described to her a much less settled sense of themselves:

> There seemed rather to be a tripleness, a quadrupleness, to consciousness and an endless play, and it went something like this: "I am me, I am what you think I am and I am who this person to the right of me thinks I am and you are all full of shit and then maybe I will tell you to your face." There was a definite core that seemed to reveal itself at the point of refusal and that refusal was arrived at, of course, at the very limit of the discourse. (Simpson 74)[7]

The racializing project assumes that Indigenous persons can be recognized, identified, described, and contained, that they are complete and can therefore report identity facts to an ethnographer because they know themselves. However, in real life, people, including Indigenous persons, experience themselves less as fixed subjects and more as having multiple and flexible identities—that is, when asked to identify only as themselves.

Within the frame of individualism and race, this argument makes sense, but the phenomenon is less evident when culture and colonialism are considered. Colonizers construct race as a means of producing a hierarchy of humans of which the colonizer's own "race" is deemed to be at the top and the colonized beneath them. This ideological tool

is then used as justification for the "superior" beings to invade, own, exploit, and cultivate. While race is fluid and can be enacted nearly anywhere, colonization is bound, like the people it threatens to overwhelm, to specific bodies and lands. While people are as unsettled as Simpson describes, when interrogated as individuals, in the moments when they recognize themselves as independent beings nevertheless also bound within kinship groups, connected worldviews, histories, and territories, they participate in a more settled shared identity. There is an individual "definite core" that hardens in the face of interrogation, but there is also a collective "definite core" that emerges when people perform themselves as a group.

This is not to imply that in these spaces our identities are suddenly resolved and constant. These are sites of epistemological debate. In the exchange of stories, gestures, touches, thoughts, tears, and laughter, the nature of, say, Métisness is subtly tested, reconsidered, provisionally confirmed or gently reconfigured, composed, and played in rehearsal. Participants engage in a continuous assessment of their status and other meanings, but these negotiations are performed in relation to like others. The codes are different from the mainstream and people are not "Other" in these spaces. When people gather *as a people* they act not only as individuals but also as part of that group— they are, there, Ojibwe, or Indigenous artists, or whatever, different from what they are when they perform themselves for dominant others. The absence of settlers acting as settlers makes these spaces less a matter of race than of culture, less about Indianness than being, for example, Anishinabeg.

This is a delicate matter. Non-Indigenous friends, colleagues, and collaborators who have long worked to raise awareness, to create opportunities, to rethink art and exhibitions, the academy, and ideas of Canada, and are themselves other-wise, are essential to these struggles. They are front-runners who risk a great deal to be allies and work toward justice and fundamental change. However, they know that the lived complexity of Indigeneity exists beyond their presence as surely as the inhabitation of white privilege, or Koreanness, or Swedish immigrantness, is incompletely available to Native people.

That said, these boundaries are not absolute but a matter of degree. Surely a second-generation Canadian of Korean ancestry who lives in Nunavut and speaks fluent Inuktitut can be said to participate in Inuit life in a more engaged way than the catch-all words "settler" or "non-Indigenous" imposes. A purpose of anti-racist work is for settlers to learn more about their hosts and hosts to know more about their

guests, to move through proximity, listening, empathy, cooperative inquiry, and action to a state of racial confusion. Settlers who become unsettled—who are aware of their inheritance and implication in the colonial matrix, who comprehend their unearned privileges and seek ways past racism—are settlers no longer. It is not that these folks have "gone Native" (though intercultural adoption and honorary citizenships are traditional possibilities!), but they have become respectful guests, which in turn allows Indigenous peoples to be graceful hosts.

Among the subjects shared in irreconcilable spaces of Aboriginality are aspects of the Indian residential school legacy that are discouraged from disclosure in TRC events, such as rage; the refusal to forgive; the naming of names; the details of intergenerational effects; the use of Indigenous people in these schools to oppress their own; the (de)formation of masculinity there; discussion of what happened to the payout money and how it distorts individuals, families, and communities; the role of public schools in the program of aggressive assimilation; the Métis who were also subjects of these places;[8] and so on.

Many residential school survivors will not tell their stories to the Truth and Reconciliation Commission. Some have not and will never speak of such things even within the safety of autonomous Indigenous spaces. As Alex Janvier writes on the back of his painting *Blood Tears* (2001), "Many, many died of broken bodies. Many, many died of twisted conflicting mental difference. Most died with 'broken spirit.' Some lived to tell about it. The rest … permanently, 'live in fear.' The rest will take their silence to their graves as many have to this day."[9]

For some, the trauma visited upon their young minds and bodies is a private matter, or, rather, these profound dislocations and violations created an impenetrable private space, a "twisted conflicting mental difference."[10] It made of their minds an asocial space of shame and despair, a disassociation seemingly beyond both Indigenous and dominant culture community. For others, hints of these experiences are shared in irreconcilable moments; that is, not as confessions designed to be reconciled in the sense of being smoothed over or brought into public agreement. They are open wounds shared with intimates for complex and inconclusive reasons. They are not for general consumption; they are not subjects of analysis. Their listeners are not only witnesses but are often intergenerational co-survivors of Indian residential schools and other forms of aggressive assimilation. All this lies behind the play of representations circulated in the theatre of national Reconciliation.

The extraordinary people who do share their Indian residential school experiences with Canadians as part of the TRC sessions do so for many reasons: to speak the truth, to witness, to heal. I do not wish to offend these folks, but I do want to discuss a peculiar aspect of the display mechanisms they are caught up in.

Conciliation or Reconciliation

Conciliation is "the action of bringing into harmony." It is an extra-judicial process that is a "conversion of a state of hostility or distrust; the promotion of good will by kind and considerate measures" and "peaceable or friendly union."[11] The word calls to mind the meeting of two previously separate parties in an amicable process. Reconciliation is a seeming synonym with a difference. *Re*-conciliation refers to the repair of a previously existing harmonious relationship.[12] This word choice imposes the fiction that equanimity was the status quo between Indigenous people and Canada. It is true that for many generations after contact the Indigenous majority had good trading relationships with some Europeans as individuals rather than nations. The serious troubles began when the visitors decided to become settlers, when traders were replaced by ever-increasing waves of colonists, when invading nations decided they would rather own the well rather than just share the water, and they reached a crescendo when these territo-ries became Rupert's Land and then Canada without consultation with the original inhabitants.

The problem with the choice of the word "reconciliation" over "conciliation" is that it presses into our minds a false understanding of our past and constricts our collective sense of the future. The word suggests that there was a time of general conciliation between First Nations, Inuit, and Métis people and Canada, and that this peace was tragically disrupted by Indian residential schools and will be painfully restored through the current process of Re-conciliation. This imag-ined conciliation before Re-conciliation probably does not refer to the moments of cooperation scattered here and there over several cen-turies after contact but rather to the post-Confederation numbered treaties between the Crown and many First Nations. However, while extensive, these agreements do not include everyone. Most of British Columbia, Quebec, and eastern and northeastern Canada is not cov-ered by treaty, and Métis are not treaty people.

Treaties are very important, but their uneven nature and their continuous violation trouble any notion of a prior universal resolution between Indigenous people and Canada. The constant repetition of the word "reconciliation" creates a screen for the content conciliation, which is a present wish that there truly was a past comprehensive settlement in order that the future can be bearable. The actual settlement was not an agreement between First Nations and Canada, it was not the treaties and was not conciliatory, but it was universal—it was the imposition of the Indian Act (1876).

The first line of the TRC's "Our Mandate" web page reads: "There is an emerging and compelling desire to put the events of the past behind us so that we can work towards a stronger and healthier future."[13] The text does not explain whose desire this is. If read as colonial desire, then Reconciliation is a continuation of the settlement narrative. The word conjures images of halcyon moments of conciliation before things went wrong as the seamless source of harmonious national origin. This imaginary constructs the Indian residential school era as an unfortunate deviation rather than just another element of the ongoing colonial struggle to contain and control Native people, territories, and resources. The present colonial "desire" is to "put the events of the past behind us" and reconcile Indigenous people with this narrative.

Anti- and non-colonial cultural workers, however, ought to reconsider the Reconciliation project. Rather than accept the idea that there was a prior period of conciliation, we recognize the fact that the need for conciliation is perpetual. Conciliation is an ongoing process, a seeking rather than the restoration of an imagined agreement. The imaginary produced within Reconciliation emphasizes post-contact narratives: the moment of conciliation settled as if it were a thing rather than a continuous relationship. This construction anesthetizes knowledge of the existence of pre-contact Native sovereignties and creates in the minds of many the sense that Indigenous people are simply a minority interest group rather than partners who make Canada possible, or peoples who want independence from the colonial nation that has been imposed upon them.

Especially from the point of view of the Indigenous leaders who signed them in good faith, treaties were nation-to-nations conciliations. Treaties recognize the pre-existing and ongoing sovereignty of the conciliating parties. This understanding is eloquently figured in the two-row treaty wampum belts:[14] two boats—for example, a British

ship and an Iroquois canoe—go down the river of life together but do not touch, do not try to steer each other's vessel. Two communities live parallel to each other and trade, but do not violate each other's space and customs. Two states, acting as states, can establish a neutral space of negotiation between their communities in which treaties are established as living agreements, in relationships that do not compromise each other's core spaces. Conciliation is not the erasure of difference or sovereignty. Conciliation is not assimilation. However, because treaties were not entered into in good faith by the colonizers, but were conceived as non-violent means to subdue Indigenous people in order to occupy their land, we ought to reconsider their conceptual value as the firm or only basis for present relations. The treaties are historical facts, but honouring them requires a continuous relationship, which includes interpretation, reinterpretation, and renegotiation. This is a perpetual conciliation. My argument is that the present Reconciliation narrative should be recast as a continued struggle for conciliation rather than for the restoration of something lost (that never quite was).

Reconciliation implies a very different imaginary than conciliation, one that carries such profound affective and historical meanings that it seems a deliberate tactic in the ongoing assimilationist strategy of the Canadian empire.[15] Whether the choice of this word is an accidental inheritance or not, it is ironic, if not sinister, that survivors of religious residential schools, especially Catholic ones, are asked to participate in a ritual that so closely resembles that which abused them.

As someone raised Catholic—my uncle is a bishop, my aunt is a nun working in inner-city Edmonton, and my stepfather was a former Jesuit priest—I cannot help but notice an ironic religious nuance in the choice of the word "reconciliation" rather than "conciliation" in "Canada's Truth and Reconciliation Journey."[16] In its religious context, reconciliation is "the reunion of a person to a church."[17] Reconciliation is a sacrament of the Catholic Church. It follows confession and penance. According the Vatican, "Those who approach the sacrament of Penance obtain pardon from God's mercy for the offense committed against him, and are, at the same time, reconciled with the Church which they have wounded by their sins and which by charity, by example, and by prayer labours for their conversion." This text is found in "The Sacraments of Healing" section of "Catechism of the Catholic Church." Reconciliation here, as in the secular colonial version, ignores pre-Catholic or pre-contact Indigenous states. It instead focuses on conversion as the site of Native origin. In sinning—or, it

seems in this case, in being sinned upon!—the penitent is separated from God and the church. Only by telling their secret to an agent of the church and engaging in penance can harmony, through atonement, be restored and the individual and church/state reconciled. Reconciliation assumes that the parties were once in harmony (through the contracts of baptism, confirmation, and communion), and only through reconciliation can the proper stasis be restored. Beyond the pale of reconciliation is the possibility that the church could be wrong. Individuals are faulty and in need of reformation, never the church. The church is a static archetype; people are imperfect beings who variously move toward or away from that perfect, Platonic universal.

This imaginary informs the secular version of "Canada's Truth and Reconciliation Journey." The relationship is individual to state, rather than the nation-to-nations or person-to-person negotiations of a conciliation or treaty model. The system requires the spectacle of individual accounts (confessions) and healing narratives (forgiveness and penance). It prefers to lay blame on its individual (mostly dead and certainly absent) members, and even then does not willingly present them for public confession and atonement. While it acknowledges that the abuses were the result of (past) systemic policy, Canada does not do anything that would risk the integrity of current dominant structures. Because the system is premised on the eventual elimination of the Indigenous, it is cautious about recognizing that it is in a perpetual relationship with First Nations, Métis, and Inuit, and so it imposes a time limit on "healing." It pays off individuals rather than recognize that harms were done not only to persons but to collective wholes. The imagined end of this restoration project is "*Canada's* Truth and Reconciliation." Truths are told, the destroyed mourned, the broken repaired, individual Natives reconciled with Canada, order restored, and the national identity endures.

You can imagine that those who were removed from their culture, language, and spiritual traditions and who were indoctrinated by religious Indian residential schools would slide rather easily into the similar confessional narratives of a Truth and Reconciliation system. And that those who retained or regained their cultural and spiritual practices are likely to be suspicious of the homology, and resist.

Cree artist, poet, oral historian, and theorist Neal McLeod explains that there is no equivalent in the nêhiyawak (Cree) language for the Western notion of an apology. The closest phrase to "I am sorry" is *nimihtatân*, which means "I regret something." McLeod explains that the word used in reference to the Indian residential school experience

is *ê-kiskakwêyehk*, which means "we wear it."[18] This is a profound difference. It is visceral rather than abstract. It describes a recognition and acceptance worn on the body. The experience is not given the intangibility of a truth but the concrete reality of a fact.

At the Montreal TRC event (2013), Indian residential school survivors were encouraged to "tell your truth." This format allows for the presentation of experience as it was lived rather than having such descriptions regulated by the constraints of legal evidence. Nevertheless, there were legal restrictions. Truth-telling was not to include the naming of individuals and institutions associated with wrongdoing "unless such findings or information has already been established through legal proceedings."[19] Truths were to be accounts of subjective experience, feelings, and perceptions, rather than the relating of facts. This may seem a subtle distinction, but in performance it means that recorded testimonies threaten to become literature rather than evidence. That is, the testimonies have no legal standing; claims will not be followed up by investigations and convictions. They are legacy documents that will be emotionally moving to some future readers, and material for academics. That is the design, anyway. Who knows what creative folks might yet do with them.

To be fair, the Truth and Reconciliation Commission, and especially the Aboriginal Healing Foundation, has developed into a complex and responsive organism that has permitted multiple anti- and non-colonial possibilities—for as long as the government entertains them. Both organizations have established numerous sites apart from state monitoring. And the public airing of the outlines of these facts, the government apology, and the work of the commission have encouraged many to discuss things that they might not have otherwise. Questions remain, however: How are we to change sites of Reconciliation into sites of conciliation? How do we prevent Reconciliation from being primarily a spectacle of individual pain for settler consumption and Aboriginal shame? How are artists and curators to contribute to the conciliation process?

Aboriginal Sovereign Display Territories

I am a long-time Alex Janvier fan, but my interest was primarily formal. I love his designs and appreciate his ability to create a unique synthesis of Western and Aboriginal styles. Then, in 1995, the Glenbow Museum hosted a travelling solo exhibition curated by Lee-Ann

Martin, *The Art of Alex Janvier: His First Thirty Years, 1960–1990.*[20] Instead of the usual artist talk and slide show, Janvier toured a small group of us through the exhibition. He spent over an hour and a half explaining every picture. The biggest revelation was that many of these seemingly non-objective works were in fact maps. In one, he pointed out where he lived relative to his kohkum, and where the good fishing and hunting spots were. That he invented a way to record his physical, relational, and spiritual territory in a format that could be mistaken for Modernist art was a great lesson. I love the idea that this hidden knowledge has infiltrated non-Indigenous spaces and waits patiently for its Native knowledge, the "secret chamber," to be revealed.

Janvier slowed at the end of the tour; the group had whittled to a handful. He spent a long time in front of his most recent paintings. They were about his experience in Indian residential school. They contained recognizable figures, buildings, and landscapes. Here, he did not want to abstract his messages. They were addressed beyond the space of irreconcilable Aboriginality. Even so, until he explained them, until he talked them into life, they remained oblique hints. It was the combination of visual art, embodied knowledge, and a gathering of engaged participants that made the experience significant, that made it exceed the colonial container.

Exhibitions of Indigenous art shown within a dominant culture space are always in-formed by the worldviews of the managers of those spaces. Reconciliation exhibitions held in these institutions are also likely to be designed within the colonial narrative: reconciliation rather than conciliation; the theory that public display of private (Native) pain leads to individual and national healing; text over speech; et cetera. If display spaces are to be potential sites of conciliation, they should not meet the dominant culture viewer halfway, in their space, in their way. The non-Indigenous viewer who seeks conciliation ought to enter Aboriginal sovereign display territories as guests. Imagine a keeping house located on reserve land (including urban reserves) that is managed by Indigenous people and open only to Native people of that territory. That would be an irreconcilable space of Indigeneity. Now, picture the same space, but open to any respectful person. That would be an Indigenous sovereign display territory (Garneau, "Indian to Indigenous") that could also be a space of conciliation. The first gallery would be directed to the people of the community by members of the community—a keeping house or ceremonial space. If the culture was oral, perhaps there would be no written signs or

catalogues; your experience would be guided by Knowledge Keepers. Sovereign display territories might be nearly identical but would make some concessions to outsiders. The degree of inclusion would be part of what would make these spaces interesting. These Native-managed spaces would include languages of the visitors. Many items would not be available to all visitors, but clever screen objects would be (photographs, models, replicas, etc.), so visitors would have a sense of the real without violating it. The theme of some of these spaces might be less a revelation of "authentic" Aboriginality and more a working through of how Indigenous people have changed and adapted within contact.

I imagine that such safe spaces would encourage Indigenous people to make work that spoke not only to their own people, but also to visitors. It would probably value (local) meaning over Western notions of (universal) quality, and blur the boundary between art and artifact. However, because it is engaged with the larger world, rather than being primarily a keeping house that preserves objects and encourages customary practices, it would also function as a cultural lab where artists would struggle creatively with the contemporary world as well as with traditional forms.

Some people might not want to share their experiences of Indian residential school because the sites of Reconciliation administered by the TRC are temporary. Knowing that an Indigenous sovereign display territory is permanent and includes visual and tactile objects that are activated by embodied knowledge (their makers and others talking about them)[21] would encourage a slow unfolding of truths. Capital *T* Truth in Canada's Truth and Reconciliation is a Platonic form designed not to be achieved in this vale of tears. These sites, like the Holocaust museums, have a more modest goal. Because no master narrative could contain these events, their designers elect to make room for both the facts and the many truths to find their form and audiences. There is no definitive story and no conclusion; there must be room, over time, for everything and everyone.

The government apology and the work of the TRC are important, but the deeper work of conciliation will be among individuals who re-cognize themselves as also other than agents of the state. Settlers visiting these permanent sites of conciliation do so as individuals who are conscious that their institutions perpetrated systematic abuses designed to assimilate or destroy Aboriginal people so they could take their land. To use the Catholic metaphor, forced assimilation is the original sin that made Canada possible. This is the settler's

inheritance and the immigrant's burden. And here is where I lose my faith, or at least stretch the metaphor until it snaps. Colonialism is not a singular historical event but an ongoing legacy—the colonizer has not left. The sin cannot be expiated. There is no Redeemer in this situation. An apology and cash payments will not absolve the stain. The government's frantic race to a post-historical space of reconciliation, rather than submission to a permanent state of negotiation, of treaty, is short-sighted.

Living Apology

So, what roles can non-Indigenous cultural workers and Indigenous people who did not go to Indian residential school play in conciliation projects? The fact and impact of Indian residential schools is not only an Indigenous issue but a Canadian issue. We all have a part to play in understanding how our lives and privileges emerge from colonialism and how we might live conciliation. Living apology requires that two parties come together in full agreement of the facts. In this case, the centre of our work is to create space and opportunity for First Nations, Inuit, and Métis people to work in as many ways as they see fit, over as long a period as they require. This activity should not be cast primarily in terms of healing. More often than not, such work opens wounds rather than heals them. Curators, and others who facilitate the production and exhibition of this sort of work, must be cautious not to replicate a Truth and Reconciliation model or models of quality framed by standards of colonialism and whiteness. We must be certain that those we work with are agents and not subjects. We must especially watch that our creative partners are not participating due to economic deprivation: selling the final commodity the dominant culture is interested in accumulating, their stories.

Government ideology and funding has created a spectacle of the Indian residential school experience as a means to distract from larger issues—primarily the environment. The public theatre of individual Indigenous people in distress is a familiar dominant culture trope designed to humiliate and contain all Indigenous people. Unlike the South African Truth and Reconciliation process that counterbalanced victim presentations with scenes of individual perpetrators confessing, apologizing, and accepting punishment for their crimes, the Canadian (white and colonial) psyche could not bear such intimate exposures and the broader implications. By focusing on Indian residential

schools, the government has reduced colonialism to a soluble problem: the schools are closed, the victims are paid off, problem solved. Now, shut up. Let us "put the events of the past behind us so that we can work towards a stronger and healthier future." We need to challenge this narrative.

The core of post-TRC aesthetic practice should be the enabling of Indigenous artists to produce works that relate their individual and collective experience of colonialism and their imaginative projections into the future. This is an alternative to the confessional and instrumentalist narrative strategies of the historical, sociological, and legal/compensation systems that make up the current system. Our role is to create safe, fluid spaces where novel means of production can occur. In these spaces, Indigenous artists learn from each other, share common experiences and artistic methods, and develop collaborations, but these spaces also support these artists to make whatever they damn well wish as sovereign creative people, not as people always defined by colonialism.

The natural participants in our project would seem to be Indian residential school survivors. But, more often than not, their needs are more basic than those satisfied by exhibition art. Because the primary survivors are often so damaged, as Janvier explains, or were disenfranchised from the means of intellectual and artistic production, few are able or willing to do this work in public. More likely, it will be the generations who continue to bear this acidic legacy, intergenerational survivors[22] who may have more emotional and educational resources to do this work, who will make this history. Some will have difficulty articulating or aestheticizing their experience, and others will simply be appalled by the idea that they should be asked to do so. The shift in attention concentrates less on what happened at Indian residential schools than on what happened as a result of them. This casts the facts in the embodied present.

A second project emerges from the first and can occur simultaneously, as long as the facts of Indigenous experience and the truths about Canadian colonial history are first seen, heard, and agreed upon to the reasonable satisfaction of the Indigenous collaborators. Such work should not be *about* Indigenous people, but a study *with* Indigenous people. Allies must understand the historical and embodied facts to the satisfaction of the First Peoples they hope to work *with*. However, even before such engagements, non-Aboriginal people should first examine—among themselves—their motives and be able to explain their need to engage in this work.

I think we should not be in such a rush to let our words imagine a reconciled, healed future. Our focus should be on creating the conditions that engender the sharing of facts in forms that cannot be as easily appropriated, measured, and contained. I feel that this work will be its own reward, that people will be transformed by the process. Not only will new relationships and knowledge be forged, but new works will also be produced: performances, texts, works of art that will all require decoding and resist decoding, and in future such readings will engender further personal transformations.

Art is not healing in itself, but it can be in relation. Art is a stimulant and a balm when taken internally, but dangerous if mistaken for experience. There is a profound difference between reading signs and being engaged by a symbol. Sharing in a discourse about histories, responsibility, and transformation among artworks and with other human beings is a corrective to the colonial desire for settlement.

The painting at the start of this essay, *Aboriginal Curatorial Collective Meeting*, tries to picture irreconcilable spaces of Indigeneity without giving away any content. I want to signal that something interesting is going on beyond the colonial gaze. At the same time, by using dominant culture vernacular, I want to show that what happens in these spaces is very like what happens in similar spaces but with different people. While the core of Indigeneity is incompletely available to non-Native people, those who come to spaces of conciliation not to repair "Indians" but to heal themselves, who come not as colonizers but with a conciliatory attitude to learn and share as equals, may be transformed.

Notes

1 This chapter is an elaboration of a talk delivered at "Reconciliation: Works in Progress Symposium and Artistic Incubation" at the Shingwauk Residential Schools Centre in Sault Ste. Marie, September 2012, at the invitation of Ashok Mathur and Jonathan Dewar. An earlier draft was published as "Imaginary Spaces of Conciliation and Reconciliation: Art, Curation and Healing," *West Coast Line: Reconcile This!* 74 (2012): 28–38. http://reworksinprogress.ca/wp-content/uploads/2012/08/wcl74h.pdf. I am grateful for the help of Ayumi Goto and Keavy Martin, whose editorial comments and questions helped guide the text toward greater clarity.

2 When the word "reconciliation" is capitalized in this essay it refers to the use and sense of the word prescribed by "Canada's Truth and Reconciliation" project. Among the several projects attempting to work past

the TRC aesthetic limitations are Ashok Mathur's work at the Centre for Innovation in Culture and in the Arts in Canada, including gatherings of Indigenous/non-Indigenous artists to in the "Reconsidering Reconciliation" project. Another related project is "Beyond Reconciliation: Indigenous Arts and Public Engagement after the TRC," a five-year (2013–2018) Social Sciences and Humanities Research Council (SSHRC) project that includes Keavy Martin (principle researcher), Ashok Mathur, Jonathan Dewar, Dylan Robinson, Steve Loft, and me.

3 See TRC, "Our Mandate," accessed August 21, 2013.

4 An especially good example is the collaborative performances of Ayumi Goto and Peter Morin: http://www.youtube.com/watch?v=6-EhhdYC6Hg and http://www.youtube.com/watch?v=0P3YM45GKVA.

5 Discussions of Indigenous anything must always consider the colonial interest in the land as property. While very early colonization of Turtle Island sought the labour of Indigenous peoples, this was soon abandoned for a concentration on settlement and mass exploitation of natural resources. As a result, the disposition of much thinking about Aboriginal people and their things is coloured by property concepts.

6 I am indebted to Carol Sheehan's exhibition *Pipes That Won't Smoke, Coal That Won't Burn*, 1983.

7 Thank you to Keavy Martin for this reference.

8 Neither I nor members of my immediate family went to Indian residential school. I am Métis from Edmonton, and descend from there, St. Paul des Métis, and Red River. Relations may have gone to the residential school built at St. Paul in 1898. If they did, it wasn't for long. It was burned to the ground—by some of the attendees, I'm told—in 1905.

9 Janvier, *Blood Tears* (painting) xi, Plate 1.

10 Janvier xi. These points, from the earlier draft of this paper, were twice cited in *Honouring the Truth, Reconciling for the Future: Summary of the Final Report of the Truth and Reconciliation Commission of Canada*: "The Challenge of Reconciliation," 280–81.

11 "Conciliation." *The Compact Edition of the Oxford English Dictionary,* 21st ed. (1981).

12 "To bring (a person) again into friendly relations *to* or *with* (oneself or another) after an estrangement." Also, "to purify (a church, etc.) by a special service after a profanation." "Reconcile." *The Compact Edition of the Oxford English Dictionary,* 21st ed. (1981).

13 Accessed 21 August 2013.

14 See "Two Row Wampum Treaty."

15 Canada is a modern empire in that it rules over a vast geography composed of numerous ethnically, linguistically, and culturally diverse (First, Inuit, and Métis) Nations.

16 This is a reference to the image used in the title of an Aboriginal Healing Foundation book: *Response, Responsibility, and Renewal: Canada's Truth and Reconciliation Journey.*

17 *The Compact Edition of the Oxford English Dictionary,* 21st ed. (1981).

18 Neal McLeod, poetry reading at the Saskatchewan Writer's Guild, Regina, Saskatchewan, 4 May 2012.

19 TRC, "Our Mandate" sec. 2f. Accessed 21 August 2013.
20 22 April–17 June 1995 at the Glenbow Museum, Calgary.
21 These spaces would not simply be containers for dead things but rather sites of living exchange. Indigenous aesthetics are inseparable from pedagogy and other aspects of life. The objects are not to be separated from use and relegated to the eye; they are part of a circuit of object, maker, and participant. This includes touch and the unfolding of the work's meanings by either the artist or someone she or he has gifted with this responsibility.
22 Acknowledging that the effects of residential schools extend far beyond those who attended them, TRC documents include numerous references to the "legacy" of residential schools. However, this fact is not acknowledged by the compensation agreements, which exclude intergenerational survivors.

CHAPTER 2

Intergenerational Sense, Intergenerational Responsibility

Dylan Robinson

We come to know the world through our senses. Our early memories are full of colour, texture, hue, and smell: skinned knees against pavement, a breeze of sun-warmed grass, pitch-covered hands. Our childhood memories are suffused with the materiality of wonder and disappointment, as well as violence and shock. Because they exist at the distance of childhood, some of these memories are less memories than imprecise textures—the feelings and impressions of past moments. We carry the spectral presence of the past in our bodies, and it is only when we encounter the likeness of the past in the present that the *thing* we have been carrying exits the body. This exit takes place through a shiver, tears, tenseness in our shoulders, smiles to ourselves. Often, an incidental cue—a passing voice, sound, or smell—can unearth a memory that exits, yet is still tethered to, the body. Tethered to memories that refuse to leave, our bodies experience sensations so powerful that they can often bring us back to moments we would rather forget. Such is the case in the memory of Barbara Johnson, who attended St. Michael's Residential School in Alert Bay, on the northernmost tip of Vancouver Island, British Columbia.

> I remember entering through the front doors, and the sound of those doors closing still haunts me when I go to places that look like … that building … when that door closes … the fear and the hurt…. Those buildings that look like it and sound like it … there's nothing you can do once you're … once you're there … once the doors shut … and you can't do nothing about it.[1] (Barbara Johnson, Port Hardy TRC public testimony, Feb. 27, 2012)

Johnson's testimony of arriving at St. Michael's is one that returns to her unbidden. The trauma of her experience reverberates, sensorially, in her present life.

Sensory memory reverberates across time not only through the bodies of residential school survivors, but also through generations of families, through communities. As a direct result of the residential schools, I did not grow up in the community my mother's family is originally from at Sqwá in Stó:lō territory. The TRC has adopted the term "intergenerational survivor" to describe those within the families of survivors who have been affected by intergenerational legacies of the schools. I do not use this term myself, though I understand the intergenerational impact of the residential schools keenly through palpable absences. Such absences are unexceptional for colleagues and friends in my generation whose indirect experience of the schools has often been waged through battles with shame, and struggles to develop healthy relationships with our families and communities. I have witnessed a pace of telling at the TRC—voices halting, seared still by pain; the time of telling punctuated by shame—that has reanimated in my own memory a host of whispered allusions, and hushed tones of refusal to speak of memories that remain too painful to be expressed. I have seen the material presence of these memories of violence, alcoholism, and abuse experienced by family members exit my mother's and grandmother's bodies through tensing voices and abrupt evasion. These memories were not given voice around family tables or at the TRC, but they claim full presence nonetheless. These absences sit alongside other vibrant memories of my childhood: tsel lhemét sqá:la, qas tsel kw'étslexw qéx híkw te sqwóqwiyel sp'áq'em.[2]

Criticism of the TRC's testimony-giving process has emphasized its orientation toward the "wound culture" (Seltzer) of consuming traumatic narratives and the Western religious model of confession (cf. David Garneau, this volume). Despite this orientation of the process toward certain expectations of performing victimry for a settler public, it is exceedingly important to note the ways by which survivors remade the TRC process as their own. In doing so we also honour the work of survivors who felt it important to share their experiences primarily with and among our families and communities. Rather than focusing on their own experiences while in the schools, a significant number of survivors used their time at TRC's national, regional, and community events to address the impacts of the schools upon their families, while affirming the current strength and vibrancy of their families in the face of this history.[3] Intergenerational survivors often chose to speak about the impact their parents' residential school experience had, and continues to have, upon their lives. Likewise, many survivors used the time allotted to them to apologize to their children

for not being able to give them the love and support that they themselves were never given, and for the forms of abuse they continued to perpetuate within their families. At the Atlantic TRC event in Halifax, Mi'kmaw Elder Iris Nicholas explained how a significant part of the learning that took place at residential school was through the behaviour modelled by teachers there:

> The Indian residential school had a tremendous effect on me. The temperament and behaviour of the nun in charge was a learned behaviour for me, the same harsh controlling behaviour they use, I use on my children. They can verify this for you. The guilt and shame I feel for the way I treated them is overwhelming at times. To overcome this feeling I remember my dad's words: "You did the best you could. Your children are here. They are good kids." (TRC public testimony, Oct. 27, 2011)

I open with these examples in order to set the stage for this chapter's focus on the centrality of sensory memory expressed by survivors at TRC events, the sensory paradigm shift former students experienced upon entering the schools, and the ways in which such memory is transmitted intergenerationally.

My intent in this chapter is to examine three sites of sensory history and sensate politics related to the history of the Indian residential schools and in Canada's Truth and Reconciliation Commission activities. I am concerned here with three ways of understanding what I call "reconciliation's senses." First, I will consider those sensory memories expressed by residential school survivors both in written accounts and at TRC events. This partial history of residential school senses seeks to better understand the non-verbal, non-representational aspects of residential school education—an education that sought to "civilize" First Peoples through repetition and rote. This repetition was enacted through daily routine—a regimen of civilization—from the repetition of prayer to the regular sounding of bells to signal the change between students' daily activities. There was also the more violent repetition of straps across the hands, of cuffs against the ears—a repetition of abuse upon students' bodies where there was failure to learn. Where the repetition of physical abuse did not teach the lesson, there was sensory deprivation—spaces without food or light, where students were confined for long periods of punishment.[4] Yet such sensory deprivation was merely the most extreme form of a new quotidian presence of absence, a systematic subtraction of those everyday moments of

singing, speaking, and touch between parents (and grandparents) and their children, and between siblings. Students were typically prohibited from interacting with their brothers and sisters who were attending the same school. Cut off from the touch of family, residential school survivors often recount an increasing sense of isolation. With the segregation between boys and girls, and between different ages, residential schools regulated contact and the haptic intimacy of touch between siblings, thus weakening bonds of kinship. The removal of daily acts of kinship and love were replaced with those of control, separation, and censorship.

Second, "reconciliation's senses" refers to the role the senses play at TRC national events and community hearings. In this context, I am most interested in two kinds of sensory engagement. The first of these involves the many forms of sensory interaction between survivors, intergenerational survivors, and witnesses, including responses to survivor testimony, and in the interactions of support between survivors. In many cases, such sensory expressions can be said to take part in different forms of reclaiming "sensory agency." To reclaim sensory agency, I argue, is to give material presence to memory previously too painful to speak of through modes of telling that both affirm cultural strength and assert an affective force upon those who are present. Witnesses, in turn, not only hear about residential school survivors' experiences, but are subject to the affective impact of the voice, of language, and time of testimony. While such visceral impacts of telling and listening to certain expressions can offer a means for survivors and intergenerational survivors to heal from trauma, we must also be aware of their equal role in the *sublimation* of redress through forms of affective over-identification. Additionally, at numerous times expressions of settler Canadian obliviousness (of residential school history, about Indigenous people) take part in the ongoing production of sensory offence, as survivors experience the slaps and jabs of continuing ignorance, denial, and abdications of responsibility offered under the aegis of "reconciliation."

While this form of oral/aural sensory experience takes place during testimony, a second kind of sensory engagement I address concerns how survivors and witnesses respond more broadly to cultural and artistic presentations that take place during TRC national events. I understand these responses to artistic events as taking part in an "aesthetics of reconciliation." This understanding of aesthetics draws upon contemporary work in "social aesthetics" (Highmore, "Social Aes-

thetics") and the "politics of aesthetics" (Panagia, Rancière) that seek to recuperate the term "aesthetics" from its fixation upon the sublime and beautiful aspects of the fine arts. Counter to the post-Kantian tradition of aesthetics, these perspectives are "primarily concerned with material experiences, with the way the sensual world greets the sensate body, and with the affective forces that are generated in such meetings" (Highmore, "Bitter After Taste" 121).

Third, "reconciliation's senses" refers more generally to a collective or national "sense" of residential school history that settler Canadians have, and the ways in which such sense might be increased. I here conclude by examining the everyday lived understanding—a "common sense," and lack thereof—that the settler Canadian public has of residential school histories and the impact these histories have upon First Peoples today. I will conclude this chapter with a proposal for ways by which the settler Canadian public might be compelled to exert a greater degree of what I call "intergenerational responsibility." I argue here that different sensory interventions might take part in a direct address to this cross-section of the Canadian public, implicating them in the intergenerational legacy that residential schools have had upon Indigenous communities today.

Toward a Sensory History of Residential Schools

Extending from 1883 to 1996, the history of residential schools is nearly as old as Canada itself. Originally called "industrial schools," the first three residential schools included Saskatchewan's Qu'Appelle, High River, and Battleford schools, and were intended to provide students with training in a variety of trades. Nicholas Flood Davin, a key figure behind the establishment of the residential schools, noted that residential school education was essential to create citizens who would "welcome and facilitate, it would be hoped, the settlement of the country" (TRC, *They Came for the Children* [*TCFTC*] 10). These first schools in Saskatchewan, like the majority of those that came after, were also deliberately located a significant distance from reserves and Aboriginal communities. In an 1883 speech to the House of Commons, Prime Minister John A. Macdonald supported this decision by claiming that "[w]hen the school is on the reserve, the child lives with his parents who are savages; he is surrounded by savages, and though he may learn to read and write, his habits and training and mode

of thought are Indian. He is simply a savage who can read or write" (*TCFTC* 6). The decision to locate the residential schools at a distance from students' home communities, then, was made with the intent not just to sever students from their cultural traditions viewed as "savage" by the church and state, but in effect to erode First Peoples' connection to their worldviews and to sever the bond between students and their families. So successful was this aim that a significant number of survivors testify to returning from residential school to feel like a foreigner in their own community, unable to communicate with family in their languages, and feeling as though they did not belong in the very home they had waited so long to return to.

Survivor accounts often narrate a dual culture shock both upon their arrival at residential school and upon their return home. As Isabelle Knockwood recounts, upon entering the Shubenacadie residential school, "My worldview or paradigm shifted violently, suddenly, permanently" and the sensory shift that accompanied her return from Shubenacadie was equally as profound: "Everything now looks different than it did before Indian residential schooling. The air smells different, the food tastes different, the sounds are different. And my outlook, my perspective on the world has changed in *every* area of my life" (TRC public testimony, Oct. 27, 2011).

Other accounts of arrival at residential school are equally as extreme. Raphael Ironstand's first impressions of the Assiniboia school in Winnipeg were that "it smelled strongly of disinfectant, and our voices echoed when we spoke. The whole place looked cold and sterile; even the walls were covered with pictures of stern looking people in suits and stiff collars" (*TCFTC* 22). Ironstand's description reflects his sense of isolation through sight and sound, an environment constituted by the absence of familial closeness and intimacy. The child calls out to the parent for love, support, and guidance, only to receive back the echo of his or her own voice. Survivors also recount how, shortly after arrival, they were brusquely stripped of their clothes, roughly bathed (in the same water used by other students who had recently arrived), and dressed in uniforms. While the girls had their hair cut to short bobs, the boys had their heads shaved. As the TRC's historical document *They Came for the Children* details, children were assigned numbers that corresponded to their clothes, their bed, and their locker. In some schools students were also expected to line up according to their numbers. As one survivor notes, "We were called by our number all the time. The nuns used to call '39, 3 where are you?' or '25, come here right now!'" (22–23).

During the TRC Campbell River community hearings, August Joseph Johnson similarly described what might be called an institutional sense of place. "I remember walking into that building," he said, "… it was … it was like the smell of the hospital. That's the first thing that came to me was that smell of the school it was so.… It smelled like a hospital to me. That's what my mind recorded" (March 2, 2011). We might consider these "institutional" sensory perceptions more comparable to perceptions of prisons and of hospitals than to the schools we are familiar with today. The analogy to prisons and hospitals here also demonstrates a strong correlation with the "correctional": in one sense with the treatment of sickness, the other with the elimination of immoral or criminal behaviour.

TRC National and Community Events

As well as serving as a place for survivors to give both public and private testimony, TRC national and community events provided an opportunity for survivors, intergenerational survivors, and non-Native attendees to present and be audience members for contemporary and traditional performance. As Beverly Diamond's and Byron Dueck's chapters in this collection attest to, the range of popular and traditional musical genres presented at these events was exceedingly diverse, from popular music to new choral compositions such as that presented at the Atlantic National Event in October 2013, where the Camerata Xara Young Women's Choir presented a staged version of Inuk residential survivor Margaret Pokiak-Fenton's children's book *Fatty Legs* about her residential school experience.

While such artistic presentations made up a significant component of TRC events, survivor testimony was the central focus of these gatherings. This testimony was witnessed by other survivors, intergenerational survivors, members of the non-Native Canadian public, and an international audience watching the event via live online streaming. Many statements were also gathered in private and in sharing circles. All of these statements are now housed at the National Research Centre for Truth and Reconciliation at the University of Manitoba, and those without privacy stipulations are available online to Canadian and global publics. A significant transition occurs when the context of engagement shifts from survivors sharing their experiences within forums that prioritized community and family support, to a context where those experiences are engaged with as objects within an

archive. While it would be problematic to privilege live testimony as somehow more authentic, present, or ethically engaged than its mediated form, the work such testimonies will do in their globally accessible state is important to consider, given the change of format that allows the viewer to pause, control, and select testimony through the ease of fast-forward and rewind. While these features may allow for deep engagement with what is viewed and re-viewed, they also place the viewer in full control of how he or she engages with the testimony. Consistently, the words spoken by survivors did not "fit" within the conventional understanding of what would commonly be identified as testimony. Their words exceeded the boundaries and norms that would constrict them as victims, as speakers of trauma, and as concerned mostly with abuse. Witnessing in the rooms I joined survivors in meant being present to what they needed to share, whatever that happened to be, and in whatever ways they deemed necessary. The expectations and implicit demands for the spectacle of abuse were often disrupted through the varied focus, time, and tenor through which survivors chose to articulate their experience. The aesthetic and rhetorical choices made by those who spoke enacted forms of sensory agency, demanding to a certain extent that survivors' experiences be engaged with upon their time. If witnessing partially locates its efficacy and ethics through the spectator's submission to the form and time of the other's appeal, then how does witnessing alter when the time of viewing and preference for viewing certain kinds of testimony are within the control of the viewer, rather than the survivor? To what extent is the act of witnessing itself elided through the engagement with an audiovisual form of testimony that the viewer can play, rewind, replay, skip, and stop as he or she desires from the comfort of home?

The agency asserted by survivors through the ways they narrated their experiences—shifting between topics, tempo, and timbres of telling—in many instances resisted the desire to consume traumatic narrative. Similarly, frequent shifts of emotional tenor during the events worked to challenge any singular identification of survivors as "victims"; community hearings and national events were sites of shifting affect. Survivors' happiness at being reunited with former school friends intermingled with anger at the continued ignorance of non-Native attendees and evasions of responsibility from the Canadian government. Sadness when giving testimony and upon hearing testimony from other survivors sat alongside the joyous affirmation of survivance in both testimony and in artistic presentations that occurred during the event. In the truest understanding of the term "affect" as

that which is between solid states of emotion, it was common for survivors to express both sadness and hope at the same time. The strength and pride of survivors' and intergenerational survivors' voices not only demonstrated their resilience but impressed itself upon the listener. Such was the case for me when listening to Ernest Puglas's testimony at the Campbell River hearings in British Columbia. Ernest's song was preceded by his father's testimony in which his father apologized to his sons for the hurt and emotional abuse he felt he had inflicted upon them, and for discouraging them from learning Ligwilda'xw songs:

> My two boys here, Andrew and Ernie, they come from a big family on their mom's side, a strong culture. And as they were growing up I was so mean to them, because they … they loved to sing and dance … and drum. And I didn't like it because I was brought up … [begins to cry] I was told not to do that anymore, and then I took it out on my kids. "Quit drumming, you don't need to do that stuff!" I said. My kid here can witness that, and my other boy Andrew. I'm glad they didn't listen to me, because they are very strong in their culture.… I just want to apologize for how mean I was to them. I didn't approve of it because how I was treated in residential school. (Campbell River Community Event, March 2, 2011)

His voice faltering and his breathing shallow from crying, Ernest's response to his father does not employ the language of forgiveness. Characterizing it as such would validate his father's treatment of him as abusive. Instead, Ernest expresses his unconditional love for his father and thankfulness for being able to hear the wider context of his father's and other survivors' stories during the hearings. Put most simply, Ernest noted, "It helps me come to an understanding" (March 2, 2012). Ernest's understanding of the circumstances that contributed to his father's anger is indeed an understanding that many First Peoples are coming to for the first time through participating in the TRC events and hearings as witnesses themselves. Shame resulting from sustained verbal abuse of residential school staff has led to a history of ongoing silence, a self-inflicted censorship of sensory expression through the felt abjection of our histories and cultural practices. At the behest of his brother, who was unable to attend the TRC community hearing, and as a means by which to give sensory agency to the unconditional love for the community and family gathered at the hearing, Ernest Puglas concluded his response by singing a love song written by his

brother for their father. At the close of the Campbell River hearing, Commissioner Marie Wilson aptly described the layering of emotions present in Ernest Puglas's response and song. She affirmed Puglas's courage by thanking him for giving the community a gift through the image of his singing. "The image you gave us," Wilson said, "shows us … what it is like, what it looks like and what it sounds like to be able to sing through your tears. Because that's what we were given by Ernie, how to sing through your tears and I found myself wondering, isn't that exactly what we're trying to do. As individuals, as a family and as a country. We must learn to find our voices … and to learn to sing through our tears" (March 2, 2012).

Tears at the events and hearings had a special role. Survivors and witnesses were asked to save the tissues used to dry their tears, and then place these tissues into marked bags. These tissues were then gathered and burned in a sacred fire that was present at each event.

Figure 2.1: Bag for Tears, TRC Atlantic National Event. November 2, 2011. Photo by Dylan Robinson.

At the end of each event, the ashes from the sacred fire were gathered and taken to the next TRC event, thus symbolically joining all survivors, intergenerational survivors, and witnesses.

The activity of gathering and burning these tears was also intended as a symbolic cleansing of sadness experienced during TRC events. In contrast, the lack of parallel symbolic forms for dealing with other emotions, including anger and shame, demonstrates a hierarchy for acceptable and "productive" ways to process grief. Moreover, unlike sadness, anger and shame have no material "product" such as tears that might be "gathered" and then transformed. Yet this is not to say that such emotions lack the same material presence. Indeed, as Iris Nicholas's testimony at the TRC Atlantic National Event in Halifax reveals, the expression of these emotions is vocalized:

> I saw a little girl with her hands tied above her head to the bed because she had bloody noses night and day.... I saw children shivering in their beds because of the thin blankets. I saw girls forced to eat their own vomit. I saw children gagging on their food because they didn't like it and they'd swallow it in fear of the nun's mighty hand. I saw and heard children sobbing in the night. I saw children hanging onto windows from the top floor to use the bathroom so they wouldn't wet their beds. I saw children lined up to show the crotch of their underwear for viewing by the nun in charge. I saw children scrambling for a slice of soggy bread that was thrown at them. I saw children sent to bed hungry and thirsty. I saw children eating out of garbage cans. I saw a young girl bleeding heavily in her bed for at least a week before they sent her to a hospital. (TRC public testimony, Oct. 27, 2011)

As witnesses to Nicholas's testimony, we are confronted with her anger and resilience directly through the quality of her voice. The routine violence she witnessed is lucidly conveyed through the brutal repetition of the phrase "I saw *children*." As with the return of sensory brutality in her experience, the strain in Nicholas's voice re-enacts the tension of witnessing the unrelenting return of sensory abuse at Shubenacadie, while the impact of those memories for Nicholas is given equal rhythmic force by her voice. As we listen to Nicholas, each repetition of "children" lacerates aurally like a strap across the skin; a spectral measure of Nicholas's experience is given material presence. Sensory memory, a kind of memory that often resonates through the subject's body upon remembering, frequently has a material immateriality that can

also have an impact on the listener with its blunt force, a comforting caress, or convulsive shivers. In testimony like that given by Nicholas, the vocal expression of sensory memory is given a measure of material force. Her voice makes contact with our bodies as listener-witnesses.

In providing a forum for survivors to voice their experience of the schools and the effects of this experience upon their lives as adults, the TRC gave survivors the opportunity to reclaim sensorial agency. That this platform allowed for survivors to speak of *any* experience either positive and negative (as well as the celebrations of cultural practices in the artistic components of the events) was significant considering the censorship of culture and language and forms of expression. In its openness toward all experience and all forms of telling, the TRC attempted to provide a counterbalance to the desensitization and silence that children experienced at residential schools.[5]

Yet in some instances, sensory memory is marked by the absence of sense in the present and the past. After recounting a memory of sexual abuse, and his subsequent experiences of blacking out after this abuse and indeed throughout his life, August Joseph Johnson, at the Campbell River community event, noted how his body "learned how to shut down pain. I learned how not to feel…. This happened to me a number of times where I started to feel nothing, I started to care for nothing" (March 1, 2012).

Abuse at the hands of residential school workers here resulted in a lack of sense—a numbness that survivors felt, and often continue to feel. This numbness also extends to a lack of sensory memory. At the Atlantic National Event, Mi'kmaw Elder Isabelle Knockwood noted, "I can tell you that in the first of five years of Indian residential schooling I do not remember talking, feeling, crying or even growing" (Oct. 27, 2011). Such responses of inaccessible memories or consciously repressed ones are also prevalent in literary biography. In Tomson Highway's *Kiss of the Fur Queen*, a semi-autobiographical novel based upon Highway's and his brother's residential school experiences, he describes the character Jeremiah's response to sexual abuse:

> Jeremiah opened his mouth and moved his tongue, but his throat went dry. No sound came except a ringing in his ears. Had this really happened before? Or had it not? But some chamber deep inside his mind permanently slammed shut. It had happened to no*body*. He had not seen what he was seeing. (80)

In some cases strategies for sensory containment are used as a tactic of survival—a way to live with the constant ringing in one's ears and the spectral impact upon one's body. In the writings of Mi'kmaw survivor Rita Joe, she describes her choice not to use her voice to give expression to certain experiences of residential school, but to consciously shelve the material immaterial objects of memory:

> It's hard for me to describe what it was like when I was little. Words sometimes will not come to me. It's as if they're stuck inside. Some of the hurt was too great, so I just bundled it up and put the little bundles away. Those bundles are still on the shelf today and I cannot open some of them. If I open them, I will cry, I will get hurt. So that's why I leave the bundles alone. It's hard enough to survive knowing that they are there. (qtd. in Sam McKegney, *Magic Weapons*, 117–18)

Joe here describes her choice to put the bundles of hurting words away. She knows where they are but chooses not to open them. The choice here speaks to Joe's larger determination not to let those memories dominate her life, and to her larger aim to acknowledge the moments of goodness and happiness in her residential school experience. As scholar of Indigenous literature Sam McKegney has compellingly argued in his book *Magic Weapons: Aboriginal Writers Remaking Community after Residential Schools*, it is important not to read Joe's choice here as a denial of the negative, but instead as a refusal to self-identify as a victim.

Expressions of Reconciliation

In addition to the survivor testimony, time at each event was given for what the TRC called "expressions of reconciliation." These expressions were made by government and church officials, the RCMP, and other organizations that sought to take part in the process of making public the history and impact of the residential schools, and in helping survivors heal from this experience. At the Atlantic National Event David Barnard, president of the University of Manitoba, gave a statement of reconciliation acknowledging that

> [o]ur institution failed to recognize or challenge the forced assimilation of Aboriginal peoples and the subsequent loss of their language, culture and traditions. That was a grave mistake.

It is our responsibility.... The University of Manitoba educated and mentored individuals who became clergy, teachers, social workers, civil servants and politicians. They carried out assimilation policies aimed at the Aboriginal peoples of Manitoba.[6]

Alongside these verbal expressions of reconciliation, material offerings associated with those expressions were often given. These symbolic objects were offered as part of the apology and were placed along with a copy of the written expression into the bentwood box, designed by the Chemainus Coast Salish carver Luke Marsten. Of particular interest to me in these expressions of reconciliation was the proprioceptive process involved in making such offerings. Here the TRC commissioners joined with those who offered their object expressions to place the material into the bentwood box. The often awkward physical negotiation that resulted was often unintentionally amusing. Negotiating how to do this seemingly simple action of placing an object in a box was rendered precarious by the small size of an object, its shape, and the navigation toward and positioning around the box. To manoeuvre around a podium with eight people each trying to maintain hold of a small carving and then together lower the object into a box on the floor is an exceptional challenge of coordination. At the risk of making a symbolic mountain out of a molehill, these proprioceptive and kinesthetic negotiations provided an apt image of the challenges faced in negotiating reconciliation itself. These symbolic material and kinetic expressions of reconciliation are just some of many symbolic expressions that occurred at TRC events described by the contributors to this volume. Another primary site of sensory engagement was through artistic presentations organized by the TRC.

The Art(s) of Truth and Reconciliation

Cultural and artistic presentations constituted a significant aspect of the TRC's activities, both at the national events and in the gathering of survivor testimony more generally. National events involved a series of public performances by prominent Indigenous and non-Indigenous singers and musicians.

While many of the artistic contributions to TRC events offered important opportunities for engagement with residential school history, healing, and demonstrations of Indigenous resurgence, it is important not to position all artistic practice at the TRC as simply the enrichment of reconciliation. While pleasurable affective experience

Figure 2.2: The Gettin' Higher Choir. Photo by Lisa Kurytnik, 2012.

of art and performance can lead to deeper desire to engage with the historical and current social and political realities of Aboriginal people, the aestheticization of reconciliation enacted through the spectacle of intercultural performance can also engender a sanitization of history. Such a critique might indeed be given in response to the Gettin' Higher Choir's performance of Inuk singer Susan Aglukark's song "O Siem" at the TRC's 2012 regional event in Victoria, British Columbia. After a full day of listening to testimony from survivors and intergenerational survivors, I sat listening in disbelief as fifty singers repeated the chorus, "O Siem, we are all family. O Siem, we're all the same," at me. As I watched the faces of the choir their belief in the feeling of alliance was palpable. Their song was offered with the intention to lift people's spirits after a day of intense testimony from residential school survivors and intergenerational survivors, and it may have done this for some. But to sing this song after three days where a history of inhumanity was overwhelmingly present felt both inappropriate and offensive. The irony of this song is, of course, that the history of abuse and cultural oppression in residential schools is anything but "the same" as the education received by settler Canadians, nor are the present realities of Aboriginal communities and the settler Canadian public "the same." Non-Native Canadians were not

taken from their parents and forced into schools where they were beaten when they spoke English. For these reasons, Canadians do not battle with feelings of shame at being Canadian. And so, while the song may have allowed some to feel uplifted, more importantly, its message of universality unwittingly afforded non-Native participants a sense of what Berthold Brecht would call "crude empathy": "a feeling for another based on the assimilation of the other's experience to the self" (qtd. in Bennett, *Empathic Vision* 10). In order to transform crude empathy's "vicarious suffering" into something that goes beyond mere witnessing as a form of "wound culture's"[7] image consumption, it is essential to question how music and other artistic practices might instead impel audiences to action of some kind, and disrupt the value of reconciliation as friendship formation.[8]

Other artistic practices are more adept at moving beyond the simplistic narration of reconciliation in the above example. As the range of contributions to this collection demonstrates, there is a growing body of work by Indigenous artists that represents residential school histories and enacts nation- and community-specific forms of resurgence. Yet to what extent does the audience's engagement with such work—occurring primarily within the space of the concert hall, the cinema, and the gallery—act as a situational sanitization of this work's social and political efficacy? The aesthetics, spatialization, and protocols of such legitimate spaces of artistic display and performance impose, through the unspoken normative codes of perception they enforce, a settler logic that can subjugate Indigenous sensory agency. Moreover, by situating artistic engagements with residential school history at a safe distance from survivors and Indigenous communities, do audiences avoid the face-to-face encounter and its potential to resist a reduction to sameness and refuse a form of reconciliation based in consensus? Although engaging with artistic work in these spaces can be an emotional experience, such spaces infrequently require settler spectators to take part in the difficult witnessing and interaction *with* survivors.

Senses-in-Common: From Reconciliation to Redress

To ask what "sense of reconciliation" the settler Canadian public has of residential school history (or lack thereof) and of the TRC's process and mandate is to question how intergenerational responsibility is felt by the settler Canadian public.

A central image used frequently in the TRC's media shows a mother carrying her child on her back. The child peeks out from behind her mother and both look directly, intently, at the viewer. Below mother and child two short sentences address us: "For the child taken. For the parent left behind." In an effort to foster a greater level of public investment in learning about the history of residential schools in Canada, the TRC has used this image extensively in its media. The image identifies the TRC's focus of supporting survivors as they share their experiences of residential schools. The emphasis here is on the TRC as process "for" First Peoples—to offer survivors the opportunity to address experiences of being taken and feelings of isolation (in residential schools, but often also upon return to a community that they felt alienated from).

And yet this media image is also "for" the non-Native public. The TRC's media image here creates a tension, an ambivalence between the closeness and intimacy of parent and child depicted visually in the photograph, and the distance evoked textually by the short phrases. The sensory tension engendered between word and image seeks what Dominic LaCapra calls "empathic unsettlement," which "places in jeopardy harmonizing of spiritually uplifting accounts of extreme events from which we attempt to derive reassurance or a benefit (for example, unearned confidence about the ability of the human spirit to endure any adversity with dignity and nobility)" (41–42). Most importantly, it asks members of the public to imagine themselves as parents whose children have been taken, or imagine the feeling of being "left behind" as a child. In sum, the image seeks to effect the public's emotional investment with the subjects of the image, and consequently, with their history. Despite the power of this image to elicit empathy for those who attended residential schools, the low rate of settler attendance at many TRC events points toward the work still to be done in engendering public education of Indigenous histories.

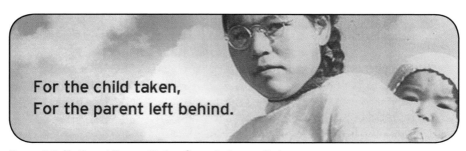

Figure 2.3: Truth and Reconciliation Commission media image.

Speaking to this lack of public engagement during a TRC community hearing in Nova Scotia, Isabelle Knockwood has noted the inequity of what is asked of survivors and what has been asked of the settler Canadian public. As Knockwood sees it, although those who give expressions of reconciliation often offer apology for their institutions' roles in the residential schools, such statements do not necessarily evidence the complex emotions of the past in a similar way to those survivors retelling their experiences. In testimony given at a community event, Knockwood confronted the difference in emotional labour of witnesses and survivors:

> The church members haven't told us about *their* experiences. The pedophiles, the clergy of pedophiles haven't told us *their* experiences. The abusers, the ones that punished us so severely, they didn't tell us how *they* feel when they were punishing us. The government is not telling us how *they* felt when they put us on Indian reservations and how happy they were to build Indian residential schools in order to kill the Indian in the child. When are they going to tell us how that felt like? (video presentation, Oct. 27, 2011)

Despite the fact that TRC events took place over a five-year span from June 2010 to June 2015, a significant proportion of the settler Canadian public chose not to attend. During this same time, I repeatedly encountered a near-complete lack of knowledge in conversations with students and in daily conversations with non-Indigenous members of the Canadian public.[9] Through the maintenance of such ignorance, settler Canadians continue to abrogate their responsibility to understand this history as their own. As the fallacious argument would have it, since settler Canadians are not themselves the perpetrators of past injustices of the state, why should they make any effort to engage in learning about this history, or to support social change in communities affected by intergenerational trauma? A large portion of the settler Canadian public remains aggressively indifferent toward acknowledging the history of colonization upon which their contemporary privilege rests. In part, the civic distance the non-Native public feels toward the TRC's processes has been mirrored in the literal distance at which these events take place. With the exception of the Winnipeg event, the TRC proceedings have taken place in convention centres (Halifax, Victoria, Montreal), on exhibition grounds (Saskatoon), and in a former residential school (Inuvik), at a safe distance from those public

spaces where the TRC's activities might be encountered by the non-Aboriginal public, and where they may take part as witnesses and even participants. One part of this may be rationalized through the need to create spaces where survivors and their families feel empowered and safe to share their experience. Another part may be rationalized by the necessary logistics of planning, for instance that winter events are not suited to be held outdoors.

In Judith Butler and Gayatri Spivak's *Who Sings the Nation State?* Butler relates a story of illegal immigrants amassing on the street in Los Angeles to sing the U.S. national anthem in Spanish. Singing "Nuestro Himno" ("Our Anthem") on the street, Butler emphasizes, "gives voice and visibility to those populations that are regularly disavowed as part of the nation, and in this way, the singing exposes the modes of disavowal through which the nation constitutes itself. In other words, the singing exposes and opposes those modes of exclusion through which the nation imagines and enforces its own unity." Butler suggests that political theorists have yet to develop the language by which to theorize this particular act of singing. To do so, "would also involve rethinking certain ideas of sensate democracy, of aesthetic articulation within the political sphere, and the relationship between song and what is called the 'public'" (62–63). Drawing on Butler's example, we might similarly consider what Indigenous sensate sovereignty would look like when enacted in the public sphere. Although there are a multitude of ways in which this might take place, I'd like here to focus upon two ways in particular by which to increase the sense-in-common of Indigenous histories among the settler Canadian public.

First, I suggest the necessity of increased public expression of sovereignty in artistic activism. As in Butler's example, the sensory qualities of the arts here hold immense potential to disrupt the normative felt experience of national belonging and spatial sovereignty. The group Ogimaa Mikana, for example, visually reinscribes sovereignty upon the landscape in work that renames street signs and historical plaques in Toronto with Indigenous histories of place. This work, taking place outside of sanctioned protocols of the state, redresses the elision of Indigenous histories in public space while directly addressing the public through signage that asks: "Welcome to our community. How do you recognize it?" Through this address, the readers are asked not *whether* they recognize Anishinaabe sovereignty and history of the location, but rather *how* they do. Similarly, in *Gego ghazaagwenmishiken pii wii Anishinaabemyin*, Ogimaa Mikana speaks exclusively to

those who can read Anishinaabemowin through the untranslated sign that filled the space of a billboard in Barrie, Ontario, in August 2014 with black text on a white background. The translation refused by the sign is *"Don't be shy to speak Anishinaabemowin when it's time."* In speaking exclusively to Anishinaabemowin speakers, Ogimaa Mikana inhabits a space of sovereign public speech, supporting the community of language speakers and learners, many of whom have inherited shame from not speaking their language as part of the intergenerational effects of the linguistic genocide that the residential schools carried out.

Second, we might reconceive the language by which we address the non-Native Canadian public. As in the case of the sonic materiality of testimony discussed earlier, and in the case of the visual materiality of Ogimaa Mikana's works, the words we use when writing and speaking of redress have great sensory import, and to acknowledge this means to harness the sensory force of a different kind of language we use when speaking of reconciliation. A first step, then, as many critics of the TRC—like David Garneau in this volume—have noted, is to move beyond the term "reconciliation" itself, and the sense of closure that the term implies. There is a great distance we must cover in addressing the histories of colonial injustice in our communities, and the contemporary impacts of such histories. This distance cannot be covered by a single process called "Truth and Reconciliation," or by a national project that seeks only to enact forms of "reconciliation."

Commissioner Murray Sinclair has consistently stated when speaking to non-Indigenous audiences,

> At the same time that aboriginal children were being taken from their families and locked up in those institutions—sometimes for years at a time—and being told that their cultures were irrelevant, that their stories and their languages were not worthy of being kept and maintained and shared with all others, at the same time that it was being done to those young aboriginal students in those schools, the very same messaging was being given to all of you [the Canadian public], and to all of your ancestors, to your grandmothers, to your grandfathers, to all of the leaders of this country who have come to take over authority. ("Shared Perspectives")

To redress the current "common sense" of Canadian history will necessitate a stronger language of sensory implication and redress that, like the work of Ogimaa Mikana, renames the lands settler Cana-

dians occupy and refuses inherited histories of ignorance. The TRC has employed the term "intergenerational survivor" to describe those who experience the intergenerational impacts of residential schools within their families and communities today. To recognize the mis-education of the settler Canadian public, however, requires a different set of terms, terms that effect different forms of felt critical reflection of their implication for the settler subject. In the previous chapter, David Garneau proposes that we begin to think of conciliation, rather than reconciliation. However, in order to begin to discuss what conciliation might entail requires a much larger reconsideration of what words settler Canadians might use to acknowledge their *intergenerational responsibility*. It requires words that speak of the public's national and civic responsibility to respond in the present to a history that few have direct experience with. Most importantly, I suggest settler Canadians we might consider using a phrase that names the continued ignorance of Indigenous histories and the lack of civic responsibility for what it is: *intergenerational perpetration*. As Israeli scholar Ari-ella Azoulay has written in the context of Israel, "The time has come for the second generation of perpetrators—descendants of those who expelled Palestinians from their homeland—to claim **our** right, **our** fundamental and inalienable human right: **the right not to be perpetrators**" (emphasis in original).[10] Like the negative affective impact of the term "post-colonial" (see introduction) and the feel-good tone of "reconciliation," the sharpness of "intergenerational perpetration" might give the reader or other listener pause for thought. Perpetration is characterized by immediate activity by one who commits a crime; it conveys a sense of violence. Google suggests completing "perpetrator of" with the actions "abuse," "violence," and "bullying." To reconceive settler Canadians as perpetrators of intergenerational irresponsibility is to shift the framework of perpetration from action to inaction. Such a shift is less exceptional when we consider the continuance of set-tler inactivity to redress the long history and multiple forms of "slow violence" constituted by the Canadian government's failure to address issues of murdered and missing Aboriginal women and girls in Can-ada, lack of drinking water and housing infrastructure in reserve com-munities, and lack of support for Aboriginal education, to name just a few issues among many. Yet, as the *Truth and Reconciliation Com-mission of Canada: Calls to Action* notes, concerted actions must be taken in order to continue the necessarily long-term process of redress that is not just the responsibility of the Canadian government. The TRC's calls to action call upon a large number of parties, including

federal and provincial governments, post-secondary institutions, the Federation of Law Societies of Canada, law schools in Canada, medical and nursing schools in Canada, all religious denominations and faith groups, all chief coroners and provincial vital statistics agencies, Library and Archives Canada, Canada Council for the Arts, the Aboriginal Peoples Television Network, and the corporate sector in Canada, to be responsible for a number of changes that, taken together, may begin to redress the legacy of residential schools. While this multi-organizational approach reflects the fact that redress is not simply contingent upon the federal and provincial governments, it also deflects the responsibilities of individuals. In the absence of individual calls for action, the document elides the potential and necessity for redress as an individual act.

As I have argued, forms of individual intergenerational responsibility can be productively made known and felt by settler Canadians through sensory calls to action. Such calls to individuals expressed through everyday public encounters with Ogimaa Mikana's work ask the public to recognize Indigenous histories of place, while changing the language we use in the work of redress asks individuals to recognize and change their perpetration of irresponsibility constituted by ignorance. To visually and aurally recognize these facts in public—by naming them in our writing and saying them aloud—extends their sensory and affective resonance. Like the time and terms survivors and intergenerational survivors demand of the witness of testimony, so too do we need to make new aesthetic and sensory choices that challenge the ease of alliance and friendship formation that exists at the heart of reconciliation.

Notes

1 All testimony referred to in the paper can be viewed at the National Centre for Truth and Reconciliation online archive, University of Manitoba.
2 These memories remain purposely untranslated from Halq'emeylem.
3 This includes the closing Ottawa event in 2015, in addition to national events in Winnipeg, Manitoba (2010); Inuvik, Northwest Territories (2011); Halifax, Nova Scotia (2011); Saskatoon, Saskatchewan (2012); Montreal, Quebec (2013); Vancouver, B.C. (2013); and Edmonton, Alberta (2014), as well as a regional event in Victoria, B.C. (2012) and numerous community events across the country.
4 It is important to note that although the vast majority of survivor accounts include sensory memories oriented toward negative experi-

ences, this is not the case with all testimony. Some residential school students have positive sensory memories, including playing in brass bands, taking part in plays, and playing hockey, to name only a few examples.

5 In fact, testimony ranged widely from challenges to the proposed Enbridge pipeline, to statements on the funding cuts and appeals for the continuance of social services for Aboriginal at-risk youth. See Robinson, "Reconciliation Relations."

6 See the full statement at http://umanitoba.ca/about/media/Statement OfApology.pdf.

7 Cf. Seltzer.

8 For a more detailed examination of this performance, see Robinson, "Feeling Reconciliation, Remaining Settled."

9 Such was the case particularly as I moved in 2015 to Kingston, Ontario, and encountered both students and members of the general public who were oblivious to the details of the TRC and residential school history.

10 My thanks to Jessica Jacobsen-Konefall for drawing this statement to my attention.

CHAPTER 3

this is what happens when we perform the memory of the land

Peter Morin

This writing records the performance.

On April 27 and 28, I performed *this is what happens when we perform the memory of the land*. This performance happened in conjunction with the Truth and Reconciliation Commission event in Montreal (April 2013). As a performance artist and researcher, I experience and document the spoken language of the residential school survivors inside my body. This documentation also considers the experience of physical space within the Truth and Reconciliation gatherings in relation to my experience as a cultural practitioner. This documentation, keeping the stories inside my body, informs the structure of this piece of writing. Collaboration was a key component to the creation of the performance. I approached Indigenous artists and allied artists to collaborate in this performance. By employing this collaborative approach, I could make a space for their creative process. I also wanted to make a space for a greater number of voices to speak in this process of Truth and Reconciliation.

Within performance-as-research methodology, the brown body becomes a matrix, a system of filters that encounters, organizes, and acquires information. The performance, and subsequent writing, is not about providing, or achieving, any form of forgiveness for past transgressions but instead attempts to focus on mapping out the experience of reconciliation inside and outside the Indigenous body. The research methodology, designed as performance, for the structure of this paper is as follows: I am a brown body affected by the colonial context. Hawaiian scholar Manulani Aluli Meyer (2003) writes, "Knowledge was the by-product with an idea, with others' knowing, or with one's own experience with the world. Knowing was in relationship with knowledge, a nested idea that deepened information through direct experience" (231).

In preparation for the performance, I consulted with Elders in Victoria, British Columbia, the community in which I lived and was a guest. The work required a different set of priorities, specifically due to its engagement with the format of the Truth and Reconciliation gatherings. The performance attempts to acknowledge the strong work of residential school survivors and how their voices create a resonance with change. There is a struggle to engage with the difficult political histories of canada, which were shaped by a government that instituted the creation and production of the residential school system. This engagement with history is as difficult within performance as it is within writing. Because of this I will leave behind the essay as a format for the communication of Indigenous-born ideas. I choose that these words become a practice, a focused attempt to perform space making through the colonial written form. Keeping this in mind, I refer to one of my teachers, Pomo scholar Greg Sarris, for guidance. In *Keeping Slug Woman Alive* (1993), Sarris writes about the challenge of conveying the context of telling through transcription:

> Writing recreates oral experience in giving ways. The transcriptions of American Indian oral literatures, for example, sometimes provide nothing about the context in which the literatures were told and recorded or the manner in which they were translated. In the end we have a story as an object devoid of the context that might suggest something about the story beyond our interaction with it as an independent text. (38)

I am an artist trained in the tradition of Western art history. I am a Tahltan Nation artist working toward articulating Tahltan Nation art history. The difficult political histories that surround the residential schools, and Canada's responsibility to face these histories, also require a different approach. My life is linked to the residential school, but I did not attend one. And yet although I did not physically go to one, I feel as if my spirit has. My connection to the residential schools in canada has included working in the Daylu Dena Band office, formerly the Lower Post Indian Residential School, advocating for residential school survivors and their grandchildren, and working with Aboriginal children and youth in foster care. Some of my family attended residential school. My mom attended the day school system as well as the vocational school system. My community is shaped by this history.

For the purpose of this written work, I propose that the created object has deeper implications for naming the act of reconciliation and its location of meaning for both Indigenous and settler society. This

acknowledgement allows for the repositioning of Indigenous spoken language as the dominant position for dialogues of reconciliation (Morin, *Circle*).

But that's just the trouble
"do it slow"
Desegregation
"do it slow"
Mass participation
"do it slow"
Reunification
"do it slow"
Do things gradually
"do it slow"
But bring more tragedy
"do it slow"
Why don't you see it
Why don't you feel it
I don't know
I don't know

—*"Mississippi Goddam," Nina Simone*

Controlled Spatializations of Reconciliation

My truth. My reconciliation. My truth and reconciliation is not invited. It feels like my truth and reconciliation is not invited to the party. Truth and Reconciliation gatherings. gatherings on the land. Residential school survivors making public testimonies. Residential school survivors making private testimonies. Residential school survivors sitting in a circle to make testimony with other survivors. Town hall meetings. Public forums for "our canadians" to speak to the difficult histories of residential school. Didactic panels that share a carefully determined language about this difficult history. Linear histories. Stand at one end and read your way backwards or forwards. Panels to help you to get a better picture.

Church listening areas. Catholic. Anglican. Protestant. Jesuit. Mennonite. Churches are listening. These churches are listening. Photographs. Photographs are listening to our longing. Photographs are documentation of the residential school project. Ask to see the book of photographs. Get the book. If you look old, they won't ask for the book back and if you look young they will bother you to be done fast.

Looking for pictures of your childhood areas. Looking for proof that you had childhood areas. Looking for proof of something. And if you are white, look at the photographs. And if you are an immigrant, look at the photographs. And if you are an intergenerational survivor of the residential school system, cry about all the stolen moments. These are stolen children. Stolen from aboriginal parents.

Booths areas. Informational access areas. Places that give out free pens and free bags and free paper. Swag. Proof that you attended these gathering areas. You found information about the residential school areas. you found a complete picture. You experienced a complete picture of the difficult history complimented by the arts and crafts of aboriginal artisans.

The Truth and Reconciliation gatherings consist of gathering spaces, spaces that divide up intention and accessibility. This division also effectively splits up time. Scheduled events are taking place throughout these separate locations simultaneously. This results in a disjointed experience, a broken connection with the events of the day(s).

This sectioning-out is about crowd control. I'm looking at this space from a Tahltan epistemological tradition; a land-based knowledge system. The Tahltan land is shaped and transformed by the movement of the Stikine River. These crowds become water, movement which flows into channels; some of these channels are places for private statement gatherings, places for public testimony, and a place for community engagement with residential school history. Within these spaces, there is a stage on which the residential school survivors can make public testimony. The survivors who give public testimony are projected on large screens for viewers at the back of the room. The event is carefully choreographed, with imagined attendance numbers. Our emotions are also carefully choreographed. Volunteers walk through the aisles with tissue and kind words. Don't interrupt the live stream broadcast of the testimony.

My truth.
My reconciliation.
My truth and reconciliation is not invited.
It feels like my truth and reconciliation is not invited to the party.
Reconciliation begins with an acknowledgement of difficult political history. This is not an easy task. It requires vigilance, vigilance against the silencing of Indigenous voices. It requires self-awareness.

The difficult task is finding actions to activate this space where Indigenous knowledge meets settler ways of being. They are bodies of knowledge that mingle and impact each other. And often their meeting requires yet another meeting.

Our bodies mediate the meeting of these two distinct areas of history. The body is a resonant chamber, a place for the articulation and amplification of many experiences. Colonization has interrupted this resonance. It has interrupted indigenous knowledge production and history. Our indigenous bodies have retained, despite countless years of contact with the colonial project, a strong ability to articulate its connection to indigenous history. In 1994, Sarris wrote a biography for Miwok artist Mabel McKay. In Sarris's book, Mabel says, "It's no such thing as art. It's spirit. My grandma never taught me nothing about the baskets. Only the spirit trained me" (2).

> The body is a resonance chamber.
> The body is a resonance chamber.
> The words breathe.
> Here.
> They are waiting for your voice.
> This voice.
> I am capturing this voice, forcing it to sleep inside these pages.
> The voice waits here for a reader to speak out loud.
> Read out whatever you want.
> Read out nothing.
> The voice is here, waiting for potential collaboration.
> Remember, no action is also collaboration.
> There are many ways
> to be implicated in these difficult
> political histories.

Performance Description: Part 1, April 27 (2.5 hours)

Objects as Tools for Witnessing

there are 3 button blankets. the blankets are epistemological areas. knowledge is produced and documented on the blankets. 2 blankets are covered with braids. these represent the cutting of braids of the children who attended residential schools. the braided blankets flank a central blanket. this blanket is covered by arranged objects:

7 rattles which are made with deer hide, beads, and human hair; raven mask carved to look like a gun; 2 drums covered in red ochre paint; carved mask covered with hair; a small box which contains a basket made of human hair; a beaded trivet; tobacco; an eagle feather; a sage bundle; bone scrapers from Nunavut; and 2 drum beaters. there are 28 carved "peace pipes" made by aboriginal children from the Yukon purchased at the Matthew Watson General Store in Carcross. there are 5 rattles made by aboriginal youth in foster care. there are 2 cups for tea.

surrounding the central blanket are traditional obi and zōri; moccasins covered in ink that were used in my first performance addressing residential school spiritual pain (Shapeshifters, Royal Ontario Museum, 2007); an early publication on northwest coast native art; and scissors.

the objects present on and surrounding the blankets are tools for shaping how this witnessing takes place. the objects, in connection with the indigenous body, become tools to produce new knowledge. the objects are writing instruments. the objects are active collaborations in the witnessing actions.

Figure 3.1: Performance space. Raven gun mask pictured bottom centre. Witnesses seated, from left to right: Elizabeth Kalbfleisch, Pauline Wakeham, Helen Gilbert, Dylan Robinson. Witnesses not pictured here: Sam McKegney, Beverley Diamond. Photo by Ashok Mathur.

the performance also includes 6 videos created by artists from across the country. artists were invite to create a video work which represents their "truth" concerning the effects of the residential school and were told that this truth would be witnessed as a component piece within the body of the performance. these videos are not seen by me until they are screened during the actual performance.

videos are made by Doug Jarvis, Ayumi Goto, Gordy Bear, Brianna Dick, Robin Brass, France Trepanier. rattles are made by artist Laura Hynds. a mask covered with hair is made by artist Rande Cook. a mask made in the shape of a gun is created by artist Barry Sam. in preparation for this performance, I visited with each artist, invited their contribution to the performance, and bartered with them for their contributions.

Figure 3.2: Ayumi Goto helping Peter Morin put on the residential school mask. Photo by Ashok Mathur.

Object/tool:
mask covered with hair/the regalia which carries the residential school story

I had a dream about a mask covered with hair before the performance. there is a lot of material written which covers the potency of hair within indigenous cultures. In the colonial project, cutting the hair of children at the residential school is a cold memory. it is a hard memory. indigenous hair reaches into the land's memory. in many indigenous cultural spaces there are highly sophisticated philosophies around hair and spiritual potency. in many indigenous cultural spaces, the cutting of hair can weaken our bodies to spiritual attack. before the residential school, no indian foolishly let their hair be cut. the symbolic significance is of cutting connection to the land.

the mask covered with hair represents an attempt to make cultural regalia which encompasses the residential school story. when we use the mask transformation occurs; it becomes an object which records history and keeps history. we dance the mask because it is alive. in the dream I had about the mask, I dreamt about its carver, Rande Cook. Rande is Kwakwaka'wakw from Alert Bay. I met with him three months before the performance. I told him my dream. I told him about the performance and what the performance was attempting to accomplish. he agreed to create the mask.

Object/tool:
raven in the shape of a gun mask/the regalia that carries the residential school story

the raven in the shape of a gun mask was created by artist Barry Sam. Barry is from Tsartlip Nation. this mask represents spiritual presence. the mask is designed with an articulated beak that mimics the sound of a raven snapping its beak. this sound is the sound of creation. the gun shoots culture bullets. these bullets keep us safe from colonial ghosts which might try to interrupt our work. the mask is a part of the regalia which keeps and addresses the history of the residential schools in Canada.

Object/tool:
hair rattles/the regalia that carries the residential school story

these hair rattles were made by Anishinaabe artist Laura Hynds. 8 months before the performance, a settler woman named Valerie Hawkins approached me with a gift. I had met Valerie 2 years earlier during a series of performances at Open Space in Victoria, called 12 making objects A.K.A. First Nations DADA (2009). these 12 performances addressed the spiritual pain caused by the residential school system and worked to uncover/articulate the depth of this pain. the series took place over 2 months and each performance varied in length from 20 minutes to 2 hours. Valerie attended all of these performances. each performance informed the previous and audiences were invited to attend as many as possible in order to begin to see the depth of spiritual pain caused by the residential school system. in the final performance, a performance about the work that smudge smoke does, we acknowledged our collective work and I asked the viewers to make a commitment to continuing to do this work of acknowledging the effects of residential schools. I asked viewers to continue working toward transforming their relationship to this difficult political history. I acknowledged there is a difficulty in articulating how we are all affected by this. Valerie attended each of these performances. she made this commitment.

in 2013, she contacted me at Open Space. she told me that she had cut off all her hair as an act of solidarity and love with the indigenous children who had their hair cut by the system. and she wanted to give me this hair. Valerie wanted me to witness this act of settler solidarity. I met with Valerie. we had tea. she told me the story of her life. I listened and accepted the hair. I had a dream that the hair needed to be made into rattles. the hair, this act of solidarity, created a depth to canadian history which I hadn't encountered before. the settler act of acknowledging the forced removal of indigenous children; the severing of the connection to land, community, and nation; and the resultant trauma of children being forced to engage with unnatural situations. children who lost their mothers and fathers and grandparents. children forced to learn and speak a foreign language.

I met with Laura Hynds about making these rattles. I told Laura the story. I talked to Laura about Valerie and Valerie's act. Laura agreed to make the rattles for the performance, for me. I left the hair with Laura.

the hair was moon-cleansed 4 times before it was used in the creation process. each of the 7 rattles is unique and has its own presence. because of the potency of hair within indigenous cultures, I made a decision for the performance that I would keep the rattles wrapped in red cloth throughout the performance. the rattles have a unique voice. I believe these rattles sing about the future. these rattles are also parts of the regalia which address and keep the history of residential schools.

Structures of Witnessing:
the performance was designed to mirror the Truth and Reconciliation Commission process. the Truth and Reconciliation gathering creates a space for residential school survivors to publicly recount their residential school experience. this public testimony is witnessed by three commissioners and by a live and online audience. the most visible reaction to the testimony is applause and sometimes standing ovations. the audience in the room takes part in this process of witnessing, but the goals of this witnessing are not clearly defined. it is not clear how much of this experience is understood. the audience applauds and often is left to rely on familiar experiences where applause is the norm. bodies of knowledge—indigenous and settler ways of being—impact each other in this situation. A dynamic of resonance between bodies is played out in this scenario. a forced meeting of indigenous ways of being and western-settler colonialism. but more about this dynamic later.

the structural component of the TRC's process of truth-telling and truth-witnessing shapes the performance, yet differs in that here artists perform their truth. artists perform witnessing. this structure is heavily influenced by indigenous epistemological structure, and within this structure the indigenous body is the agent of change. it is the indigenous body which is creating the space of witnessing within an indigenous system. the indigenous body creates a resonance. this resonance travels between our difficult political histories and indigenous ways of knowing. At this point I'm thinking of tears; tears articulate an excess of energy.

I am reminded of witnesses who watch the potlatch. in some pacific northwest communities these witnesses are selected to act as the memory of the event. they watch, record, document, and perform the order of events. these witnesses become living memories of the potlatch.

I was also interested in having the performance space address indigenous land. One way for me to do this was to invite the scholars and colleagues whom I had worked with over the past two years at TRC events to sit in a row of chairs. these chairs contributed to re/defining the performance space. This re/defining allowed for indigenous knowledge systems to be employed. These colleagues became witnesses, they became living memories. these chairs became witness chairs. the chairs became the host chairs. this performance space was shifted into a community gathering. the performance became an act of community. sitting in the chairs allowed the scholarship team to become performance collaborators, their bodies contributing to the shape and depth of the performative action. we were holding something like a potlatch. we were invited to become living memories of the events.

I asked Ayumi Goto to perform with me. in the performance we represented the balance of male and female. Ayumi is Japanese Canadian. I invited her to bring pieces to the performance space. Goto and I represent separate beings. Ayumi invoked Noh theatre traditions and painted both of our faces as Noh masks. These masks acted as spiritual protection and supported our witnessing of truth. Goto's Noh masks contributed to the design and shaping of the space. these masks make me feel safe. safe enough to allow the space to be an active collaborator in the creation of the performance. safe enough to bring/ask ancestors to join in this act of witnessing truth. the Noh masks are ancestor masks.

the performance begins before the viewers arrive, 30 minutes before our proposed start time. Goto and I shake rattles which were made by aboriginal children in foster care. these rattles and their songs help to prepare the space. we are shaking out the colonial gaze. we are shaking out the colonial ghosts. we are inviting ancestors to join us. we are inviting global ancestors to join us. we are inviting future ancestors to join us. we are inviting residential school ghosts to join us. everyone is a witness. the rattles take us throughout the space. through bleachers. through corners. behind blackout curtains. through doors. through windows. then people arrive. they sit in the appropriate seats. people are seated. the performance begins before the viewers arrive because I want to make reference to the structure of the TRC gatherings where people come and go. leave and enter. finding seats. not finding seats. looking lost. the survivors are on stage, giving their testimony during all of this.

there is speech making. I make a speech about the order of events within the performance. I acknowledge how we all arrived in this location. I acknowledge the land as a collaborator in the performance. I acknowledge the original people of the land. I acknowledge ancestors. I acknowledge collaborators. I explain the collaborative effort of the performance. I let the viewers know that I haven't seen any of the videos or audio by the collaborators before this moment. I explain that this mirrors the truth-telling of the residential school survivors during the Truth and Reconciliation gatherings. I acknowledge the line of empty chairs. I invite the honoured guests to come and sit in these chairs. they are honoured guests and active collaborators in the creation of this work. they are hosting the creation of this work. when they are seated we begin.

the motivation is for Goto and me to respond to the videos/audio utilizing the objects present on the blanket. nothing is scripted for us beyond this direction. witnessing. singing a response. active witnessing requires a response and a space for a response. it also requires the embodiment of the difficult political histories which influence our daily lives. tradition implies a type of participation, one that is not only within the present moment, but with ancestors guiding and shaping the process (Ridington). invoking this form of tradition, this participation, letting this idea of participation influence our actions within a space, tends to shatter colonial spaces. cultural practice which is shaped by participation of everyone present reinforces ancient memory and reinforces the importance of indigenous history as a guiding creative force. a force that redefines the space.

"Water/Star Song" sung by Robin Brass. Soto performance artist.

Robin says, "In the Creator's name I shake hands with each and every one gathered here today. I would like to give thanks to gitchi-manitou for this day and for this opportunity to share. I would also like to thank Cheryl Littletent for permission to sing and record the following song for this gathering…. I am greatly honoured. As my contribution to this event, I humbly sing this prayer song in the name of healing. It is a woman's song known as the 'Water/Star Song' and it is sung by the women in ceremonies and women's lodges back home.

"It is an honour for me to sing it for the people gathered at the Truth and Reconciliation Commission hearings; to all of the survivors of residential schools, to the memory of those passed on, and to all of our relatives."

and Robin sings. this is when I realize Goto and I have made a space for our ancestors. the body creates a resonance. ancestors witnessing truth. ancestors wanting to witness truth. ancestors witnessing the truth of the residential school survivors during the Truth and Reconciliation gatherings. the action, the response, the movement, ancestors witnessing truth. the body feels this deeply. the body allows for deep reflection. the truth and reconciliation gatherings do not provide a space for culturally based witnessing. I don't consider applause a cultural act. sitting around a talking circle is not the same as sitting in a talking circle. at times the applause seems empty. it occurs to me that this structure doesn't allow for ancestors to witness the survivors' testimony. my body feels this emptiness. my body also responds with the need to sing a response. but there is no space to respond with anything other than applause or a standing ovation or just walking away.

Goto shakes a rattle. I start cutting. the blades of scissors clicking through pages of an aboriginal art history book. one of the witnessing acts was cutting up a book of northwest coast aboriginal art. this act of cutting was an act of liberation. releasing the aboriginal artwork from the containers of artifact. making a space for these artworks to contribute their voice into the realms defined by the performance area.

at times the Truth and Reconciliation Commission gatherings leave me feeling hollow. not because of survivor testimony, but because the shape and structure of the TRC national gatherings do not provide much space for individuals' songs to be sung. perhaps the testimony of the survivors is actually a song. the testimony does travel through my body like a song travels through bodies. I know this feeling as indigenous practice.

the space seems ready for witnessing.

Video by Brianna Dick. Coast Salish artist. Coast Salish youth.

she shares her words and recites two poems. written after the government of canada released the residential school settlement money. two poems that address the effect of the residential school system on her life.

in the first poem she says, "the body is not immune to such catastrophe."

in the second poem she says, "you bring out the stereotype in me.
you bring out the government in me. the lies. the promises. the smile
contradiction in me. you bring out the indian act in me. the money
in me. the labels. the rez. you bring out the pity in me."

I feel her voice. her voice is strong. the words speak without
apology. Goto and I shake our rattles. these rattles allow a space
for ancestors to witness. witnessing these stories. witnessing these
survivor stories. witnessing the stories of the younger generation. we
move around the performance area. making revolutions within our
performance area. these rattles write a response to Brianna. the body
writes a response. shaking rattles. made by aboriginal kids in foster
care. this rattling is mixed with the silent hair rattles.

Video by Doug Jarvis. Settler artist.

Doug's voice. in his studio interspersed with footage taken at Beau
Dick's copper-cutting ceremony. this footage was documented at
the footsteps of the Victoria legislature. Namgis hereditary chief
Beau Dick cut his copper. the copper is connected to his position
as chief. Beau Dick is responsible for taking care of this material
object. Beau Dick cut this copper as a traditional act. this was
the first copper cutting to take place on the west coast in over 50
years. Beau Dick created this act, a traditionally defined act, to
add energy to the idle no more movement. this act, this cutting, is
designed to address the actions of a leader who has lost his way. a
leader whose actions are causing harm to the community instead of
contributing strength to the community. Beau Dick was attempting
to address the actions of the BC premier and Canada's prime
minister. from one chief to another. this cutting is an act which sets
in motion a course of retribution or reconciliation for the chief who
has lost his/her way.

we are drumming. Goto and I and ancestors are drumming. our
drumming writes a response to Doug. an acknowledgement of his
words. an acknowledgement of his truths. Doug is speaking about
the importance of Beau Dick's act. to him as a canadian. to him
as an ally to indigenous nations. drums are covered in red ochre.
drums are singing. ancestors start singing into the surface of drums.
this little light of mine. witnessing and remembering the songs sung
by residential school children. the songs sung by the children who
attended residential school. a performance by the children. singing

into drums. I envision drums as portals. they have the ability to activate space. they also aid in time travel. singing into drums brings our voice, our voice in the present, directly to the ancestors' realm.

Video by Gordy Bear. Cree artist. Cree youth.

he is speech making. he says, "talking to you today on residential school influence and how it has affected youth today. I'm not just speaking on behalf of myself. I'm speaking for a whole bunch of youth as well. I'm speaking for all the youth who are unaware of how residential school has affected them. on how it changed how it would have been if the residential school never happened."

he says, "a lot of youth don't even know they've been affected by residential schools. they think it is just something that happened. it's been over and done with. they don't know that what happened still lingers today. they don't know that we don't speak our languages every day. anymore. they think that English is the primary language."

shaking rattles. we are tricksters. we are human beings. revolutions continue. silent rattle. silent rattle writes down Gordy's words. ancestors are always witnessing. standing silent. watching Gordy. screaming. hooting. hollering. it is moving to see this young man share these words. these words are medicine when they come into contact with our bodies.

Video by Ayumi Goto. Japanese artist.

Ayumi's performance persona is gei shagyrl. her words. gei shagyrl is drumming on an artist's palette. drumming and moving through the ocean water. the freezing cold ocean water. the act is determination. forward movement through icy cold resistance. walking through the sand with deliberate steps. deliberate steps write a history. acknowledge a history. a beautiful geisha walking with deliberate steps through this cold ocean water. she is walking toward a land. through adversity. through her own difficult political history. her regalia writes a story.

I put on my regalia. the button blanket which is covered with braids. the blanket is covered with the braids that were cut off the children at residential school. ancestors wearing the regalia. this body writes a story. the body with the regalia with the movement writes a story. witnessing geisha. mirroring geisha. beadwork.

bone scrapers. I am moving in revolution. wearing the regalia. and scraping the beadwork with the bone scraper. the sound is like nails on a chalkboard. the scraper is trying to unmake beauty. like the residential school tried to unmake beauty. unmake the body. unmake knowledge. unmake history. the geisha's body writing a story about her own unmaking. she is writing a story of violence against bodies. drumming continues. drums inform the space. they invite the participation of hearts. drumming invites ancestors to shape the space.

Video by France Trepanier. Mohawk artist.

her voice tells a story about sacrifice. her voice talks about the hair cut off the children. hair is falling. being lost. being cut. cut. cut. cut. it is a portrait of a Mohawk artist, swinging her long hair around in a circle. her hands gather the lost hair. her hands start to shape the lost hair into a basket. picking up the pieces. picking up many small pieces. France sent a small box to the performance space. after we witness the video, I open up the box. inside the box is a small hair basket. I show the basket to the viewers.

ancestors witness this sacrifice. ancestors witness this transformation. ancestors witness our continued living. I open the box. I see the basket. I am pulled out of the performance. I am humbled by France's act. there is no more rattling. there is no more drumming. there is only physical heartbeats and silence. the act is so deep and full and moving.

dancing with braid blanket. dancing with mask on. the witnessing ends. the witnessing of truth ends. and we become Morin and Goto again. we also have work to do to contribute to this performance. I put the mask covered with hair on. I put the braid blanket on. I ask someone to sing for me. the viewers think I'm crazy. awkward silence. I need someone to sing so that I can dance with the regalia. an audience member sings "Crazy" by Patsy Cline.

Crazy, I'm crazy for feeling so lonely
I'm crazy, crazy for feeling so blue

I knew you'd love me
as long as you wanted

And then someday you'd leave me
for somebody new

Worry, why do I let myself worry?
Wond'ring what in the world did I do?

Crazy for thinking that
my love could hold you

I'm crazy for trying
and crazy for crying
And I'm crazy for loving you

Crazy for thinking
that my love could hold you

I'm crazy for trying
and crazy for crying
And I'm crazy for loving you.

I dance.

I dance a circle.

I put the mask on Goto.

the regalia which remembers

the story of the residential

school.

the dance that remembers

the story of the residential

school.

the dance that we dance

when we want to remember

our survival

from the residential school.

the dance we dance

to remember our strength.

I ask Ayumi, "what song would you like me to sing, sister?" a brother asking a sister what song she would like to practise dancing to. a cultural act. learning. learning to dance. learning to dance a mask in a safe space. before dancing the mask in front of the community. this connection was something that was interrupted for a time by the residential school system. many brothers didn't get their chance to sing for their sisters. their chance to help their sisters prepare for their demonstrations of cultural knowledge.

I sing a song. Goto dances. She dances one revolution of the performance area. She returns. I take the braid blanket off her. I tell the audience, "I am going to cut this hair. and it is going to fall on the ground. and I am going to pick it up. and it's going to be okay." their silence is full. I make the cuts. the scissors cut loudly. I pile the hair. there is no breath in the room.

Figure 3.3: Peter Morin cutting the hair of the mask, worn by Ayumi Goto. Photo by Ashok Mathur.

I ask, "are you okay, sister?" I walk across the performance space to ask Goto if she can continue. this act. this question. a brother checking in on a sister who is hurt/hurting. a brother checking in on a sister who experiences sadness. something that wasn't supported by the residential school structure. brothers were separated from sisters. the ability of family to see the circle of family was broken in residential schools. this performance created the situation which allowed for the moment to become fully expressed. a brother reaching out to protect and nurture his younger sister's hurt feelings. this was not a stolen moment, stolen by siblings suffering underneath the thumb of their residential school experience. I wonder if this is reconciliation.

I ask Goto to dance for me. what song shall I sing for you, sister? she asks me to sing "This Little Light of Mine." I sing for my sister. she dances in the hair mask. the regalia of the residential school remembers but doesn't drown inside the story. it activates the history, along with activating our present moment. the moment is very clear. we are living history. we are dancing history. we are contributing to an indigenous history of this land.

a final speech. I acknowledge the mask maker and the hair mask.

Figure 3.4: Mask, after its hair has been cut. Photo by Ashok Mathur.

I ask:

what is the life of this regalia that carries part of the residential school story?

what is the purpose of this specific regalia?

how will we remember this act?

Performance Description: Part 2, April 28 (30 minutes)

a dance for the regalia which remembers the residential school story. a dance to protect the commissioners (Murray Sinclair, Wilton Littlechild, Marie Wilson). the regalia which remembers the residential school story was danced. it was awakened to its purpose. the viewers were awakened to their purpose, which was also to remember the residential school story. what does it mean to remember? to remember is an act that resonates inside your bones. remembering means more heartbeats and a chance at immortality. isn't this why we make art? the chance to articulate the deep resonance connected with remembering. more than words, the created object remembers. our remembering. the act is in concert with the memory of the created object. together our memory

is a fortress against the elements. Skawennati Fragnito was my collaborator for this part of the performance. she and I represented the male and female aspects. she was a dancer. she wore the mask. I was a rattle. I wore the rattles.

set up the performance area:
12 rattles. wrapped in red cloth. a bowl of tobacco. 2 bone scrapers. ipod.

the performance starts on time. "Water Star Song" is playing. people arrive. instructions are given to the audience. Skawennati starts tying the rattles to my body. I start tying the rattles to my body. I tie the bone scrapers to my legs. I tie the mask to cover Skawennati's face. she is now a masked dancer. I put on the ipod. I blindfold myself. I begin hearing "Break My Bones" by the Pixies. As the song starts, I start shaking and singing. the rattles. the bone scrapers. the ipod. my throat is constricted. the air passageways are blocked. I am shaking. I am singing. I am rattling. I am jumping. it feels like my arms are shouting. it feels like my legs are shouting. I am a distinct feeling of eternity. Skawennati is dancing. the ipod immediately falls. I continue

Figure 3.5: Peter Morin and Skawennati tying rattles onto each other.
Photo by Dylan Robinson.

to rattle. the idea is to rattle until it is time for everyone to dance. the bone scrapers fall from me. I continue to rattle. then I shout, "start the music." the music is the dance remix "Sweet Nothing" by Calvin Harris, originally by Florence and the Machine.

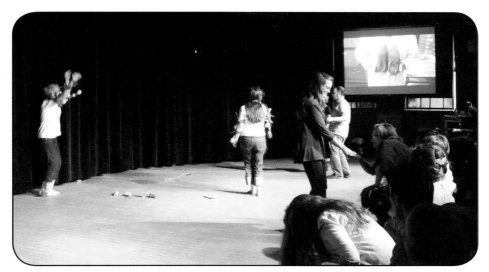

Figure 3.6 (top): Keavy Martin inviting guests to dance. Photo by Dylan Robinson.
Figure 3.7 (bottom): Guests dancing, Skawennati wearing mask in centre. Photo by Dylan Robinson.

So I put my faith in something unknown
I'm living on such sweet nothing
But I'm trying to hope with nothing to hold
I'm living on such sweet nothing
And it's hard to learn
And it's hard to love
When you're giving me such sweet nothing
Sweet nothing, sweet nothing
You're giving me such sweet nothing

So I put my faith in something unknown
I'm living on such sweet nothing
But I'm trying to hope with nothing to hold
I'm living on such sweet nothing
And it's hard to learn
And it's hard to love
When you're giving me such sweet nothing
Sweet nothing, sweet nothing
You're giving me such sweet nothing

So I put my faith in something unknown
I'm living on such sweet nothing
But I'm trying to hope with nothing to hold
I'm living on such sweet nothing
And it's hard to learn
And it's hard to love
When you're giving me such sweet nothing
Sweet nothing, sweet nothing
You're giving me such sweet nothing

So I put my faith in something unknown
I'm living on such sweet nothing
But I'm trying to hope with nothing to hold
I'm living on such sweet nothing
And it's hard to learn
And it's hard to love
When you're giving me such sweet nothing
Sweet nothing, sweet nothing
You're giving me such sweet nothing

a perfect song to sing to colonization.
a perfect song to dance to.
the audience is invited to dance.
Skawennati dances.
the bone scrapers have fallen off me.
I am shaking. I am jumping.
I am blindfolded.
I land on the points
of one of the bone scrapers.

the song repeats.
I continue to jump.
I continue to shake.
I continue to rattle.
I continue to suffer.
Skawennati continues to dance.
I land on the bone scraper again.
and again.
and again.

I continue to jump.
I continue to shake.
It feels like I am the air.
time and my relationship to the space
has shifted.
this is the purpose.
it is time to take off the blindfold.
I wake up. I see that I am surrounded.
a circle of audience-witness-dancers.

I see the mask.
I dance as a mirror.

I sing
I sing along to the music.
I sing for all of us.
I sing to the past.

then, the dance is over.

we see the blood on the floor. later on, Keavy Martin tells me the blood looks like crow footprints. the kind that crows make through light snow. except these are written in blood.

I end with speech making. what was this dance? why was there rattling? why did I feel the need to become a big rattle? my body. a reference to the land. a reference to the power of the land. as much as the residential school is a reference to the land. these schools are history. they live within a strand of the indigenous history of this land. they are not the whole history. understanding these parts. understanding our relationship to the whole. a brown body. a Tahltan body. a new ceremony. a new dance to address a current historical trauma. much like a dance to remember smallpox. or a mask that remembers death. thinking about the commissioners of the Truth and Reconciliation Commission. thinking about the work that is required of them. thinking about how to keep them strong. I offer this work. this dance. this remembrance. to them. to their work. to keep them strong. because we need them. we need them to finish strong. we need them to look at these stories and tell us their opinion. we need this because it helps us to see the next steps. I honour them and their work. and I ask ahdighi denetia to keep them safe.

Conclusion: a brown body performing the aesthetics of reconciliation

From this point
I will avoid the silence of punctuation
because there are no silences when speaking from the heart

My silence is determined
this silence has purpose
I am able to make this response
because I am brave *today* and this bravery
leads me to believe these words might live well
I carry the voices of the residential school survivors
carry their testimony with me
I put them on a shelf inside my body
you should too
I combine their silences with mine
I am considering canada's Truth and Reconciliation
with my own truth and reconciliation

there is a separation
because I've decided to stop speaking to canada
reconciliation concerns itself
with the ground that canada is built upon
this is a nation-to-nation conversation
written within corrupted political structures
residential schools are not invisible within these structures
we have danced these histories now
danced in places across the land
our testimony is our song
a mothership of intervention into existing land-based systems
indigenous collaboration exists as a land-based system
it is more than working together for a shared goal
it is more like our work together creates policy for the nation
a canadian collaboration?
I never think about reconciliation
it is an inherent component of every act
a breath
breathe in reconciliation
breathe out reconciliation
canada has no breath
canada's breath is shallow
it requires work
effort
attention to detail
the performance

this is what happens when you perform the memory of the land:
be afraid
we have a memory of the land
begin one year earlier
with dreams
with calls to ancestors
with awareness
I imagined planning a potlatch
an established indigenous structure
that allows for ancestors to witness
there is an order of events
an established creative process to follow
visits with ancestors
visits with elders

tea is involved
gifts are made
finding out who needs to be involved
listening to ancestors to include the right people
and finding out who needs work
who I can pay to make objects
collaboration on many levels
working with colleagues
to discuss knowledge and the shape of knowledge
understanding that these conversations
influence the shape of the performance
understanding that the form
and witnessing as performance
are the same
working toward a shared goal
a space to investigate
whether truth and reconciliation is possible
a space for many voices to consider

the shape of the performance follows the shape of ceremony
it is a space with a defined beginning middle and end
agreements are made
voices work in concert
a resonance of heart voice land voice ancestor voice
the body
is a resonance chamber

I offer this
reconciliation is not new
it has roots which run deep down into the land's memory
here in this land
it is not new that nations organize efforts and stand together
what is difficult here
is the requirement to write a new form of reconciliation
one that successfully articulates
canada made mistakes
and children were hurt

CHAPTER 4

Witnessing *In Camera*: Photographic Reflections on Truth and Reconciliation

Naomi Angel and Pauline Wakeham

On June 1, 2008, as Prime Minister Stephen Harper offered an official apology to Indigenous peoples for the Government of Canada's administration of the Indian residential school system, Shawn A-in-chut Atleo, hereditary chief of the Ahousaht First Nation and former national chief of the Assembly of First Nations, sat with his grandmother in the House of Commons and listened. Atleo's grandmother had raised seventeen children, all of whom had been taken from her care and sent away to residential schools. In his recounting of the apology, Atleo reflects, "At that moment, a peaceful calm and happiness washed over both of us ... at last, in the final years of her long and incredibly rich life ... [my grandmother] had the opportunity to witness a modest measure of justice for her and for so many of her generation" ("First Nations" 33). Sharing this sense of possibility, Atleo's grandmother turned to him as Harper spoke in Parliament and said, "Grandson, now they are finally beginning to see us" (33). As Atleo's grandmother suggests, reconciliation is often conceptualized in terms of shifting dynamics of visibility through which past injustices that were once kept "out of sight" are brought to the foreground of national consciousness, thereby ostensibly transforming relations of seeing and being seen between dominant and aggrieved parties.

Such visual dynamics of recognition are foundational to Western genealogies of justice and human rights. As Sharon Sliwinski demonstrates, the role of vision in these processes is not merely tropological or reducible to optical metaphors. Instead, the "recognition" of what the preamble to the 1948 Universal Declaration of Human Rights calls "the inherent dignity and ... the equal and inalienable rights of all members of the human family" has entailed much more than a formal acknowledgement of legal rights; it has also involved shifts in perception enabled by the work of visual culture (qtd. in Sliwinski 103). In this context, Sliwinski retraces the entangled histories of

human rights and photography to demonstrate how "[t]he ideal of a human subject naturally endowed with dignity and rights migrated through public imagination, in part, by virtue of spectators' passionate engagements with pictures" (9). This "circulation of images," Sliwinski contends, helped "produce a ... complex constellation of feelings" through which "human dignity came to be imaginatively extended to (and withdrawn from) distant others" (9, 5). If photography played a vital role in the emergence of human rights, however, it often did so through an inverse relationship—through capturing scenes of violence and atrocity and, thus, creating a visual archive of humanity's darkest limits, of the depraved denial of the basic rights of life and security of the person. As a case in point, Sliwinski analyzes how photojournalism brought "Allied publics ... face-to-face" with the graphic atrocities of the Holocaust, an encounter that "shattered previously held notions of a shared humanity" and led to the resurrection of those ideals in new forms through the drafting of the Universal Declaration (12–13). And yet, the case of the Holocaust is relatively atypical in terms of the visual dynamics bound up in the "imaginative extension" of humanity for, both historically and still to this day, such processes of recognition have tended to reinforce Western subjects' position as spectators who gaze upon the plight of non-white others. It is no coincidence, therefore, that human rights advocacy was vested with a new urgency in the wake of the Holocaust, when the presumed distance of the Western spectator's gaze was tested by the scene of "auto-violence" in which the other in question, this time, could be situated within a visual spectrum of whiteness (Rajan 160).[1]

While the national imaginary is saturated with patriotic visions of Canadian peacekeeping and human rights protection initiatives projected onto a backdrop of distant geographies, the scene of human rights has recently returned home. With the commencement of the Truth and Reconciliation Commission of Canada in June 2008, the same month as Harper's apology, Canada became the first G8 nation and long-standing liberal democracy to initiate such a forum—an act that, in summoning the idioms and mechanisms of transitional justice typically employed in the aftermath of oppressive regimes, articulated a self-proclaimed liberal democratic nation to the scene of apartheid in South Africa, civil war in El Salvador, and military dictatorship in Chile. And, yet, the connection between gross human rights violations in nations of the global South and colonial genocide in Canada has been resolutely denied by the settler state and often disavowed by a heterogeneous settler society that, according to TRC Commissioner

Marie Wilson, would rather remain "comfortably blind" to these injustices (qtd. in Lalonde).[2] If, as Shawn Atleo's grandmother suggests, in the wake of Harper's apology and the commencement of the TRC, "now they are finally beginning to see us," what is it, precisely, that non-Indigenous Canadians are starting to recognize? And what are the persistent blind spots and the ongoing limits of a settler public's vision of justice?

"Comfortable blindness" to colonial genocide in Canada is the product of many factors, including the state's strategic dis-articulation of specific policies such as residential schooling from an overarching system of colonization, as well as the temporal isolation of past policies from their reinventions in techniques of settler occupation and assimilation in the present. When disconnected from a host of related colonial policies and re-framed according to the alibi of the state's "treaty obligations" to provide education for Indigenous children, residential schooling's pivotal role in a multi-pronged assault on Indigenous lifeways is obscured.[3] And, yet, the persistent disavowal of the gross human rights violations engendered by the Indian residential school system (IRS) may be enabled not only by what is occluded from view, but also by *how* residential schooling is *made visible*—how it has historically been represented in photographs and how that particular image archive continues to be recirculated today by the mainstream media as well as by the TRC itself. Unlike the many images of bloodshed made famous by photojournalists' exposés of war-torn sites across the globe—images such as Nick Ut's Pulitzer Prize–winning 1972 Vietnam War photo of then nine-year-old Kim Phuc burned by napalm or Greg Marinovich's 1991 Pulitzer snapshot of a man set on fire during the violent struggles to end apartheid—the photographic archive of residential schools is of a very different order.[4] Rather than being motivated by the goal of divulgence that has become the stock-in-trade of photojournalism and now social media in conflict zones, the image record of residential schools is composed largely of photographs taken by school and church staff as well as government officials seeking to produce propagandistic scenes of institutional order. There are no photographs of the deaths of thousands of children in residential school custody or the rampant psychological, physical, and sexual abuse that occurred within the schools' walls. These images largely remain outside of the frame, so to speak.[5]

In noting the distinctive status of the residential schools photographic archive, the point is not to lament the absence of graphic violence captured on celluloid. The perverse logic underpinning much

human rights photography—namely, the necessity of seeing the pain of others in order to be roused to action—is a deeply fraught dynamic. So too is the risk, as Susan Sontag famously warned, of looking as an "act of non-intervention," desensitized apathy, or even voyeurism (qtd. in Sliwinski 9). Instead, we engage the specificity of the IRS image record in order to consider the resultant responsibilities of witnessing colonial genocide when its visual archive does not conform to normative expectations of the genre of human rights photography. Such differences between generic norms and IRS visual representations, we contend, may be mobilized to aid and abet settler Canadians' denial of human rights violations within their own geopolitical borders, thereby confirming the mistaken assumption that the "elsewheres" of the globe are the places where the real problems lie. The ubiquitous scenes of classroom instruction and posed student portraits that pervade the [IRS] historical record seek to approximate the normalcy of educational experiences in schools across Canada, enabling some viewers to see what they want to see—the signs of "progress," of a benevolent church and state performing social and moral uplift—rather than the disturbing traces of the assimilationist project's assault on Indigenous peoples. The responsibilities of grappling with the IRS therefore necessitate a disruption of habituated ways of seeing and new methods of reading the shadows and absences in residential school photographs—methods of making loss visible and attending carefully to the long-term, attritional impacts of residential schooling's compounded attack on family, community, culture, language, spirituality, and life itself that exceed the photographic freeze-frame.

In this essay, we contribute to the critical disruption of ingrained ways of (not) seeing colonialism in Canada through an analysis of the multiple layers of mediation that shape the photographic archive of residential schools in the current moment of "truth and reconciliation." The first layer examines how the mainstream media, church organizations, and the TRC mobilize images to tell the story of residential schools and to catalyze public witnessing. The second layer then considers how Indigenous survivors and community members are intervening in photographic archives to unsettle dominant ways of framing residential schools and, most crucially, to tell their own truths. Finally, the third layer permeates and informs our discussion of the first two, as it involves examining the lenses we bring to witnessing and the limits of our own vision as settler scholars. Since 2010, we have collectively attended the TRC's national events in Winnipeg, Inuvik, Halifax, Saskatoon, and Montreal, as well as the regional events in Victoria and

Toronto. Our insertion, throughout this essay, of photographs we have taken at these events seeks to interrogate the processes of re-framing and archiving in which our scholarly work is implicated. In examining the interplay between these multiple layers of mediation, we mobilize photography as metaphor, medium, and method for examining the complex tensions shaping the TRC's labour of exposing the history and ongoing impacts of the IRS amidst a struggle over the seen and the unseen, or what may reach the public eye.

Witnessing in Black and White

Since Harper's 2008 apology, news reports regarding the Indian residential school system have proliferated in the mainstream media. The publication of almost any article about residential schools or the Truth and Reconciliation Commission is accompanied by black-and-white archival photographs of students in classrooms or posed in front of institutional buildings. Often the particular institution is chosen randomly in relation to the content of the news article and displayed with no, or at least very little, explanatory information.[6] Despite the fact that the Truth and Reconciliation Commission repeatedly seeks to remind the public that "the last residences (Gordon's Student Residence and the Prince Albert Student Residence in Saskatchewan, and the Yellowknife, Inuvik, Cambridge Bay, and Iqaluit residences in the Northwest Territories) did not close until the mid-1990s," the images the commission uses in its educational materials and reports are often from much earlier periods (*They Came for the Children* 20). For example, the cover of the commission's 2012 research publication, *They Came for the Children*—a public education report that outlines a general history of the residential school system—features black-and-white photographs from the 1930s, 1940s, and 1950s on a sepia-hued backdrop (Figure 4.1). The TRC's final reports, released in June 2014, including *Honouring the Truth, Reconciling for the Future: Summary of the Final Report of the Truth and Reconciliation Commission of Canada*, *The Survivors Speak*, and *What We Have Learned: Principles of Truth and Reconciliation*, reinforce the use of photographs depicting residential school life from earlier periods of the institutions' operation, often without providing any reference to dates, thereby cultivating a generalized sense of pastness.[7] Additionally, across these three volumes, many of the same images are reprinted more than once. For instance, all thirty-five of the photographs published in *What We*

Have Learned are repeated in *Honouring the Truth*. Such repetition produces a visual effect that artificially limits the geographical and historical diversity of the schools. The ubiquitous circulation of such older archival photographs in media and TRC publications thus generates a semiotics of pastness—a set of visual codes that cue the spectator to associate the IRS with a more distant temporal realm, thereby implicitly framing the work of witnessing as an act of retrospection, a looking and feeling backwards into history that risks shifting perspective away from the present state of settler-colonial relations in Canada. The discomfort produced by a recognition of the spatial proximity of human rights violations in Canada is thus mitigated by the semblance of temporal distance.

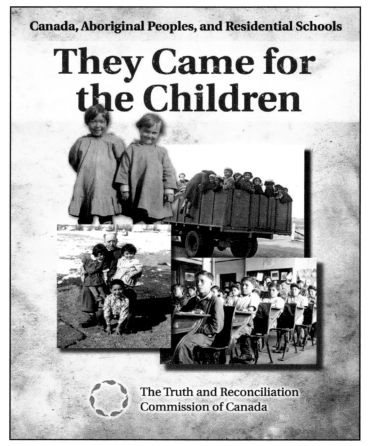

Figure 4.1: The cover of the Truth and Reconciliation Commission of Canada's 2012 research publication *They Came for the Children.*

Such a retrospective model of witnessing risks reinforcing the temporal containment strategies of dominant reconciliatory discourses in Canada. As several scholars have observed, Harper's 2008 apology sets the tone for this approach, characterizing residential schools as a matter of the past—what the apology calls "a sad chapter in our history" that is ostensibly now closed and succeeded by new and improved episodes in the narrative of national progress.[8] This stance is reinforced throughout Harper's apology via the rhetorical deployment of anaphora, or the repetition of the phrase "we now recognize" for strategic emphasis. Specifically, Harper remarks,

> the Government of Canada now recognizes that it was wrong to forcibly remove children from their homes and we apologize for having done this. We now recognize that it was wrong to separate children from rich and vibrant cultures and traditions[,] that it created a void in many lives and communities, and we apologize for having done this. We now recognize that, in separating children from their families, we undermined the ability of many to adequately parent their own children and sowed the seeds for generations to follow, and we apologize for having done this. We now recognize that, far too often, these institutions gave rise to abuse or neglect and were inadequately controlled, and we apologize for failing to protect you. ("Statement of Apology")

Through this reiteration, the *mea culpa* "serves to reassure contemporary national subjects that they [and the current administration] bear no responsibility for the implementation and execution of the residential schools system" (Dorrell 32). While the apology thus attempts to absolve the current nation of accountability for the IRS, it also implicitly mitigates the culpability of the government and citizenry of earlier eras by suggesting that the wrongs they committed are only "recognizable" as such "now," with the benefit of social enlightenment in the intervening years. This logic thus suggests that to judge the IRS by the moral and juridical standards of today would be to impose a mistaken presentism upon the interpretation of historical events. Instead, residential schools must be understood through the historical lenses "of their time," where such a "time" becomes a mitigating factor in the indictment of church and state. In so doing, the past is artificially homogenized as a time of unknowing when, in fact, ample evidence demonstrates that the residential school system's dangers were documented for the federal government and in the popular press during the early twentieth century.[9]

The problems resulting from retrospective models of witnessing are further complicated by the image archive from which school experiences are reconstructed and the methods through which its pieces are re-assembled. In reconstructing a photographic history of residential schools, "a scant handful" of archival images have repeatedly been chosen over and above others, acquiring "iconic" status as the definitive "representation of the residential school experience" (Racette 52). Among the most frequently reproduced images is a pair of "before and after" photographs of Thomas Moore, a Cree student at the Regina Indian Industrial School, that have become emblematic of IRS assimilation. These images were first published in the Department of Indian Affairs' annual report for 1896, where they were utilized as visual evidence of the schools' effectiveness—a strategy of photographic propagandizing first pioneered by Captain Richard Henry Pratt, principal of the Carlisle Industrial School in the United States which became the founding model for Canada's IRS (Racette 52, 49). In the dyad, Moore is reduced to two colonial stereotypes: the "savage" and the "modern." The "before" image shows Moore with braids of long hair and in traditional dress (Figure 4.2). And, yet, peeking out from under his "tradecloth tunic" at the neck and wrists is a "checked shirt" that suggests deliberate costuming (Racette 53–54). He is positioned against a nondescript background outside of time and context; according to Sherry Farrell Racette, "[t]o emphasize his 'primitive' state, the furniture and floor are covered with fur pelts" (53). In his hand is placed a toy gun—a prop that is perhaps supposed to construct Indigeneity as a threat to settler security. In the "after" image, Moore's hair is shorn and he is dressed in a school uniform—a tidy suit with a cap resting beside him (Figure 4.3). In his reading of the image, historian John Milloy notes that Moore is "framed by the horizontal and vertical lines of wall and pedestal—the geometry of social and economic order; of place and class, and of private property[,] the foundation of industriousness" (5). The potted plant positioned on the column beside Moore also serves as a "symbol of civilized life, or agriculture. Like Thomas, the plant is cultivated nature no longer wild" (Milloy 6). In the "after" image, Moore's stance is less confrontational. With one hand on his hip and one arm resting on a stone column, he is meant to evoke a sense of confidence and ease in his new role as citizen-subject (5).

In its recirculation in several scholarly studies—most notably as the cover image and introductory anecdote for Milloy's book *A National Crime: The Canadian Government and the Residential School System, 1879 to 1986*—and as a frequent pedagogical tool in well-known

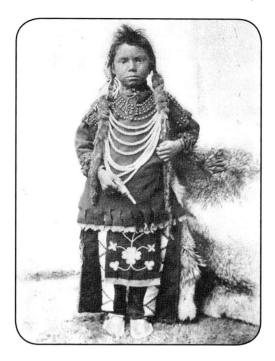

Figure 4.2: Thomas Moore upon entering the Regina Indian Industrial School, circa 1896. Reproduced with the permission of the Provincial Archives of Saskatchewan. Document R-A8223(1).

Figure 4.3: Thomas Moore, "after tuition" at the Regina Indian Industrial School. Reproduced with the permission of the Provincial Archives of Saskatchewan. Document R-A8223(2).

resources such as the Legacy of Hope Foundation's online residential schools exhibit, *Where Are the Children?*, and the brief discussion of residential schools at the First Peoples Hall at the Canadian Museum of History,[10] the photographic dyad of Thomas Moore has become emblematic of the genre of "before and after" images that visually telegraph assimilation's effects. However, the photographs' significance as a "before and after" set has lately accrued a doubled status, coming to represent not only the "before and after" of an Indigenous child's experience with the IRS, but also a "before and after" index of two ways of seeing or two ideological lenses for viewing the residential school project. In this sense, the photographs have become part of a metanarrative contrasting public perceptions of assimilationist ideology during the height of the operation of residential schools and in the post-apology moment today. According to Milloy, for turn-of-the-twentieth-century government officials, the photographs positioned Thomas Moore as "the vanguard of a magnificent metamorphosis" (6). Through "an empire-wide task of heroic proportions and divine ordination," residential schools ostensibly rescued Indigenous children from their doomed race and rehabilitated them into good national subjects who could contribute to Canada's industrial capitalist progress (6). From this perspective, the photographs of Moore telegraphed a triumphant story of his entrance into a Canadian futurity founded upon the cornerstones of "European industry" and Christianity (5). Such perspectives thus served to naturalize and legitimate the "metamorphosis" of Moore as an inevitable process through which "savage" Indigenous ways were superseded by the benefits of civilization.

In scholarly and public educational materials produced in recent decades, the Thomas Moore dyad is often now recontextualized in terms of what, to echo Stephen Harper's apology, "we now recognize" about the residential school system. The lens through which Moore's transformation was once read as a "magnificent metamorphosis" of social and moral uplift is now characterized as a mistaken historical perspective—an unenlightened "before" state prior to the nation's current moment of reconciliatory awareness. As Racette observes, the photographs' "staged poses, graphic impact, and dramatic intent have allowed them to be reframed from their original purpose of promoting the project [of residential schooling] into the visual tools of exposure and denouncement" (52). Today, the Moore photographs may be recontextualized as encoding signs of the erasure of culture, language, and community. Moore's shorn hair is now understood as "visual testimony" of institutional uniformity and a "deeply symbolic and trau-

matic gesture enacted on the bodies of children" who, in their own cultures, often understood hair cutting as part of mourning processes (Racette 59). In the "after" image depicting Moore's refashioning as a "civilized" subject, the artificiality of his ostensibly casual, confident pose hauntingly belies the institutional manipulation of young children. The Moore dyad is thus a useful "visual tool" because it transcends the singular freeze-frame of photography to provide a time-elapsed imaging of assimilation that provides a visual analogue to the now-famous slogan "to kill the Indian in the child." But like the credo itself, which is a product of misquotings and recitation without a rigorous return to archival sources, the Moore image has also become reduced to a rote visual mnemonic for what we *think* we *now know* about the IRS.[11] In the process, Moore is reduced to an emblem of colonial violence in ways that may deny the particularity of his personhood and experience. In yet another step further removed, Moore risks becoming displaced from the focus of the image altogether, and what becomes centred instead is the re-education of settler perception in the current moment of "truth and reconciliation."

Cultivating a too-easy sense of the transparency of assimilation in the Moore dyad risks obscuring ongoing colonial relations and ways of seeing—lenses that may be focused differently than in the past but which may still obscure perceptions of the full extent of colonial violence and the ongoing structures of colonization in Canada. For example, although the time-elapsed quality of the photographic dyad brings cultural loss into visibility in certain ways, it is important to remember that the visual differences portrayed in the two pictures may be dramatic, yet the time span between the two images is relatively short. Moore was still a child in IRS custody when the second photograph was taken, and it is clearly as staged as the first. Thus, the losses of identity and culture that are crystallized through these images constitute a highly manipulated version of what assimilation's effects upon Indigenous children looked like. This particular vision of "metamorphosis" is intended to re-frame loss as success. The "assimilated" Moore appears healthy, strong, and middle class. In reality, however, the experience of residential schools often produced drastically different results, leaving students with malnourished bodies racked by diseases such as tuberculosis (Miller, *Shingwauk* 305) and marked by corporal punishment and physical and sexual abuse. Additionally, unlike the prosperous-looking Moore, most residential school graduates left the schools impoverished and unprepared for many forms of work, having spent more time performing manual labour in

these institutions than receiving educational instruction (Miller, "Reading Photographs" 469).[12] Unlike the sense of confidence conveyed in Moore's "after" photo, many children graduated from residential school in a state of profound displacement and discomfort, denied acceptance into white Canadian society as a result of ongoing racism and yet similarly isolated from their families and home communities owing to their forced loss of language and culture. It is also crucial to note that all too many children never lived long enough to graduate. As the TRC's summary final report details, as a result of the fact that "[m]any records have simply been destroyed," the "number of students who died at Canada's residential schools is not likely ever to be known in full" (*Honouring* 94). With the available data, however, the TRC has ascertained that at least "3,201 reported deaths" occurred in the schools (96) and that as late as 1945, the death rate in the schools "was 4.9 times higher than the general death rate" in Canada (97). Moreover, the status of the Moore "after" image rhetorically suggests that Moore's assimilation—and, hence, the ramifications of this particular form of colonial violence—is complete, as though the trauma of residential schools ended when students were discharged. Such a perspective risks obscuring the long-term effects of residential schooling and the ongoing reverberations of intergenerational trauma within Indigenous communities. What were the attritional impacts of Moore's experience in the IRS several years after the "after" picture was taken?[13]

The fact that Thomas Moore's name is known and is repeatedly recirculated along with his "before and after" images is, in itself, exceptional given that most IRS students remain unnamed in the colonial photographic archive. However, even Moore's name cannot be taken at face value, as the 1896 Indian Affairs annual report truncated his name from the way it appeared in school records as Thomas Moore Keesick. It is also quite likely that Moore had a Saulteaux name that was expunged by colonial systems of documentation.[14] The sense of personalization that the naming of Thomas Moore creates consequently occludes how, in many senses, Moore has been reduced to a cipher of vanishing aboriginality like many of the countless unnamed students depicted in the IRS photographic archive.[15] Recognizing the ubiquity of the Thomas Moore photographs and the concomitant lack of knowledge of the boy who was depicted in them, filmmaker Louise BigEagle sought to find out what happened to Thomas Moore Keesick after these pictures were taken. What she discovered is that Keesick, a member of the Muscowpetung Saulteaux First Nation, was enrolled in the Regina Indian Industrial School, along with his siblings Samuel

and Julia, on August 26, 1891. Thomas was assigned the institutional identification of "Number 22" and was frequently referred to by number rather than name. Four years after becoming a student at the residential school, Keesick was sent back to his home community with an illness, believed to be tuberculosis, where he died shortly thereafter at the age of twelve. Keesick's sister, Julia, also died as a child. BigEagle's research thus powerfully reveals how the "after image" of Keesick presented a false image of assimilation's effects that differed drastically from the reality of this child's experience (Benjoe).[16]

The limits of the colonial archive and the information it excludes have a bearing upon how these photographs are mobilized to tell the story of the IRS today. In corporate media reports that reproduce stock archival photographs each time a story on the general theme of residential schools is published, the specificity of location is at times treated as irrelevant—a picture of a particular institution becomes a generic stand-in for the complex totality of the IRS, and the faces of students become ciphers of "the Indian child." The names of students are almost never provided with such images; if explanatory captions for the images are offered at all, they are labelled according to the name of the institution that subsumes the identities of all its wards. The corporate media's recirculation of the colonial archive's methods makes the institutional apparatus loom large and thereby risks eclipsing the identities and perspectives of students. In so doing, such framings may inscribe a visual corollary to what Roger Simon identifies as the potential complications involved in listening to survivor testimony at the TRC. As Simon astutely cautions, "there is present in contemporary society a historically specific, socially organized mode of regarding the pain of others that has the potential to deny a person a subjectivity that is self-constituting. This is particularly troubling in the context … [of settler publics learning about the pain of Indigenous people] as it seems to edge towards a replay or reinstituting of colonial power relations" ("Towards a Hopeful Practice" 131). According to Simon, the risks are great that settler publics may reduce Indigenous survivors' truths to a standardized "narrative of victimhood" in which "the singular story becomes a reiteration of previous stories" (132). "On such terms," Simon continues, "all residential school stories start to sound the same and therefore interchangeable, leading to diminishing interest in listening and learning because there is essentially nothing different that might be said, no further questions to be asked, and nothing new to learn" (132). When pictures of unnamed children, posed in uniforms that overwrite their cultural and individual identities, are recirculated

with ubiquity as generic examples, their faces—like their truths—may start to become "interchangeable" to settler publics or homogenized as a general narrative of what residential schools looked like. Photographs risk becoming read as "a reiteration of previous" photographs, prompting habituated forms of looking without seeing. "In these circumstances," Simon warns, "the circulation of stories of pain and loss turns into a spectacle that configures moments of anguish and suffering into a historical thematic in which the accounts collected by the commission lose their specificity and historical grounding and, even more crucially, lose their transitive force, diminishing the possibility of the repair needed for a more just future" (132).

Such dynamics of spectacle are particularly pronounced in a postcard produced by the United Church of Canada's Residential Schools Archive Project (Figure 4.4). Distributed for free at the archive's exhibit in the TRC's "Learning Place," the postcard features a black-and-white photograph of a scene from inside an IRS classroom. In this image, a row of male and female students are depicted practising their writing of cursive script on a blackboard. Each student is on the verge of completing a set of "ooo" with an eerie level of precision and uniformity. Mounted on the wall above them is a phrase extracted from Hebrews 12:2 that reads "Looking unto Jesus"—an exhortation that sits uncomfortably with the sense of confined perspective embodied by the students' positioning with faces pointed toward the blackboard looming in front of them. With the children's visages obscured from view, only their backs visible to the camera, the image reduces the students to blank, deracinated subjects being remade in the image of white Christians. The figure of the cipher represented by each rigid, uniformed body is further amplified by the cursive script of "ooo," which resonates as text full of emptiness, signifying nothing. On the verso side of the postcard, no explanation of the photograph is provided, not even a school name or date (Figure 4.5). Instead, the postcard is used to advertise the church's online archival project, www.thechildrenre membered.ca. Next to the web address is the invitation, "Visit to look at historic photographs, documents or information about each of the 14 schools operated by the United Church of Canada between 1849 and 1969." The only other text provided on the verso side is an excerpt from the United Church of Canada's 1986 apology, which states, "We tried to make you be like us and in so doing we helped to destroy the vision that made you what you were."

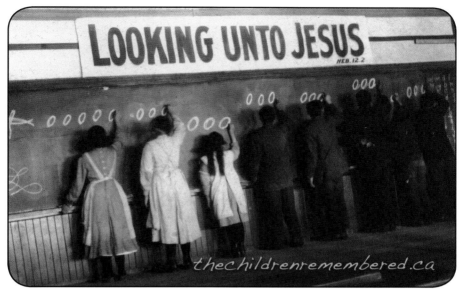

Figure 4.4: The front side of the postcard produced by the United Church of Canada's Residential Schools Archive Project.

Figure 4.5: The verso side of the United Church postcard.

By pairing the photograph's resonances of restricted sight with the apology's reference to "destroy[ing] the vision that made you what you were," the postcard seems to play upon a knowing sense of irony regarding the blind spots of the IRS project and its fraught interpretation of "Looking unto Jesus." But the postcard's use of irony as a medium for expressing contrition and remorse feels misplaced, undermining the gravity of the situation. It is reminiscent of Stephen Harper's "we now recognize," which seeks to limit culpability and reconstruct the apologetic subject as a figure of insight who has overcome the blindnesses of history. The ironic tone is further troubled by the very medium of the postcard itself—a genre of souvenir or memorabilia—which risks trivializing the assimilative violence of the photograph as well as the immense responsibilities of witnessing involved in the labour of truth and reconciliation. Deploying this postcard as an invitation to the United Church's online archival project casts the work of witnessing as a form of historical tourism, a glancing backwards here oriented through the lens of temporal distance rather than the typical framework of a geospatial remove associated with the postcard genre that dispatches scenes of an exotic elsewhere for visual consumption. The result is the reinforcement of relations of looking that risk turning this image into a consumable spectacle.

The image reproduced as a postcard by the United Church is also included in the TRC's 2012 research publication *They Came for the Children*. The photograph is included in a section entitled "The Role of the Churches," which describes the work of different church organizations in the operation of schools but does not discuss the particular institution depicted in the image. As with many instances throughout the report, the photograph is used to border the text, serving as a form of supplementary "visual interest." The only information pertaining to the photograph is the caption directly below it, which states, "In his 1899 book *The Indians: Their Manner and Customs*, Methodist missionary John Maclean wrote that while the Canadian government wanted missionaries to 'teach the Indians first to work and then to pray,' the missionaries believed that their role was to 'christianize first and then civilize.' This photograph was taken at the Methodist school at Red Deer, Alberta, sometime between 1914 and 1919" (14).[17] The TRC's historical report certainly provides more context for this photograph than the United Church's postcard, and the document's sober tone is vastly different from the tenor of playful irony mobilized in the postcard. And yet, the TRC report's enlistment of photographs as "visual interest" to enliven written narrative encourages readers to

glance at the picture in passing—a form of looking without seeing that reinforces assumptions about photographic transparency and about the correspondence between image and reality that do not address the troubled contexts of these images' production by school officials.

Despite the important differences between the uses of the photograph in the United Church's postcard and the TRC's report, both reproductions of the image encourage understandings of the IRS based on what is made visible within the photograph rather than what remains absent, occluded, or unrepresentable. Such mobilizations of the IRS photographic archive in an era in which the scene of truth and reconciliation has been domesticated in Canada invites comparison between the visual field of residential schools with the imaging of other human rights violations across the globe. While most images of human rights abuse capture viewers' attention through graphic shock—through the immediate viscerality of a scene of horror that departs from the norms of many Western subjects' daily existence—the classroom photograph from the Red Deer school may, when viewed with a quick glance, be absorbed into the domain of the familiar for settler Canadians who may also have practised cursive writing on classroom blackboards. In the process, spectacle is paradoxically contained within the mundane realm of quotidian experience. As Racette notes, "[a]t first glance, many photographs of children in residential schools are indistinguishable from the broader genre of school photography" of the period (49). This deliberate borrowing of visual conventions on the part of residential school photographers has engendered a complex interpretive legacy for viewers today. The deliberate photographic construction of the IRS according to the visual codes of educational normalcy thus continues to solicit fraught forms of (mis)recognition in the present— namely, a false sense of equivalence among settler audiences who see something of their own, or at least their grandparents', classrooms in the pictures. Such responses have all too frequently been expressed in online comments posted on major Canadian news outlet websites. For example, when researchers from the TRC's Missing Children Project announced that they found three thousand documented deaths of children while in IRS custody, one reader remarked, "Really!!! I could tell stories of the one room school I attended, and the whipping/strapping received from the teachers, and I believe thousands of Canadians could tell the same story" ("Residential School Survivor"). By relativizing the experiences of Indigenous people as part of a harsher era in which physical discipline of students was apparently acceptable, this non-Indigenous reader, like many others, dismissed residential

schools' status as a genocidal policy targeted at a particular racialized population. To disrupt such relativization, it is crucial to return to the scene depicted in the United Church's postcard to ask, How might the photograph register differently for non-Indigenous viewers if, as just one example of many, the language they were forced to write on the blackboard was not their own and if they were forbidden, often with corporal punishment, from speaking the only language in which they could communicate with their families?

The archival photographs analyzed in this section highlight the complex dynamics of exposure and concealment, spectacularization and normalization, that inflect the ways in which IRS history is reconstructed through pictures. The examples of recirculation discussed here call into question the transparency of these images as pedagogical tools, the assumed content that they ostensibly telegraph, and the challenges involved in the re-education of settler perception today. While corporate media, online exhibitions, and the Truth and Reconciliation Commission's efforts in public education through images provide instructive lessons about mobilizing the IRS photographic archive, survivor interventions at the TRC offer alternative ways of re-framing the challenges of witnessing *in camera*. It is to those interventions that we now turn.

Double Vision: New Lines of Sight

The Truth and Reconciliation Commission of Canada's status as the first TRC established "as part of a judicially mediated agreement instead of through legislation or decree" has had significant impacts on the commission's mandate and structure (International Center for Transitional Justice [ICTJ], "Canada's TRC"). Created as part of the 2006 Indian Residential Schools Settlement Agreement negotiated between the Assembly of First Nations, Inuit Tapiriit Kanatami, the federal government, church organizations, and lawyers representing survivors, the TRC's mandate reflects the tensions between the differential investments of the multiple signatories. While the Truth and Reconciliation Commission was charged with the task of making visible to national and international publics the history and ongoing impacts of the residential school system, the commission's investigative powers were structurally limited by its mandate. Specifically, survivors were prohibited from naming the names of those who committed crimes against them, ostensibly due to the need to adhere to privacy legislation. Such

information could be disclosed only *in camera*. Moreover, while survivors were constrained by the law in this regard, the commission itself was stripped of the force of law. As Roland Chrisjohn and Tanya Wasacase assert, the "commission can (1) subpoena no witnesses, (2) compel no testimony, (3) requisition no document. It cannot find, charge, fine, or imprison" (222).[18] The commission was therefore structurally constituted such that the investigation and exposure of criminal acts might fade from view while a therapeutic emphasis on healing social divides was spotlighted.[19] In this latter scenario, the TRC risked becoming implicated in the production of a fraught spectacle in which the burden of disclosure fell to Indigenous people, who, in a strange inversion of the logic of the Catholic confessional, might be asked to lay bare their sorrow and suffering before the nation (Chrisjohn and Wasacase 226).[20]

At the crux of the commission's mandate, therefore, is a tension between exposure and concealment, privacy and spectacle. Our title's invocation of the concept of "witnessing *in camera*" seeks to refract these complexities through the use of photography as metaphor, medium, and method. The Latin phrase *in camera*, meaning "in private" or "in chamber," invokes the discourse and "procedures of … law," referring "to occasions when the content of legal proceedings are deemed too sensitive … for public observation" and the court must continue its work "away from the public eye" (Sliwinski 4). What is deemed "too sensitive" according to the framework of the TRC's mandate, however, is the identities of perpetrators, who are able to remain anonymous. Conversely, the most intimate details of survivors' trauma may be made public, yet denied evidentiary force in terms of prosecuting and convicting guilty parties. We therefore invoke the phrase "witnessing *in camera*" in a doubled sense: (1) to signal how the TRC was constituted by its mandate as a site of revelation while being constrained by the regulation of privacy, and (2) to demonstrate how the use of photography and other lenses of mediation at the TRC and beyond have become implicated in these dynamics of concealment and exposure.

One of the most significant sites at the TRC for making visible survivors' experiences was the commissioners' sharing panels—the largest and most public type of forum for people to share their truths.[21] While there were high-profile panel discussions about themes related to reconciliation that often included well-known survivors, those sessions were organized on an invitational basis. Such panels at times contributed to the production of a "star system" of famous survivors and the

inscription of a model survivor teleology in which adversity was succeeded by overcoming.[22] In contrast, the commissioners' sharing panels were open to whoever wished to provide a statement, though registration was required in advance. The TRC's lack of subpoena powers to compel testimony resulted in the majority of speakers at this forum being residential school survivors, intergenerational survivors, or family and community members, though that was not always the case. These sessions took place in large conference rooms with seating for a few hundred witnesses. Speakers were brought to a table on a stage positioned across from at least one commissioner who listened and took notes while the process was filmed. The proceedings were simultaneously projected onto large screens positioned around the room and often live-streamed on the Internet. The set-up of the room with the stage, the microphones, cameras, and screens structured the panels as a performative site that further complicates what Tanana Athabascan scholar Dian Million aptly calls the "convoluted process" of "witnessing one's truth to power" in which Indigenous people may be interpellated into "highly proscribed roles and subject positions" (160). As survivors offered their testimony, their images and words were quite literally magnified, their faces projected onto screens, their voices transmitted through microphones and headsets. Cameras filming speakers often zoomed in or out, focusing upon a shaking hand or the fall of tears, framing the testifying subject in particular ways.

Despite the constraints imposed by the commission's mandate, many parties have worked to overcome these limitations. We want to note that the terms of the commission, as proscribed by the Settlement Agreement, pre-dated the commission's existence as brought to life by commissioners Murray Sinclair, Wilton Littlechild, and Marie Wilson. In their daily labour, the commissioners exercised immense compassion and respect, pushing against the boundaries of the mandate in ways that attended to the interests of survivors and that gave the TRC a constantly evolving shape in practice that exceeded the formal elements set out in the IRSSA. Most especially, Indigenous survivors, families, and communities altered the TRC, reoccupying the forum in ways that sometimes challenged or patently refused proscribed speaking roles. Speakers at the commissioners' sharing panels were typically allotted only fifteen minutes each—a time constraint often remarked upon and resisted by those who noted the impossibility of sharing their truths in such a short duration. As John Bosum, a Cree man who spent ten years at the La Tuque residential school in Quebec, noted toward the end of his public statement, "I only have one minute of

my fifteen minutes of fame left" (Bosum).[23] Bosum's comment demonstrated his keen awareness of the spectacular space of the TRC while also subversively deflating the power of the cameras and the public gaze to confer authority upon his testimony. The implication was that his truth-telling both preceded and exceeded the fifteen minutes of attention it was given in that forum.

At the TRC's Northern National Event in Inuvik, Northwest Territories, Petah Inukpuk, a former residential school student and then-mayor of Inukjuak, Nunavik, offered a powerful example of altering relations of looking and of mobilizing photographic archives. During his testimony at the commissioners' sharing panel, Inukpuk held up for the commissioners, the audience, and the cameras a black-and-white photograph of his great-grandfather Qumanguq, taken at Little Whale River between Kuujjuarapik and Inukjuak (Inukpuk) (Figure 4.6). Qumanguq was born in 1840 and passed away in 1890. Inukpuk used the photograph as a visual mnemonic not only for the narrative content that he wished to focus on in his testimony, but also for the *form of remembering* that he wished to prioritize. Rather than conforming to implicit expectations regarding the types of testimonial content to be shared at the TRC—testimony centred on the time spent within residential school and the particular harms students experienced in these institutions—Inukpuk instead oscillated back and forth between a time prior to the impacts of residential schools upon his community, a period emblematized for him by his great-grandfather, and the experiences of his people today, thereby destabilizing the centrality of the details of

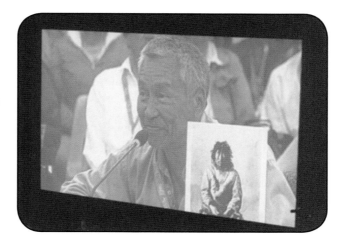

Figure 4.6: Petah Inukpuk holds up an image of his great-grandfather Qumanguq while giving testimony in Inuvik.
Photograph by Naomi Angel.

residential schooling. In an interview with Michael Swan, a journalist for the *Catholic Register*, Inukpuk implicitly critiqued the therapeutic discourse common at TRC events. Drawing attention to the colonizing dynamics of such showcasing of grief, Inukpuk commented, "Our people are becoming like white people, lingering on their pain too long" (qtd. in Swan). In contrast, Inukpuk mobilized the photograph of his great-grandfather as a way of bringing into focus a culturally specific method of communal recovery—a return to the teachings of the land and the traditions of his people. Speaking of Qumanguq's deep knowledge of the Arctic, Inukpuk reflected, "To live in this environment, you have to use all of your brain.… It's finding the right solutions all the time. That is what we're good at. We're not good at counting the riches, but solving problems" (qtd. in Swan). In so doing, Inukpuk resisted the colonial model of rendering Indigenous peoples "therapeutic subjects" who serve as proxies for the nation's catharsis (Million 171), outlining instead a land-based method of agential problem solving grounded in community knowledge and resources.

Inukpuk's relation to the picture of his grandfather is emblematic of the colonial power relations that have historically structured Indigenous people's encounters with photography. Rather than being passed down by Inukpuk's family over generations, the photograph was held by the Anglican Church and, more specifically, by Reverend Donald Marsh, a former missionary who began his work in the Arctic in "Eskimo Point," or what is now called Arviat, in 1929. Marsh acted as bishop of the Arctic between 1950 and 1973 and, in the early 1970s, gave anthropologist Bernard Saladin d'Anglure a collection of nineteenth-century photographs, including the image of Qumanguq. According to Saladin d'Anglure, the photograph was most likely taken at the Anglican mission of Little Whale River by a missionary or by the trader of the Hudson's Bay Company factory during the period, James Laurence Cotter (Saladin d'Anglure). When the Avataq Cultural Institute was developed to represent the land claim region of Nunavik in the 1980s, Saladin d'Anglure offered copies of the images to the Avataq Cultural Institute's archives, where Inukpuk was later united with the photograph of his great-grandfather. The circuits of colonial photography thus often alienated Indigenous families from ancestral images in a way that paralleled residential schooling's literal separation of kin. By reclaiming the image of Qumanguq, Inukpuk sutured back together the bonds of kinship as a healing practice focused not upon the settler state but upon the reconnection of Inuit families and communities.

When accompanied by his powerful testimony regarding the importance of land-based problem solving and cultural knowledge, Inukpuk's action of displaying the image resignified a photographic genre that has long been overdetermined by an ethnographic yearning for so-called lost Indigenous authenticity (Figure 4.7). Renato Rosaldo has referred to such ethnographic impulses as "imperialist nostalgia"—a mournful "pose of 'innocent yearning'" which disguises the fact that what the "agents of colonialism long for" are "the very forms of life they intentionally altered or destroyed" (107–8). In other words, "[i]mperialist nostalgia revolves around a paradox: A person kills somebody [or some aspect of his or her identity], and then mourns the victim" (108).[24] Inukpuk, instead, disrupted imperialist nostalgia by re-framing the photograph of Qumanguq in terms of what anthropologist Lisa Stevenson has called an Inuit "ethical injunction to remember" (179). Ethical memory is a form of living memory based not on an abstract set of rules or codes but, instead, on "a series of skills one learns by *practice*" (180; emphasis in original). In Inuit communities, the ethical injunction to remember therefore requires not simply the

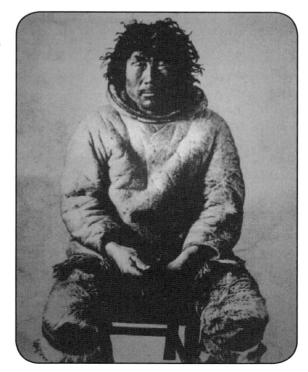

Figure 4.7: The photograph of Petah Inukpuk's grandfather Qumanguq. Photograph courtesy of Petah Inukpuk and the Bernard Saladin d'Anglure fonds/ Avataq Cultural Institute/BSA-124.

knowledge of traditional practices, like seal hunting, but also their *enactment*. In this context, Inukpuk employed his great-grandfather's photograph as a spur to a form of ethical memory for his community. Looking at the image, he tacitly suggested, is not an end in itself—it is a catalyst for *doing*, or taking action by re-engaging in the practices of Inuit ancestors that offers a powerful antidote to the loss of cultural knowledge produced by assimilationist programs such as the IRS.

While Inukpuk used the photograph to spark recognition for his own people, his words and deeds also issued a challenge to other audience members, for in displaying the image of his great-grandfather, Inukpuk turned it away from himself and toward the commissioners, the audience, and the cameras. In so doing, he implicitly drew attention to the ways both Qumanguq and he have been subject to the colonial gaze, even in the moment of speaking at the TRC. Naomi's photograph of the jumbo screen positioned to the right of Inukpuk, magnifying his image as he spoke, seeks to refract these multiple layers of mediation by drawing attention to a series of frames-within-frames (Figure 4.6). On one level, there is the archival image of Inukpuk's great-grandfather. The white trim of the photograph appears stark against the colourful backdrop of Inukpuk and the audience seated behind him. Inukpuk himself is framed by the parameters of the large screen and the black backdrop behind it. Naomi's photograph gestures beyond the mediation of the screen's frame by situating the Jumbotron within the context of the Sir Alexander MacKenzie school gym, the site of a former residential school in Inuvik, which was transformed into the auditorium for the commissioners' sharing panels at the Northern Event. But the photograph taken by Naomi is able to widen the scope of perspective just a bit, ultimately restricted by its own vantage point—that of an audience member, a witness, and a scholar seeking to document Inukpuk's intervention. The photograph is marked by our desire to make sense of—by archiving and visually returning to—the unfolding work of the TRC as we participated in the national events. These acts implicate us in the chain of looking as well as the chain of mediation, but they have also engendered images that look back at us.

In re-viewing the scene of Petah Inukpuk's testimony through Naomi's photograph, we are confronted by both Inukpuk's and Qumanguq's return gazes. If Inukpuk used his great-grandfather's photograph as a spur to memory for his community, what ethical injunction to remember is he calling settler witnesses to with this doubled return gaze? Looking and listening, like remembering, must

not be construed as an end in itself. Feeling moved by Inukpuk's testimony is also insufficient, as it may become another mournful posture that, like imperialist nostalgia, operates as an alibi for complicity as a beneficiary of ongoing colonial structures. How must we act now that we have looked? While these questions must be continually returned to, we have decided that, as a first step, this means sacrificing the luxury of anonymity that witnesses can take comfort in sitting among large crowds in the commissioners' sharing panels by introducing ourselves and sharing our work with those who have bravely faced the spotlight, including John Bosum and Petah Inukpuk. It means making what we write accountable and available to Bosum and Inukpuk and being willing to dialogue about it. It has also meant conducting further archival research about Qumanguq and his photograph and sharing what we have learned with Inukpuk. The truth is that in taking these minimal steps of reaching out, John and Petah have given us much more than we have given them. The generosity and graciousness returned to us by John and Petah have been immense.

While Petah Inukpuk mobilized the high-profile site of public testimony at the Northern National Event to re-frame photographic archives, another remarkable process of reconstructing collective memory occurred in the "Learning Place" set up in the town's Midnight Sun Recreation Complex. As part of the General Synod of the Anglican Church's archival display, items collected by a school nurse named Mossie Moorby, who worked at the Anglican hostel in Inuvik, known as Stringer Hall, were featured in an exhibit (Figure 4.8). During her employment in Inuvik between 1964 and 1972, Moorby retained photographs of school children as well as string art and drawings that students made while waiting in the infirmary. At the top right position of the exhibit is a photograph of Moorby in her nurse's uniform, standing in the infirmary treatment room at Stringer Hall "with three brothers who she was very fond of—Jimmy, Floyd, and Wayne Dillon" in January 1965.[25] Moorby is portrayed as a maternal figure who "painstakingly kept and labelled" the children's photographs and string art as a parental and personal, rather than institutional, act (Sison, "Anglican Exhibit"). The exhibit also displays Moorby's letters recounting her experiences in Inuvik to her own adult children living in Ontario, positioned alongside her correspondence with students' parents, who, an *Anglican Journal* article reports, "most[ly] … thank … her for the care she gave to their children, and ask … her to tell them to write home" (qtd. in Sison, "Moorby"). Through these intersecting epistolary circuits, the archive implicitly draws parallels

Figure 4.8: The General Synod of the Anglican Church's archival display of the Mossie Moorby collection materials at the Truth and Reconciliation Commission's Northern National Event. Photograph by Naomi Angel.

between the separation of Indigenous parents and residential school students and Moorby's distance from her own family in Ontario— parallels that risk relativizing very different conditions of separation from kin, thereby obscuring the structural differences of colonialism that distinguish them.

As part of the archival exhibition's complex entanglement of the institutional and the intimate, Moorby's daughter and custodian of her deceased mother's collection, Anne Campbell, travelled to Inuvik in hopes of meeting students her mother had worked with. Framing the archive as a labour of love, Campbell remarked, "She [Moorby] loved the kids and I just know that they loved her, too.… If I can bring some happy memories back to the kids who lived at Stringer Hall, that would be wonderful" (qtd. in Sison, "Moorby"). In allowing friends and family members of the students depicted in the school photographs to take home with them photocopies of these images, Campbell positioned herself as both a keeper and giver of family memories, similar to the way that her mother had imagined herself as a parental proxy and intercessor between Indigenous parents and their children far from home. As much as Campbell perceived her act to be an intimate one,

the photographs she copied and disseminated are overdetermined by an institutional frame. Lined up on black display boards are generic headshots of each child, all posed in the same position with their bodies turned at a slight angle, right shoulder in front, arms at side. Beside each photograph is typed information, including the students' first and last names and the month and year of the portrait, as well as taxonomic archival codes. Each child is posed against a grey backdrop devoid of any indicators of location or historicity—the child is framed outside of time, a symbol of a horizon of future possibility, frozen in a state of purity where the effects of separation from kin, culture, and language, as well as the potential harms of physical and sexual abuse, have yet to mark themselves upon the body, the way they might with further passage of time. Like the "after" image of Thomas Moore, which anticipates the child's future as a successfully assimilated subject without documenting the harsh material realities of Moore's present and future, the Moorby collection's images similarly defer the scene of residential schooling's possible long-term, attritional consequences. The child's destiny is suspended in an anticipatory moment, thereby perpetually staving off the protracted ramifications of residential school.

The framing of the Moorby archive as a collection that could, to recall Campbell's words, bring "happy memories back" simplifies the terrain of remembrance indexed by these photographs and reinscribes the colonial power asymmetries shaping the archive as the repository of memory and knowledge itself. Throughout the course of the five-day Northern National Event, however, former residential school students, as well as their friends and families, altered the relationship between keeping and giving memories entrenched in the Moorby archival display. Upon encountering images of themselves, their former classmates, or their parents, aunties, and uncles, visitors to the "Learning Place" intervened in the archive displayed before them. According to General Synod archivist Nancy Hurn, something "astonishing" occurred. "Someone came along and began to identify the (students) in the photographs" who were no longer alive. "There were four in one row—two had died by suicide, one by drowning, and one of cancer," she remarked (qtd. in Sison, "Anglican Exhibit"). This former Stringer Hall student obtained yellow Post-it notes and began to affix emendations to the descriptions mounted beside each photograph. In so doing, the unnamed student catalyzed a process of collective revision as more former students and family members adopted the same technique and used Post-it notes to correct misspelled names, re-identify former students in terms of their kinship relations rather than through their status as institutional wards, and update information on people displayed in the images.

Other stories were also added about students who never returned home from Stringer Hall, those who have since passed away, and those who overcame the losses and violations incurred to chart their own futures (Figure 4.9). Beside the fall 1967 picture of Daniel Sikrikkuk is a Post-it that renames him as Daniel Sikrikkuk Rogers and tells in condensed form the heartbreaking story of his passing—he "drowned summer 1971 when he went to the aid of his brother Freddie" (Figure 4.10). Freddie's photograph is also included in the exhibit and beside his image are two Post-it additions, one that renames him as "Freddie Rogers (now)" and a second that explicates the renaming in the following short-hand: "Sikrikkuk is Inuit name. Rogers English name. Inuit given father's first name" (Figure 4.11). In an explanatory note implicitly addressed to a non-Inuit audience, the Post-it amendment telegraphs the widespread effects of a distinct mid-century form of colonization in the Arctic in which, in a matter of a few decades in the post-war period, Inuit were displaced from their lives on the land, forced to live in settlements, given new names and "E" or "Eskimo" identification numbers by colonial officials, and placed in residential schools.

Despite these devastating changes, many former residential school students overcame immense odds to reassert Inuit agency in establishing land claim and self-government agreements. As a testament to these achievements, Post-it notes on the Moorby exhibit also identify those who have become community leaders, such as Edna Pigalak, then commissioner of Nunavut (Figure 4.12).[26] In scripting these revisions, the former students and community members interrupted the Moorby archive's assumed power to gift memories. The amendments also challenged deterministic narratives about the residential school system that have either obscured the intergenerational trauma this colonial policy has engendered or sought to relegate all former students to destinies of victimry. The former students of Stringer Hall strategically renegotiated the colonial archive in order to "*re*search for the fragments of … [them]selves which were taken, catalogued, studied and stored" and to assert their status as active remembering agents rather than archival objects (L. Smith 58–59).

But what does it mean that the emendations to the archive were made in the form of "Post-it" notes? The Post-it is a medium that signifies the provisional and the temporary, but it is also a medium that stands out, that marks and holds a place like a bookmark, so as to return to it frequently. As a mobile form of message-making, the Post-it was used creatively by those who sought to revise the archive.

Figure 4.9: Robert
Toasi and Simon
Taipana, former
students who have
passed away and
are remembered by
friends and family at
the Northern National
Event. Photograph by
Pauline Wakeham.

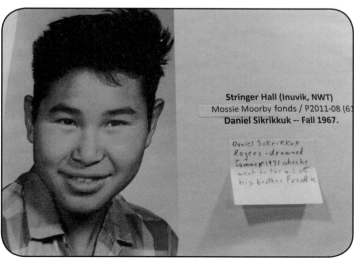

Figure 4.10: The late Daniel Sikrikkuk Rogers. Photograph by
Pauline Wakeham.

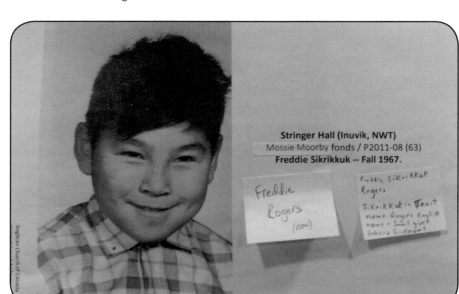

Figure 4.11: Freddie Sikrikkuk Rogers, brother of the late Daniel. Photograph by Pauline Wakeham.

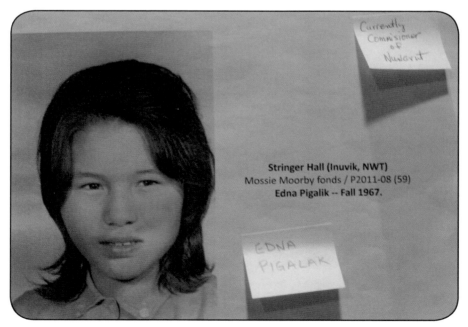

Figure 4.12: School photograph of Edna Pigalak. Photograph by Pauline Wakeham.

While some Post-its were neatly placed directly below the typed identificatory information, in other instances, the note was used to cover previous text, as in the case of what is presumably the renaming of Jayko Palongayak (Figure 4.13). Here, the Post-it overwrites the colonial archive's method of naming and identification entirely. As a provisional and supplementary marker of amendment, the Post-it made manifest the archive's incompleteness and the limits of colonial institutions' knowledge of the subjects they were designed to regulate. At the same time, these supplementary additions raise questions about future decisions regarding the General Synod of the Anglican Church's archives and, more specifically, the Mossie Moorby collection. How much information offered by former students will be retained by the archivists? Will that information be kept in the form of Post-its that bear the personalized traces of each author's penmanship, or will the revisions become "data" that are incorporated into revised, official typescript? As the events at the Northern National Event suggest, the photographic archive of residential schools is not a static and transparent window onto the past but, rather, a site of struggle shaped by ongoing colonial power asymmetries in which the meaning of the IRS and its ramifications today are currently being re-negotiated.

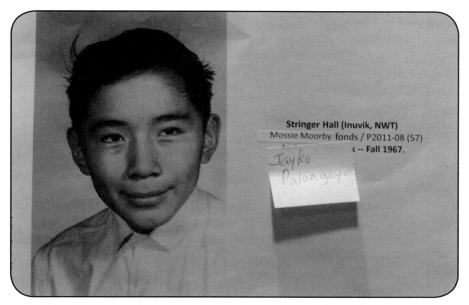

Figure 4.13: Photograph of Jayko Palongayak. The name given to him by the administrators of Stringer Hall is overwritten. Photograph by Pauline Wakeham.

Witnessing the Archive

Truth commissions themselves are often about the production of an archive. Verne Harris, deputy-director of the National Archive of South Africa during the South African TRC, saw the reconciliation process as "profoundly, an archival intervention" (qtd. in Krog et al. 65). As the South African TRC gathered testimonies, "it was engaging archive, rescuing archive, creating archive, refiguring archive" (65). For this reason, understanding the interventions that truth commissions make involves a critical re-examination of the archives upon which such commissions draw and which they in turn create. This essay has sought to consider the particular material, social, and affective dynamics of the photographic archives used, recirculated, and generated by the mainstream media, educational organizations, and the Truth and Reconciliation Commission itself in reflecting upon the history and ongoing implications of the residential school system. Our chapter has also considered the forms of witnessing that archival negotiations and photographic practices may ignite. The very act of "taking" photographs at TRC gatherings where people are courageously sharing very personal and often extremely difficult experiences alludes to the complicated ethical terrain of documenting these events. We have therefore photographed only certain types of moments or scenes, none ceremonial or involving sacred knowledge, most without people, focusing instead on educational exhibits, buildings and structures, and instances of visual mediation themselves like the picture-within-a-picture of Petah Inukpuk and his great-grandfather. Whereas pictures are "taken," the process of witnessing suggests an exchange, a dialogue. This chapter has explored some of the ways in which photographs may be remobilized in ways that do more than "capture," opening up opportunities to share perspectives. The Post-it notes added to the Mossie Moorby display and Petah Inukpuk's use of his great-grandfather's photograph may signal some forms in which a conversation in and through images can take place.

By sharing some of our photographs here, we hope to further engage in that conversation while also exposing our vantage points as settler witnesses and academics to the critical gazes of others. Part of that exposure requires situating ourselves as authors, explaining our investments in our research, and also reflecting upon our own implicatedness in structures of colonial power. The editors of this collection asked me (Pauline) to write a preface to this essay that introduced myself and my co-author, the late Dr. Naomi Angel, to our readership up-front so that people could "see," via a verbal snapshot, more of who

we were at the outset. I decided to wait until the end of this essay, however, because my dear friend and colleague, Naomi, who passed away on February 22, 2014, after a courageous struggle against breast cancer, wanted to be known in terms of her life, not her death. Naomi was the very embodiment of life and she loved it dearly, most especially because of her husband, Mitchell, and her beautiful son, Nate. Naomi's living voice is what I wanted to speak throughout this essay, not to be overshadowed by the story of her tragic passing at the age of thirty-seven. I also hoped that revealing more about ourselves as authors at the end might be in keeping with this essay's goals—namely, of not detracting attention away from the primary objective of foregrounding, first and foremost, the courage of residential school survivors.

Naomi and I first met at the TRC's Northern National Event in Inuvik in 2011. We grew close quickly as we witnessed together the profound events that unfolded in the town that week. It was my first time listening to residential school survivors share testimony and I did not know how to process the experience. As I would later come to realize, unlike the TRC's other national events that occurred in large cities, often hosted in major hotels and convention centres, the time and place of Inuvik 2011 was a very different moment. There were no possibilities for dispersal across a large city at the end of a day. There was no way of escaping into the quotidian habits of metropolitan life that most southern settlers are accustomed to. The privilege of leaving or even taking a break from what the residential school system means is a privilege that only settlers in Canada can experience. In Inuvik, that privilege was at least temporarily altered, but certainly not erased. There, I was granted the immense gift of not being quite so anonymous and of not being able to leave the work of witnessing at the end of the day. Each evening, survivors and settler witnesses sat at the same picnic tables at the community feasts. Each night, the town gathered in the Midnight Sun Recreation Complex for song, sharing, and laughter. In short, my time in Inuvik brought me the gift of being in community, and with it came the gifts of being profoundly emotionally and intellectually challenged.

It was through watching Naomi walk through the town and photograph signs, murals, and black-and-white archival photographs as they were displayed on the Jumbotron outside of the school that I began to see things I had overlooked. Through viewing her photographs, Naomi taught me about how she witnessed, and that caused me in turn to think—and see—differently as well. That was the inspiration that sparked this essay. How might photography function as a record of witnessing, exposing the people behind the camera and

their relation to what they have seen? How also, in situating that act of taking pictures in relation to a much longer history of photography concerning residential schools, might I come to re-view my own relation to the settler colonial gaze and to settler colonial power?

This latter question is a difficult one because it prompts me to consider what makes me different from the Reverend Donald Marsh or Mossie Moorby and her daughter—makers and keepers of archives. For instance, as I witnessed the Moorby archive being transformed hour by hour, day by day with Post-it emendations at the Northern National Event, I too became an archival collector. Recognizing the importance of the intervention taking shape and its potential ephemerality, I documented the process with my camera. In so doing, I became implicated in the long and complicated history of archiving that I am analyzing. In one sense, my photographs may preserve these important interventions by former students and community members at the TRC, thus serving as a new counter-text to the Mossie Moorby exhibit. Such photographic records of Indigenous community members' interventions may provide future ways of calling the Anglican Church to reflection about their own documentary processes and to reconsider how archival materials are displayed and interpreted.[27] And, yet, this particular photographic record of what happened in Inuvik now resides with me just as the Anglican Church archive continues to retain ownership of the original photographs and the string art that belongs with the students themselves. After my experience in Inuvik, due the unease that I felt as a generator of a new archive about residential schools—even if that archive might constitute one of a period of confronting colonialism—I did not use my camera much at subsequent TRC national events. For others, taking pictures at TRC events may mean photographing family and friends engaging in a profound collective experience of speaking truth to power, but for me as a settler scholar, my relation to any images I take is a much more fraught one shaped by potential gains in academic capital. While Naomi and I wrote this essay with an intent to honour residential school survivors, at the same time, the fact that our photographs from Inuvik remain in the possession of me and Naomi's family and for use in an academic essay is something that benefits me. This has prompted me to contact the Gwich'in Social and Cultural Institute and the Inuvialuit Cultural Resource Centre—organizations representing the Indigenous nations on whose land Inuvik is situated—and to send them copies of my photographs for their own purposes. Copies of this book will also be sent to these organizations as soon as they are available. In this sense,

I hope that one fruit of this photographic archive that I created and to which I am responsible will be further engagement with Indigenous organizations and communities. The gift and responsibility of these images may be one that unsettles me, but if struggling with them keeps me asking questions of myself and seeking dialogue, perhaps that is a start. It should not, however, be an end.

Notes

Many thanks to Keavy Martin and Dylan Robinson for their ongoing support of this essay and their incisive feedback on its many drafts. Thank you also to Bev Diamond, Byron Dueck, Helen Gilbert, Elizabeth Kalbfleisch, Sam McKegney, Peter Morin, and Niigaanwewidam Sinclair for their companionship and insight as we learned from the TRC together. Our conversations over the past several years have had an immense impact on my thinking. Thank you to Emily Kring and Stephanie Oliver for their astute and precise research assistance in helping to ready this manuscript for publication. Thank you to John Bosum and Petah Inukpuk for allowing their words and photograph to be shared in this essay. Thank you to Robyn Green for her friendship to both Naomi and me and for being there to grieve with me when the unthinkable happened. Thank you also to Mitchell Praw, Naomi's husband, for enabling Naomi's photos and words to be published here.

1 While our chapter is inspired in part by Sliwinski's book, our essay also responds to and seeks to complicate Sliwinski's repeated references to "the world spectator" (11) who engages with visual "representations of distant events" (5). We argue that the privilege of occupying the position of "the world spectator" is all too frequently a privilege of the white Western subject. The assumption that such photographs represent "distant events" may perpetuate the West's failures to recognize the gross human rights violations that occur within its own geopolitical borders.

2 Truth and reconciliation commissions have been conceived as a mechanism of what is known as "transitional justice," an "approach to achieving justice in times of transition from conflict and/or state repression. By trying to achieve accountability and redressing victims, transitional justice provides recognition of the rights of victims, promotes civic trust and strengthens the democratic rule of law" (ICTJ, "What Is Transitional Justice?"). Arguably, transitional justice is predicated upon a teleological understanding of political progress in which nations of the global South attain their most just versions by remaking themselves in the West's image of liberal democracy. In Canada, the question of "transition" is a particularly fraught one as the same settler government structure that perpetrated the original human rights violations against Indigenous peoples continues to be in power during the operation of the TRC (and the commission itself is a department of that same federal government). The question of structural transition is therefore bypassed and reconciliation is expected to proceed without it. For comparative analysis of Canada's

TRC with other TRCs around the globe, see Matt James's "Uncomfortable Comparisons" and Michelle Bonner and Matt James's "The Three R's." With regard to the state's denial, one need only recall that just over one year after his June 2008 apology for the government's administration of residential schools, Prime Minister Stephen Harper told reporters at a press conference during the September 2009 G8 summit that Canada is "one of the most stable regimes in history.... We are unique in that regard.... We also have no history of colonialism. So we have all of the things that many people admire about the great powers but none of the things that threaten or bother them" (Ljunggren).

3　For example, in 1927, the Indian Act was amended to make residential schooling compulsory for children between the ages of seven and fifteen. In the same suite of amendments, religious and cultural practices such as the potlatch were banned and it became illegal for Indigenous groups to hire lawyers or mount legal cases. With regard to the alibi of "treaty obligations" that Harper references in his 2008 apology, as J.R. Miller notes, "[i]n the negotiations that gave rise to the seven numbered treaties of western Canada in the 1870s, a number of First Nations leaders were seeking an arrangement with Canada that would provide assistance to them in adjusting to profound economic change that was going on in their region." Some leaders wanted "schooling that would" equip "their younger generation with knowledge about and from the society that was soon to flood into their region. All of the numbered treaties contained a clause that committed the Crown to provide 'schools on reserves' or at least teachers for future reserve communities" ("Troubled" 361). These leaders thus envisioned schools situated on the reserves and developed in conjunction with reserve leadership—a system vastly different from the IRS that was designed instead to remove children from their homes and communities.

4　For an insightful discussion of the legacy of *Trang Bang, 1972*, the photograph of Kim Phuc taken by Huyng Cong "Nick" Ut, see Chapter 3 of Thy Phu's *Picturing Model Citizens: Civility in Asian American Visual Culture*. Less scholarship has been published regarding Greg Marinovich's "burning man" photograph of Lindsaye Tshabalala, a Zulu man who appears to have been an unsuspecting passerby during a battle between African National Congress supporters and members of the Zulu Inkatha Freedom Party on September 15, 1990, in Soweto, South Africa. A reproduction of the image and brief commentary may be found in *Moments: The Pulitzer Prize Photographs, A Visual Chronicle of Our Time* (Buell 202–5), a collection that, in its superficial treatment of the images, turns scenes of gross human rights violations into fare for coffee table consumption that risks producing the desensitization and voyeurism of which Sontag warned.

5　Sherry Farrell Racette provides an excellent account of photographs taken over the more than one-hundred-year history of the IRS. Racette explains that these photographs "can be grouped into three general categories: photographs to illustrate government reports and other official publications, those taken by staff and visitors, and a remarkable group of photographs taken by students at the Spanish Indian Residen-

tial School" (51–52). The first two types of photographs described by Racette are the vast majority, while the last constitutes an extraordinary exception and was made possible during the brief period from 1952 to 1958 by Father William Maurice, who "built a darkroom and trained several boys to develop film and print photographs" (52). According to Racette, this group of students at Spanish "had access to cameras, and these photographs show a remarkable inner view of residential school life…. However, there is a striking, unsettling similarity to many of them" (52). A selection of images from the Spanish Indian Residential School are displayed online through the Shingwauk Residential Schools Centre's website: archives.algomau.ca/main/sites/default/files/Spanish 5.pdf. These images are held at the Shingwauk Centre's archives and are from the Father William Maurice s.j. fonds.

A disturbing exception to the conventional propagandistic photographs of the IRS is one posted on CBC Nunavut's Facebook page on June 4, 2015, following the release of the TRC's final reports. The photograph, taken in 1937, is a close-up of the bodies of four boys (only three are visible within the frame of the image) who froze to death upon attempting to escape the Lejac residential school in Fraser, British Columbia. The boys have been identified as Allen Willie (age eight), Andrew Paul (age nine), Maurice Justin (age eight), and Johnny Michael (age nine) and are depicted with their bodies lying on stretchers above the snow, their hands and legs bound together with twine, awaiting burial. The image may be viewed at https://scontent-lga3-1.xx.fbcdn.net/hphotos-xfp1/v/t1.0-9/10425465_662652277202707_25665815117694 65988_n.jpg?oh=ac885e78aa8c8d881ff3ee1452744da9&oe=57947A11

6 See, for example, Mark Kennedy's "Attitudes of 'Coldness'" and Doug Saunders's "Residential Schools, Reserves." Further citational information is provided in the bibliography of this book.

7 An interesting exception is a photograph of the Grandin College girls' basketball team posing inside a gymnasium that appears to have been taken in the 1950s or 1960s, though no date is provided (*Principles* 82). More photos of later periods such as this would help the public to visualize how residential schooling co-existed with their own life spans, possibly sparking greater reflexivity about the privilege of non-Indigenous Canadians. Another significant departure from the use of historical photographs occurs in the TRC's volume *The Survivors Speak: A Report of the Truth and Reconciliation Commission of Canada*. The preface to this document, which provides a general overview of the history of residential schools, uses historical images. However, when the report transitions into chapters largely composed of testimony from survivors that has been excerpted and compiled according to different themes regarding residential school experiences, the report then features portrait photographs of adult survivors quoted throughout. From one perspective, these more recent portraits infuse the document with a sense of survivors' current adult existence. However, the pairing of these images with retrospective testimony phrased in the past tense also serves to mark the temporal distance between the current moment and residential school experiences of the past.

8 See Wakeham, "Cunning" 219–24; Mackey 49; Martin, "Truth, Reconcilia-
tion" 49–58; and Dorrell 32.

9 As an example, scholars frequently refer to Dr. Peter H. Bryce's 1922
*The Story of a National Crime: An Appeal for Justice to the Indians of
Canada*, an exposé of the dangerous health conditions of residential
schools (Dorrell 34). Bryce was a medical inspector for the Department
of Indian Affairs who repeatedly warned the government of the poor
health conditions and high tuberculosis rates in residential schools.
According to Bryce, between 1883 and 1907, 24 percent of students died
while in IRS custody (Dorrell 34).

10 In the First Peoples Hall at the Canadian Museum of History (formerly
the Canadian Museum of Civilization), the second Moore photograph is
accompanied by a text panel that reads, "'After' photo of Thomas Moore,
the same child as in the previous photograph, but now dressed in a
school uniform and with his hair cut" (qtd. in Brady 412). As Miranda
Brady notes, "the panels do little to critically engage Moore's transforma-
tion, leaving many questions such as whether 'Thomas Moore' was the
name given to this boy upon entering residential school" (412). Thus,
although "the text panel suggests Moore underwent a transformation,
it does not suggest how this transformation profoundly affected him,
his community, and future generations" (Brady 413). The Moore dyad is
also republished in J.R. Miller's *Shingwauk's Vision: A History of Native
Residential Schools* (198) and his essay "Reading Photographs, Reading
Voices: Documenting the History of Native Residential Schools" (472–73).

11 In his apology, Stephen Harper refers to the credo "as it was infamously
said, 'to kill the Indian in the child,'" without directly attributing this
phrase to a speaker. Harper's recitation of this phrase is typical of the
way that many news articles and scholarly reports similarly mention
the phrase without citation. More careful research demonstrates that
a historical source has yet to be located in the archives. The closest
documented phrase comes from Captain Richard Henry Pratt, who, after
serving in the U.S. Cavalry during the Red River War of 1874–75, which
forcibly removed several Southern Plains groups onto reservations in
Indian Territory, became the principal of Pennsylvania's Carlisle Indian
School and declared that "all the Indian there is in the race should
be dead. Kill the Indian in him and save the man" (261). Pratt made
this assertion in a paper he read at the Nineteenth Annual Conference
of Charities and Corrections held in Denver, Colorado in 1892. Many
sources that refer to the phrase "to kill the Indian in the child" cite
David Nock's *A Victorian Missionary and Canadian Indian Policy*
(1988). For example, the Royal Commission on Aboriginal Peoples' final
report (1996) states, "'To kill the Indian in the child', the department
aimed at severing the artery of culture that ran between generations and
was the profound connection between parent and child sustaining fam-
ily and community. In the end, at the point of final assimilation, 'all the
Indian there is in the race should be dead'" (1: 349). While no footnote
is provided for the first sentence quoted from RCAP above, a footnote at
the end of the second sentence cites page 5 of Nock's book. However,
on page 5 of A Victorian Missionary, Nock quotes Pratt's phrase, "[k]ill

the Indian in him and save the man," and clearly identifies Pratt as the author. Nock's *A Victorian Missionary* does not make any reference to the phrase "to kill the Indian in the child." In noting these inaccuracies, our intention is not to suggest that government officials did not make many statements that reiterated similar viewpoints on assimilation. Rather, the point is to suggest that by not attending more carefully to residential school archives, we may reproduce rote narratives of what we think we know about the IRS without probing more deeply and learning more about the fraught history of this system.

Similarly, although Moore's photographs are frequently republished in historical texts, there is inconsistency in the information provided: the source of the photographs is variously cited as the Indian Affairs' annual report of 1896 and 1904. Milloy's book identifies the photographs as appearing in the Department of Indian Affairs' 1904 annual report (3). Racette asserts that the photographs were published in the Department of Indian Affairs' 1896 annual report (54) as does the *Where Are the Children?* online exhibit. Upon checking Indian Affairs' annual reports through this time span, the only place in which the Moore photographs are published is in the 1896 annual report, which may be found as part of the Government of Canada's sessional papers for 1897 (sessional papers publish departmental reports from the preceding year) (Dept. of Indian Affairs).

12 See also the TRC's *Honouring the Truth, Reconciling for the Future: Summary of the Final Report of the Truth and Reconciliation Commission of Canada*, pages 81 to 84, on what it terms "institutionalized child labour" in the residential school system (82). The same report details hunger and malnutrition on pages 89 to 94 and the serious health concerns posed by the schools as well as the high death rates on pages 94 to 103.

13 The photographs of Thomas Moore have been strategically re-framed in Cree artist Jane Ash Poitras's mixed-media art installation *Potato Peeling 101 to Ethnobotany 101*. The title of her piece is an indictment of "the bigotry exhibited by residential school staff in assigning their students … remedial tasks like potato peeling as they assumed Aboriginal students did not have the intelligence to engage in more challenging intellectual pursuits" (Brady 413–14). Additionally, the title references the ways that students were exploited to perform menial labour crucial to the maintenance and daily operation of the institutions ("Potato Peeling 101"), as well as the simultaneous devaluing and appropriation of Indigenous knowledges ("Ethnobotany 101") (Brady 414). In Poitras's work, the Moore pictures are positioned among a collage of IRS archival photographs in a way that seeks to recontextualize these images to reveal the violence of this system. Using the blackboard as the backdrop for the piece is a technique for "reclaiming and transforming this familiar image of schoolrooms into a representational strategy of her own teaching" (McCallum 114).

14 Thomas Moore is the name of an Irish poet who travelled to the United States and Canada in 1804. His visit produced several popular poems including "A Canadian Boat Song."

15 After emailing the Provincial Archives of Saskatchewan for further information about Thomas Moore, Naomi received the following reply from archivist Tim Novak: "The only information we have on Thomas Moore comes from the student register for the Regina Indian Industrial School, 1891 to 1908 (microfilm R-2.40, see entry No. 22). He was actually admitted to the school on August 26, 1891 when he was 8 years old. He was a full blooded Indian from the Saulteaux tribe. He was from the Muscowpetung Band which is about 35 miles northeast of Regina. His full name was Thomas Moore Kusick. His father was St.(?) Paul Desjarlais (deceased) and his mother's name was Hanna Moore Kusick. The boy was a Protestant and had previously attended Lakes End School. His state of education upon admission consisted of knowing the alphabet. His height was 3 feet, 11 inches and he weighed $54\frac{1}{2}$ pounds. There is a note in the admission register that directs one to look for page 20 in the Discharge Register. However, we do not have this document and therefore we do not know when he completed his education" (Novak).

16 BigEagle's short documentary, *I Am a Boy: Thomas Moore Keesick*, premiered in March 2015 and is available for viewing at: http://www .riismediaproject.com/i-am-a-boy/.

17 Though the TRC dates Maclean's book to 1899, his book was first published in 1889.

18 According to article 2f of the TRC's mandate, the commission is prohibited from "making any findings or expressing any conclusion or recommendation, regarding the misconduct of any person, unless such findings or information has already been established through legal proceedings, by admission, or by public disclosure by the individual. Further, the Commission shall not make any reference in any of its activities or in its report or recommendations to the possible civil or criminal liability of any person or organization, unless such findings or information about the individual or institution has already been established through legal proceedings" ("Schedule 'N'" 3).

19 We consider the IRS a form of genocide based on the UN Convention on the Prevention and Punishment of the Crime of Genocide (1948). Article II of the UN convention outlines a list of five actions, *any* of which on their own, when "committed with intent to destroy, in whole or in part, a national, ethnical, racial or religious group" constitute an act of genocide. While section IIb—the act of "[c]ausing serious bodily or mental harm to members of the group"—is certainly relevant to the IRS, section IIe—the act of "[f]orcibly transferring children of the group to another group"—is the clause that is particularly salient with regard to the IRS (United Nations General Assembly 280). Roland Chrisjohn and the Praxis Collective have convincingly revealed how, during and after the drafting of the UN convention, "the Canadian government took steps, internally and externally, to assure that the word 'genocide' would never become linked with its actions and policies regarding indigenous peoples in the residential schools" ("Genocide" 245–46). Such measures included attempting to influence the UN to limit the definition of genocide to the mass murder of a specific collectivity (238) and, in 1952,

limiting Canada's "adoption" of the convention by including only "40 per cent of the specific acts set out in Article II" in the "sections of the Criminal Code of Canada dealing with genocide as a crime in Canada" (241). The subsections in Article II that included "'Causing serious bodily or mental harm,' 'Imposing measures intended to prevent births,' and 'Forcibly transferring children'" were not included in Canadian domestic law (242). Despite the federal government's attempts to prevent association of the IRS with genocide, the Law Commission of Canada, "[a] former federal government advisory body," acknowledged in 1998 the "genocidal intent" of the residential school system (Bonner and James 12).

20 See also David Garneau's discussion in this volume of reconciliation as a sacrament of the Catholic Church which—in the context of the TRC— places the burden of mending ties squarely on the shoulders of survivors (32–33).

21 During each TRC national event, there were three primary ways of providing statements to the commission. The largest forum, as mentioned, was the commissioners' sharing panels. On rare occasions, we witnessed a retired RCMP officer and members of the Roman Catholic Church speak during this type of forum. Smaller public forums were called sharing circles, where speakers sat in a circle in the middle and witnesses sat in seats around that smaller inner circle. These sessions were led by members of the TRC's Indian Residential School Survivor Committee, and while time constraints were often placed upon statements in these forums, sometimes those constraints were more relaxed, allowing the speakers to take the time they needed. The sharing circles were therefore spaces where survivors often provided longer and more difficult statements. Both of these forums were open to the public and were videotaped; notices were displayed throughout the space that all statements could be recorded by media and other parties. Additionally, private statement-gathering sessions were held throughout the course of the TRC events.

22 In a conversation among our research group on June 25, 2012, Peter Morin noted that the "star system" of survivors featured at TRC events prioritized those former students who have gone on to achieve notoriety in mainstream Canadian society. This system, Peter observed, was not always reflective of the recognition of Elders and figures of importance within Indigenous communities. We are grateful to Peter for these insights.

23 Bosum's entire testimony is available on the Truth and Reconciliation Commission of Canada's online archive. Bosum's testimony took place at the Québec National Event on April 25, 2013, 1:10:22 p.m.

24 While the IRS was approaching its period of peak operation, photographers of the early twentieth century travelled across Canada and the United States to capture on celluloid the supposed last glimpses of tribal authenticity before the "vanishing Indian" disappeared forever. As practitioners of what has become known as "salvage ethnography," these photographers were part of the frenzy of turn-of-the-century culture-collecting that sought to rescue token remnants of what Edward Sheriff

Curtis called "a race doomed to extinction" (qtd. in Wakeham, *Taxidermic Signs* 91). While such ethnographic photography and Indian Affairs' pictures of Thomas Moore might initially appear to contradict each other—one genre depicting pastness, the other envisioning futurity—the logics were in fact complementary, united in framing the supposed inevitability of Indigenous cultural (and often also biological) death. These ideological similarities, however, are dissimulated by the differential public affects these photographs cultivate. In romanticizing the death of Indigeneity, salvage ethnographic photography engenders imperialist nostalgia. In contrast, the Department of Indian Affairs' "before and after" images of Thomas Moore camouflage the violence of assimilation through a narrative of social optimism and national progress. From this perspective, Moore's transformation is framed not as a traumatic loss of culture, language, and community, but rather as social and moral uplift that has enabled his entrance into Canadian futurity. Through these different and yet mutually reinforcing affective scenes, ethnographic photography and the Department of Indian Affairs' photographs both depict forms of vanishing Indigeneity—be it a kind that recedes into the past or a form that sloughs off like a dead skin as the Indigenous child grows into civilized maturity—that naturalize this loss as inevitable extinction and, in so doing, obscure the violence of colonial policies that banned Indigenous cultural and religious practices and tore families and communities apart.

25 The quoted text is typed directly beneath the photograph.
26 Edna Pigalak's married name is Edna Elias. The latter is the name used in her governance career.
27 I do not wish to foreclose the possibility that Indigenous community members themselves photographed the emendations to the Moorby archive. I have not seen any such images in online forums, but it is entirely possible that such images do exist and are being put to a range of uses.

CHAPTER 5

"Aboriginal Principles of Witnessing" and the Truth and Reconciliation Commission of Canada

David Gaertner

Witnessing and testimony are essential components of every truth and reconciliation commission,[1] and the Truth and Reconciliation Commission in Canada is no exception. However, these key terms are ideologically loaded and have historically excluded Indigenous knowledge systems (for instance, *Delgamuukw v. British Columbia*).[2] While Schedule N of the Indian Residential School Settlement Agreement (which contains the TRC mandate) obliquely addresses "Aboriginal principles of witnessing," there is no concrete gesture toward unpacking precisely what these principles might entail or how they might speak to or against Western systems. Further, the homogenizing use of "Aboriginal" risks lumping all Indigenous knowledge systems together—precluding the possibility of difference and/or contradiction in the definition of a key term.

On May 10, 2006, the Canadian federal government approved the IRSSA, the largest class-action settlement in Canadian history.[3] The IRSSA was agreed upon by all parties involved: the Government of Canada, legal counsel for former students, churches, the Assembly of First Nations, and Inuit representatives. As part of the agreement, the TRC was initiated in order to both acknowledge and document the injustices and harms committed against Indigenous people as a result of the Indian residential school system. The commission, supported by the TRC Secretariat (a federal department), is funded by monies set aside for the compensation owed to Indian residential school survivors, which the Canadian government is required to pay under the IRSSA.[4] In the following five years after the agreement was reached (later extended to six), events were scheduled to take place across Canada that would encourage survivors to share their stories in a

supportive—but public—forum, allowing settler Canadians and Indigenous people to bear witness to the traumatic history of residential schools. At the time of this writing, the testimony collected is going toward building a report on "the effects and consequences of the IRS system" (Schedule N), which will be housed at the National Research Centre for Truth and Reconciliation at the University of Manitoba and its West Coast chapter, the Indian Residential School History and Dialogue Centre, at the University of British Columbia. The TRC is not primarily a tool of the state, nor is it simply an exercise in archival memory. Most specifically, it was established to "contribute to truth, healing and reconciliation" (Schedule N) between Indigenous and non-Indigenous groups in Canada.

While the TRC is not a formal legal process, insofar as it does not hold subpoena powers and cannot compel attendance or participation (as opposed to the South African TRC, which was dependent on subpoena powers),[5] both Schedule N, which serves as the official TRC mandate, and the commission that follows from it are highly regimented legal instruments that follow very specific rules and regulations. Schedule N was written in direct response to a class-action lawsuit filed August 20, 2007, by the Honourable Frank Iacobucci, former national chief Phil Fontaine, and legal representatives of both former Indian residential school students and the churches involved in running those schools. The commission has seven goals (a–g), which it was initially mandated to complete "within five years" (Schedule N). Within that five-year mandate there are both two-year and five-year timelines to be followed, which cover everything from the "preparation of a budget" to the "completion of … statement taking / truth sharing" (Schedule N). The mandate itself is broken down into eleven sections, almost all of which have individual subsections and some of which have sub-subsections. The entirety of the document is twelve pages long and includes three footnotes, one of which—the note on witnessing—I will examine in detail in this chapter.

A concern for many critics who have studied the TRC mandate has been what I call here an "ideology of economy," or rather, the way in which Schedule N and the commission work to contain the delicate process of reconciliation within a highly regimented and restrictive Western structure aimed at controlling expenses and ensuring financial stability for the capitalist state. As Carole Blackburn emphasizes, this is not so much reconciliation as it is neo-liberalism, an attempt to monetize a public service for the private sector.[6] Jennifer Llewellyn argues, "if reconciliation is about restoring relationships, it is more akin to a process than an end point to be achieved. Relationships

are dynamic and ever changing" (190). A commission that wants to address reconciliation on a moral and epistemological level must be willing to accommodate a dynamic, open-ended system, something that the current TRC, with its focus on goals, timelines, and economic stability, has struggled to accomplish.

The restrictions placed on Indigenous epistemologies within Schedule N are most clearly indicated in one of the three footnotes included in the document. In line c of the TRC's goals, it is stated that the commission will "witness, support, promote and facilitate truth and reconciliation events at both the national and community levels" (Schedule N). Next to the word "witness" is footnote subscript referring the reader to the bottom of the page (or back of the book, depending on which version of the publication you are consulting).[7] The footnote reads, "This [to witness] refers to the Aboriginal principal of 'witnessing.'"

There is no elaboration on what this very vague footnote might mean or entail in Schedule N, which indicates that it is based on at least two troubling assumptions: (1) that readers are an audience of insiders and therefore already understand what an Aboriginal principle of witnessing is, and (2) that there is a cohesive principle of witnessing that Indigenous people across Canada adhere to—an assumption that I endeavour to disprove below. At best, the footnote suggests that there is something more to be said: that "Aboriginal principles of witnessing" are a concept that the commission needs to unpack.

The phrase "Aboriginal principles of witnessing" was considered in further detail in 2009 on the TRC website (TRC.ca). The expanded definition came three years following the publication of Schedule N, likely in reaction to questions regarding the original footnote from reporters.[8] That supplemental definition reads as follows:

> The term witness is in reference to the Aboriginal principle of witnessing, which varies among First Nations, Métis and Inuit peoples. Generally speaking, witnesses are called to be the keepers of history when an event of historic significance occurs. *Partly because of the oral traditions of Aboriginal peoples, but also to recognize the importance of conducting business, building and maintaining relationships in person and face to face.* (TRC, "Honorary Witness"; my emphasis)

I have emphasized a portion of this text for reasons that will become apparent shortly, but please bear those phrases in mind as you continue reading. TRC Commissioner Marie Wilson echoed this definition in a 2012 address to "honorary witnesses" of the TRC, which included

prominent names such as Paul Martin, Joe Clark, and Adrienne Clarkson, highlighting the importance of keeping and sharing testimony: "We need prominent helpers who will not only live out their right to know the truth here, their responsibility to *remember* what they have learned here, but who will also commit to *taking forward and teaching others* and spreading the word" (qtd. in Narine, "Honorary Witnesses Promise"; my emphasis). Paralleling the National Research Centre, which will house the statements, documents, and other materials gathered by the TRC over the course of its mandate, TRC witnesses are instructed to carry with them a living record of residential schools along with the emotional/cognitive impacts of receiving and holding such testimony, a mandate that was ratified with the installation of honorary witnesses to the TRC in 2009.

The (supplementary) TRC definition of witnessing offers a provocative way to think about the concept outside of a Western framework, which, as Shoshana Felman illustrates, relies on the "legal pledge and the juridical imperative of the witness's oath" (Felman and Laub 204). The "Aboriginal principle of witnessing" employed by the TRC is dependent on a notion of active witnessing, in which the audience both receives and shares testimony to historical trauma. A witness in this sense becomes a living archive—a repository of history guaranteed by mutual consensus. In a short piece composed for Salon.com, Samantha Nock (Métis) beautifully outlines the dynamics of this principle as it persists in relation to Western formulations. According to Nock,

> Too often we think that the act of listening is equal to the act of witnessing. Listening is passive. We can listen, however your ability to listen lets you, while making to-do lists in our heads, thinking of what we are going to have for dinner, or what we are going to say next. When we witness a story we are not only present physically, but emotionally and spiritually, to hold this story in our hearts. When someone tells us their story, that story becomes a part of us. When you witness someone's story, be it a comedy or a tragedy, you are carrying a part of that person with you now. You have entered a very specific and powerful relationship that exists between the storyteller and the witness.

Opposed to the active witnessing that Nock outlines here, at stake in the Western definition of "witness" is the question of "line of sight" that connects subjects to an event.[9] In a Canadian court of law, "any evidence that is offered by a witness of which they do not have direct

knowledge" cannot testify to "the truth of what was contained therein" (Sopinka 173). This definition offers a specific spatial and temporal relationship to an event in which the witness has an uninterrupted line or course to the event in question. It is not so much that "seeing is believing" here—as much as *seeing sets up the terms for believing.* Once sight has been established, then, and only then, can testimony be balanced inside the binary of true and false. In Western ideology, the proper witness is thus always the (eye)witness, insofar as proximity and line of sight stabilize truth. The TRC challenges this definition by putting the responsibility of the act of witnessing on the individuals who accept testimony on historical events, as opposed to the individuals who directly experienced those events. What is at stake in this formulation is thus not how experience is mediated in the act of witnessing, but how it is proliferated.

While the TRC and Commissioner Chair Murray Sinclair are committed to the ideological shift out of Western formulations, they have been elusive in their descriptions about the specific traditions "Aboriginal principles of witnessing" arise from, inhibiting scholars' ability to make and contextualize arguments regarding its epistemological impact. When questioned about what the TRC means by "Aboriginal principles of witnessing," Justice Sinclair is on record as saying that he is "unsure about the meaning behind this footnote" (qtd. in Angel), but that "Aboriginal principles of witnessing often entail a component of responsibility for maintaining the integrity and longevity of an event." As he clarifies, underlining inclusivity as the basis for the TRC's designation, "this principle of witnessing is particularly important for cultures that use oral traditions." In appealing to the oral tradition, Sinclair links "Aboriginal principles of witnessing" to a deeply rooted pan-Indigenous tradition, which exceeds the borders of any specific community. As Renate Eigenbrod argues, "oral traditions form the foundation of Aboriginal societies, connecting speaker and listener in communal experience and uniting past and present in memory." Oral traditions serve as "the means by which knowledge is reproduced, preserved and conveyed from generation to generation" (Hulan and Eigenbrod 7). The conflation between "oral tradition" and "Aboriginal principles of witnessing" positions the latter as a fundament of Indigeneity *in toto*, at least as it applies between the east, west, and north coasts of Canada, providing the rhetorical weight necessary for Sinclair to levy a definition that stretches from coast to coast to coast.

Given the way it allows the TRC to mobilize as a politically cohesive unit against the Goliath of settler colonialism, pan-Indigeneity is a necessary rhetorical tool. However, the imprecision of the origins

of the TRC's employed definition does raise some cause for concern. Tracing the lineage and philosophy of the "witnessing" definition employed by the TRC, it appears that the definition that Sinclair and his fellow commissioners are evoking is connected to a very specific community and the compounding pressures of a specific moment in time—Musqueam and the 2010 Vancouver Olympics, respectively—which provides the space to better contextualize the original TRC footnote and its online supplement.

The year 2009 was an important time for the visibility of Indigenous issues on the Northwest Coast. With the Olympics looming, the Vancouver Organizing Committee (VANOC) was working hard to present a healthy relationship with the First People on whose land the games were to be held (O'Bonsawin 143). Defining witnessing via Coast Salish protocol for the purposes of "invit[ing] First Nations peoples to participate" in the 2010 games was an integral part of the procedure (Atleo, "Re: Vancouver" 1). VANOC's definition, as taken from the Four Host First Nations (FHFN, including the Lil'wat, Musqeuam, Squamish, and Tsleil-Waututh nations), is as follows:

> Being called to witness by the Coast Salish and Interior Salish peoples of Canada is an honour, a tradition dating back long before contact with European cultures. Salish peoples' history is an oral history. The role of a witness is to record the message of the event in their hearts and minds, and afterward, remember and validate the special occasion by carrying the message and sharing it with friends, neighbors and community members. (qtd. in Koptie 114)

The connection between VANOC's definition and the TRC's should be readily apparent, particularly in the insistence on carrying and sharing testimony. However, opposed to the TRC definition, VANOC explicitly connects the notion of the active witness to Coast Salish and Interior Salish traditions using a definition devised by the FHFN and undersigned by former national chief Shawn A-in-chut Atleo and the CEO and executive director of the FHFN Secretariat, Tewanee Joseph. Given that VANOC was responding to Northwest Coast contexts, it is not surprising (in fact it is rather heartening) that the committee turned to local contexts and local traditions, but its definition also opens up the question of locality in the TRC designation.

As I illustrate above, certain care was put into the definition of witnessing employed by the TRC to demonstrate its inclusive nature. By appealing to the oral tradition, Sinclair and the TRC attempted to register this definition as something that applies to the many Aborig-

inal communities involved in the reconciliation events. However, as I demonstrate below, certain remarks from the TRC website are *exactly* the same as remarks given in a ceremony conducted by Musqueam Elder Larry Grant on behalf of the FHFN. The similarity between these definitions raises questions about the TRC's relationship and responsibility to communities beyond the Salish Sea and compels us to consider alternative definitions from individuals and communities for whom this sense of witnessing does not apply.

Three months before the TRC released its supplemental definition on TRC.ca, Grant conducted a Witnessing Ceremony at the Richmond Olympic Oval on the occasion of the visit of the emperor and empress of Japan. The event was one of many leading up to the Olympics, which introduced international dignitaries to Olympic sites. In that ceremony, Grant welcomed the emperor and empress to Northwest Coast territory on behalf of the FHFN and explained the importance of a Witnessing Ceremony, which he defines as a ritual of both receiving and sharing history:

> We call witnesses to be the keepers of our history when an event of historic significance occurs in the Coast Salish world. *We do this in part because our traditions are oral, but also in recognition of the importance of conducting business, and building and maintaining relationships, in person and face to face....* We call upon all of the members of the audience to record this event in their minds and their hearts and to share the story of what happened here today. ("Witness Ceremony")

Grant is not credited in the TRC.ca definition of "Aboriginal principles of witnessing," but reading the two passages side-by-side (particularly the portions that I have italicized in Grant's definition and the definition on TRC.ca, offered above) illustrates that the TRC, if not directly borrowing from Grant, is at least employing a definition that has been quite explicitly connected to Northwest Coast traditions, both by the FHFN and VANOC. According to Grant, "what may not be apparent regarding the words of 'witnessing' used by TRC Commissioner is that [the] TRC Commission had been exposed to other Coast Salish community members in the TRC's travels. The Commissioners would have heard the description many times before using the witnessing process" (personal correspondence).

A Northwest Coast definition of witnessing in a TRC document is not entirely surprising, given that the TRC has deeply aligned itself with Coast Salish iconography in other facets of the commission—the most obvious example being the bentwood box carved by Coast Salish

artist Luke Marston, which sits centre stage at all TRC events.[10] However, by presenting Grant's definition of witnessing as a pan-Aboriginal application, similar to the oral tradition, the TRC risks normalizing a geographically specific tradition that may or may not apply across all communities, making it difficult for communities who view witnessing in unique ways to make their designations heard—particularly if they are counter to the "official" definition. The fact that Sinclair and the TRC (albeit tacitly) rely on Coast Salish meaning to stabilize their own definition of witnessing problematizes Sinclair's insistence that the commission's definition is pan-Aboriginal.

To be clear, in critiquing this model I am not attempting to undercut the importance of Northwest Coast traditions of witnessing, or to argue that these traditions represent an unsuitable model for the TRC. Indeed, as Grant illustrates so effectively, the Northwest Coast tradition offers a very powerful form of witnessing, which underlines the responsibility and action that must go hand-in-hand with the passive act of receiving information. While Northwest Coast traditions offer an exceptional model of an "Aboriginal principle of witnessing," I argue that we need to make plain that the tradition currently evoked is linked to a *particular* Indigenous perspective, which should not be uncritically applied across Aboriginal communities. Once we are aware of the specific traditions attached to the TRC definition of witnessing we can begin to see how alternative Aboriginal principles of witnessing might complement or contradict the current model. As such, having detailed the Aboriginal principle employed by the TRC above, this chapter unpacks an alternative principle of witnessing via Anishinaabe artist Rebecca Belmore and her video-art piece *Apparition*, which was included in *Witnesses: Art and Canada's Indian Residential Schools*. Via a close reading and contextualization of her work, I argue that Belmore's piece complicates the "official" definition of witnessing, by interrupting the demand to remember and share implicit to the TRC.

Bare Witness

Bearing witness is full of risk and exposes vulnerability in the speaker, particularly when that testimony is offered to strangers. Given that it applies to both Indigenous and settler communities, the model of witnessing employed by the TRC relies, at least partially, on what David Garneau refers to in this volume as "a spectacle of individual pain for settler consumption": a means for the government to distract from the

larger issues of colonialism that continue to pervade in Canada (34). In order to interrupt the consumptive model of bearing witness that he identifies, Garneau proffers a model of "Indigenous refusal": a system of "non-compliance [that] signals the need for forms of representation outside of the current Reconciliation narrative" (23). According to Garneau,

> the colonial attitude is characterized not only by scopophilia, a drive to look, but also by an urge to penetrate, to traverse, to know, to translate, to own and exploit. The attitude assumes that everything should be accessible to those with the means and will to access them; everything is ultimately comprehensible, a potential commodity, resource, or salvage. (23)

Building from these ideas, I argue that residential school survivors who offer their stories of abuse and trauma for the commission are not simply "bearing" witness, that is testifying to their experiences in an objective manner, but rather "*baring*" witness: exposing themselves to a scopophilic gaze driven by the colonial desire to know and own. "Baring witness" is a courageous act of making oneself vulnerable to the other, but it also risks commodification and misuse, an issue that must be addressed carefully and with sensitivity.

Much of the testimony offered by residential school survivors is an explicit act of baring witness. For instance, in his groundbreaking 1990 interview with Barbara Frum, Phil Fontaine, who was not yet national chief, described in vivid detail how he was sexually abused in residential school and the dramatic impacts this abuse had on his life. The interview is heartfelt, honest, and jarring, and Fontaine is described as "holding nothing back" in this "tell-all interview" ("Phil Fontaine's Shocking").

In baring witness in this public forum, Fontaine played a major role in Canada's eventual address of Indian residential schools (Miller, "Reconciliation" 137–38). He also set a remarkable precedent for other survivors, demonstrating, in a very public forum, the possibility of speaking to these traumatic and difficult histories, which had been held beneath a cowl of silence for so long. Fontaine's testimony reminds us, as does the TRC, that not all witnesses are necessarily settlers. The most important audiences are most often the families, friends, and communities of those who are offering the testimony. As the Aboriginal Peoples Television Network so aptly put it, the stories offered by survivors, "help Canadians understand the legacy of residential schools, but more importantly help survivors and their families heal" ("Raw Video").

Without overshadowing its importance then, in broadening the scope of the audience to the settler community, Fontaine's historic interview also illustrates how baring witness can be recuperated into the colonial system. Aside from changing the way Canadians view residential schools, the intimate interview also initiated a trend toward a "pay-for-pain" model, in which survivors of residential schools were compelled to lay bare their suffering to collect financial restitution (Carter). Indeed, in order to receive compensation beyond the Common Experience Payment ($10,000 for the first year attended and $3000 for each subsequent year) mandated by the IRSSA, "the claimant must prove the abuse and the harms 'on the balance of probabilities'" (Indian Residential Schools Adjudication Secretariat) via an Independent Assessment Process (IAP). Payment amounts in the IAP are contingent on pain incurred as decided by a court adjudicator. As Kevin Loring (Nlaka'pamux) sardonically puts it in his post-IRSSA play, *Where the Blood Mixes,* "it depends on how bad it was, eh. Most people are getting about fifteen grand. If it was real bad, you get lots more" (24).

By requiring survivors to expose themselves in order to receive restitution, the TRC positions reconciliation as a process dependent on victims who must continue to put themselves at risk. While baring witness may help to fill in the picture of Canada's violent colonial history, as Roland Chrisjohn (Oneida) and Sherri Young so rightly argue, a "healing" system cannot demand that victims speak to their suffering: "What if someone doesn't want to stand up in a room full of strangers and recall, and talk about, and dispute, the most horrible moments of her or his life, but still wants justice?" (60).

* * *

Rebecca Belmore's work interrupts the pay-for-pain model by testifying to residential school violence while refusing to bare her suffering. *Apparition* was a central component of *Witnesses: Bringing Residential Schools into the Present,* installed at the Morris and Helen Belkin Art Gallery (University of British Columbia, 2013). *Witnesses* was timed to open just before the Truth and Reconciliation Commission arrived in Vancouver. The exhibit prepared audiences for the acts of witnessing and testimony that the commission would demand, while providing critical and aesthetic access points to representations of testimony, forgiveness, apology, and reconciliation. Twenty-two artists, curated by Geoffrey Carr, Dana Claxton, Tarah Hogue, Shelly Rosenblum, Charlotte Townsend-Gault, Keith Wallace, and Scott Watson, contributed to the exhibition, which included Belmore, Skeena Reece,

Jamasie Pitseolak, Henry Speck, Carl Beam, Adrian Stimson, and Lisa Jackson, among others. *Witnesses* is the best-attended exhibition ever mounted at the Belkin Gallery, which has been open for eighteen years (M. Turner), demonstrating the deep resonance of these issues with the university and the art-going publics. In its ability to represent the pain and horror of residential schools, *Witnesses* seemed to speak to a desire—in both Indigenous and settler communities—to contend with this dark chapter of Canadian history.

Following the TRC's lead, the *Witnesses* exhibit was built out of a definition of witnessing in which audiences were meant to receive the history and emotion surrounding residential schools and then share it with their own communities. In the final sentences of his essay for the exhibition catalogue, entitled "Bearing Witness: A Brief History of the Indian Residential Schools in Canada," Geoffrey Carr writes,

> Visitors to this exhibition have been asked—through artwork, accounts of survivors, and the catalogue—*to share in the work of witnessing* the history and present-day legacy of the Indian residential schools. It is up to each who have looked upon the testimony to consider what has been seen and to ask of themselves not only how they are connected to this difficult history, but also how they can contribute to some measure of justice, healing, and reconciliation. (19; my emphasis)

Contrary to his appraisal, however, many of the pieces in this exhibition, particularly Belmore's, challenged the definition that Carr evoked. Belmore's contribution to *Witnesses* was a large-scale video-art installation featuring the artist herself posed against a white, ethereal background. The video loop, four minutes in length, begins by slowly fading in on Belmore in a white T-shirt and jeans, kneeling in front of the camera; a piece of duct tape covers her mouth. The artist stares directly into the camera and therefore directly at the audience, but her gaze, like the background she is set against, is *tabula rasa*, contributing to the overall sense that this piece is more of a space to collect the projections of the viewer than it is a projection of the artist's thoughts on residential schools. Roughly midway through the piece, Belmore moves from the kneeling position—which, as *Vancouver Sun* art critic Kevin Griffin notes, emulates the position of prayer residential school students were forced to assume—to a cross-legged sitting position. Still holding the audience's gaze, Belmore then slowly tears the duct tape away from her lips. Once it is removed she stands up and walks out of the frame. The loop then repeats, returning to Belmore kneeling with the duct tape over her mouth.

As a genre, video art has a rich connection to witnessing. This relatively new art form, in its formal relationship to the gaze, explicitly connects audiences to the notions of sight and proximity that are so prevalent in Western definitions of the witness, while also disrupting the perceived stability of the witnessing subject. The first video artist is generally argued to have been Nam Jun Paik, a Korean-American artist, who used the first publicly available video camera (Sony's Portapak) to shoot footage of Pope Paul VI's visit to New York (1965). Paik's cinéma-vérité interpretation of the visit was seen as a striking critique of the "global media machine," which used technology to obfuscate the "real" of societal events by mediating them through voice-overs, editing, and commercial breaks. Paik's video represented a purity of form that could be used to disrupt the hegemony of the corporate, colonial gaze and to bear witness to history in an unmediated form. These political origins prepared the ground for future critical responses to the medium. The political implications of video art, which are intimately connected to its aesthetics and technology, are productive points of analysis. Born out of the politics of Vietnam, video art "represented the first challenge to the hegemony of the mainstream media controlled by its oligarchy of commercial, political and military interests" (Elwes 5), making it a charged means for artists to "speak back" to the system.

In the 1970s and 1980s, video artists such as Sergei Eisenstein and Martha Rosler began using improved editing technology to collide images in complex systems of montage meant to "explode" historical narratives and provoke critical thinking. In the 1990s, because video had recently become less expensive to produce and easier to distribute, it was also—censorship notwithstanding—an immediate way for Indigenous people to respond to the media and the propagation of colonialist attitudes surrounding the so-called Oka Crisis. Alanis Obomsawin's *Kanehsatake: 270 Years of Resistance* had a particular impact on the media landscape. Shot from inside Mohawk barricades and then edited together with personal testimony, visual art, and archival material, Obomsawin's montage technique revolutionized Aboriginal video. In editing together her own footage with video from the CBC, sound bytes from Société Radio-Canada, text from the *Gazette*, and photos from the national archives, Obomsawin reclaimed, reused, and repurposed the "popular" narrative surrounding Oka to illustrate the deep history of the conflict and the love and pride that shaped Kanesatake resolve.

In the way that it draws attention to the gaze and testifies to history and personal experience, video art is an influential form of witnessing. According to Sara Kindon, the way in which video art comments on the "practice of looking" produces "a looking that does not objectify, does not point to an object as if it was distant from the viewing object or absent from the viewing place" (149). As such, video art has the potential to become a powerful means to upset the patriarchal/colonial gaze by providing artists and audiences with the opportunity to "reposition themselves in the world" (149). Indeed, as Peter Kardia has noted, perhaps the central issue that arises out of cultural production as it is connected to video art is "the interaction between the position and place of the witnessing subject and the imaginative project embodied in the work" (qtd. in Elwes 6).

Following in the tradition of Paik, Eisenstein, and Obomsawin, *Apparition* speaks to a number of key issues within the framework of "witnessing." A key element here is language. As Belmore acknowledges in her artist statement for this work, the piece "is an artwork that reflects my understanding of the loss of our language [Anishinaabemowin]" (*Witnesses* 35). While Belmore grew up around her mother tongue, she is unable to speak it. Residential schools played a determining role in this loss, interrupting the inheritance of language as it is passed from one generation to the next, by punishing students for speaking their mother tongues and generating shame around Native language and Native epistemology. Residential schools were built on the idea that "only by removing children from their parents, prohibiting Indigenous languages, and banning cultural practices could students be removed 'from evil surroundings' and be relocated in the 'circle of civilized conditions'" (Carr 11). The tape across Belmore's mouth in the piece is thus indicative of the ways in which Indigenous languages were stolen from Indigenous communities through the residential school system. Inasmuch as their languages were stolen, there is also a critical epistmological gap in the ways in which survivors can communicate their experiences in these schools—given that English, the language of the perpetrator, becomes the vehicle through which they must bear witness.

Using the lack of language as an entry point, Belmore's video installation then intervenes in colonial history and the violence of residential schools not by breaking silence but by mobilizing it: while the audience is captivated by Belmore's gaze in *Apparitions*, the artist offers no words, English or Anishinaabemowin, that might fulfill the consumptive

desire of a colonial audience. Indeed, Belmore draws attention to that desire when she removes the duct tape from her mouth but continues without speaking. While, on the one hand, removing the tape suggests personal agency, the ways in which the artist has freed herself from set-tler-colonial hegemony and the silence of the subaltern, her continued refusal to then speak—to *bare witness* to the trauma and violence that inflicted her silence—interrupts the victim/perpetrator dialectic of testi-mony/apology and subverts settler expectations, which circulate around knowing the pain of the other. In walking out of the scene, Belmore completes the gesture of refusal, leaving the audience with only a blank canvas, a radical space of lack that refuses recuperation into a settler-colonial narrative of forgiveness—what Schedule N identifies as "an emerging and compelling desire to put the events of the past behind us so that we can work towards a stronger and healthier future" (Schedule N). Then the loop begins again. The tape is back across the mouth. The story remains untold, making the non-telling, and its repetition, one of the primary takeaways.

According to the poet and art critic Michael Turner, *Apparition* is "a refusal to express ... loss in the language of its exterminator." As an "Aboriginal principle of witnessing," *Apparition* haunts the domi-nant narrative of the TRC, refusing incorporation into the narrative of "education" toward the settler-colonial horizon of "closure." As a loop, there is no telos to this piece, no end-goal that might match up with a five- (or six-) year mandate. There is also nothing concrete or tan-gible that the active witness (i.e., audience) might receive and share. As Slavoj Žižek illustrates, the gaze and voice are both objects, "that is, they do not belong on the side of the looking/seeing subject but on the side of what the subject sees or hears" (Lagaay 59). In the TRC definition of witnessing, the object of the voice or of the gaze is what makes active witnessing possible—it allows the looking (or hearing) subject to collect and to share his or her experience. Silence, however, is a condition of lack that *creates* the space for voice. As Žižek puts it, "the first creative act is therefore to *create silence*—it is not that silence is broken, but that silence itself breaks" (*Parallax* 154; emphasis in original). Video art is particularly effective in these regards because of its ability to hold the tenor and visual component of a silent subject, making the object of that silence that which video art transforms into something tactile and uncomfortable while holding the history of that silence spectrally present.

In the sense of its silence, Belmore's principle of witnessing is composed around Garneau's above-mentioned notion of "Indigenous refusal." Installed at a university art gallery just before the TRC events

at Vancouver, *Witnesses* was very much caught in the tension of sco-pophilia (the desire to objectify the seen or heard event) and the drive to know and translate what Garneau identifies as Native trauma. *Apparition* refuses the scopophilic desire by refusing to bare the trauma of the subject—while still bearing witness to the violence inflicted by residential schools. Rather than making trauma evident, or "a potential commodity, resource, or salvage," as Garneau puts it (23), *Apparition* refuses access to the artist's pain; it refuses to speak, to translate, to provide explanation; and it refuses assimilation into a settler-colonial narrative of reconciliation in which "public display of private (Native) pain leads to individual and national healing" (Garneau 35). In the sense that it refuses access, that it denies the settler witness any explicit entry point into the suffering of residential schools, *Apparition* is also an act of what Tuscarora artist and scholar Jolene Rickard calls visual sovereignty, "the border that shifts Indigenous experience from a victimized stance to a strategic one" (qtd. in Hearne xxix). Belmore's piece refuses to offer up her pain as commodity and compels its audiences to consider the implications of their own desire as it relates to the trauma of residential school survivors.

Irreconcilable Spaces of Witnessing

The exhibit at the Belkin gallery asked viewers to consider the ways in which witnessing is inflected beyond the scope of the "face-to-face" relationship that the TRC definition privileges. In the public and political space of the TRC, as in the gallery, witnessing always takes place in relation to a third: the person or people who, while witnessing themselves, also bear witness to the witness. For instance, when I was viewing Belmore's piece at the Belkin, I was acutely aware of how I, as a privileged white male and an inheritor of the resources acquired through violence of settler colonialism, was being seen as I received this devastating testimony to residential schools and Canadian history. That awareness shaped my relationship to and my understanding of the work. Was I demonstrating the proper respect? Did I look appropriately moved or upset at the correct moments? Did I spend enough time with the piece in order to demonstrate my willingness to engage/empathize with the artist's position as a white male settler?

To be clear, I realize the narcissism of these anxieties. This exhibit was clearly not about me and it is almost certain that the other viewers were caught up in their own experiences/emotions/anxieties. Nonetheless, I want to suggest this is part of my point. Witnessing rarely

takes place within a vacuum; that is to say that what it means to bear witness (or even more so, to bare witness) is inextricable from the places where we are asked to do so and the people we do so with. This is not simply a matter of an "other" intruding into one's personal space or actively and purposely interfering with the act of testimony, but a matter of the ways in which one's *reception* of an event or piece of art is inflected through the interpellating[11] effects of the presence of a third—the one who guarantees me as a witnessing subject.

The presence of the third, and its effects on the act of bearing witness, is at the centre of the argument for irreconcilable spaces of Aboriginality, which Garneau outlines in this volume. He writes,

> Irreconcilable spaces of Aboriginality are gatherings, cere-mony, nêhiyawak (Cree)–only discussions, kitchen-table con-versations, email exchanges, et cetera, in which Blackfootness, Métisness, and so on, are performed without settler atten-dance. It is not a show for others but a site where people simply are, where they express and celebrate their continuity and figure themselves to, for, and with one another *without the sense that they are being witnessed by people who are not equal participants.* (27; my emphasis)

I take some issue with Garneau's suggesting that people are ever "sim-ply who they are," that is to say, I doubt whether it is possible for someone to just be, especially within the context of over a century of identity legislation, but the primary point—that Indigenous people need to engage with issues of reconciliation without the presence of settler others—is an essential one. Because, as Garneau notes, wit-nessing takes place within a Judeo-Christian model of forgiveness and reconciliation,[12] the TRC model discourages survivors from testifying to their rage and resentment, their refusal to forgive, and/or their desire for revenge. There is no naming of perpetrators in this TRC; there is no talk of how "pay-for-pain" systems further harm communi-ties—because this is not conducive to the TRC mandate in which the first sentence declares a "desire to put the events of the past behind us" (Schedule N). Garneau's suggestion is that the presence of a set-tler witness, defined by him as those who "are aware of their inher-itance and implication in the colonial matrix" (29), implicitly alters the ways Indigenous subjectivity develops and grows out of dialogue between Indigenous people. Garneau conceives identity as that which is located in the space *between* subjectivities (as opposed to being implicit to the subject him- or herself). To borrow from the language

of psychoanalysis, the subject's desire is always already bound up in the desire of the Other.[13] That is to say that for Garneau, "Indigeneity" is always already unfolding in the discourse across community, family, and kinship relations and, as such, is dynamic and responsive.

Because of colonial power dynamics, Garneau argues that inviting a non-Indigenous guest into an Indigenous space risks the incursion of a colonial ideology into Indigenous discourse. The infringing "colonial attitude," as Garneau puts it, is founded on the fallacious belief that "Indigenous persons can be recognized, identified, described, and contained"—which stagnates the dynamism of a subjectivity that is conceived *across* a group or community (27). As Garneau puts it, "whether the onlookers are conscious agents of colonization or not, their shaping gaze can trigger a Reserve-response, an inhibition or a conformation to settler expectations" (27). As a third, the presence of a settler in an Indigenous space inflects (in terms of reification) how the Indigenous people in that space may testify to their experiences and bare witness to the testimony of their friends, family, and peers. This, in turn, inflects the expediency of growth, change, and resurgence in that community.

While it may read so at first, Garneau's argument is not an essentialist critique. It resists reification. There is room for non-Indigenous people in irreconcilable spaces of Aboriginality. Irreconcilable spaces of Aboriginality are open to settlers as long as they have gone through some process of decolonization and are prepared to be good guests: "Settlers who become unsettled—who are aware of their inheritance and implication in the colonial matrix, who comprehend their unearned privileges and seek ways past racism—are settlers no longer," Garneau states (29). As a settler scholar myself, I of course agree with him that settlers, "through proximity, listening, empathy, cooperative inquiry, and action," can "unsettle" themselves and become respectful, contributing guests in Indigenous communities (29). However, I would stress that the process of unsettling is ongoing. The role I play as a settler scholar in Indigenous studies on the West Coast, where there are no treaties in place, is to be perennially aware of my guesthood and to guard against the complacency and entitlement that comes with "making oneself at home" in a space that begins to feel comfortable as I meet, learn from, and become friends with people in a given community. If new participants are invited into Indigenous groups that I feel welcome in, I must be ready to accept that my presence may, from one moment to the next, be unwanted or restricting for new members. When this moment arises, I must be willing to graciously remove

myself or be open to the suggestion that I take my leave, at least until a later date. As anyone who has guests that visit regularly knows, part of being a respectful guest is knowing when to exit.

Exclusion is not an emotionally tranquil event, and as one of my colleagues pointed out to me, there is a very real difference between ethos and practice. Not being invited to an event, or, even more so, being asked to leave one, stings, particularly if I feel that I am a respectful and contributing member of that community, or that I have a "right" to attend (be it through academic credentials, personal relationships, or financial contributions). These moments of disjunction are disquieting, of course, but they should also be taken as instructive—because, in Paulette Regan's sense of the word, they are *unsettling*. Exclusion is a "profound disturbing of a colonial status quo" (Regan, *Unsettling* 60) that provisions against the colonial desire to "penetrate, to traverse, to know, to translate, to own and exploit" (Garneau, this volume, 23). Acknowledging, not just through theory but through action, that some knowledge is off-limits to you personally is not only an ethical gesture, it is good academic practice. No one is welcome everywhere. Recognizing one's boundaries is in itself an academic gesture: it facilitates the growth and rigour of knowledge and opens up stronger lines of communication *across* communities. As Joy Harjo (Creek) writes, "protocol is a key to assuming sovereignty. It's simple. When we name ourselves ... we are acknowledging the existence of our nations, their intimate purpose, insure their continuation" (119). In naming ourselves, and thus our status as guests, we also acknowledge the existence of borders and the hosts' right to open or close them.

Building on the idea of recognizing the *necessity* of exclusion, I would further suggest that in order for Garneau's theory to fully function as a decolonial (or non-colonial) methodology, practitioners need to imagine the possibility of their own suspension from irreconcilable spaces of Aboriginality because these spaces are intersectional, which is to say that race, gender, class, sexuality, and ability interact on multiple and simultaneous levels *within* these spaces. In this sense, it may be necessary for Indigenous men to remove themselves from communities considering Indigenous women's issues, or for straight contributors to extract themselves from spaces concerned with queer or two-spirit issues. This is not to say that men or straight people have nothing to add to these conversations, but that their presence, well-intended though it might be, inflects the content and direction of the conversation therein. What makes Garneau's critique so powerful

is how it bequeaths on individual readers the knowledge that their presence can have an impact on the ways in which individuals bear (or bare) witness to their communities and implement resurgence. Individuals *within* these spaces must recognize that there are times when they need to acknowledge their own position as outsider. In Garneau's sense, "witnessing," at least as it is defined by the TRC, may be technically impossible, given that its mandate, at least in part, is to introduce "outsiders" to the history of residential schools. In order for "irreconcilable spaces of witnessing" to function within a public/ political space such as the TRC, more consideration is necessary of the specific borders that turn and intersect throughout that space.

Conclusion

Attempting to contain "Aboriginal principles of witnessing" to a footnote reproduces colonial power by limiting the ways not only in which history can be told, but also how it can be received. While the inclusion of a Northwest Coast model provides an excellent place to begin decolonizing a very loaded Western term, as of this writing the TRC has yet to explicitly acknowledge this model of witnessing as community specific. As such, it risks perpetuating a pan-Aboriginal epistemology that obfuscates territory-specific perspectives. As Belmore helps to illustrate, much more needs to be done in terms of determining the logistics and ethics of an Aboriginal principle of witnessing that requires participants to carry and disseminate the pain of others. In fact, Belmore's piece alters the ways in which we might think of the very foundation of witnessing by outright rejecting the demand to keep and share via the disruptive force of silence. *Apparitions* compels audiences to think critically about irreconcilable spaces of witnessing insofar as it refuses the art gallery, a public arena functioning in relation to the TRC, as a place to consume her suffering.

In light of both Belmore's and Garneau's work, it is clear that more work needs to be done that considers what witnessing means for individual communities and traditions. According to Murray Ironchild (Piapot), "there are over 600 First Nations communities and each one has a different approach [to reconciliation].... What does reconciliation mean in each of these languages? Everyone's understanding and interpretation of reconciliation will be different, and perhaps this is something we need to look at" (408). The same, I argue, is necessary for witnessing—a founding principle of the TRC's mandate and its

function as a program of healing. The TRC is structured around the witness baring him- or herself to the public in the name of truth and healing. Of whose reconciliation do we speak if we are never certain who the witness is or from where he or she speaks?

Notes

1 See Feldman; Brounéus; and Craps.

2 In 1991, Chief Justice Allen McEachern of the Supreme Court of British Columbia denied the land claims of the Gitksan and Wet'suwet'en peoples on the basis that they had no written documents to support their claims. This, despite the fact that Gitksan and Wet'suwet'en plaintiffs had provided hours of testimony that illustrated, via oral traditions, their claims to the land. McEachern's decision was overturned by Chief Justice Antonio Lamer in 1997 on the basis that the court's insistence on written documentation created "an impossible burden of truth" (Lamer qtd. in McCall 431) for those groups that did not have written records. The *Delgamuukw* decisions raised important questions about what is and what is not considered "proper" legal testimony and set a precedent for closer reading of legal terminology as deployed in a legal setting—which this article undertakes.

3 See Aboriginal Affairs and Northern Development Canada.

4 See Treasury Board of Canada Secretariat.

5 See Arthur.

6 In a neo-liberal economy a nation without ambiguities and contradictions is simply a better business partner. As such, reconciliation is a sound investment, not a moral imperative. As one Canadian government official admitted to Blackburn, "we just need to get on with developing British Columbia. We can't with this unresolved aboriginal rights and title issue out there. So we're looking for certainty so we know what the rules are and can get on with business, developing the province" (587).

As Blackburn makes clear in her work, reconciliation is not first and foremost about achieving a utopic ideal of coexistence with Aboriginal people. Rather, "resolution" is about erasing the contradictions that interfere with business. Jeff Corntassel, Chaw-win-is, and T'lakwadzi make a similar argument. According to them,

> Given an overarching desire to secure a stable land base to facilitate corporate investment, the Government of Canada, as well as certain provinces, including British Columbia, have begun to use the language of reconciliation in negotiations with Indigenous peoples (for example, in the B.C. Treaty Process as well as in the proposed "New Relationship" legislation) in order to establish the "certainty" of a land claim in such a way as to facilitate the extinguishment of original Indigenous title to the land. (145)

7 Schedule N is available online and via print publications from the Aboriginal Healing Foundation.

8 In 2010 at a TRC conference at New York's International Center for Tran-
 sitional Justice (ICTJ), journalist Naomi Angel questioned Justice Murray
 Sinclair, Chief Wilton Littlechild, and Marie Wilson about this particular
 footnote.
 Justice Sinclair explained that although the meaning of the footnote
 is debatable, Aboriginal principles of witnessing often entail a com-
 ponent of responsibility for maintaining the integrity and longevity
 of an event. In traditional ceremonies, like namings for example, the
 witness is called upon to remember the event, maintaining its history
 into the future. This principle of witnessing is particularly important
 for cultures that use oral traditions. (Angel)
9 I have an earlier essay that deals with this issue in more detail. See
 "Translating Reconciliation."
10 Elizabeth Kalbfleisch's chapter in this volume contains a detailed analy-
 sis of Marston's bentwood box. For more on Northwest Coast definitions
 of witnessing, see the chapter by Peter Morin.
11 By "interpellation" I am referring to Louis Althusser's position that the
 fully actualized and coherent subject is an illusion. For Althusser, subjec-
 tivity is constituted by ideology and the Other who names and identifies
 us.
12 Garneau's assessment of the TRC may seem to overstate the importance
 of the Judeo-Christian model in the Canadian context. However, I would
 argue that his analysis is quite accurate. While the Canadian TRC has
 attempted to foreground a ceremonial context, it has yet to contend
 with its genealogy—particularly its relationship to the South African
 TRC, led by Archbishop Desmond Tutu, probably the most famous living
 proponent of reconciliation. Tutu's reconciliation was firmly rooted in
 Christian ideology and the imperative to "love thy neighbour," which he
 argues one should be willing to do "not just once, not just seven times,
 but seventy times seven, without limit" (273). Without being openly
 addressed, the spectre of Tutu hangs over the TRC and shapes its man-
 date.
13 The desire of the Other is a particularly Lacanian formulation. Accord-
 ing to Lacan, "Man's desire is the Other's desire, in which the *de* /of/
 provides what grammarians call a 'subjective determination'—namely,
 that it is qua /as/ Other that man desires…. This is why the Other's
 question—that comes back to the subject from the place from which he
 expects an oracular reply—which takes some such form as '*Che vuoi?*',
 'What do you want?' is the question that best leads the subject to the
 path of his own desire" (qtd. in Žižek, *How to Read Lacan* 42).

CHAPTER 6

Polishing the Chain: Haudenosaunee Peacebuilding and Nation-Specific Frameworks of Redress

Jill Scott and Alana Fletcher

In this chapter, we explore the potential for Indigenous and in par-ticular nation-specific traditions and practices to enhance the current and emerging measures of reconciliation and redress[1] for Indigenous people. There is already a significant body of scholarship on the short-comings of official discourses of reconciliation (Garneau, "Imaginary Spaces" 34–35, Loft 45, and D. Turner, "On the Idea of Reconciliation" 109–11), but our focus here departs from previous examinations of the reconciliation process by inquiring into the potential for Indigenous and nation-specific forms of redress. Rather than attempting a more general overview of what various Indigenous cultures and traditions can offer the reconciliation process, we have chosen to engage with Haudenosaunee peacemaking and peacebuilding traditions for the following reasons: we live and work on the traditional territories of the Haudenosaunee and Anishinaabe, we have established respectful relations with the Haudenosaunee community of Tyendinaga, and the Québec National Event of the Truth and Reconciliation Commission, which informs our observations here, took place on Haudenosaunee territory.

In order to create a context for our analysis of Haudenosaunee rituals of condolence and atonement and of the terminology of rec-onciliation and redress in Indigenous languages, which is our cen-tral focus, we begin with a brief summary of some of the rhetorical features of Harper's official 2008 apology to Indigenous peoples for the legacy of the Indian residential school system in Canada. Our dis-cussion of Western forms of apology serves as a springboard for an inquiry into the conditions of possibility for expressions of apology and modes of redress that are less dependent on colonial discourses

and are informed instead by Indigenous practices and traditions. We emphasize that, where Western notions of conflict resolution respond reactively to a breach or a wrongdoing, Haudenosaunee traditions tend to emphasize regular and proactive forms of relationship building. Often referred to as "polishing the chain," "removing the brambles from the path," or "building the fire," these serve to guard against eroding relationships. Finally, we ask whether the TRC has adequately and appropriately acknowledged and incorporated nation-specific modes of reconciliation, and we suggest that future redress movements explore creative means of integrating Indigenous practices and traditions, including Indigenous languages, rituals and ceremonies, storytelling, and peacebuilding traditions. Taking our cue from the collection's broad conception of "aesthetic action" as encompassing not only Indigenous creative arts but also cultural practices, discourses, and languages, our focus on language points out several ways in which the structural grammars of TRC events and the words used to describe the reconciliation process do not translate for Indigenous communities. Integrating Indigenous languages, rituals, stories, and peacebuilding traditions is, we argue, an important form of aesthetic action that future reconciliation processes must undertake.

Our observations are informed by our engagements with debates around the future of Indigenous–settler relations in Canada, in particular the Indian Residential Schools Settlement Agreement and the events leading up to this; by the direct experience of attending the Québec National Event of the TRC; and by interviews and consultations with members of the Haudenosaunee community of Tyendinaga. As settler scholars of Indigenous literatures and cultures living and working within clear view of this healthy and active Haudenosaunee community, we had the great privilege of consulting with community members about issues that directly affect them. In all cases, we respectfully made clear the nature of our inquiry and have been at pains to work with community members to ensure a faithful representation of their views. In this paper, we have therefore grounded our analysis and argument on the words of Haudenosaunee Elders, Knowledge Keepers, teachers, and community leaders wherever possible. In using conversation and consultation as part of our research methodology, we hope that this contribution partially enacts, celebrates, and outlines the collaborative, reciprocal, and relationship-focused alternative Haudenosaunee tradition offers to Western conceptions of apology and reconciliation.

For those less familiar with Haudenosaunee cultures, it is worth pointing out that "Haudenosaunee is the self-identifying term for traditionalists adhering to the governance of the Great Law and the Confederacy of the Six Iroquois Nations," while "Iroquois" and "Iroquoian" are more anthropological terms used to connote "a broader culture grouping which historically shared a language family, clan structure, and agriculture in which corn was prominent" (Brant Castellano, Personal interview). *Rotinohshonni*, according to Kanien'keha teacher Bonnie Jane Maracle, is the Kanien'keha (Mohawk) word for "people of the longhouse"; the word *Haudenosaunee* is, in fact, a Seneca word that has come to be used as the self-identifier (Personal interview). The Confederacy of the Six Iroquois Nations was formed by the Peacemaker with the help of Aionwatha, and includes the Mohawk, Oneida, Onandaga, Cayuga, Seneca, and, later, Tuscarora nations. Throughout our paper, we will refer to Haudenosaunee peoples, while understanding that this term encompasses a diversity of cultures and traditions.

If we accept that residential schools were part of a larger colonial project that attempted to systematically wipe out Indigenous cultures by halting the transmission of language, clan and family structures, historical knowledge, and spiritual traditions, then an apology exclusively framed by Western secular discourse would seem to maintain the continuity of the colonial project that brought about the wrongs in the first place. Prime Minister Harper's 2008 official apology to First Nations, Métis, and Inuit peoples on behalf of the Government of Canada[2] serves as a reference point for a discussion of the criteria for a "good" or "good enough" apology. Scholars including Trudy Govier, Charles Griswold, and Linda Radzik have noted the key elements typically included in standard Western concepts of apology: the wrongful party must admit responsibility for the act committed and acknowledge that it was wrong;[3] acknowledge the harm done and the suffering of primary and secondary victims; express remorse and regret, and display compassion for those affected;[4] promise to refrain from future wrongdoing; and make amends or offer redress.[5] Apology may also include a desire to reconcile, a request for forgiveness, and self-imposed consequences. Beyond these conditions of content, the form and medium of an apology also have a significant impact upon its success. An apology is a performative act—that is to say, it requires one or more interlocutors, on whose approval the success of the act hinges.[6] According to Haudenosaunee scholar and activist Marlene Brant Castellano, an apology must therefore be delivered in a credible

manner with appropriate solemnity, and the wrongdoer must appear to be genuine and sincere in the sentiments expressed (Personal interview).[7]

In this context, it is important to make the distinction between interpersonal apology and political apology.[8] First, where interpersonal apology can take place between individuals, political apology almost always includes a third party as proxy for the wrongdoer and/or victim. As the representative of the Canadian government, Stephen Harper apologized on behalf of all Canadians for wrongs committed by a previous government. Among the recipients of the apology were survivors of residential schools, but many of the primary victims did not live to receive the apology firsthand. Second, political apology is never free of partisanship. Government leaders do not issue an apology unless it is in keeping with the public will. However, such apologies are invariably constructed in such a way as to mitigate the scope of the wrongdoing because not all citizens feel that an apology is required. Third, political apologies are often worded to limit legal liability to avoid having to take responsibility for large-scale compensation. Finally, where interpersonal apology almost always includes some form of dialogue or response from the injured party, political apologies are often unilateral utterances. The monologic nature of political apology jeopardizes reconciliation because it gives the perpetrator rhetorical authority, which silences and potentially revictimizes the injured party by disavowing his or her story (Scott, *Poetics of Forgiveness* 155–61).[9]

On the surface, Prime Minister Harper's 2008 apology meets many of the requirements for an effective apology in the Western tradition. It acknowledges wrongdoing and recognizes the harm done; it expresses regret and suggests the desire to avoid future wrongs. Harper declares, "Today, we recognize that this policy of assimilation was wrong, has caused great harm, and has no place in our country." The rhetorical feature most recognizable in the speech is repetition. The words "we recognize that … and we apologize for having done this" act as a refrain, giving the narrative a rhythmic or even poetic tone. The lilting repetition can be seen as an aesthetic of comfort—typical of laments or elegies—but it also has a lulling or dulling effect, making it difficult to focus on the meaning of the words.

The apology also fails to meet a number of criteria for successful Western apology, as it includes subtle mitigations of responsibility and diminishes wrongdoing. The first example of this occurs in the first paragraph of the speech: "In the 1870s, the federal government, *partly in order to meet its obligations to educate Aboriginal children*, began

to play a role in the development and administration of these schools" (our emphasis). The implication here is that education was part of the treaty agreements, which had been signed by the Crown and Indigenous peoples. This claim exemplifies excuse and justification. Another attempt to mitigate responsibility is Harper's reference to the schools as "joint ventures" with the Anglican, Catholic, Presbyterian, or United Church. In drawing attention to the role of religious institutions, the speech seems to imply that because the administration of the schools was left to the discretion of the churches, the abuses that were carried out in these schools were perpetrated by clerics. This is an example of blame. A third rhetorical gesture that diminishes wrongdoing is the mention that "some former students have spoken positively about their experiences." While perhaps not all former students feel residential schools were harmful, this statement shows a lack of insight into the overarching wrong done by residential schools, which were part of an assimilationist colonial system that attempted to wipe out Indigenous cultures. This statement also insinuates that some of the schools were really not that bad, and that they were established with the best of intentions. All intention aside, the fact is that the system brought about a cultural genocide. Euphemism is a further rhetorical gesture that detracts from the impact of Harper's apology. Harper observes, "The legacy of Indian Residential Schools has contributed to *social problems* that continue to exist in many communities today" (our emphasis). To refer to the effects of residential school trauma as "social problems" is a form of blaming the victim.

There is already a significant body of criticism on Harper's apology,[10] and it is not the intent of this paper to reproduce it in an exhaustive critique of the apology's colonial framework. Rather, our purpose is to use the rhetoric of Harper's apology as a departure point for an inquiry into alternative forms of apology and redress which more effectively integrate Indigenous intellectual and cultural traditions. One of the most pressing reasons for pursuing such an investigation is the fact that Indigenous redress is differentiated from restitution for other minority groups (e.g., Japanese Canadians or Ukrainian Canadians) by the question of sovereignty. Prime Minister Harper's apology on behalf of the Government of Canada raises a fundamental paradox. The apology assumes the legitimacy of the Canadian state and its sovereign authority over Aboriginal people; however, many Indigenous people—the Haudenosaunee, in particular—do not recognize Canada and do not consider themselves Canadians. Indigenous peoples inhabited these territories long before there was any notion of nation-state—whether Canada or the United States, for that matter—and see

themselves as nations unto themselves, responsible unto themselves. On the question of self-government, Haudenosaunee scholar Taiaiake Alfred writes, "[Terms like] 'Aboriginal self-government,' 'indigenous self-determination,' and 'Native sovereignty' [are] founded on an ideology of Native nationalism and a rejection of models of government rooted in European cultural values" (*Peace, Power* 26). Anishinaabe scholar Dale Turner similarly asserts that the rights of Indigenous peoples "flow out of Aboriginal peoples' legitimate status as indigenous nations" *(This Is Not a Peace Pipe* 6). Harper's apology includes a clear request for forgiveness and a desire for "healing, reconciliation, and resolution." His reference to the 2007 Indian Residential Schools Settlement Agreement and the imminent launch of the Truth and Reconciliation Commission acts as a prelude to the stated wish that this be a "positive step in forging a new relationship between Aboriginal peoples and other Canadians." As Alfred and Turner point out, the sovereignty of Indigenous peoples differentiates them from these "other Canadians" in the multicultural mosaic. As Turner puts it, "Indigenous rights are not merely a class of rights" (15). This insistence on the sovereignty of Indigenous peoples in Canada prompts our recognition of the insufficiency of gestures of apology and reconciliation framed by Western discourse and colonial relationships.

Following this recognition, we might ask what kinds of gestures of apology and reconciliation would avoid replication of a colonial discourse that undermines Indigenous sovereignty. First, we consider whether apology is even a relevant concept in an Indigenous worldview, and how "apology" and "reconciliation" are represented in Indigenous languages. Next, we ask how an apology might account for Indigenous knowledge systems, and of what it might consist. Finally, we examine the degree to which nation-specific knowledge was incorporated into the format of the TRC, focusing specifically on the Montreal TRC event. The purpose here is not to develop a definitive model of Indigenous redress, but rather to explore the conditions of possibility for Indigenous apology in the spirit of open-ended inquiry, with curiosity, creativity, and a solid helping of courage. Similarly, while we do critique the TRC, we want to emphasize the spirit of possibility in which this is done: rather than merely pointing out flaws in the existing process of reconciliation, we see this analysis as planting seeds for the next steps in repairing relations between Indigenous and non-Indigenous people in Canada, in which specific Indigenous languages and cultures need to play a larger role.

We suggest that without appropriately acknowledging Indigenous languages, reconciliation efforts will not have the positive impact on Indigenous–settler relations that is desired on all sides. We see language as a vehicle for culture, and consider the loss of Indigenous languages as the loss of whole worlds and worldviews. Providing tangible resources and establishing favourable conditions to revitalize Indigenous languages is thus an essential part of redress, which will serve to build trust and restore relations. The recommendations in the TRC's "calls to action" confirm this view, calling among other things for the creation of an Aboriginal languages act, the appointment of an Aboriginal languages commissioner, the development of courses and programs in Aboriginal languages, and the provision of appropriate funding to enable the recommendations (recommendations 14, 15, 16).

Part of the assimilatory policy of residential schools involved severing children's connection to their mother tongue. Offering an apology in English, the language that cut the mother tongues of children in residential schools, risks replicating this victimization. While it is perhaps unrealistic to expect that the apology be provided in each of the many Indigenous languages once spoken in what is now Canada, it would have been an important gesture to include more than just a few words in a few languages. On the other hand, we also recognize that while English and French are not Indigenous languages, they are a valid and valued vehicle of expression for the majority of First Nations, Inuit, and Métis people who speak these languages. The complexities of advocating Indigenous language revitalization while acknowledging the legitimacy of English as a language for Indigenous expression is well expressed in Creek Cherokee scholar Craig Womack's statement that English is "an Indian language" (404). We look to Indigenous languages primarily for the "restorying" that takes place when concepts of apology and approaches to redress embodied in Indigenous languages are compared to those conveyed by the English language.

"Restorying" is Jeff Corntassel's way of describing the healing and destabilizing role of storytelling. His description of restorying begins with Taiaiake Alfred's re-reading of the word "Canada," which is derived from a Kanien'keha (Mohawk) term, *Kanatiens*, meaning "they sit in our village" (Corntassel, Chaw-win-is, and T'lakwadzi 2). In this example, Corntassel restories Canada as a nation of illegal squatters, empowers Indigenous languages, and uses humour to subvert the dominant narrative of Canadian sovereignty. English denotations and

connotations of such words as "apology," "forgiveness," and "reconciliation"—words used extensively throughout the discourse surrounding official apologies for state-sanctioned residential schools and the move toward redress—are similarly reframed and restoried by their Indigenous language interpretations. In order to ascertain whether the concept of apology exists in the diverse Indigenous traditions, we would need to seek suitable words or phrases in each of the many Indigenous languages spoken by First Nations, Inuit, and Métis peoples,[11] and then ask whether these terms can be translated across vast cultural divides. While this is a daunting task, movement toward a language-specific understanding of the different concepts of apology and reconciliation is by no means impossible. We take the view that Indigenous words matter, and that, as settler scholars, we have a duty to use Indigenous expressions where they are available to us—not as token examples, but to disrupt the easy flow of comprehension for settler audiences, and to resist our own participation in the history of linguistic colonization.

In her recent volume, *Stories in a New Skin: Approaches to Inuit Literature*, Keavy Martin performs this very function by insisting on Inuit expressions and repeating these throughout. Martin offers detailed linguistic analysis of many Inuit words in order to demonstrate the ambiguities and complexities of meaning making in the stories and cultures she investigates. She takes pains to offer her readers a view into the rich tapestry of Inuit languages. For example, she explains that the word *Inuit* literally means "people" or "human beings" (it is the plural of *Inuk*, meaning "person") with no notion of nationhood attached, but that it has become a marker of ethnicity, leading to the potential contradiction that those who are not Inuit are therefore not human. Martin goes on to describe further complexities to the word *Inuit* that allow the reader a glimpse into the very different worldviews embedded in the linguistic specificity (34–35). In his contribution to this volume, David Garneau engages with this debate from a different angle, suggesting that "irreconcilable spaces of Aboriginality" arise through Cree-only discussions around the kitchen table and through email exchanges, the purpose of which is not to exclude those who do not understand Cree but to "perform" Indigenous identities apart from a settler audience (27). The approaches taken by Martin and Garneau are examples of how to integrate Indigenous languages, and these approaches inform our own investigation. While we recognize the barriers to gaining full expressive competencies in Indigenous languages, we take seriously the challenge to engage with Indigenous languages, and to assert their primacy, as part of the implementation

of Indigenous methodologies. We therefore offer the following exam-
ination of terminology around reconciliation and apology in a selec-
tion of Indigenous languages to demonstrate how the words used by
Harper and the TRC might be interpreted through the specificity of
Indigenous worldviews.

If we consider the vocabulary that appears consistently in the
official documents of the Truth and Reconciliation Commission, we
find that the words "reconciliation," "acknowledgement," "recognition,"
and "apology" occur with great frequency. Looking closely at the lan-
guage used on the TRC website, we find a repetition of key words and
phrases, for example, "The truth telling and *reconciliation* process … is
a sincere indication and *acknowledgement* of the injustices and harms
experienced by Aboriginal people and the need for continued heal-
ing" ("Our Mandate"; our emphasis). How do these key words and the
concepts they embody translate into Indigenous worldviews? Simul-
taneous interpretation was a backdrop to all the TRC national events.
Headsets were available at the entrance to the main hall, and booths
at the edge of the auditorium housed the many translator-interpret-
ers. During the statement giving, one could turn the channel to any
of the languages and listen for the sounds and songs of Indigenous
tongues. At the TRC national event in Montreal, language was a visceral
part of the experience. The potent mélange of English, French, and
Indigenous languages destabilized old dichotomies of English–French,
English–Indigenous to create new frameworks. The mix of comprehen-
sion and incomprehension that one experienced as a listener to the
cacophony of languages at the event opened up "the kind of space of
not knowing that brings about new imaginings, new possibles, new
seeings" (Scott, field notes). The question remains, however, whether
translation is really ever possible. For a non-native speaker of Indig-
enous languages, a breakdown of the change in meaning that occurs
when the concept of reconciliation is translated into Nuu-chah-nulth,
Mi'kmaq, or Kanien'keha can help us understand the complexities of
this question.

As Corntassel notes, there is no word for "reconciliation" in the
language spoken by the Nuu-chah-nulth people, whose territories
stretch across approximately three hundred kilometres of the Pacific
coast of Vancouver Island:

> The Nuu-chah-nulth word *oo yoothloothl*, "looking after (or,
> looking beyond)," exemplifies a commitment to move forward
> or beyond the problem. According to Nuu-chah-nulth Elder,
> Barney Williams Jr., when communities need to deal with

challenges, the process begins with the family. *Hishimyoot-hoothl* means "to gather our family." This means the family will meet to discuss the problem and together they will strategize how best to deal with the situation. (Corntassel, Chaw-win-is, and T'lakwadzi 5)

The process involves several meetings with families before a larger gathering (*nuushitl* or *maathmaya*) of other communities is called to witness the situation and suggest possible solutions. These gatherings close with the phrase *yoots pah nah*, meaning "we will be careful as we go," to ensure that all return home safely, and *iisaak*, a wish for all to live in a respectful way.

This example demonstrates the ways in which cultural values are embedded in language, but it also reveals much about Indigenous forms of relational repair. We learn that conflicts are resolved in groups, first in families and then in larger communities; solutions are sought through participatory dialogue or exchange; the process occurs over a significant period of time; and ceremony and spiritual traditions are integrated into the renewal of relations. As Beverley Diamond notes in her contribution to this volume, "reconciliation" is also difficult to translate into Mi'kmaq, and its rendering in this language similarly evokes communal actions of conflict resolution. Two words are needed to connote "reconciliation" in Mi'kmaq: *aniapsit*, conveying the action of reconciling, and *apiksiktuak'n*, conveying the result of the action (this volume, 255). This latter word is more widely used for the process in general, as the emphasis is on the way positive action moves society forward. As in Nuu-chah-nulth, these words are implicated in peacebuilding ceremonies that are communal in nature; for instance, each new year in the Mi'kmaw community of Membertou (Cape Breton Island, Nova Scotia) begins with a ceremony in which the community gathers in a circle and individuals shake hands with one another, saying "*apiksiktadult'nk*," conveying that the new year is begun with forgiveness of the past and with a clean slate of social relationships (this volume, 255).

In light of our above discussion of Indigenous and nation-specific expressions, we now consider the English-language terms "reconciliation," "acknowledgement," "recognition," and "apology" and how they were rendered in the language of the Haudenosaunee, who hosted the Québec National Event on Kanien'kehá:ka territory. According to Wilhemina Beauvais, a speaker from the community of Oka, the closest equivalent in Kanien'keha for "reconciliation" is *taesetewato-ro'serí:io'ne*, a phrase that can be expressed as "that we may once

more be good friends." In order to better understand how this phrase creates its meanings, we need to see the various parts: *tae* indicates the future; *setewa* indicates the pronouns we, us, you all, everybody; *toro'se* is the wish to be good friends; and *rí:io'ne* establishes the continuous nature of the action (any utterance ending in *io'ne* indicates "good" or "nice") (Beauvais; Maracle). The wish to be friends is at the core of the expression, quite different from the English word "reconciliation," which, beginning as it does with the prefix "re," implies that there is something wrong that needs to be fixed.[12]

The English word "acknowledgement" has many possible extensions in Kanien'keha, for example, *kaienteré:on ne orihwí:io*, meaning "truth is recognized" and *karihwahnirá:ton tsi tó:ske se'*, meaning "proven to be true." We note that in each of these cases English uses a noun, whereas the Kanien'keha expression comes in the form of a verb phrase. Kanien'keha, like many Indigenous languages, is strongly verb based, such that meanings are integrated into verbs instead of using separate prepositions and tense words. Some linguists even challenge the very distinction between nouns and verbs in some Indigenous languages (Mithun 11). The verb-based structure of Indigenous languages in general and Kanien'keha in particular has repercussions for nouns such as "apology" and "forgiveness." The Harper apology, for example, contains the oft-quoted phrase, "The Government of Canada sincerely apologizes and asks the forgiveness of Aboriginal peoples of this country for failing them so profoundly." In Kanien'keha, "to apologize," *sewatathrewáhtha*, is equivalent to "asking to be forgiven," and "forgiveness," *aonsakonwa'nikónhrhens'se*, is expressed as "to pardon." We see that apology and forgiveness must be expressed as actions rather than as nouns, as in English. Where nouns connote a certain degree of permanence, whether material or conceptual, verbs are in motion, constantly in flux and changing over time. If we relate this to Kanien'keha, it seems that forgiveness and apology are part of an unfinished process evolving over time, rather than a one-time condition or state of being. We also note that to apologize and to forgive are much more closely related in Kanien'keha than in English, leading us to conclude that the process of repairing relations is perceived in the Haudenosaunee view as an action-based practice.

The idea of using translation as a pathway to restorying raises another important aspect of Indigenous cultures, namely that of oral narratives. Performative and participatory storytelling is an essential means of establishing communal values, creating new meanings, and transmitting ancestral knowledge. As Jo-Ann Archibald has pointed out, some oral narratives are sacred knowledge, passed down from

Elders to new Keepers, who must in turn accept responsibility for the story, for its appropriate use, and for its survival. Oral stories create meanings through extended allegory, mythology, and intersecting magical worlds, offering teachings in oblique ways that require interpretation and specific knowledge on the part of the interlocutor. Children will hear different messages in the stories than their parents will, and Elders may hear yet other embedded messages. Crucially, oral narratives are not static texts, but rather living histories; they are dynamic and vibrant conveyors of culture and modes of belonging. One possibility of paying homage to oral traditions would be to embed the gesture of regret in the form of a parable or fable, allowing for different interpretations by different groups, Indigenous and non-Indigenous, young and old, men and women, each according to his or her listening. As the focus of this volume makes clear, there is no one way to express regret or forge new relations, and as Garneau indicates, whether oral or written, words can confuse and complicate. He therefore advocates for artistic and non-verbal expressions as a way to create new meanings: "Art is not healing it itself, but it can be in relation" (this volume, 39). Whether written or oral or artistic, our point is that frameworks of redress do well to attend to Indigenous and nation-specific traditions. We will return to this idea later, with an analysis of how the Montreal TRC event framed and presented personal and life experience stories.

Having touched on some aspects of Indigenous customs and culture, including interconnections of Indigenous languages and worldviews, the role of community, dialogue, ceremony and sacred traditions, storytelling and oral traditions, and historical continuity, we turn to Taiaiake Alfred's and Doug George-Kanentiio's discussions of "rituals of condolence" as a lens through which to conceive forms of Indigenous redress. Alfred introduces rituals of condolence, an ancient and sacred custom among the Rotinohshonni, as a "metaphorical framework" for his deliberations on his people's grief and discontent resulting from historical and ongoing systems of colonial oppression: "The condolence ritual pacifies the minds and emboldens the hearts of mourners by transforming loss into strength" (*Peace, Power* 9). In *Peace, Power, and Righteousness*, Alfred laments the separation of two competing value systems in many Indigenous communities: one rooted in traditional teachings and community relations and the other imposed by the colonial legacy and state structures (25). By framing his thoughts through the ancient rituals of condolence, Alfred hopes to restore the primacy and power of traditional systems of leadership and governance.

The first part of the rituals of condolence, Alfred explains, is "On the Journey," the coming together of people in song to "express sympathy or consecrate a new relationship" (17). As a sign of respect, names, roles, and titles are recited. Part two is the "Welcome at Wood's Edge," where visitors are welcomed by the hosts in three parts, "Rejoicing in Our Survival," "Recognizing Our Pain and Sorrow," and "Recognizing Our Responsibility to Our Ancestors" (18). After these introductory rituals comes the "Requickening," with twelve phases, the first of which involves the rhetorical gesture of clearing the eyes, throat, and ears. Other elements include healing the society; addressing the source of bodily discomfort ("What's wrong?"); repairing communal space (both material and metaphorical); showing leadership and unifying the people; warning about the dangers of money or bribes ("Beware of Magic"); and "Lighting the Torch" (to respect knowledge and ensure good communication) (18–19). The next parts of the rituals of condolence are "Sacred Songs"[13] and "Keep Listening to Them," which counsels participants to keep the traditional teachings in their hearts and minds as they move forward to adapt and change. This is followed by a warning about possible dangers on the road home, whether the physical threat of enemies or the risk of forgetting the teachings (20).

Where Alfred's focus on condolence places these rituals in the realm of grief and mourning, Doug George-Kanentiio emphasizes rituals of atonement: "Atonement or the making right, the reestablishing of balance, the restoration of sanity, alleviation of grief and the resumption of life is of primary concern to those individuals, families, communities and nations, which exist within the circle of Haudenosaunee" (1). George-Kanentiio emphasizes the distinction between Western legal systems, based on retributive justice, and Haudenosaunee justice, founded on rituals of reconciliation and atonement (3). Restorative justice measures, introduced relatively recently into Western courts, are at the core of the ancient traditions of Haudenosaunee law. Offenders must make amends by offering a formal apology before a public assembly, which decides on appropriate consequences— either the return of stolen goods or service commensurate to the harm done. Victims can be involved in deciding the punishment, but all consequences must result in restoring the wrongdoer to good standing. The offender cannot be removed from society, but must be reintegrated (3).[14] Rituals of atonement are meant for the wrongdoer, but they also serve to strengthen the community, restoring mental, emotional, and spiritual clarity (*kanikenriio*) to all parties. The mottoes of "atonement without revenge" and "forgiveness without sacrifice" are central pillars of the system (George-Kanentiio 4).[15] These practices

clearly encompass a broad process of recovery, including both mourning and atonement, each of which will be important in helping us think through ways of incorporating Indigenous forms of redress into structures of apology and reconciliation.

These practices are also tightly bound up with story, as George-Kanentiio's approach to discussing them evinces. George-Kanentiio begins his discussion of these ceremonies by invoking the formation of the Haudenosaunee Confederacy in the twelfth century, when the prophet Skennerahowi ("he who makes peace") brought an end to war by forging an alliance of nation-states based on *Kaiienerekowa*, a common set of rules known as "the great laws of peace" (1).[16] An elaborate system of formal governance was developed, with *Roiiane* ("nice people") representatives chosen in a series of public forums, nominated by a *Kontiianehson* ("clan mother") with the endorsement of the clan, which follow a maternal line.[17] *Roiiane* and *Kontiianehson* serve as arbitrators and judges to resolve conflicts (3). The establishment of the Haudenosaunee Confederacy itself is wrapped up in the legend of Skennerahowi and Aiionwatha's battle against the Onondaga warlord and sorcerer Atotoha. So great was Atotoha's anger that he killed all seven of Aiionwatha's daughters. Despite his anger and sorrow, Aiionwatha saw special snail shells on the lake bottom, which he made into a string of beads. The purple and white beads represent the transition from blood to clarity, from war to peace. The beads are woven into wampum belts to form patterns with symbolic meaning (George-Kanentiio 5). The wampum belt is just one of the allegories of atonement and redress woven into the ritual ceremonies. But it illustrates the ways in which storytelling is seamlessly integrated into the materiality of symbolic instruments, sacred traditions, and artistic expression, and how all of these are inseparable from systems of governance, law, and medicine, and from sacred traditions. George-Kanentiio calls these rituals "peace thinking" and "peace acting" (9), introducing Indigenous reconciliatory modes as performative practices.

Turning now to Haudenosaunee traditions more generally, we see that establishing and maintaining good relations is an ongoing practice. This practice is often referred to in such figures of speech as "polishing the chain," "removing the brambles from the path," or "building the fire." These metaphors refer to the elimination of obstacles to good communication or friendship (Jennings 121). Literally translated from the Iroquoian roots, "the word for chain in Iroquoian language means something like arms linked together"; thus these figures of speech can be read as referring to practices of strengthening relations, connections, or links (Jennings 121, 116; see also the Grand Council of the

Haudenosaunee's *Polishing the Silver Covenant Chain*, which takes "polishing the chain" as its central metaphor for building relationships with federal and state agencies in the United States). According to Brant Castellano, many Haudenosaunee ceremonies and stories do indeed emphasize the importance of strengthening relations and continually building peace. Whereas in Western colonial societies conflict resolution is often a reaction to a breach or a wrongdoing, in Haudenosaunee cultures repair is rarely separate or different from ongoing peacemaking practices and the object is not to punish but to reintegrate the offender as quickly as possible for the overall health and well-being of the community (Brant Castellano, Personal interview). According to Kanien'keha teacher Bonnie Maracle, a wrongdoing is not seen as an offence against an individual but as an offence against the Great Law of Peace, and until this is made right, the whole of the community is in jeopardy (Personal interview). The Two-Row Wampum tells this story, not in words but in images. It tells the story of peace between the Haudenosaunee nation and settler nations, but the emphasis is not on the separation between these groups. The three rows of white beads represent the clarity of healing (George-Kanentiio 3). As such, they do not keep the nations separate but rather form bridges of peace, strength, and a good mind, values that make up the foundation of the Great Law of Peace (Maracle).

As we have attempted to show, apology is more successful if it does not stand on its own, but is rather viewed as a part of larger and ongoing measures of redress. The most visible and public effort to redress the wrongs of the Indian residential schools system in Canada is the TRC, established in 2008 and concluded in 2014. While efforts were made to integrate Indigenous traditions into TRC events, such as the Fire Ceremonies and sessions at the Québec National Event on the Two-Row Wampum and the Treaty of Montreal, there was less emphasis on nation-specific traditions, such as Haudenosaunee rituals of atonement and condolence. Nuu-chah-nulth Elder Barney Williams Jr. expressed concern that his people's traditions were missing from the structure of the TRC (qtd. in Corntassel, Chaw-win-is, and T'lakwadzi 140). Corntassel therefore advocates for the inclusion of Indigenous methodologies and experiential knowledge in processes of reconciliation, placing special emphasis on the cultural and spiritual dimension of survivors' experiences as an "alternative to the political/legal constraints of the TRC process" (2). We would go one step further, however, and suggest that these cultural and spiritual dimensions might be fruitfully integrated into legal frameworks, and that to truly incorporate Indigenous holistic worldviews, judicial and

sacred traditions[18] should be considered as simultaneous and reciprocal elements. Here, we analyze the degree to which nation-specific approaches that combined spiritual, legal, diplomatic, and peacemaking practices were honoured within the structures of the Montreal TRC national event.[19] This analysis, we hope, will point out both positive integrations and shortcomings that can be remediated in future redress movements in Canada. The TRC website and all its materials used the international language of political reconciliation to discuss relational repair between Indigenous peoples and non-Indigenous Canadians. While it is clear that great care was taken to maintain a respectful discourse, there was little mention of the role of Indigenous peacemaking traditions in developing the TRC process and its implementation. Because each of the national events took place on the territory of a specific nation, however, it was important to build the specific peacemaking practices of these nations into the events. Each national event was hosted by the nation on whose traditional territory it took place, and efforts were made to integrate Indigenous representation into each event, such as traditional ceremonies as part of the opening and closing, as well as the roles of Firekeepers and Elders. These aspects were an important part of the national events and were tied to the hosting nation, but they were nonetheless outside of official sessions. The national events had certain commonalities in structure, such as the division of sessions into categories including the commissioners' sharing panels for survivors' public statements; "Expressions of Reconciliation," where various non-Indigenous groups offered "Statements of Reconciliation" and placed symbolic gifts in the bentwood box;[20] and "It Matters to Me," an open-mic event that encouraged individuals to comment on what reconciliation meant to them. These standardized divisions might be considered part of the "syntax of contrition" of the events. On the one hand, this predictable syntax provided a stable frame for the highly emotional experiences of the TRC; on the other, it acted as a constraint that precluded the integration of nation-specific peacemaking and peacebuilding traditions. For instance, the Montreal event featured sessions on the Haudenosaunee Two-Row Wampum traditions and the Treaty of Montreal, and the opening and closing ceremonies were accompanied by aspects of traditional ceremonies, but Haudenosaunee languages and cultures seemed, at times, like symbolic add-ons to the overall structures that governed each TRC event. It was a tall order to incorporate nation-specific modes of redress without having them appear as tokenism, and so we acknowledge this as a challenge for the future.

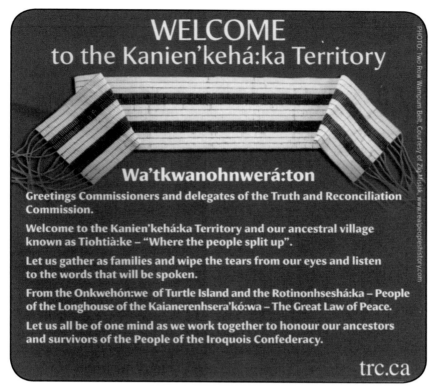

Figure 6.1: Image included in program of the Québec National Event of the Truth and Reconciliation Commission, Montreal, April 24–27, 2013.

The way that stories were shared at the Montreal event can also be examined for parallels with, and departures from, oral storytelling practices specific to the Haudenosaunee. As our earlier discussion of Haudenosaunee condolence and atonement rituals demonstrates, story-telling is intimately bound up with practices of peacemaking, both in the context of atonement and in the broader context of diplomacy. While Haudenosaunee-specific practices remained largely outside of the standardized framework of the Montreal event itself, the most prominent nation-specific image of the event—the Two-Row Wam-pum—suggested that a course of peacemaking steeped in a Haude-nosaunee tradition of storytelling, dialogic meaning making, and restorying would follow from the event. As colonial historian Francis Jennings notes, wampums have various functions in Haudenosaunee traditions, but most of them include the wampum's embodiment of

a story, record, or message (101, 104–5, 108). The picture of the Two-Row Wampum featured on the TRC Montreal event's program under the heading "Welcome to the Kanien'kehá:ka Territory" (Figure 6.1) invited the reader to draw a parallel between the record-keeping function of this treaty wampum[21] and the record-creating function of the TRC. Jennings observes that, in the Haudenosaunee view, a wampum literally contains the message or record written or embedded in it. The moment of a wampum's creation is future oriented: the wampum organizes the present and future relations of two parties, and can be later used as a mnemonic device to recall the terms of the agreement it records, or to legitimate the truth claims made by each side over those terms (105).[22] The statement of Justice Murray Sinclair (chair of the TRC) quoted later in the Québec National Event program underlines the similarly future-organizing and history-recording function of the TRC: "One of the things the TRC is attempting to do," Sinclair asserts, "is to establish a national memory about residential schools, so that in four or five generations, no one can say 'this never happened'" (5).

The story sharers who participated in the various panels at the Montreal TRC event reiterated the desire to create an intersubjective record of the commission. Some who shared their statements made explicit their desire for the audience to "make sure that the stories are passed on and kept alive" (statement from D. Larivière, Scott field notes); others implied that aspects of their statements, like poems, were being given or passed on to the audience (statements from E. Ottereyes and A. Bearskin, Scott field notes) in a way that prompted the audience to consider how these "gifts" were to be used. The drawback of the TRC's emphasis on creating an archive of cultural memory is that this focus deferred dialogue to some future moment: although audiences were encouraged to understand themselves as participants and to take action in their lives in response to statements, it was nonetheless the case that a kind of numbness could take hold and leave one to receive survivors' stories in a somewhat passive way (Scott, field notes). This is inconsistent with the oral tradition of the Haudenosaunee (as well as other Indigenous oral traditions), in which the audience actively participates in creating the meaning of the story. The audience shows approval of what has been said through affirmations such as *"hen"* or *"tho"* in Kanien'keha, or English affirmations like "uh-huh," "yeah," or "yes" to indicate that, as Tom Porter says in describing audience response to the Haudenosaunee Thanksgiving Address, "our mind is agreed" (10). In the Stó:lō tradition, Jo-Ann Archibald draws attention to the importance of collaborative meaning making

through other means, such as story repetition and talking circles to discuss individual understandings and experiences of a story (115). The audience members at the TRC event in Montreal do not participate in the story or share their experiences of its meanings, but rather "sit in silence and wait for the next speaker.... We don't know what to say or do. We are just here" (Scott, field notes). At times, sessions felt like participatory meaning-making opportunities, and at times it felt as though little meaning was made from the personal experience stories told at the TRC. Regardless, it was the responsibility of the hearers to find ways to create interventions, personal or political, that honoured the value of the stories and their tellers.

To reiterate, our concern that nation-specific practices of peace-making have not yet been fully integrated into the official discourse of reconciliation should not be read as a dismissal of the Truth and Reconciliation Commission. The commission was given a daunting task of balancing interests of very diverse Indigenous communities and cultures with those of non-Indigenous Canadians, building on international models of quasi-judicial processes of reconciliation. Our point is rather that the Truth and Reconciliation Commission is part of a larger continuum of redress, and that creative means should be sought to more deeply and thoughtfully embed nation-specific practices into future processes of repair and redress. These efforts would be supported through investments in the revitalization of Indigenous languages, for much of the knowledges embedded in the stories and songs of Indigenous cultures are conveyed via the specificity of phonemes and the sonemes of Kanien'keha and Cree and Algonquin and Inuktitut. Our brief examination of the verb-based syntax of Kanien'keha, which refuses to nominalize relational repair but insists instead on action and practice, provides one example of how integrating nation-specific traditions can benefit the understanding of all.

We emphasize that Indigenous ways of knowing, being, and doing have much to offer in terms of helping us think through larger issues of reconciliation, not just between Indigenous and non-Indigenous peoples in Canada, but for all processes of redress and conflict resolution. The TRC's "calls to action" clearly support this view with the recommendation to "develop culturally appropriate curricula" that include the history of residential schools, treaties, and Indigenous peoples' contemporary contributions to Canada (recommendations 10 and 62). Another recommendation, integrating Indigenous laws and legal traditions into Canada's constitutional and legal orders, will further support the project of redress through cultural recognition (recommendation 46).

By honouring the future-oriented recording of the past that the TRC instantiated, we are paving the way for remembering as a form of redress. The commission's archive of video-recorded testimonies, its promotional literature, and the abundance of critical, cultural, and artistic works on the TRC and its process form a metaphorical wampum that records this moment of reconciliation and the past wrongs out of which it is born. Returning to and renewing our commitment to this record will guide future and ongoing redress processes in a spirit of peacebuilding and strengthening relationships.

Notes

The authors gratefully acknowledge the generous assistance of the Haudenosaunee community of Tyendinaga on the Bay of Quinte, including Marlene Brant Castellano, a Mohawk grandmother and professor emeritus of Trent University; Tewateronhiáhkwa Wilhelmina Beauvais, a Kanien'keha speaker from the community of Oka who teaches at the Tsi Tyonnheht Onkwawenna Totáhne in Tyendinaga; and Iehnhotonkwas Bonnie Jane Maracle, a Kanien'keha speaker from the community of Tyendinaga.

1 In recent decades as minority groups in Canada and around the globe have sought acknowledgement for historical harms, the terms "reconciliation" and "redress" have become heavily saturated with meanings. In *Reconciling Canada: Critical Perspectives on the Culture of Redress*, Jennifer Henderson and Pauline Wakeham understand "reconciliation" as a "shared signifier for renewed relations" (9), whereas "'redress' seems to be frequently invoked by marginalized constituencies in search of justice for grievances, connoting something more than the nebulous conception of a national 'coming together' or 'eliminating of differences' often associated with reconciliation, and suggesting, rather, a demand for accountability, compensatory action, and concrete reparations" (9). While we speak broadly of reconciliation in this paper, we understand that reconciliation and redress are part of a larger project of repairing relations.

2 Harper's apology marks the culmination of many events, including the Royal Commission on Aboriginal Peoples, the final report of which was delivered in 1998, exposing the depths of the abuse, trauma, and intergenerational suffering caused by residential schools. The RCAP gave rise to the Aboriginal Healing Foundation, which was established to help individuals, families, and communities come to terms with the effects of the abuse. In response to class-action suits launched by individuals against the government and the churches, the Indian Residential Schools Settlement Agreement was reached in September 2007, which offered "Common Experience Payments" to survivors ($10,000 for the first year and $3000 for every year thereafter; individuals could make claims of up to $275,000 for specific sexual or physical abuse but only if they had evidence). At the time of the settlement, the government also announced

the Indian Residential Schools Truth and Reconciliation Commission, which would begin its work in 2008. In 2008, the Residential Schools Survivors of Canada wrote an open letter to Prime Minister Harper "insisting that the state provide a full and public accounting of, and take full and public responsibility for, the creation and implementation of the Indian residential schools system" (Dorrell 27). The 2008 Harper apology can be seen as the culmination of all these events.

3 Beyond simply stating that one committed the act and that it was wrong, it is important that the wrongdoer give a detailed account, exposing the full truth of what happened. This has been a particularly important factor in transitional justice proceedings, such as truth and reconciliation commissions (see Griswold).

4 Typically, the dominant emotion in apology is compassion, but Linda Radzik argues that shame and even self-hatred are appropriate emotions (94).

5 The terminology around apology is ambiguous. For example, atonement is a religious word that encompasses both apology and some form of compensation; redress and reconciliation can also be understood to include both apology and making amends (see Scott, *Forgiveness*).

6 There has been some debate about what constitutes a "performative act" or "performative utterance." J.L. Austin's original definition of performatives was restricted to those utterances which perform—or, as the title of Austin's seminal work suggests, "do"—something, as opposed to simply describing it, for example, the statement "I sentence you to death," as made by a judge in a trial, or "I give and bequeath my watch to my brother," as stated in a legal will (Austin 5). As the modifiers to these statements reveal, performative utterances must be made in appropriate conditions for them to be, in Austin's terms, "felicitous." While expressions of apology do not fit Austin's strictest definition of performatives, there are strong parallels between apology and promise, which Austin defined as a performative contingent upon further action. Apology, like the promise, requires that the speaker sincerely intend to follow his or her expression with behavioural change, and that the speaker actually do so. In this manner the apology is contingent, as is Austin's promise, on both intent to fulfill the statement, and its eventual fulfilment. All of the performative acts described by Austin are contingent upon social convention and can be contested (14–15); similarly, statements of apology are judged appropriate according to social convention, and are accepted or rejected on a case-by-case basis.

7 Marlene Brant Castellano emphasizes the significance of performance in Haudenosaunee culture. The Haudenosaunee tend not to return repeatedly to words written or spoken in the past. Rather, it is the performance that matters. Brant Castellano notes that Indigenous people present at the 2008 apology were listening keenly to the manner in which Prime Minister Harper delivered the apology (Personal interview). If they were moved, it was because of the sincerity and genuineness of emotion connoted in the performance.

8 For a good discussion of political apology, see Charles Griswold, *Forgiveness: A Philosophical Investigation*, 134–94.

9 Eva Mackey examines the specific limits, silences, and absences in the Harper apology. By limiting the scope of wrongdoing or crime, she argues, the apology reproduces colonial relational structures. She suggests that integrating a more complex understanding of the material process of land theft would enable a more responsible reconciliation process (48). We agree with Mackey's position and we also point out that apology is often mired in the conundrum that the apologizer gains rhetorical authority and potentially silences (or revictimizes) the victim (see also Scott's discussion of inappropriate apology in *A Poetics of Forgiveness* 89–112).

10 For instance, Matthew Dorrell argues that the apology is a "narrative of progress" that "confines the abuses of the residential schools system to the past while removing the contextual information needed to understand the schools system as a critical component of a larger and continuing colonial project" (28). Dorrell further critiques the language of closure and resolution, which hinders sincere reflection about Canadians' complicity in the oppression and inequalities (28). In their article, "Colonial Reckoning, National Reconciliation? Aboriginal Peoples and the Culture of Redress in Canada," Jennifer Henderson and Pauline Wakeham also point to the absence of the term "colonialism," arguing that the failure to define the "attitudes that inspired" residential schools "enables a strategic isolation and containment of residential schools as a discrete historical problem" (1). Still others point to the fact that apology without specific forms of redress will not lead to reconciliation or forgiveness. Taiaiake Alfred writes, "Without massive restitution, including land, financial transfers and other forms of assistance to compensate for past harms and continuing injustices committed against our peoples, reconciliation would permanently enshrine colonial injustices and is itself a further injustice" (qtd. in Corntassel, Chaw-win-is, and T'lakwadzi 6). Finally, Eva Mackey emphasizes the absence of references to "treaties and land and structural historical issues" as the main shortcoming (54).

11 The Task Force on Aboriginal Languages and Cultures recognizes that there are fifty-three Indigenous language groups in Canada (Galley 256).

12 David Garneau speaks to the difficulties of the word "reconciliation," suggesting instead "conciliation," "the action of bringing into harmony," as an alternative (this volume, 30). Ultimately, Garneau concludes that affective, non-verbal, and artistic articulations may have a greater potential to bring about such "peaceable or friendly unions" than linguistic ones.

13 Alfred explains that because of the sacred and secret nature of these songs, their content cannot be revealed, only the themes (20).

14 Serious crimes, such as murder, rape, and sexual abuse, are punishable by death (George-Kanentiio 3).

15 Aiionwatha, one of the disciples of Skennerahowi, became the most effective advocate for the establishment of the Confederacy (George-Kanentiio 4).

16 The alliance included Mohawk, Oneida, Onondaga, Cayuga, and Seneca, with Tuscaroras joining in 1715 when they fled North Carolina (George-Kanentiio 2).

17 There are nine clans in Iroquois society: hawk; snipe and heron (sky); bear, wolf, and deer (earth); and turtle, eel, and beaver (water). The Mohawk have only three clans, bear, wolf, and turtle: "Clans are essential to Iroquois life: Disputes, property, property disbursement, ceremonies, marriages and political stature all are rooted in clan affiliation" (George-Kanentiio 2).

18 The role of sacred traditions in Indigenous worldviews requires that we rethink our notions of spirituality. In Western systems, religion is often compartmentalized, separated off from government, law, and other social institutions. In an Indigenous framework, ritual, ceremony, and sacred traditions are fully integrated with every aspect of life. Here, Margaret Somerville's notion of the "secular sacred" is one way of understanding the role of the sacred in Indigenous traditions. For Somerville, the sacred arises from recognizing and developing shared values. The secular sacred involves understanding that these shared values permeate every aspect of our lives rather than being bracketed off as the purview of organized religion or discrete spiritual experiences: "It is probably a mistake to see the secular and the sacred as being opposites. Rather, the 'pure secular' and the 'pure sacred' are opposite poles on a continuum, and the secular sacred is comprised of various degrees of each" (67).

19 In *Canada's Indigenous Constitution*, John Borrows identifies eight distinct Indigenous legal systems (104) and highlights the importance of examining them within their "indigenous societal frameworks" (59). We see the TRC's mandate to include Indigenous practices as one that should not artificially lump together the diverse protocols and ceremonies surrounding peacebuilding into one tradition, but instead maintain their specificity, as Borrows insists.

20 For a consideration of the materiality of the TRC's bentwood or *Medicine Box*, see Elizabeth Kalbfleisch's contribution in this volume.

21 Embedded in the Two-Row Wampum pictured on the TRC Montreal event program is a record of the Two-Row Wampum Treaty, also known as the *Kaswhenta*—the agreement made between representatives of the Haudenosaunee and representatives of the Dutch government in 1613. The treaty is considered by the Haudenosaunee to be the basis of all their subsequent treaties with European and North American governments, including the Covenant Chain treaty with the British in 1677 and the Treaty of Canandaigua with the United States in 1794. The two rows signify the two distinct and sovereign nations involved in the treaty (see Jennings 116).

22 As Jennings notes, Iroquois leaders throughout the twentieth century have used wampums in this latter way, to reiterate the sovereignty of their nations to governments introducing policies that obscure this status (101).

CHAPTER 7

Acts of Defiance in Indigenous Theatre: A Conversation with Lisa C. Ravensbergen

Dylan Robinson

Dylan Robinson: Thanks for agreeing to do this interview, Lisa. I wonder if you might give readers a quick introduction to who you are, and say a little bit about what you do.

Lisa C. Ravensbergen: Well … I am a tawny mix of Ojibwe/Swampy Cree and English/Irish, from Manitoba and Ontario. I have been a visitor on unceded Coast Salish territory since 1992, and I'm raising my son here amidst mountains and ocean. I'm a multi-hyphenate theatre artist, a play-maker, actor, dramaturg, writer, director, and sometimes dancer. I supplement my interdisciplinary practice with the joys of motherhood and the challenges of self-produced works. My primary practice is rooted in the Aboriginal theatre community—this is where I return. I am also privileged to enjoy a variety of collaborations both as a creator and as a performer in a variety of communities across the country.

DR: Maybe we can start by talking about some of the work you've been involved in—that you've either acted in or created—that has an explicit relationship to residential school history. There's also the question of what Aboriginal theatre in Canada *doesn't* have some … [*pause*] implicit relationship to residential school history.

LCR: Hmm. [*pause*] One of the first pieces I co-created was a theatre/dance piece called *The Place Between*, which explored the lineage of loss through four generations of women and how spirits can haunt or heal the living. I also performed the role of June in Kevin Loring's Governor General's Award winner, *Where the Blood Mixes*, for Theatre North West in Prince George. In Kevin's play a group of residential school survivors are forced to face their past when a daughter of one of the men returns home after two decades to confront him. More recently, I performed in the second production of Drew Hayden Taylor's *God and the Indian*—a co-production between the Firehall Arts Centre in Vancouver and Native Earth Performing Arts in Toronto. And

no, I didn't play God … shocking, I know. [*laughs*] The play is about a residential school survivor who confronts the priest she believes was her abuser. Another collaborative theatre/dance piece I'm currently developing is *The World Is the World*, which is about the things we cannot bear but carry anyway; among other things, it sources geno-cide—residential schools being part of that.

DR: Then, if we want to think about the part of my question about Aboriginal theatre's implicit relationship to residential school history … you know I paused as I said that, because I was thinking, "By saying that everything is implicitly affected by residential school history, how much agency do I give that history and its reach into everything else?"

LCR: That's like saying, "Well, how much agency do you want to give colonization?" The accepted national narrative seems to believe that our collective trauma is the only thing we—Indigenous people and artists—think or care about. This perpetuates the larger myth that our worth lies only in the story that includes settlers. Ah, now that's the spirit of colonization! As much as the trauma of residential schools is indeed part of our present Indigenous reality, the colonized-narrative fails to acknowledge that we also remain indivisible from things like honour, pride, courage, agency, and self-determination.

DR: It's obviously not a one-or-the-other kind of equation.

LCR: If it is, then we're in trouble.

DR: I think sometimes people do treat it that way, though. And of course those are hard choices people make as well, to say—both sur-vivors and artists—to say, "No, I'm not going to give that narrative, that history, *any* agency."

LCR: Yes, for me, I defy its ownership on my will. I defy its objective to define for me, my sense of self. I defy it by enacting ancestral knowl-edge in my mind and heart, translated through my artistic work. For me, this kind of recalcitrance becomes performance—a performance that defies a narrative that for generations has invisibilized us. The energy of this conflict ultimately decolonizes what some might call the heart of theatre: dramatic action. When I perform or author works for the stage, I am not just *revealing* who we were or portraying ideals of who I am/we are, I am embodying where we *are* in the story. I become a bookmark in revising (his)story. Essentially, my voice silences those who've been speaking for [us for] far too long, on and off the stage.

DR: And where we're at in that story is quite different from where settler Canadian audiences are at, and where universities, school boards, and obviously our provincial and federal governments are at. And so those situations of knowing rub up against each other to produce an expectation around the kind of narratives that we should be telling. Artistic practices are influenced greatly by these expectations.

LCR: And I'm not expected to have ownership over my own story. When the federal government began implementing policies to deal with "the Indian problem," the conscious design was to silence me from telling my own story, even to myself. The purpose of our "education" in the territory known as Canada has been to retell and celebrate the hero's journey of the colonizer.

DR: Those structures of policy changed the way in which we are able to tell and even sometimes want to tell those stories.

LCR: Oh, sure! I'm expected to just interpret what has come before me. But this expectation also inspires revolution. It ignites rebellion against structures of silence. I mean, how dare I tell *my* story? How could my experiences and my knowledge possibly be as good/true/important as the knowledge we learn in school? What could an Anishinaabe artist who is a *woman* possibly speak authoritatively about? How dare I! This spirit—this tension—is part of what draws me to making new work; I'm interested in creating worlds that actively honour my intercultural existence vis-à-vis feminine and hierarchical power dynamics. I'm interested in *how* I can tell a familiar story in a new way—a way that inverts Euro-rooted narrative and performance structures.

DR: This is what I've heard Cree-Métis scholar Deanna Reder refer to as the "Indigenous logics" that structure the work, instead of Indigenous content imported into Western forms.

I'm wondering if we could talk a little bit more specifically about the projects that you named and your experiences creating them or performing in them, how that work developed and unfolded.

LCR: I can attempt to! [*laughs*]

DR: Even if you could fill in a few more of the details about some of the performances you've been involved in: *Where the Blood Mixes*, *God and the Indian*, and your own pieces, *The Place Between* and *The World Is the World*.

LCR: Well, in *God and the Indian* and *Where the Blood Mixes*, as well as in *The Place Between*, the characters weren't interested in *defining* reconciliation; their life choices were either moving toward it or away from it. Similarly, I didn't go into rehearsals or performance thinking, "Oh, I'm this woman ... these women are enacting trauma." For all the women, their choices and actions bring them into direct conflict with a society that devalues their agency in some way. They must wrestle with cultural, emotional, physical, and spiritual disconnect within themselves and with beloveds who are, or who have been, lost to them in some way or another. With *The World Is the World*, the characters are archetypal: "He" and "She." Over the course of the show, audiences realize they are dead—"stuck" spirits, technically—being guided through a kind of reconciliation process with what has happened prior to their arrival. The performers are their guides. It is structured around ritual that transforms us all into light ... theoretically an echo of pure energy and the first light we see upon birth. Um, it's still in development; we haven't figured out all the details yet. [*laughs*]

These shows are definitely fiction but they are not necessarily imaginary. The stories in Kevin's and Drew's shows are told through a spirit or a body that may be broken and yet defiant in its living. The plays are also communally sourced and, as such, feel very personal— are very personal—echoes of real people's stories—survivors and their family members—who sit in the audience.

Much like *The Place Between*, *The World Is the World* is an interdisciplinary piece utilizing dance, theatre, and myth-story. The associations are more visceral, abstract, and spiritual. The poetic aspect of both stories fascinates and challenges me, along with my collaborators, to create something I've not seen on stage before—decolonizing parameters of what "narrative" is. In both cases, the conception of the pieces was mine, but the final process and product involves a rich, detailed, collaborative research process that involves amalgamating seemingly disparate information and form ... of course, constricted by time and money. In all these instances, I think of my process as slowly chipping away, working archaeologically—to either construct or deconstruct things like image, narrative, methodology, characterization, until a world and reality emerges. I work on my feet—writing as it comes to me, in cycles, in circles, shaping the essentials of the physical performance as I go.

For me, this process mirrors elements of reconciliation: it is a work in progress; we don't really *know* what it is. Yet. There's an immediacy to defining reconciliation: it demands discovery (in the moment). And

I don't mean in that classic explorer mindset. Or maybe I will appropriate it for our purposes here. [*laughs*] What I mean is that people want to define reconciliation based on normative standards of what it has been or how we value it. It's like they need to prescribe, they need to "move on" now; they need to know what *we're* going to do, and what *they* should do, rather than giving reconciliation time to define itself or allow survivors and Aboriginal community members the time and space to lead that discovery. The shows I've mentioned all challenge the notion that mainstream society has dibs on authour(iz)ing reconciliation, and, yeah, that can be an uncomfortable paradigm shift for unconfronted privilege.

DR: Something that a few authors in the volume have discussed is the medium-specific efficacy certain art forms have in telling residential school experience and legacy. For example, theatre is particularly suited to representing story through the combination of the embodied, the visual, and the aural. I'm wondering what you think the role and efficacy of theatre is, in the "age of reconciliation" as it's been called. Or what does theatre do poorly? [*laughs*]

LCR: Hmm. [*pause*] That's a good question—

DR: Or we can come back to it.

LCR: Please, Dylan, I just woke up! [*laughs*]

DR: It's in the category of "interview questions not to ask early in the morning!"

LCR: [*pause*] What has always been is this: Canadian theatre operates in service to the Euro-Aristotelian model of performance. For me, this is where contemporary theatre fails: it lacks pliancy. The only stories it readily accommodates are those that somehow perpetuate the myth of Euro-narrative superiority. As such, any story sourced from an Indigenous experience can be categorized, at best, as an "issues play" or an "educational play." Then any shared humanity within any Aboriginal stage-story is reduced to political rhetoric, embraced only by those who either follow that "cause" and/or who want to be educated about such things. I'm thinking a bit sideways now, but I was recently asked in an interview, "Do you think that plays like *God and the Indian*— and other residential-school-focused plays—do a good job of educating society, about what 'North American Natives' went through in residential schools?" And I thought, "Wow, interesting assumption that we as Indigenous artists make plays to educate you!" [*laughs*] I don't

know anyone who says, "Shakespeare wrote his plays to educate us about being British." It's a really messed-up assumption—this *colonial* assumption—that, "Well, obviously we know everything, but we'll allow you dear Indians to teach us about the *few* things we don't know." [*laughs*]

DR: The demand to "educate" is pretty strong across the boards. It's our everyday reality.

LCR: Yeah, and if it's *not* about educating then, really, why are you even here …? [*comedy question voice*]

DR: [*laughs*] "Um, what else can you do?"

LCR: There's an assumption that we are expected to edify.

DR: Part of what I find challenging about theatre is precisely "the education" I'm given, what I perceive as overly didactic presentation and form. Where stories become merely content, merely information. I feel like the form is oriented toward, as you said, "What does this work tell us about Indians?" And the audience emerges from a show with the self-congratulatory feeling of learning so much about Indians. They've got their content.

LCR: That pat on the back just legitimizes one's existence while maintaining a cosmology about who is in service to whom. I mean, the growing audience of Indigenous theatre is still learning how to witness us, so many come with a sincere generosity of expectation, of being given to, "Okay, so I'm going to *learn* something." Of course, we have been conditioned, too—through colonization, through the residential schools and the Scoops—we have been conditioned to *placate* the ignorance of our audiences; if we don't find ways to please them, then they may turn against us and we may discover they really aren't on our side. All of which is a mirror—a projection of dysfunction and of our systemically patterned way of relating to one another. Meanwhile, Indigenous artists balance on the razor's edge *while* jumping through hoops—

DR: That sounds precarious.

LCR: If funders, theatre companies, and ticket holders don't recognize or are not happy and in alignment with the stories we're telling, then we're not going to get funded and there won't be bums in seats. Perhaps they say, we're not "Indigenous enough" or the form is too different from other "Native plays," or it's more political than educational. But, hey, let's give thousands of dollars to another Shakespeare

festival—you know, because they tell universal stories! Our universal story, on the other hand, historically illustrates how pan-Indigenous people exist to *help* non-Indigenous theatre companies and audiences.

DR: Often I feel like theatre is much too oriented toward spoon-feeding this kind of education as consuming content. And I don't need or want that kind of education, *or* the way it's presented. It feels like a lot of theatre that I see makes stories more easily consumable, or made consumable by being within forms that are recognizable. A case in point would be the Royal Winnipeg Ballet's *Going Home Star*. "Key points on residential schools!" [*laughs*] And then I think, "Well, wait a minute, what makes this important to experience in the theatre, rather than reading about it? Is this history just being put on stage because it's an opportunity to make it look beautiful, to aestheticize history?" The form silences the political efficacy and potential to unsettle what it known.

LCR: Part of reconciliation demands we value *both* sides of the story, but "Canada" is just learning how to take responsibility for listening to us. And believing what we say. So, we dumb our story down. I mean, "Canada's" story would be so much more palatable if we—my artistic colleagues and I, along with our allies—would just remain silent about residential schools and the generational impact of what has led us all to present-day notions of nationhood. It's easier to abscond responsibility if reconciliation remains an idea or philosophical construct. Putting our stories on stage enlivens very complicated ideas.

So, many people prefer not to hear or read about residential schools, never mind share physical space as an audience member with that kind of story, because it's painful. It's confusing. Broad-strokes statement here: the average "Canadian" is uncomfortable bearing witness. In fact, more than one person who didn't want to attend the shows I've mentioned told me, "It would kill me," due to whatever was happening in their own lives—Aboriginal and settler alike. They said, "I couldn't, I wouldn't have been okay, I would have been a mess by the end of it." Which I totally get.

I also hear people say, "There is so much *realism* in that story, that my soul will hurt, and I can't afford to be sobbing for three hours after the show." But people—especially those removed from ceremony and the ritual of communal gathering—seem to underestimate the tremendous power that lies in bearing witness, in being a witness. For me, this is key to reconciliation. Witnessing empowers change. Aboriginal theatre, then, in this context and within in its very nature, becomes a tool for decolonizing the performer–audience relationship. Choosing

not to engage meaningfully with one of our most important stories, even when staged, deprives us all of the potential for transformation within a collective consciousness.

DR: So this leads me to a question I have about different audiences. Because you were talking about Indigenous and settler audience members, and from my point of view, Indigenous audiences don't need and are not interested in that kind of didactic presentation about our own experiences or histories in our families because many have lived it and others have inherited it.

LCR: Totally. Indigenous audiences don't need theatre in the way it's been offered; theatre has privileged a very particular story since its inception. It's artistic "success" as a form has relied on exclusion. Some of my initial impulse in going to theatre school was in reaction to this; I wondered if it was even possible to see myself on stage. Value-affirmation for life experiences outside theatre's codified "norm" simply did not exist for me up to that point; I could list on half of one hand the productions and characters that mirrored me and the experiences of my family and community. I was tired of waiting for proof that my Indigenous reality serves more than educating the Great White Hope.

My ongoing work, then, is a way for me to say, "I'm not going to take another spoonful of that sugar. I am going to speak now, or I am going to dance now, I am going to *remember* now. I am not going to wait for your permission." My great delight is that I'm not alone in this. I don't presume to change the world with the next piece I perform, write, or create, but I *do* believe that I am someone's seventh generation and part of that, in my job as a theatre artist—not unlike the Greek, German, or the English theatre before me—is to give honour by embodying the emotional, physical, intellectual, and spiritual realities of my world. What is different is how I also venerate my community's *lived* Indigenous knowledge.

When people ask me how I prepare for roles [that are explicitly exploring residential school experiences], I respond, "How does one prepare to tell a *lived* experience?" It is its own process of reconciliation: accepting what is and has been, accepting the truth—beautiful and awful—about what has transpired, what endures, and the multi-faceted intentions which continue to perpetuate existing racist and assimilative systems. The story of residential schools is one of many sources by which we incarnate the dynamic intersection of a "Canadian" existence.

Some say we're in an "age of reconciliation" and lots of people are feeling really good about each other, but I don't think we're there yet; I'm concerned that people are confusing the word "reconciliation" with "assimilation."

DR: So this leads me to the question, What kinds of "reconciliation," or even moving away from that word completely, what "things" do we need to do right now in the theatre? Things that don't come out of that presumption of educating.

LCR: We must govern the telling of our own stories. There are still way too many stories that haven't been spoken or heard. More and more, Indigenous theatre artists are expected to lead the way—but only as long as it's recognizable to the existing power/knowledge structures and theatrical milieu. It's not until we're seen as something other than an obstacle to the hero Canada's journey—when we are not viewed as victims, or burdens to the system, or as terrorists, and as more than just survivors—that our relationship to mainstream audiences and society will transform into one where we are equally vital and aspiring in our art and humanity. Part of this process requires "Canada" to reconcile that is how they once did/do view us.

After all, we've been reconciling these things for a long time now; from the moment the first settlers arrived, First Peoples have been forced into perpetual reconciliation within ourselves and within our communities. Everyone else is just awakening to this truth; they are still groggy and lethargic from the comfort and privilege that the fiction of colonization offers. [*pause*] Like the word "reconciliation," "theatre" and especially "Native/Aboriginal/Indigenous theatre" continues to negotiate its demarcations. Early work like Tomson Highway's challenged the status quo because it began to strip Emperor Canada of its clothes. [*laughs*] Thankfully, this vital work continues today.

I like it when our stories don't explicitly answer "What should we and/or the government do?" because the onus is not on us to right wrongs that were never ours to begin with. And even when we do stage our position, some folks still get uncomfortable—especially those who want a white male antagonist about as much as they want another blockade to ruin their golf plans. [*laughs*] These are the same theatre allies who won't demonize oil and mining resources on traditional/treaty lands; they also won't buy a ticket to see a show they or their audiences "don't get," and they won't expose themselves to new kinds of stories or sounds that somehow possess a whiff of otherness

or racial authenticity. They abstain from "reconciliation theatre" and avert their eyes, just like when Stephen Harper's decapitated head passes by. [See interview with Hanuse Corlett.] They are not complicit; they just want *us* to make it easy for them ... and better *now*. End rant. [*laughs ... pause*] You know, think most people just want to feel safe. They want happy endings; they want loss to lead to noble things like justice and redemption. Some, more than others, look to the future; they don't want to dwell in the past—the past, after all, is where things went wrong. In the broadest sense, I think people want to see themselves and their stories memorialized on stage.

DR: So, what does theatre do for us?

LCR: Do? [*pause*] It reveals us. It makes us visible. All of us. When I was a much younger woman, I was told the fact that I exist is a political act. I've come to understand that it's a political act to be *seen*—to self-determine how I'm seen and what is done with that knowledge. There's something incredibly empowering about the legitimacy of my voice when I create or perform work; my voice is not just a token one. I am more than what is perceived on the surface. My defiance transcends aesthetic or artistic form—it is embodied in a living, breathing act of transformation.

Part of what I *love* about making and performing theatre is its potential to a higher calling of equality where I get to bring what *I* know of this particular story, while the audience, as witness, bring *their* knowledge, and *we* have a conversation. And when Indigenous work is on stage, that voice plays an integral part in leading the conversation. Even in classical/traditionally "white" roles, if those characters are inhabited by a brown body, that character's previously one-dimensional worldview has the potential, for possibly the first time, to be enlivened and coloured [*laughs*] by a complexity that encompasses more than just an ethno-European experience of power, time, history, land, et cetera. The work is richer for it and, I'd like to think, so are we.

DR: I'm interested in what constitutes action, when we talk about art. This is also the subtitle of the book, "taking aesthetic action." It's a way of thinking of artistic practices as not simply representational, or for contemplation and reflection, but as ways of *doing* things. For me this is tied directly to the function of Northwest Coast First Nations cultural practices, how our work—our songs, or stories and oratory, our regalia—together enacts law, it documents history, these are things that are actions. But I don't think these forms of "taking action" begin and end within our longhouses—they enter into our contemporary art

practices, our contemporary theatre, our music presented in non-sacred spaces. Do you have any thoughts in terms of theatre, or in terms of specific projects, about whether the theatre of reconciliation enacts anything?

LCR: Hmmm, well, [*pause*] theatre consciously incites action—by making audiences feel their own feelings in public, *with* a room full of strangers. It's a vulnerable experience for performer and audience alike. The wonderful thing about art—in general, but particularly in theatre for me, anyway—is the immediacy of the empathetic response. The empathetic response, "Wow, that totally lands, and I concur"—or, "I'm offended, I disagree completely, and I wanna walk out."

Even in the *feeling* of it, an audience member, as witness, is totally given an opportunity to choose—theatre has the potential to alter one's life outside the theatre: What do I do with the knowledge I now possess? What do I do with how I'm being affected intellectually, emotionally, physically … spiritually?

One's alignment or disequilibrium with the story being told on stage reveals some aspect of one's hidden self—where an inner oppressor or inner colonizer may be exposed. I sense that this moment of revelation is key to reconciliation because it insists on the manifestation of action, rooted in choice: to align with newness and change or to align with what is familiar and stick with what has always been.

And at what point do we actually engage with reconciliation if we *refuse* to engage in our collective dysfunction? And who better to address what is taboo than artists? Who else wrestles so feverishly [*laughs*] to make the invisible visible? And when it works? Wow, there's such a unique potency to theatre: it can totally dislocate somebody—transport them—to real and imagined places inside themselves. For those who know, this is the work of our medicine people … dwelling in mystery, making our very essence visible, heard … sometimes even understood. Theatre artists enable and create a kind of sacred space for people to witness themselves anew and to acknowledge those around them differently. I don't mean to sound precious, but to look at Aboriginal theatre this way, it does affirm the nature of security as a collective measure.

[*Pause*] Or, okay, another story [*laughs*]: My son was given drum teachings this summer. One of the teachings he was given was about taking the lead when singing. At nine, he's just beginning to understand that the circle—the community—is waiting for him to lead, to find his voice. In the meantime, as he learns, the circle will guide him and hold him. He's learning what it is to hear his own voice. He's

reminded that he is seen. His safety is reciprocal. He's learning how to be responsible for the space each person takes until he is ready to accept the role he'll one day fill.

Canadians don't yet understand where our stories come from; they need time to adjust to playing a supporting role. They don't trust that universality can travel from us to them. They're still learning how to see us in all our profound … heterogeneity. I mean, the way we define reconciliation—on and off stage—both frightens and bewilders them. But! There is also movement; they sense the need for change, they're beginning to hear it and see it, even if they don't yet wholly trust it.

Really, taking aesthetic action, like reconciliation and decolonization, is a verb—it creates, reacts, chooses; it enacts change. Ultimately, aesthetic action is a call to what will be and a response to what is no longer unseen; it embodies individual and societal potential. I like to think that artists who dig, wrestle with, and reveal the complexity of what is broken and thriving bring us all closer to changing the rhetoric of how we tell our national story … one word, one image, one note, one performance at a time. This ability to take creative action is so powerful; it *is* power.

Note

This interview took place on September 11, 2015, and was subsequently revised and expanded.

CHAPTER 8

"pain, pleasure, shame. Shame": Masculine Embodiment, Kinship, and Indigenous Reterritorialization

Sam McKegney

In October 2011, during a survivors' sharing circle at the Atlantic National Event of the Truth and Reconciliation Commission, a Cree woman recalled in eloquent and shattering testimony her forced separation from the younger brother for whom she had cared prior to residential school incarceration. Seeing her brother alone and despondent on the boys' side of the playground, the survivor recounted waving to him in hopes of raising his spirits, if only for a moment. A nun in the courtyard, however, spied this forbidden gesture of empathy and kinship, and immediately hauled the young boy away. To punish him for having acknowledged his sister's love, the nun dressed the boy in girls' clothes and paraded him in front of the other boys, whom she encouraged to mock and deride his caricatured effeminacy.[1] In her testimony, the survivor recalled the hatred in her brother's eyes as he was thus shamed—hatred not for his punisher, but for her, his sister, whose affection had been deemed transgressive by the surveillance systems of residential school acculturation.

What became clear to me as I witnessed the woman's testimony was that this punishment performed intricate political work designed to instruct boys to despise both girls and "girly" boys and to disavow bonds of kinship. The punishment's dramatization of gender opposition, its construction of the feminine as shameful, and its performative severing of intergender sibling relationships informed the type of masculine subjects those involved in administering residential school policies were invested in creating. Furthermore, it became clear that these punitive pedagogies of gender cannot be disentangled from the years of rape the survivor went on to describe enduring from a priest at the same institution. Nor can the gender dynamics of these impositions be extricated from the survivor's

expressed vexation that she still refers to the baby she later birthed in the residential school at age twelve as "him," even though the child was torn from her before she could discern the biological sex. These acts of psychological, spiritual, and physical trauma constitute embroiled elements of the same genocidal program, one that has sought not only to denigrate and torment Indigenous women, but also to manufacture hatred toward Indigenous women in shamed and disempowered Indigenous men.[2]

This chapter focuses on the coerced alienation of Indigenous men from their own bodies by colonial technologies such as residential schooling. I argue that the gender segregation and the derogation of the feminine and the body that occurred systematically within residential schools were not merely by-products of Euro-Christian patriarchy; they were not just collateral damage from aggressive evangelization by decidedly patriarchal religious bodies. Rather, this nexus of coercive alienations lay at the very core of the Canadian nation-building project that motivated the residential school system. The systemic manufacturing of Indigenous disavowals of the body served—and serves— the goal of colonial dispossession by troubling lived experiences of ecosystemic territoriality and effacing kinship relations that constitute lived forms of governance.[3] Following Mark Rifkin, I understand the attack on "native social formations … conducted in the name of 'civilization'" as an "organized effort" to make Eurocentric notions of gender "compulsory as a key part of breaking up indigenous landholdings, 'detribalizing' native peoples, [and] translating native territoriality and governance into the terms of … liberalism and legal geography" (5–6). This process of translation serves to delegitimize Indigenous modes of territorial persistence and thereby to enable Indigenous deterritorialization—both in the sense of forcing Indigenous peoples to "become what [they are] not" (Colebrook xxii) and of removing Indigenous peoples from particular land bases in order to speed environmental exploitation, resource extraction, and non-Indigenous settlement. I contend that each of these objectives was at play in residential school policy and practice in Canada. This chapter thus rehearses the preliminary steps of an inquiry into a crucial but heretofore unasked question in this era of supposed reconciliation in Canada: If the coordinated assaults on Indigenous bodies and on Indigenous cosmologies of gender are not just two among several interchangeable tools of colonial dispossession but are in fact integral to the Canadian colonial project, can embodied actions that self-consciously reintegrate gender comple-

mentarity be mobilized to pursue not simply "healing" but the radical reterritorialization and sovereignty that will make meaningful reconciliation possible?

The chapter proceeds by theorizing the technologies at play in residential school obfuscation of what Rifkin calls "indigenous forms of sex, gender, kinship ... and eroticism" (5) through analysis of selected literary depictions by residential school survivors that focus on gender segregation and the shaming of the body.[4] I then assess the political fallout of such impositions through a reading of Cree poet Louise Bernice Halfe's "Nitotem." I argue that Halfe's poem depicts the disintegration of a young Cree man's sense of embodied personhood through shame, a process in which his body becomes instrumentalized as a weapon capable of assaulting both women and the very principles of kinship that hold his community together. The paper concludes by considering the potential for what Maoli scholar Ty P. Kāwika Tengan calls "embodied discursive action" (17) by Indigenous men in Canada to reaffirm bonds of kinship and enact cross-gender solidarities that might encourage Indigenous reterritorialization. A model of such action is offered by the Residential School Walkers, a group of predominantly young Cree men who walked 2200 kilometres from Cochrane, Ontario, to the Atlantic TRC event in Halifax, Nova Scotia, in support of residential school survivors. The paper examines a variety of Indigenous contexts—including Gwich'in, Mi'kmaq, Inuvialuit, Maori, and Maoli—to demonstrate the widespread and systematic nature of colonial technologies of disembodiment; yet, having begun with the testimony of a Cree residential school survivor, the paper hinges on analysis of a poem by a Cree writer before culminating in discussion of the extra-literary, embodied actions of Cree men who, I argue, model what Cree scholar and poet Neal McLeod refers to as the "ideals of the *okihcitâwak* ('worthy men') from *kayâs* (long) ago" (*Gabriel's Beach* 10).[5]

Before I continue, I must explain that I choose to begin with a paraphrase of this survivor's testimony aware of the fraught ethics of witnessing. I was one of perhaps twenty witnesses encircling the intimate survivors' sharing circle in Halifax when this testimony was delivered directly across from where I was sitting. I took no notes at the time, but when I returned to my hotel room later that evening, I recorded recollections of the day: documentation, field notes, emotional debriefing. The testimony in question affected me a great deal— as it appeared visibly to affect others in the circle—and I have thought about it many times since October of 2011. It has also profoundly influenced the work on Indigenous masculinities in which I have been

engaged since then. Thus I feel it is necessary to acknowledge and honour that influence by engaging further with the words this survivor chose to share that day.

Although survivors are made aware that their "statement[s] will be audio and video recorded" and that all testimonies gathered in "Sharing Circles with the Survivor Committee" are therefore "public," such sessions are not available for streaming on the TRC website like testimonies offered before the commissioners' sharing panels. For this reason, I could not return to and transcribe the testimony in the survivor's own words. I approached the TRC media liaison to ask if a transcript of the testimony might be available and also whether the TRC has protocols through which researchers (or others) might contact specific survivors to seek permission to discuss their public testimonies in a respectful way. I was informed that there are no such protocols currently in place and that the testimony I sought is available in neither transcribed nor audio/visual format; if I wished to discuss this testimony, I thus needed to use my own words to express my memory of the survivor's statement, thereby risking misrepresenting her words and experiences or, worse, manipulating her testimony to forward the argument of this paper. As has been argued with relation to several international TRCs, the position of academic onlooker can be characterized by voyeurism, consumption, and lack of accountability—tensions amplified by my status as a settler scholar. I am aware, therefore, that the safest position ethically is to avoid discussing this testimony altogether.

However, I have been reminded in my discussions with Indigenous colleagues and friends that silence is not an apolitical stance and that ethical witnessing of trauma involves working toward the ideological and political changes that will create conditions in which reconciliation becomes possible. At the close of the TRC regional event in Victoria, Justice Murray Sinclair encouraged all of those present—Indigenous and non-Indigenous—to take their experiences of the event home to their families and communities and to share those memories in the service of change ("Closing Remarks"). Because I feel the survivor testimony in question performs important work in the service of understanding colonial impositions on Indigenous cosmologies of gender that will forward possibilities for politicized reconciliation, I include the paraphrase even as I know that doing so is ethically troublesome. As an anonymous survivor declares in *Breaking the Silence*, "My story is a gift. If I give you a gift and you accept that

gift, then you don't go and throw that gift in the waste basket. You do something with it" (Assembly of First Nations 161). This chapter is part of my effort to "do something" with this gift.

Breaking Bonds of Kinship

"It could be *anytime* in the 1920s or 1930s" (9), writes Gwich'in author Robert Arthur Alexie, announcing the representative nature of a young boy's arrival at residential school with his little sister in the 2002 novel *Porcupines and China Dolls*. The siblings are "herded into a building and separated: boys on one side, girls on the other. The young girl tries to go with her brother, but she's grabbed by a woman in a long black robe and pushed into another room. The last thing he hears is her cries followed by a slap, then silence" (10). "Sometime during his first month," Alexie continues, the young boy will "watch his sister speak the language and she will be hit, slapped or tweaked. He'll remember that moment for the rest of his life and will never forgive himself for not going to her rescue. It will haunt him" (12). The boy's feelings of powerlessness, guilt, and vicarious pain provide context for the dysfunctional gender dynamics in the novel's contemporary social terrain; they also resonate all too frequently with the testimonies of residential school survivors. Of the close to one hundred testimonies I have witnessed either in person or on the TRC's podcasts,[6] the vast majority have referenced the pain of separation from siblings, also mentioned in testimonies found in several collections: *Resistance and Renewal* (1988) by Celia Haig-Brown, *Breaking the Silence* (1994) by the Assembly of First Nations, and *Finding My Talk* (2004) edited by Agnes Grant. Former Shubenacadie Indian Residential School survivor Isabelle Knockwood argues that traditionally, among the Mi'kmaq, "[o]lder brothers and sisters were absolutely required to look after their younger siblings. When they went to the Residential School, being unable to protect their younger brothers and sisters became a source of life-long pain" (60). At the Atlantic TRC event, Keptin of the Mi'kmaq Grand Council Antle Denny elaborates, "We all come from a nation where family is the most important thing. As an older brother you're taught to look after your younger brother and your sisters, and in these schools we could not even do that. When you look at the stories that I have heard, it makes me … quiver."

In *The Circle Game*, Roland Chrisjohn and Sherri Young invoke Erving Goffman's term "permanent mortification" to theorize the lasting impact of the incapacity to protect loved ones from residential school violence. Chrisjohn and Young demonstrate how the pain of witnessing "a physical assault upon someone to whom [one] has ties" can engender enduring shame or "the *permanent mortification* of having (and being known to have) taken no action" (Goffman, qtd. in Chrisjohn and Young 93). The terminology is apt insofar as mortification is defined as both "humiliation" and "the action" of "bringing under control … one's appetites and passions" through "bodily pain or discomfort" ("Mortification"); it also evokes a sense of benumbing. Public displays of violence and humiliation were used in residential schools not only to produce a docile and obedient student population, but also, more insidiously, to damage empathy. The experience by which the young boy is "haunted" in Alexie's novel indeed begins as empathy—the vicarious torment of hearing his sister suffer. Yet shame becomes the cost of that empathy and ultimately works to condition its suppression. The initial pain at another's agony becomes contaminated by guilt and is thereby repositioned within the onlooker. Thus the burden of the perceived experience endures a forced migration from the primary victim to the onlooking loved one, who is actively discouraged from future empathetic impulses by the trauma of the experience. The pain becomes, in a way, an archive of perceived personal inadequacy that isolates and alienates, standing between—as opposed to uniting in their suffering—the siblings so tormented.[7]

Within the rigidly patriarchal ideological space of the residential school, the corrosion of kinship bonds through permanent mortification undoubtedly bears gender implications. Inuvialuit writer Anthony Apakark Thrasher's autobiographical discussion of residential school social engineering instructively documents the ways that boys were taught to hate women and to view their own bodies as sinful. Thrasher writes:

> We were told not to play with the girls because it was a sin. I found this strange because I had played with girls before I came to school. At home I used to watch after my sisters Mona and Agnes. I even learned how to mix baby Agnes's milk. I loved them. But now I wasn't supposed to touch them and thinking about girls was supposed to be dirty.…
>
> One day Sister Tebear from the girl's side of the school accused George, Charlie, Adam and me of sinning with the girls in the basement. We were all out at the playground at the time. But

Sister Tebear pointed me out with the three other boys and we were brought in before Sister Gilbert and Father L'Holgouach. We were strapped to a bed and whipped with a three-foot watch chain made of silver. Sister did the whipping and Father okayed it. My back was bleeding, but something else burned more. Shame. It was branded in my mind. After this the silver chain never left me. Even to this day you can see the scar on my back. (23)

Thrasher depicts a series of assaults upon his youthful understandings of gender, embodiment, and propriety. His role as a responsible brother is made sinful and he is "protected" from the feminine by segregation. When he is actually able to engage in embodied acts of youthful play that are gender inclusive, such actions are disciplined in a manner that insists upon the inherent sinfulness of the flesh and reinforces hierarchical binaries of male over female and spirit over body. These teachings are, in effect, etched upon Thrasher's skin in scar tissue. The body is marked by punishment as a physical reminder of the supposed filthiness of desire, a conception of desire that denies the existence of a sensual that is not always already sexual. The shame Thrasher evokes here is layered: he is shamed for the supposed sin of sexual desire, which Sister Gilbert seeks to beat out of his body, *and* for his weakness (both physically and in relation to the biopolitics of Aklavik Roman Catholic Residential School) as a young male unable to fend off the wrath of a female overseer. And as Sister Coté demonstrates dramatically, the boys are taught to perceive women as inconsequential, inferior, and grotesque: "She lined us boys up against the wall and showed us what she thought of girls—'Winnie, Wilma, Rosie, Mary, Jean, Margie, Lucy, Annabelle … this is what I think of them!' And she spat on the floor and stamped her foot on it. 'That's what I think of them!'" (23).[8]

Survivor accounts from the TRC and elsewhere indicate that Sister Coté's pedagogy of gender is far from uncommon. Knockwood, for instance, recalls the nuns at Shubenacadie providing

their own version of sex education, which was that all bodily functions were dirty—dirty actions, dirty noises, dirty thoughts, dirty mouth, dirty, dirty, dirty girls. [Sister] took one girl who had just started her first period into the cloakroom and asked her if she did dirty actions. The little girl said, "I don't know what dirty actions are Sister. Do you mean playing in the mud?" [Sister] took the girl's hand and placed it

between her legs and began moving it up and down and told her, "Now, you are doing dirty actions. Make sure you tell the priest when you go to confession." (52)

What makes Thrasher's depiction of the nuns' denigration of the feminine particularly troubling is its contextualization within a narrative that ultimately betrays some of the anti-woman views thrust upon its author as a boy. For example, later in his narrative, Thrasher glosses a sexual encounter involving six Inuit men and two female prostitutes with the comment, "These nice-looking women had less morality than the most primitive people you could ever find" (74–75). "Entirely absent from Thrasher's recollection," as I argue elsewhere, "is any self-reflexivity about the 'morality' of the men implicated in this sexual act" (*Magic Weapons* 97). Rather, Thrasher falls back upon chauvinistic teachings, like those of Sister Coté, that paint women as the source of all transgression. My point is that through the residential school's refusal to affirm familial bonds between siblings, its segregation of male students from female students, and its indoctrination of Indigenous youth with patriarchal Euro-Christian dogma, the Canadian government sought to alienate Indigenous men, like Thrasher, from nation-specific understandings of gender. In this way, the Canadian government worked to efface "traditions of residency and social formations that can be described as *kinship* [which] give shape to particular modes of governance and land tenure" (Rifkin 8). The violent inculcation of shame was the primary tool in this process of social engineering, and the conscription of Indigenous men into a Western regime of misogyny and related violence against women have been two of its most damaging and protracted effects.

The Manufacture of Gendered Violence

Halfe's inaugural collection, *Bear Bones and Feathers* (1994), explores the legacies of colonial interventions in Cree cosmologies of gender. A former student of Blue Quill's Indian Residential School in St. Paul, Alberta, Halfe includes several poems that explicitly or implicitly locate residential schooling among these interventions, paying close attention to how the stigmatization of Indigenous bodies encourages intimate violence. Poems like "Ditch Bitch" and "Valentine Dialogue" track the internalization by Indigenous women of racist fantasies

about the grotesque nature of their physicality—"My brown tits / day shame me / My brown spoon / fails me" ("Valentine Dialogue" lines 22–25)[9]—while poems like "Tribal Warfare" and "Stones" track the development in Indigenous men of anxiety and even panic about physical inadequacy:

> Men day
> hang dere balls
> all over da place
>
> scream at dem
> beg dem
> pray to dem
> g ah sh
> even
> swear at dem. ("Stones" 1–3, 11–16)

Each of these gendered corrosions of self-image works to compromise sensual intimacy and collaterally to endanger members of Indigenous communities; Halfe's poems are populated by several female figures whose corroded self-worth heightens their vulnerability to the violence that erupts out of male characters' feelings of inadequacy.

Halfe examines this dynamic most closely in the poem "Nitotem," which offers a chilling portrait of a young boy abused at residential school who returns to his home reserve, where he rapes women. The poem begins with Halfe's speaker observing the intensification of the boy's isolation through residential school violence. Sister Superior "squeezed and slapped" the boy's ears until they "swelled, scabbed and scaled" and he could no longer "hear the sister shouting / and clapping her orders at him / or the rest of the little boys" (2, 4, 5–7). The assault on his ears—which is emphasized by the alliterative connection among the action, its perpetrator, and its effects—blocks both the boy's sensory experience of the world and his social connection with the other boys. Deafened to his environment, he becomes imprisoned within his own body and unable to participate in the homosocial community of boys, a separation stressed formally by the line break between "him" and "the rest of the little boys." His exile is then consummated at the poem's close when the boy-turned-young-man walks with "shoulder slightly stooped," never looking "directly at anyone. / When spoken to he mumble[s] into his chest. / His black hair cover[s] his eyes" (30–33).

The third and fourth stanzas then provide the turn in the poem that locates a causal relationship between the shaming of the body, the derogation of the feminine, and sexual abuse in residential school, on one hand, and the eruption of misogynistic violence in Indigenous communities, on the other:

> He suffered in silence
> in the dark. A hand muffled his mouth
> while the other snaked his wiener. He had no
> other name, knew no other word. Soon it was no
> longer just the hand but the push, just a gentle
> push at first, pushing, pushing. Inside the
> blanket he sweated and felt the wings
> of pleasure, inside his chest the breath burst
> pain, pleasure, shame. Shame.
>
> * * *
>
> On the reserve he had already raped two
> women, the numbers didn't matter.
> Sister Superior was being punished. It was
> Father who said it was woman's fault
> and that he would go to hell. (16–29)

In one sense, the three symbols separating these stanzas represent a temporal shift that emphasizes the intergenerational legacies of residential school abuse, as the sexual violence endured by the young boy spills out into the community. Yet I argue there is more to it. The three symbols Halfe uses to formally fracture the poem hint at the three amputations that I am arguing were enacted at residential school to subdue empathy in the service of Indigenous deterritorialization—first, the severing of mind from body (and the concomitant derogation of the body); second, the severing of male from female (and the concomitant derogation of the feminine); and third, the severing of the individual from communal and territorial roles and responsibilities (and the concomitant derogation of kinship and the land).

The separation of mind and body in "Nitotem" appears legible through psychoanalytic and trauma theories that view the suppression of bodily experience as a dissociative response to trauma.[10] Unlike the suppression of bodily sensation as a means of escaping cognitive recognition of acute violation, however, the fissure engendered between subjectivity and embodied experience in Halfe's poem is not momentary but chronic. The opening and closing lines of the poem map

the suppression of the boy's sensory experience via assaults by Sister Superior that compromise his hearing, while the weight of shame draws his face to his chest, delimiting his capacity to see. At the same time, his embodied subjectivity is further threatened by making private moments into a public spectacle: "Here everyone looked / and laughed at your private parts. / Soon they too were no longer private" (13–15). With his private parts no longer private, the boy is coaxed to perceive his body as distinct from his personhood.

The stanzas quoted above then metamorphose this crisis from the sensory to the sensual. The boy's conflicted experiences of "pain" and "pleasure" provoke confusion within the dogmatic ideological space of the residential school. Halfe's frantic language of "pushing, pushing" and "sweat[ing]," which leads to the "wings of pleasure," propels the stanza into the experiential chaos of the "breath burst[ing] / pain, pleasure, shame. Shame." The second "Shame" here comes down like a verdict, carving the poem in two, both formally and temporally. The last of three sets of alliterative pairs, this final term—repeated—stands alone, its own sentence (in both grammatical and judicial senses). "Shame" manifests as a tool of erasure cutting the boy off from the pleasures of the body, enacting a symbolic amputation—or one might even say a symbolic beheading—that denies integrated, embodied experience through the coercive imposition of a form of Cartesian dualism. The mind is forced to treat the body as that which is other than self, creating conditions in which, as the following stanza depicts, the body can become a weapon.

Disembodiment and Hypermasculinity

The coerced disembodiment of Indigenous men is further complicated in popular cultural representations by the semiotic treatment of Indigenous males primarily as bodies. As Brendan Hokowhitu argues in the context of Maori masculinities, the synecdochic stand-in of Indigenous male body for Indigenous male-embodied agentive subject demonstrates

> the link between enlightenment rationalism and colonization, where the enlightened reason of European man, in a Cartesian sense, was allegorically opposed to the physicality of the unenlightened, the savage. The process of colonization did not mean [Indigenous men] were to reach the echelons of enlightened reason, however: rather what was imperative to

> the colony was the domestication of their physicality, the sup-
> pression of their passions, the nobilization of their inherent
> violence. (2322)

Colonization has borne many of the same tenets in North America, col-
lapsing Indigenous men with physicality while technologies of social
engineering like residential schools seek to limit embodied experi-
ence and replace it with fear of and revulsion toward the body. Hence
the absolute panic revealed in maniacal punishments of bedwetting,
erections, and vomiting documented in the historical literature on res-
idential schooling.[11] Brian Klopotek notes that "[f]or at least the last
century, hypermasculinity has been one of the foremost attributes of
the Indian world that whites have imagined" (251). Elizabeth Cromley
adds, however, that although it has been conceived as "physically cou-
rageous and bold," the "manhood of the Indian" in popular cultural
representations has remained tethered to "ruthless violence" (269). As
Daniel Heath Justice argues in a recent personal interview, Indigenous
male bodies have come to be viewed as "capable of and a source only
of violence and harm. When that's the only model you have … what
a desolation, right? When your body, the only way your maleness is
or should be rendered is through violence, through harm, through
corrupted power. It's just tragic." Justice adds that according to "the
models of hyper-masculine maleness that we get—if the male body
isn't giving harm, it's taking pleasure. It's always extractive. It's either
assaultive or extractive. One or the other, there's nothing else. And
that is such a catastrophic failure of imagination, as well as a huge
ethical breach" (McKegney, *Masculindians* 144–45).

I argue that the ideological fallout of such colonial imaginings
of Indigenous masculinity undergirds a paradox within assimilative
social engineering in Canada: on the one hand, the inherent physi-
cality and violence of those racialized and gendered as Indigenous
males has been continually reinscribed through the media, literature,
film, and art, while on the other hand, violence and shame have been
wielded systematically through residential schooling, the Indian Act,
and the legal system to discourage sensual, embodied experience. I
contend that some of the legacies of trauma coming to light in the
testimonies of residential school survivors during the TRC can be
understood, at least partially, as a consequence of treating those racial-
ized and gendered as Indigenous males *only* as bodies (without "the
advanced intellectual and moral capacity to master their masculine
passions" [Bederman 85]), then systematically manufacturing disavow-
als of the body through shame. Among the effects of such pernicious

pedagogies is the recasting of Indigenous male bodies as distinct from subjectivity and selfhood, as tools to be used and discarded. And this coerced *dis*integration—this state of disembodiment at the collision point among Cartesian dualism, imposed racial inferiority, and corporeal disgust—simultaneously works to sustain violence through the instrumentalization of the alienated body.

Indeed, the fracturing of mind and body, as depicted in Halfe's poem, is not strictly a consequence of individual experiences of abuse—although these are undoubtedly at play—nor is it merely a product of Judeo-Christian reverence for the soul over the body. Rather, it is a key weapon within the dispossessive arsenal of Canadian colonial policy, which seeks to deterritorialize Indigenous nations and corrode Indigenous sovereignties by compromising embodied connections to place and to kin. In residential school pedagogies of gender, shame is activated through the derogation of the body, coercing children's humiliation with their physical selves in order to produce docile subjects. At the same time, this shaming of the body constitutes a primary tactic for removing physical beings from ecosystemic relations with their environment. As the sensory capacity of the body is assaulted—as evidenced in the "scabbed" and "scal[ing]" ears of the title character in Halfe's poem—the potential for ongoing experiential connection to place is suppressed. Thus, it isn't just the physical removal of the child from ancestral territories and communal connections that facilitated the Canadian colonial agenda, but also the targeted attacks on the child's frameworks for interacting with the other-than-human. In much the same way that the body becomes instrumentalized as a tool of alienated agentive subject (body ≠ self), so the land becomes coercively alienated as an exploitable resource. Rather than upholding an ethos of reciprocity in which "the tribal web of kinship rights and responsibilities … link[s] the People, the land, and the cosmos together in an ongoing and dynamic system of mutually affecting relationships" ("Go Away, Water!" 151), residential school technologies of social engineering were mobilized to isolate the individual student as discrete, disembodied, and deterritorialized. If one is a disembodied soul, one can be anywhere, but if one is an embodied individual indigenous to a specific territory and tribal community, one inhabits a series of relationships to that place along with the roles and responsibilities of ecosystemic persistence. To be clear, I contend that the bodies of Indigenous youth have been deliberately targeted for violence and humiliation within (and beyond) residential schools for the primary purpose of suppressing embodied experiences of the land and of kinship. And the denial of

these embodied experiences was calculated to extinguish Indigenous modes of social formation and territoriality. To dispossess Indigenous youth of their capacity for integrated, embodied experience has been to dispossess Indigenous nations of land and sovereignty.

Both fictional and (auto)biographical depictions of residential school testify to the debilitating effects of alienation from lands and land-based practices. The title character in Maria Campbell's "Jacob" is described as "jus plain pitiful" upon his release from residential school, because "[h]e can['t] talk his own language" and "he don know how to live in da bush" (107–10). Thrasher explains: "Every time I'd go home from school I saw older boys who ... couldn't survive.... [I]n winter teenaged boys who should be able to trap and hunt had to rely on their parents.... Some also forgot how to speak Inuvialuktun" (84). In *Indian School Days*, Basil Johnston portrays the year of his release from residential school as being characterized by the struggle for "survival," recounting several abortive attempts to generate means of subsistence from selling chopped wood to hunting raccoons to skinning squirrels. In each case, his lack of territorial knowledge and his disconnection from the community ensure failure until he ultimately determines that it would simply "be better to go back to school" (178). In this way, Johnston's narrative tracks the perverse effectiveness of residential school technologies of deterritorialization. It is perhaps with similar struggles in mind that Campbell's speaker exclaims, "No matter how many stories we tell / we'll never be able to tell / what dem schools dey done to dah peoples / an dere relations" (103–6).

The title of Halfe's poem "Nitotem" is translated as "my relative, could be anyone" (128). What's interesting about this translation is that terminology pertaining to Cree-specific systems of kinship that extend beyond the "reproductive notions of transmitted biological substance" (Rifkin 9) actually devolves through the conditions depicted in the poem into a marker of anonymity. In a personal interview, Cree poet and scholar Neal McLeod explains that while in contemporary Cree, the stem *-tôtê* denotes "friend" and the *-m* ending denotes "something very dear or close to you," in classical Cree, kinship terms that include *-tôtêm* are used to formally address one's relations within the kinship network—here the prefix *ni* indicates first-person possession. Linda Goulet adds that *nitotem* carries with it a connotation of intimacy; it suggests "those to whom I am open." Whereas the identifier "my relative" should affirm interpersonal connections and clarify the individual's roles and responsibilities within a kinship structure, here the term fails completely to identify the poem's focal character: he "could be anyone." The systematic assault on Indigenous cosmologies

of gender and Indigenous kinship structures enacted through the sep-
aration of boys and girls, the shaming of the body, and the corrosion
of empathy creates conditions in which the cyclical violence depicted
in Halfe's poem can proliferate. The number of women raped "didn't
matter" because the disembodied, alienated, and wounded title char-
acter fails to recognize their humanity—he fails to recognize them
as kin. Having been robbed of the capacity for integrated spiritual,
physical, emotional, and mental experiences, he no longer perceives
himself as a participatory element of the world he inhabits; his empa-
thy is destroyed. In this way, the violent suppression of embodied
experience along with the manufacture of gender animosity fractures
and disintegrates not only the individual victim of residential school
violence, but also the community, the nation, and the expansive web
of kinship relations—largely through shame. These are the legacies
of over a century of residential schooling in Canada that need to be
addressed if meaningful reconciliation is to become possible.

Embodied Discursive Action and Radical Reterritorialization

In his presentation at the fall convocation of the University of Win-
nipeg in 2011, chair of the TRC Justice Murray Sinclair indicated that
for survivors of residential schooling, "the greatest damage from the
schools is not the damaged relationship with non-Aboriginal peo-
ple or Canadian society, or the government or the churches, but the
damage done ... to the relationships within their families." Sinclair
argued, therefore, that "[r]econciliation *within* the families of survi-
vors is the cornerstone for all other discussions about reconciliation."
To conclude, I posit that in their 2200-kilometre trek from Cochrane,
Ontario, to Halifax, Nova Scotia, the Residential School Walkers per-
formed three mutually formative reconciliatory acts that serve the
vision Sinclair describes. The first involves honouring the body as
integral to and indivisible from the agentive self. The second involves
affirming responsibilities to and roles within the family—with "family"
construed in accordance with Cree principles of kinship that extend
beyond the limits of nuclear family biology. And the third involves
(re)connecting with the land as an active principle of kinship.

Patrick Etherington Jr., a twenty-eight-year-old man from the
Moose Cree First Nation, explained to reporters during the walk that
when the generation preceding his "went to residential school, they
became hard[;] they didn't know how to love and they passed this on

to us" (qtd. in "Walkers"). He added on a personal note, "My dad and me, for a while there, the love was always there but sometimes he's never showed it" (qtd. in Narine, "Creating Awareness"). In an online testimonial posted on YouTube, Etherington Jr. elaborates:

> When they went to residential school, the survivors had to become tough. They had to become like robots ... in order to survive. And when they left the residential schools, a lot of them didn't deal with it.... So by not dealing with it, they actually passed it down to us, the younger generation.
>
> And I see it in our communities all the time.... We're still like robots almost. We don't know how to feel. We don't know how to express ourselves. I see that all the time on my reserve. It's starting to show its ugly face now too, in my home community of Moose Factory, through suicide....
>
> So that is the main reason I'm walking: the issue of suicide. We have to try to break this cycle. We have to learn to feel again. We've got to learn how to love. Because those survivors were deprived of it. They were deprived of love when they were at those schools. (qtd. in CSSSPNQL)

By identifying the marathon walk as a strategy for addressing the emotional and sensory legacies of residential school experiences, Etherington Jr. affirms the capacity of embodied actions to self-consciously reintegrate minds and bodies and to foster emotional literacy—with learning to "feel again" maintaining both sensory and affective valences. In his welcoming address from the TRC national event in Montreal, Mohawk Elder John Cree drew upon the metaphor of the journey to express the need for emotional and physical (re)integration. He stated that the longest distance a man will ever travel is the distance required to bring together his head and his heart. Cree's words are particularly resonant with the Walkers' journey, which is both literal and symbolic, involving the physical movement of wilful bodies over territory while affirming struggles within agentive subjects toward integrated personhood that honours embodied persistence and feeling.

The Walkers' movement upon the land can therefore be usefully understood as what Tengan calls an "embodied discursive practice," in which "men come to perform and know themselves and their bodies in a new way" (151). For Tengan, "bodily experience, action, and movement [play] a fundamental role in the creation of new subjectivities of culture and gender" (87). The young men of the Residential School Walkers use the "bodily experience" of agentive (as opposed

to forced) "movement" over territory to better "know themselves and their bodies"; in this way, they contest the fiction of Cartesian dualism and resist the colonial pressures of both coerced disembodiment and forced relocation. Through walking and speaking publicly, these men strive to enact, embody, and model non-dominative yet empowered subjectivities as Cree men, subjectivities that honour the capacity to "feel" and to "love" while exhibiting physical strength, stamina, and masculine solidarity.

By sharing the walk with his father, Patrick Etherington Sr., and his father's wife, Frances R. Whiskeychan, Etherington Jr. engaged in locatable actions designed to reclaim the intimacy and familial connection residential school policy functioned to suppress. However, the vision of family that the Walkers trekked to "reconcile" exceeds the biologically determinate (and patriarchal) conceptions of family imposed on Indigenous nations by the Indian Act.[12] At the Atlantic National Event of the TRC, the Etheringtons and Whiskeychan addressed Robert Hunter, James Kioke, and Samuel Koosees Jr.—the other young men from their community who accompanied them on the journey—by familial pronouns as sons and brothers, thereby evoking Cree ethics of kinship. Etherington Jr. traced the intergenerational contours of such ethics, proclaiming, "I'm doing it for the Survivors—but more for the youth. There is a big problem with suicide in my community. The youth are lost" (qtd. in "Walkers"). Reaching out to the generations preceding and following his own, Etherington Jr. signalled inclusive notions of communal solidarity. He added in Halifax, "I walked for my buddies who did it and for those that have attempted it" (qtd. in Sison, "A Walk"). Constructing their embodied actions in a narrative of communal purpose, the Walkers exercised responsibilities embedded in Cree ethics of kinship to enable Cree (and Indigenous) continuance. In this way, this group of young Cree men, whose bonds were cemented along stretches of open road between Cochrane and Halifax, served what Neal McLeod identifies as the "ideals of the *okihcitâwak* ('worthy men')" who "measured their lives by ideas of bravery, courage, and selflessness" (*Gabriel's Beach* 10, 105). The connection to Indigenous warrior societies was certainly not lost on the men themselves, who were photographed throughout their journey in T-shirts depicting images of nineteenth-century Indigenous warriors, displaying the word "Warrior" in bold letters, or bearing the Mohawk warrior flag.

The community of worthy young men forged on the journey appears to embody principles of kinship, and, as Rifkin argues, the affirmation of Indigenous "social formations that can be described

as *kinship*" simultaneously serves Indigenous modes of territoriality to which kinship roles "give shape" (8). To affirm Cree kinship is to affirm Cree relations to the land. That is why the particular form taken by the Walkers' public action is so significant. The 2200-kilometre journey is not merely symbolic. It is a testament to embodied relations with the landscape; it is an assertion of ongoing Indigenous presence, an expression of resilience, and an affirmation of belonging. In short, this journey constitutes an act of radical reterritorialization that honours and reclaims the land through embodied discursive actions that simultaneously honour and reclaim the body. And, of course, both land and body are essential elements of personhood from which residential schooling sought to alienate Indigenous youth. Ironically, the opportunities created at TRC events for the Walkers to discuss the experiences of their journey were often characterized by a peculiar stillness that masks the physicality of the endeavour. For example, in Halifax, an ad hoc session was organized to honour the Walkers at the close of the survivors' sharing circle in which the testimony that begins this paper was offered. In this windowless testimonial space, each of the Walkers was encouraged to translate his or her experiences of the monumental trek into words. Although the testimonies proved eloquent and powerful, the disjuncture between the physicality and motion of their content and the stillness of their form proved somewhat unsettling.[13] As a useful supplement to these testimonies, Samuel Koosees Jr. has since posted a video of photographs from the journey that emphasizes the solidarity among the Walkers, the beauty of the territories through which they travelled, and the joy, laughter, and feeling engendered through their embodied discursive actions.[14] Of particular interest here are photographs in which the men lampoon the touristic monuments of colonially imposed provincial borders. In one case, the four men are shown in subsequent images leaping toward then hanging from the "Welcome to New Brunswick" sign (5:07–5:16). In another, tricks of perspective are employed to portray Etherington Jr. crouched and apparently holding the miniature bodies of Samuel Koosees Jr. and James Kioke in either hand in front of the "Welcome to Nova Scotia" sign (6:17–6:28). Each of these photos is preceded immediately by images that evoke masculine strength. In the first case, the four young men are shown in a self-portrait, walking together in solidarity and purpose with the leading Walker holding a ceremonial staff. In the second case, the comic photo at the Nova Scotia border is preceded directly by images of each of the four men shooting arrows at a target. Juxtaposing images that evoke spectres of Indigenous warriorhood with images that humorously exploit per-

spectival shifts to trouble the solidity of Canadian colonial borders, Koosees Jr.'s video engages in a creative remapping that honours the strength, humour, and agency of the Residential School Walkers along their reterritorializing trek.

At the Atlantic TRC event, Etherington Jr. described long stretches of silence as the group travelled the edge of the highway. As they walked and walked, he noted that each of his companions' head was bowed to the earth. Only upon reflection did he realize that he too had his head down, much like the figure in Halfe's poem who "walk[s], shoulders slightly stooped / and never look[s] directly at anyone" (30–31). "What are we doing?" Etherington Jr. recalled asking himself before commanding his gaze upward to survey the world around him. "And it was beautiful," he concluded. Etherington Jr.'s words, it seems to me, offer a visual image that resonates with survivor testimonies documenting the debilitating imposition of shame as well as the struggle to regain senses of self-worth. Walking in solidarity with his kin and raising his eyes to honour the landscape, Etherington Jr. rehearses an embodied cultural pride that colonial history has sought to deny him. The action itself is a physical expression of selfhood and cultural integrity, and its public avowal at the TRC heightens its resistant force while extending its pedagogical shadow. The model of non-dominative Cree manhood enacted and articulated by Etherington Jr. and his companions offers both "survivors" and "the youth" a prototype for the reformation of what Tengan calls "masculinities defined through violence" (151), in a manner that refuses to disavow masculine strength, physicality, and agency. To borrow the words of Justice, "That's a warrior's act, as well, to know what's needed to be done and to do it boldly and without need of response. To fight against shame through love" (McKegney 145).

Etherington Jr. saved his final comments in the sharing circle at the Halifax event for residential school survivors—those targeted most directly by colonial technologies of dis-integration, dis-embodiment, and de-territorialization. "This is what I've done for you," he said. "This is what I've *chosen* to do for you." With the insertion of the word "chosen," Etherington Jr. affirms ongoing individual agency even as he declares himself accountable to others in an expression of kinship responsibilities. This choice, this willed performance of embodied discursive action, attests to the ultimate failure of residential school social engineering. Like the words of the anonymous survivor whose testimony began this article, Etherington Jr.'s words and actions are a gift to be honoured.[15] Etherington Jr. refuses the identity of inevitable victimry, self-defining not as a second-generation product of residential school violence, of

the denigration of the body, and of the obfuscation of gender complementarity, but as one voice among many that would call the elements of peoplehood back to balance.

Notes

I would like to acknowledge the Social Sciences and Humanities Research Council for two grants that have supported my research and travel. I would also like to thank Naomi Angel, Jonathan Dewar, Bev Diamond, Byron Dueck, David Garneau, Helen Gilbert, Elizabeth Kalbfleisch, Keavy Martin, Ashok Mathur, Peter Morin, Dylan Robinson, Jill Scott, Niigaanwewidam Sinclair, and Pauline Wakeham for generative conversations and generous insights that have informed my thinking on this project. I would like to thank my research assistants, Cara Fabre and Jennifer Hardwick, for their professionalism, insight, and effort. And I would like to thank Margery Fee for magnificent editorial suggestions. The chapter's limitations are my own.

1 See Assembly of First Nations (42) for a parallel example.
2 This system is connected to class as well as race. The same system that works to empower "pure" women like nuns and middle- and upper-class girls and women renders other women impure and sexually available to all men.
3 For the purposes of this paper, "ecosystemic territoriality" refers to an abiding relationship of reciprocal knowing with(in) a specific constellation of geographic places; such relationships are enacted and affirmed through embodied practices and rendered meaningful through the embedding of personal experiences and stories within narratives of intergenerational inhabitation. By appending the term "ecosystemic," I seek to affirm the interdependency of the human and the other-than-human in specific geographical spaces (while acknowledging human propensities to traverse ecosystems). See also Colebrook and Liffman.
4 Robert Arthur Alexie, Anthony Apakark Thrasher, and Louise Bernice Halfe are all residential school survivors.
5 The focus of this chapter is on Indigenous men specifically—with full recognition that all genders are mutually affecting and affected in a relational manner. For critical discussions of targeted colonial disruptions of Indigenous women's roles and responsibilities, see Andrea Smith's *Conquest: Sexual Violence and American Indian Genocide*, Mishuana Goeman's *Mark My Words: Native Women Mapping Our Nations*, and Kim Anderson's *A Recognition of Being: Reconstructing Native Womanhood*.
6 TRC podcasts can be found online at the National Centre for Truth and Reconciliation Archive: http://nctr.ca/map.php, as well as through the TRC national event pages at http://www.trc.ca/websites/trcinstitution/index/phpp=92.
7 While the act of suffering together has the potential to strengthen interpersonal connections—as Basil Johnston's celebration of the community

forged among the boys at St. Peter Claver's Indian Residential School in *Indian School Days* attests—the institutional will was clearly to use such technologies to alienate the individual as completely as possible from social and familial ties and re-create her or him as a discrete, autonomous (albeit racially inferior and undereducated) individual within the Canadian settler state.

8 The nuns were themselves, of course, subject to patriarchal discipline within the hierarchical power structure of the Catholic Church and the Western sex/gender system more broadly. The behaviours reported by Thrasher, Knockwood, and Alexie were complexly informed and circumscribed by a Western sex/gender system that has treated the body as both symbolically female and the source of sin. In accordance with this causal structure, the female is configured as the source of evil, and purity becomes contingent on the disavowal of the female. Thus, within the gendered theological structure in which the nuns functioned daily, the female is perceived as responsible for sin, and is hated for arousing sinful thoughts in men who have vowed to remain pure—ideological conditions that undoubtedly affect the anxious and violent actions of the nuns depicted above.

9 In a recent interview, Halfe explains that Indigenous women in Saskatchewan have "reclaimed the word 'brown spoon'"—which has been used historically to denigrate Indigenous women's sexuality—as a way of talking about and affirming the vagina. By discussing "not only the power of spoon but the community of spoon where people are nurtured from it, where we give feast to the people, they lick it, they nurture themselves with it, and they give birth from it," these women celebrate the agentive power of Indigenous women's sexuality and work toward conditions in which Indigenous women's sensual desire will be naturalized and honoured; they reposition Indigenous women as desiring subjects rather than mere objects of male sexual desire. "The healthy men," Halfe concludes, "know that what is between our legs will devour them" (McKegney, *Masculindians* 44).

10 In the Oxford *Dictionary of Psychology*, Andrew M. Colman defines "dissociation" as the "partial or total disconnection between memories of the past, awareness of identity and of immediate sensations, and control of bodily movements, often resulting from traumatic experiences, intolerable problems, or disturbed relationships." Evidence of trauma's causal role in the instigation of "disconnection" between cognitive registry and "immediate sensations" is amply supplied by a number of articles found in *The Journal of Trauma and Dissociation*. See also "Dissociation and Trauma" by Peter Fonagy and Mary Target and "The Causal Relationship between Dissociation and Trauma: A Critical Review" by T. Giesbrecht and H. Merckelbach.

11 Such coerced disavowals of the body occurred among female students as well, as evidenced by performative shaming around menses and similarly maniacal punishments of bedwetting and vomiting. See, for example, Knockwood's discussion of "sex education" for the female students at Shubenacadie quoted on pages 199–200. My effort here is

not to suggest a fundamental difference in colonial attitudes toward Indigenous female and male bodies, but rather to focus critical attention on the particular ramifications of such treatment on male-identified populations who have endured residential schooling.

12　See Bonita Lawrence's "Gender, Race, and the Regulation of Native Identity in Canada and the United States: An Overview."

13　Having witnessed the preceding survivors' sharing circle, I stayed in the room to attend the Residential School Walkers special session of the TRC in Halifax. When I say that the tension between stasis and motion proved "unsettling," I'm describing my own experience of the session along with my reflections on it after the fact.

14　At the time of printing the video can be found on YouTube at http://www.youtube.com/watch?v=PrVK1wsraow.

15　This chapter represents part of my own efforts to honour these two gifts.

CHAPTER 9

"Our Roots Go Much Deeper":
A Conversation with Armand Garnet Ruffo

Jonathan Dewar

Jonathan Dewar: When did concepts of truth and/or reconciliation first strike you—as a person, and later as an artist, scholar, thinker, activist, and member of the community? When did you think about the need to uncover things that are unknown, hidden? When did you (if ever) have a concept of the need to reconcile, within a community or across communities?

Armand Garnet Ruffo: That's a really good question. I think you'd have to go right back to the community I grew up in. Chapleau had a residential school, the St. John's school. In fact, a friend just forwarded me an email about someone saying that they should look into the kids that disappeared at the Chapleau residential school because it was quite an infamous school. But I have to say it wasn't really part of my consciousness because nobody talked about it. And frankly, I wasn't that interested. Growing up in Chapleau was all about keeping your head down and fitting in. In fact, my greatest loss and shame is that I didn't even bother to learn Anishinaabemowin from my grandmother, who spoke the language fluently. So I suppose in one way or another my artistic practice is connected to loss as much as it is to any kind of reconciliation—maybe it's about reconciling with loss.

JD: That was in the sixties and seventies?

AGR: That's right, when very few people questioned assimilation— didn't have the means. We fished right there by the ruins of the residential school, at the rapids. Eventually it was torn down, and a field was left there. When I asked my mother about the building, she said something like "don't worry about that." But I have to say I didn't really think about those things until much later when I started to write, you know, professionally. Much later.

Growing up in the sixties, you didn't hear much about Aboriginal culture, and what you did hear was usually negative, derogatory. Certainly there wasn't anything in school. At home I was fortunate enough to grow up with a lot of family stories and history, especially because Grey Owl was in a sense part of our family—he lived with my great-grandparents; my great-uncle was his canoe partner—so I grew up with tons of stories about the old times in and around Biscotasing, where we come from. And once in a while, my grandmother would tell us the odd traditional story, you know about how the birch got its stripes, or something like that. So I grew up with some stories and knew they existed, but I really didn't know very much, and it really didn't occur to me at the time to ask my grandmother about them. As I said, growing up was all about fitting in. It was only later when I got my academic legs, so to speak, that I started reading anything I could get my hands on: authors like Basil Johnston, researching collections by people like Elizabeth Clarke—whose informants, by the way, are famously "anonymous." Then when I moved to Ottawa to work for the *Native Perspective Magazine,* I became good friends with Wilfred Peltier, a great Odawa storyteller, who became a mentor, and I guess there was no turning back. I was hooked.

JD: When you were doing that sort of work, you refer to it as research. Was it intellectual in that sense? Emotional as well?

AGR: I think I was just really interested in my heritage, what's out there, what had been suppressed. And I just gobbled it up. The more I learned, the more I realized how much had been lost, and I suppose the sense of loss was overwhelming.

JD: So you began to develop this intellectual and artistic sensibility, and issues around residential schools—perhaps stemming from your journalist experience—started to come up?

AGR: It was only later on into the late eighties that people started talking about it a little more, and in the early nineties, I began to teach creative writing at the En'owkin Centre in Penticton, B.C. It was a big issue there. The En'owkin Centre was an artistic centre of both the visual arts and writing, so how could it not be an issue? A lot of the students had experienced the intergenerational impact of it. They would be writing or painting and suddenly this stuff would start coming out—the abuse. Even though they hadn't necessarily gone to a residential school themselves, the experience was part of their com-

munity. Growing up in the shadow of one of the schools, I just started putting two and two together. And I realized the impact of it on my own family!

The germination for my film *A Windigo Tale* came out of that experience. I remember one student had suffered sexual abuse in her community, and it got me thinking about the legacy of this trauma and how it's passed on from generation to generation. So that would have been about '93. It was like a seed that would later grow into the play and film.

JD: Did you actually start writing what became the script for *A Windigo Tale?*

AGR: It was still just the idea. I was editing *Grey Owl* at the time. Once I finished it, I moved on to *A Windigo Tale*, which started off as a small play with three people. I was thinking about a story about a family and what happens to them over time. I was also at that point getting more and more interested in Native spirituality. I don't mean spirituality solely in terms of the ceremonies, which I was already participating in; I'm talking about our mythic story-cycles. I was getting really interested in our oral tradition. One of the things I learned at the En'owkin Centre—which, by the way, was a really good place for me to be at that time—from people like Jeannette Armstrong, the director, and all the other people who passed through there, like Lee Maracle and Simon Ortiz, is that one of the ways to really know who we are is to know where we come from. And how do we know where we come from? Well, we have this great body of oral stories, our original literature, which writers like Thomas King and Tomson Highway were drawing on for their own work.

JD: Now, did it strike you when you saw some of those seminal works—you mentioned Jeannette Armstrong and *Slash*, and obviously Tomson Highway and *Rez Sisters* and later *Dry Lips [Oughta Move to Kapuskasing]*—that for all the hard truths in those pieces, the *silences* of residential schools were still overwhelming? Because it's not overt in those three works.

AGR: What struck me is that they were talking about the *impact* of the schools rather than talking about the schools directly. Loss of language. Loss of culture. Loss of self. And I wanted to talk about those issues as well, but I also wanted to tie them directly to the schools—as Tomson would do later in his novel [*Kiss of the Fur Queen*]—maybe because of

the residential school in Chapleau. I realized that the way to do it was to go back and look back at our traditional stories, to use the mythic to address contemporary issues. So that's why I said, okay here's a family [in *A Windigo Tale*], but how do I work in this mythic element to address both the direct impact and the intergenerational impact?

JD: Going back to *A Windigo Tale* then, because you received some of your funding in part from the Aboriginal Healing Foundation [AHF], some people might look at that fact, and then look at the film, and tie that work to the idea of healing. Some people might write about that work and say that because it was tied to the AHF, this work is *inherently* about healing. So I want to touch on that more. Do you see your movement into a desire to include that mythic element in your artistic sensibility—in your artistic practice—as healing, in a sense? For your community and your audience?

AGR: Absolutely. As Ovide Mercredi said when he was grand chief of AFN [Assembly of First Nations], you cannot suppress a people for so long and not have them hold on to their identity and want to promote it, and struggle and fight for it. And I think when you do that, it's already in a sense healing, because what you're doing is giving validity to your identity. You're saying, my identity as an Ojibwe or Cree or Haida or Métis, or whomever, has validity. To be specific, though, yes, the mandate from the AHF was to use artistic expression to examine the impact of the residential schools, and that's exactly what I set out to do. I purposely wanted the film to be "healing" in a broad sense—the way I saw it, the film should focus on solutions and not simply add to the problems. And to be honest, the focus on healing resulted in mixed reviews. The film was received with open arms by the Aboriginal community, winning a couple of best picture awards at Indigenous film festivals, but, at the same time, some mainstream film critics slammed it, saying it was too didactic, that it had too much resolution. But to me, that was the point in making it!

JD: If in your personal life—and perhaps in your artistic development, your intellectual development—you're actively *reclaiming*, why are you doing that? Is it for you? Is it for an audience?

AGR: I think it's both. Though I have to say I'm not always conscious about it. Whatever I'm working on has to do with my own learning, with my own desire to inform myself about my culture, and it's also a communal effort to share something. I mean, isn't that what artists and writers do?

JD: Okay, you haven't said the word "educate." Are you consciously avoiding saying that word? The reason I ask is that it's in the mandate of the Truth and Reconciliation Commission—it's around some of the language they use about the role that artists would play. For instance, on the consent form for artistic submissions, it says, "The TRC believes your artistic expression is very important and can help us educate people about what happened in Indian Residential Schools. We hope that you will consent to allowing the TRC to use your work of art to do this education by signing the consent below."

AGR: When I write something, I'm just trying to do the best job I can. I don't set out to educate per se, even though the didactic element might end up in there as it did with *A Windigo Tale*. Now back to what you were saying: when I got the money [from the Aboriginal Healing Foundation], I knew that their mandate was healing and education, but I already had the play before I started writing the screenplay. So I already had my template and knew that the story was a good fit for them.

JD: So early 2000.

AGR: Yeah. So the play was already there. I sent the play in with the synopsis of the movie, telling them what I wanted to do. Somebody agreed that it was a good fit. I have to add that it was still early days for the AHF, and I think they were still figuring things out, and therefore open to the kind of project that I presented them. It was risky for them because feature films are difficult to make and cost a lot of money, but to their credit they took the chance and supported me.

JD: It wasn't just a fund; it was a healing fund [announced in the Government of Canada's Minister of Indian Affairs and Northern Development, *Gathering Strength: Canada's Aboriginal Action Plan*], which was important.

AGR: Yeah, my play fit because it was talking about what they were looking for. I left the En'owkin Centre knowing I wanted to tell a story that talked about the intergenerational impact. Initially, I was hesitant: it wasn't my story, but one of the students told me that I should write it, and so I used it for inspiration, but of course I re-imagined it. And here's another thing: I went for a walk on the reserve while visiting my family, it was winter, a clear evening, and I noticed that everybody had a television and a dish. I said to myself that I need to get this story out on television so people will see it.

JD: It's like you were saying you felt you had a responsibility to this individual—and to the issue. Do you see yourself, or artists more generally, as having a responsibility? Is that a burden you would place on yourself willingly, or do you struggle with the idea that as an Aboriginal artist you have this responsibility that might be different from someone else?

AGR: Back in 2004, I travelled with a group of Native writers from Canada to Australia, where we met up with some Maori writers from New Zealand, and the host Aboriginal writers' group. And you know, there were no barriers between us. We all kind of just glommed on to each other, and we exchanged ideas, and travelled with each other across Australia. And what brought us together was the sense that we have a project that's larger than ourselves. We understood innately that we all have a job to do, and we all felt that our work was contributing to the benefit of the larger group, the larger community, whether it was Aboriginal Australian, Maori, or Native. I like to think of Jeanette Armstrong's seminal essay, "The Disempowerment of First North American Native Peoples and Empowerment Through Writing," in this context, where she talks about the responsibility of Native writers and challenges us to expose the lies and tell the truth to everyone, including our own people, about what really happened. So, yes, I believe we do have a responsibility.

JD: You certainly are making it sound like Aboriginal artists have a great responsibility. Is that something that one can put on somebody else? Or is it something that one assumes?

AGR: Well, I can only speak for myself. I certainly wouldn't presume that every Aboriginal artist feels the same way. But I certainly know a lot of Aboriginal artists who do feel that this is part and parcel of who they are, and of their work. Who said that being Native in Canada is a political act in itself? At least for those not assimilated.

JD: So the art making was political, even if the artwork itself thematically is not overtly political.

AGR: Exactly. It's getting back to that notion that you're giving a people who've been silenced a voice. So I think making any kind of statement is political, especially if you are promoting traditional culture, because capitalism is essentially contrary to traditional Aboriginal values. The way I see it we have two options: assimilate, give up our cultures, stop being an obstacle to so-called progress, and be rewarded

monetarily, or hold on to what is left, dig in, and do whatever you can to survive as a people and, of course, pay the price. So as we move into the twenty-first century, Aboriginal peoples are in a bind, because without our languages, traditional cultures, and values, we'll end up like every other Canadian. Therefore, if you express yourself traditionally, talk about spirituality, as far as I'm concerned you are making a political statement.

JD: Yeah. That's pretty heavy.

AGR: It does sound heavy, doesn't it. I'm reminded about my work on the Ojibwe painter Norval Morrisseau: Morrisseau's sense of spirituality was so profound that I think despite all his dysfunction—he suffered sexual abuse in residential school—he was able to turn his back on money because he didn't value it, and that freaked people out.[1] And I think that was his protest, his grand gesture of defiance and resistance. I should add, though, that because one's work may be political, it doesn't mean it can't be artistically innovative and interesting. Again, one only has to think of Norval Morrisseau's greatest work. It may not be overtly political, but it certainly comes out of his Ojibwe identity, and to me that's political in its own right.

JD: You've just had this experience of having had your film shown at the TRC—the national event in Halifax. Do you see these venues as definitely beneficial, but possibly also problematic or inherently limiting because of the formal nature of the setting and the need for palatability?

AGR: I think there's a place for that kind of exposure. I mean, my film is pretty explicit in some ways. It's really visceral in a sense. A girl goes to the residential school and suffers abuse, and now she's a woman and the stuff she experienced comes back to haunt her family. So it's really on the nose, and a venue like the TRC is a good forum for discussion.

JD: There's a call at the TRC for artist submissions, and I argue that that call for artist submissions is much more on the truth and testimony side. It basically says we know you have a story to tell, and if you are more comfortable telling it through your art, submit it to us. But, like I mentioned, this is followed by page after page after page of "how we will use it based on the consent that you give us." So, do you think that that kind of approach values art as *art*?

AGR: That's interesting. The TRC has a specific mandate, and I suppose they see artistic expression—in whatever genre—as mediating raw experience, and therefore providing an alternative means for people who have gone to residential schools, or have "second-hand exposure," to engage in the TRC, and hence the call. That said, in a sense it does put artistic expression in a box, doesn't it? The work submitted has to adhere to a specific theme, or purpose.

JD: I mean you can submit anything, but they've said "tell us your story."

AGR: Yeah, I guess it all depends on who's doing what. I mean a lot of artists are already dealing with this material, so then if it fits the mandate, why not? As I said earlier, much of the work by Aboriginal artists and writers is political anyway, and I should add topical, so I'm sure the call is a good fit for a lot of people.

JD: Well, my feeling, and perhaps I'm overthinking this, but there's a danger in saying oh, of course, Armand Garnet Ruffo and his film, we'll put that in the art category. But Joe Nobody, who gave us, frankly, not a great poem, we'll put that as an artifact.

AGR: Who ultimately makes these decisions? I don't know, and I have to say it's so difficult to judge what's good and what's bad, even though people do it all the time. I mean, my film won best picture at both the American Indian Film Festival and the Dreamspeakers Film Festival, but, as I said, the few reviews I read were mostly critical. Then, again, I didn't make *A Windigo Tale* for a non-Aboriginal audience. I made it specifically for the Aboriginal peoples. I mean, ultimately, the story is saying, "we need to look at our own traditions for healing." Most non-Aboriginal people just don't get it. I mean, most don't know anything about the residential school experience, let alone our traditions, so how can they? So I guess if Joe Nobody speaks to Aboriginal people honestly, Mr. Nobody's work will find an audience whether it's considered art or artifact.

JD: As an educator, and somebody who teaches Aboriginal literature, do you really find that sort of typical dynamic: that there's this schism between the Aboriginal and the non-Aboriginal audience/reader/student?

AGR: Absolutely. And that's why I think Aboriginal literature courses need knowledgeable teachers who can walk in both Aboriginal and non-Aboriginal cultures, because you are literally bridging a cultural divide.

JD: What if one of those intelligent non-Native students was to say something like "well, if it was good art, I'd get it." Like if the criticism was that it's only here because of affirmative action, or whatever we're going to call it.

AGR: I could get into discussing cultural theory here, but suffice to say that all art has a certain context, and the idea of a universal art, we know, is a fallacy. You need some kind of frame of reference. You engage with the art just as it engages with you. It's a reciprocal relationship. So just as an Aboriginal student may view Western art, and it may mean little or nothing, I can't expect a non-Aboriginal student to understand Aboriginal art. It's all about having some kind of frame of reference. This is why I love teaching Aboriginal literature—you frame it in the right way, and suddenly a light comes on in a student's head.

JD: So, do you have any misgivings around the idea of the TRC's $20 million fund for commemoration initiatives? They've said they're going to look at everything from the tried-and-true monument—if that's what someone proposes—to a community that wants to have a Sunday afternoon gathering of some sort. So it could be permanent or it could be ephemeral.

AGR: Well, again, I have no problem with it. I guess it depends on the community, it depends on what one means by commemoration. Not that we shouldn't think about it critically. I mean there was an Elder on CBC radio, asking what has all this stuff accomplished. He was saying that he went through residential school, and his people are still being locked up and thrown in jail. And we still have the lowest educational attainments in the country.

Many of our First Nations languages are on the verge of extinction and government after government has done little, if anything, about it. There's not even a repository, a library, of Indigenous languages in the country. To put up a statue, yes, it's important to commemorate what happened, and I think there's a place for that, but we can't stop there. We want to memorialize so we don't forget it, but let's also celebrate the future. Let's celebrate the things that we can do now to make things better, not only focus on what happened.

JD: I like that idea: a statue's okay, but also build the institutions.

AGR: Exactly. Our own institutions—that's what we need now! When we started this conversation, we talked about healing, and we talked about the role of the artist. Well, the role of the artist for me is to prod and poke society in whatever form that may take. So where are we as

a people in this society? Where do we stand? At the end of the twenty-first century, will we even be here? Is all this stuff currently going on just lip service? Isn't the agenda still really about assimilation into capitalism and ultimately taking control of what little land we have left, by whatever means? Before long Aboriginal politicians will be sitting in the House of Commons working for the government of Canada, and then what?

JD: Back to the activism.

AGR: Yeah, right now we are basically being legislated out of existence. That's happening now, and so healing, yes, being healthy is critical, but we better also take the next step, and soon.

JD: After the government's 2008 residential school apology, do you see any difference? And I'll say one particular thing I'm thinking about. At the very least, if we give no other credit to those parliamentarians, all of their words are in one of the most permanent records in Canada, which is what's said on the floor in the House of Commons in a session. So at least certain elements of truth were spoken by the prime minister and other leaders, the parties who spoke. Is that a positive?

AGR: Sure. It's positive, and it means a lot to many survivors, but it has to be followed up by something tangible, by concrete action! Something has to change. We had the Aboriginal Healing Foundation, and nothing came of their recommendations, and now the Truth and Reconciliation Commission is coming to the end of its mandate. What will happen to its recommendations only time will tell. Meanwhile, we're supposed to commemorate the past and feel comforted by the new Human Rights Museum. We now have more children in social care than at the height of the residential school period, and we have over a thousand missing and murdered Aboriginal women. I could go on and mention the number of Aboriginal men and women crowded into Canada's prisons, but we know the facts all too well.

JD: Yes, I feel like you've said some really important things here. You've mentioned the idea of commemorating by building institutions and those attendant things like legislation and policy if need be. If we changed our frame of reference and approached commemoration differently, do you think we could get it right? And maybe make those increments of change?

AGR: Yeah, I think so. I think as long as it doesn't just stop with commemoration, implying that there's this kind of closure, because really there's no closure. It's still going on. The system has effectively negated

our presence, because traditionally—and I'm not talking about being co-opted here, which is also a huge problem—our worldview is different from that of European society. We would never do anything like the tar sands. To have that mindset means that you believe the land is essentially a dead thing. When you have a people whose values are at odds with the fundamental structure of the society, a society built on the exploitation of people and the land, then that society can only do two things to accommodate those people: eliminate them—incarcerate them, for example—or assimilate them, pay them off. Economic development as panacea. And, as far as I can see that's what's going on.

JD: How come your art isn't much, much more overtly political, based on those things you just said?

AGR: I think my first book, *Opening in the Sky*, was very political, and there were certainly elements of it in *At Geronimo's Grave*. That said, I do believe in the goodness of people. I think generally, people are decent. They want the best for their children. They want clean water and clean air. What I'm talking about is structural. When I work, I'm writing for that ideal reader. I'm not trying to alienate anyone. Maybe that comes with age. Also, I think right now, in my own life, where I am, I'm much more interested in the mythic, the spiritual. I think just to focus on colonialism is, like Thomas King said, to cut yourself off at the knees. Our roots go much deeper, and these days, that's what I'm interested in.

JD: Okay, which is inherently political in itself, as we were saying. So the last question I have is, if someone were to create a space for artists—let's call it a collective or collaborative effort—to come together and poke and prod at this notion of reconciliation, what advice would you give? Or what would you want to see—if you were one of the artists implicated in such an activity—as one of the people organizing it, or one of the people invited to exhibit, or show, or exchange?

AGR: Well, like I said, for me it's important also to show our potential. We need the vision of where we can be, before we can get there. I think right now, we know the present, we know the near past, in terms of residential school, and we're learning about our distant past, but we still don't know our future—where we can go. I'm concerned about our children seven generations from now. Will our beautiful cultures and languages survive another hundred years? I'd like to see a vision of us with our cultures intact, playing an active and positive role in Canada. So, yeah, that's the kind of artistic call I'd like to see. How do artists envision a positive future for us on this land? I think right

now we need that vision more than ever. Louis Riel knew this when he said that his people would sleep for a hundred years and when they awoke, the artists would give them their spirit back. Let's look forward to another hundred years.

Notes

This chapter is based on a conversation recorded on October 31, 2011, at Armand Garnet Ruffo's home in Ottawa.

1 See Ruffo's 2014 creative biography *Norval Morrisseau: Man Changing into Thunderbird* and his 2015 *The Thunderbird Poems*.

CHAPTER 10

"This Is the Beginning of a Major Healing Movement": A Conversation with Georgina Lightning

Keavy Martin

Keavy Martin: I was hoping that we could begin by hearing a bit about you—where you're from and how you came to be a filmmaker.

Georgina Lightning: Sure. Well, I'm born and raised in Edmonton. My family's from up north, in the Sawridge area. I was born and raised here, went to school here, and then moved to Los Angeles in 1990 to continue my studies because I wanted to become an actor. I took every kind of acting class I could from every well-respected coach, and I became a coach myself.

I raised my children in the film industry as they were always at plays and in theatre with me. Pretty soon, I got hired by production companies to coach their actors, so I was always on the set, watching the rehearsal process, working with the actors, and watching the director. That was my film school: it was being on a set, and it was amazing.

And so, there was one point when I was working with John Fusco on *Dreamkeeper* in Calgary. We were on a flatbed, going over some bumpy hills to go to the buffalo shoot—1400 buffalo, with a bunch of actors and extras—and John said, "Georgie, why don't you direct?" "No, no, no, I can't do that—I have too much to learn. Maybe one day when I grow up." But he said, "No, you work with actors already, and that's the biggest part of directing. The rest is just technical. If you can take a script and you can work it—and you can work with actors—you can direct. You hire professionals; you get the best of the best around you and let them do their job, and you just do yours."

Well, my head is a garden, and it planted a seed, which grew whether I wanted it to or not. Pretty soon, it just manifested into the opportunity, and here I am.

KM: And when did you decide to start *Older Than America*?

GL: That was born out of a project we produced called *Sawtooth*. We needed a really scary environment for these people in the woods to end up at; it had to be really haunted. And I said, "Just use a boarding school. That would be the scariest place ever." And my co-workers were like, "Huh?" "You know—a boarding school, a residential school." They didn't get what I was talking about, and it never really panned out.

But it stayed with me, that idea. One day I was just sitting there, thinking *I need to take that subject, because it won't let me go*. It seemed to marry with everything that was going on at the time with racism, with missing and murdered women—everything. I knew I needed to build a story around that. So once I married that idea and committed to it, it transpired into a film.

KM: And how was it received?

GL: It's all over the world now; it's in different languages; it had a life that I wasn't expecting. It took my whole world into a totally different place that I was not prepared for, but it ended up being very exciting. I just had to surrender to it, you know? It had its world premier at South by Southwest, and it was one of the top eight films in the competition. From there, it just took off. It won the White House EPIC Award, and that created a whole new world because it garnered a different type of attention and notoriety.

So a tour was planned to Ivy League schools and conferences and places that I wasn't used to. There, we weren't getting your film festival questions anymore. It was completely different; I had to be accountable and responsible for answering them. It took me on a whole different journey of discovery, because it wasn't my goal to be the spokesperson on residential schools.

What it taught me was that people don't know anything about that history, really. Even our own people—First Nations people—don't know the truth of what really happened. A lot of them. A lot of them are products of residential school, but because of the silence, they don't really know what happened to their parents or their grandparents. So when we were having the screenings, a lot of times, young people would be crying and saying, "You know, I haven't talked to my mom in months, and I'm going to call her and I'm going to tell her I love her and now I understand why she never …" or "I understand why my grandmother never said 'I love you.'" You know, all that coldness—the disconnect and the fragmentation that happened because of residential school. I was blown away by that.

But when we went into the Ivy League schools, that was where I was shocked, because these people are putting up their hands and asking, "So, did that just happen in Minnesota?" (because we shot it in Fond du Lac). I'd say, "No! Oh my goodness! Who are the educators here?" And they're all so proud and putting their hands up. "Shame on you guys! You are shaping the future leaders of this country; this is an Ivy League school"—and they don't even know the true history. I mean, residential school was all over North America. There's a whole political agenda attached to it, and that they don't know this is unreal. They're going to be dealing with treaty issues and land issues and resource issues.

And then the healing aspect as well: at some of the screenings where it was predominantly non-Native audiences, you'd get so much emotion from non-Natives saying, "I had no idea." And there was guilt attached to that, because they had bought into the negative stereotypes, and they felt bad about it. And they're apologizing left and right. But I'd say, "I'm not looking for apologies; we're just looking for reconciliation. We want to form an understanding and educate people, and find ways that we can build the bridge and fill in the gaps so that we can all unite." Because both sides need healing: the people who were involved who have bloody hands and want to get rid of that, and then the people who are products of it, you know? A lot of healing needs to happen.

KM: Yes, there's a lot of work to be done. And for you take on this role as an educator—it must be a lot.

GL: Yes, there's so much to cover, and there's so many different ways of delivering the story. How's it going to be the most effective?

For the new project—the trilogy—I narrowed it down to target our audience of delivery: ages fourteen to twenty-four, for the first one. It's called *Fantasies of Flying* and it deals with trauma-induced depression and suicide. Some people think that the high rate of suicide is with our older generation—with the people who are retired and alone. That used to be the truth, but it's no longer. Now it's our children that are dying of suicide, and at very young ages. Nine years old, you know? I didn't even know what that was when I was nine. I had no idea what suicide was; I had no clue. I think the fact that it's an option with our youth now is a crime—that, and that there's not more being done. So I just really think that we need to shine a light on that. And then come up with different healing modalities to try to prevent suicide. How do we engage with our youth so that is no longer an option?

The second film is called *Path to Freedom*. It sounds corny, but the truth will set you free—free from depression and genocide and ignorance. Knowledge is power, and all those other clichés. It's demystifying the myths out there—the stereotypes everybody believes. Let's take those and reveal the truth. Let's get rid of that stuff, you know? Because the hatred is born out of that; the racism is born out of ignorance.

So in order to relieve some of the racism, we need to educate. The delivery is going to be from the children, because I learned hatred when I was six years old. I learned what racism was when I was six. So we might as well teach our adults and six-, seven-, and eight-year-old children. It's a different approach, but I'm really excited about it; I think it will be most effective.

KM: So is it also a documentary?

GL: Yes. It is a documentary. We're going to use a lot of stock footage as well, though, and it'll be young kids dressed in period costume from Scotland, Ireland, wherever. There'll be different people that came over into this country, and they'll explain why their families or ancestors came here in the first place and about the system of racism that was built.

KM: And the third film?

GL: The third one's called *Grandmother's Medicine*. And that is connected to the missing and murdered women. The fact that we have over two thousand missing and murdered women and no investigation and no inquiry from our prime minister, it doesn't make any sense to me. If there was even a quarter of that many people missing from, say, Ottawa, there would be a national alert. But it's Native women, so "who cares?" I don't understand that. Before, women used to be considered sacred. Next to the Creator, we give life. But now, we're considered whores. There's no value to us. When we go missing, there's no investigation. And that doesn't make any sense; we have to figure that out. How are women being treated all over the world, and where did we get that attitude from?

Even amongst our men now, the church's attitude of "women are beneath" has infiltrated all of our reservations, too. So it's about empowering women, giving women their voice back, giving them their power back. And the truth, too, because these kids don't know that the pipe came from the women. Where did the sweat come from? Where did all these ceremonies come from? Women. You know? So we need the truth told—from our Elders, too.

KM: And so is it mainly local communities that you're going to be talking to? Or is it folks from all over the place?

GL: Well, first of all, the global view—women all over the world—and then let's take a look at our own backyard. I come from domestic violence where my dad was violent to my mother. And then my ex-husband was violent. I was raised to think that was normal, that it was acceptable. But it's not, you know? I learned; eventually, I figured it out. And I went on a healing journey. I learned that I have a right to be treated with respect, but that wasn't something I was taught. So I think if we can teach our young girls that, maybe we can prevent some of that stuff.

KM: These are going to be such important films. Now, *Older Than America* was screened at the first TRC national event in Winnipeg. Did you get to be there to see how it was received?

GL: Yes. The TRC was … it was an emotional screening for me. I'd been imagining what it might be like, and it way exceeded any kind of imagination I had. When I showed up there, they had booked the museum, and [Cathy Busby's] *We Are Sorry* was installed on the walls—the words, the letters were so big; the apology was giant. I stood there and felt like a little tiny nothing, like an ant compared to this giant apology.

And then we go into this theatre, and people were there with a certain energy, right? Because it was the first national event after the apology that Harper gave. The potential was limitless. So first of all the screening happened, and then we go over to the Scotia Bank Theatre for this big drum circle. People were expressing themselves in so many different art forms, with music and with pictures and with paintings and singing and dancing and vocal storytelling. It was just overwhelming, and I was so excited. I felt like this is the beginning of a major healing movement that's going to happen all over. I mean, there were people from all over the place; they came from all over the country. This was the beginning of something big, and I was so honoured and humbled.

But then cut to: I'm back in Los Angeles and then I have a personal experience that happened…. Basically, childhood stuff came up to haunt me thirty years later. My last major trauma was when I was eighteen years old, so thirty years later, in January 2012, I have a crash. And what happens is all of these memories I had blocked—very well, apparently—were flooding me. All of these crazy, awful, violent memories. And so, I was looking for answers.

Those memories were awful and I found out that they were stored all over my body; I was having different kinds of pains all over the place. That trauma stored in your body. So, that's when I decided I need to go on a healing journey. I need to do something about this, and I need to go back to where my trauma lives, which is at the city of Edmonton. Because this is where everything happened. My childhood was here. So I thought, "Okay, I'm going to go to Edmonton. Harper gave that apology in 2008; they started this Truth and Reconciliation movement all over. I bet you the whole entire country is about healing—a whole movement. I'm going to plug myself into this and just heal."

I came here, and I was really heartbroken; there was no healing movement. Maybe there's little tiny pockets here and there. But this city has the second-largest population of Aboriginal people: around 62,000, Lewis Cardinal tells me. So I'm thinking, "That many Natives, and Alberta's the wealthiest province.... I don't get it! I don't get why there isn't major healing going on everywhere." If anything, it's worse than it was before I left, because the budgets on everything—especially health and wellness—are decreased like crazy. It just doesn't make any sense to me. The budgets are going down and all the epidemics are increased wildly now. Everything from incarceration, addiction, domestic violence, kids in care, you name it. Not only that, but the city of Edmonton itself as a whole is higher in stats on all these epidemics. This should be a place where every area of the system is completely overhauled. But it's not. We've got to shake some stuff up here.

KM: It really seems like you had a calling to come home. It's been tough, but from what I know of you so far, you are somebody who shakes things up. I've seen you shake up crowds of people; when you speak, people listen. So when we talk about a healing movement, I'm wondering what that looks like. What are the factors that are involved, and what's missing here in Edmonton?

GL: To me, true healing has to deal with the spirit, because suicide, depression, addiction—all of that comes from broken spirit. So, where I'm going with the whole healing journey in my film is to really establish the medicine wheel, in the deepest regard.

The physical element would be what would I eat, how I work out, how I treat my body, the environment I put myself in—everything. So, I'm going to replace my diet with the Indigenous diet and the superfoods diet. It's the best from the Indigenous countries from all over the world: the traditional foods, like fish, and wild game, and berries and

roots. The Indigenous diet. We're not going to have any sugars at all; no flour—nothing that gives us diseases. And no spices—things that distract your brainwaves. I'm going to do this thing for six months.

To me, if you're truly doing healing, you have to look at every single aspect; you have to look at your body, your mind, your heart, and your spirit. Simultaneously, you have to work on everything to truly heal from trauma, and I'm talking serious trauma—I'm sure my story's the same as most Native Americans across this country. So, if I can heal myself and transform my brainwaves and my programming, I know anyone can. Because it's the same story everywhere. So I'm going to truly discipline myself, and it's about getting all the support systems in place—people to support these spiritual journeys. So the pipe, you know, we really need that. We need the sweat lodge and the different ceremonies.

And then I want to look at the Western way that things are being done and turn it on its butt, basically. Because I've tried them all. In L.A., everybody has a therapist. You talk about it at dinner parties: "Oh, so who are you seeing now?" And everybody's trying to, you know, enlighten. It's kind of the chic thing to do—to go and get spiritual masters and stuff. But, I'm noticing that here, it's not. The word "therapist" is still associated with a stigma that has to do with crazy people, like at the hospital. Or when people go get a therapist because it's mandatory from court. That stigma is a huge challenge here.

And so many people can't afford to pay for therapy! If you're a single mom and you've got three kids, you can't afford anything extra. You can't afford health and well-being then. I called Indian Affairs about non-insured benefits, and I said, "Okay, what do I do if I want to get a therapist? I want to get a therapist and I want to do some really serious trauma work." "Well," they said, "you go find a therapist and then we'll approve up to maybe fourteen visits." Fourteen visits? And I said, "Wow! Tell me what therapy works in fourteen sessions, because that's huge! I want to tap into that!" But, of course, she got mad at me, and sloughed me off the phone quickly. But I was just shocked that after this prime minister's apology and the TRC that they're only going to allow fourteen visits—even *knowing* about the trauma now, because the residential school statements are out in the open. We're products of that kind of violence, and they're going to give fourteen sessions.

What does that mean? It's enough time for me to go talk a couple times to somebody; they can write me a prescription; they've got a couple weeks to test it on me, and if I need an adjustment they can

change my prescription, then I'm on my merry way. It doesn't make any sense. That's not dealing with the trauma; that's "drug-slugging" me. And then you end up like me, thirty years later, in Los Angeles, crashing, with these crazy memories that you've blocked years ago because you didn't deal with it. So then we've got the highest rate of suicide; we've got eight people dying in Hobbema last year. A twenty-five-year-old beautiful young girl who just did two years of college, and she had her whole life ahead of her, hung herself. A couple of weeks later, her twenty-eight-year-old friend hangs herself.

And even on our own rez, you say, "What's going on here? What's happening? What are we doing for suicide?" And they say, "Well, we have a department over in Ermineskin," so you go to Ermineskin and you say, "What are you doing for suicide? What's going on here? What programs are happening?" And they say, "Well, we actually have a suicide prevention program, but the budget is $60,000 a year." What? That's not even one person's salary, and that's for everything. And this is an area where the rate of suicide is off the charts. That doesn't make any sense to me. So there's so many different aspects. The film wasn't going to be that complex at first, but then it just got bigger, and bigger, and bigger because you realize what's missing.

Then you have to start researching: how do you heal from trauma? I started studying post-traumatic stress disorder. How did different countries deal with their trans-generational trauma? I've talked to someone in London, and they've had suicide for centuries; we've had it for decades. So I asked, "How are you guys dealing with suicide?" And they say, "Georgie, we're looking at you guys for answers. We've only been really dealing with suicide prevention for a few years, and it's based on a program that was designed in Calgary."

But there's Wales, and Scotland, and their number one cause of death amongst youth is suicide. It's third here, but there, it's first. It's a global epidemic. A million people die every year. In the U.S., every nineteen seconds, someone's dying of suicide. It's like having 9/11 every single day. That's how big it is.

KM: Why do you think film is so effective as a medium through which to address this?

GL: You can reach numbers. The numbers are limitless, and you can reach people all over the world. When I'm at conferences on, say, stopping the violence against women, there's maybe two hundred people there. And maybe half of them will get the message. The other half are there because they get paid to be there, and they're kind of in and out

and they're talking to friends and stuff. So maybe half of those people will actually get a message, and maybe half of *those* people will actually do something about it. Whereas if we make a film, and if it gets heavy rotation on a broadcast—with a good broadcast licence—and it gets a DVD distribution, and you can put it on YouTube, you can do anything. You can reach people all over the world. Idle No More is proof of how the Internet—how media—works. It's the most powerful tool in the world, and I'm just so addicted to that. That's the power that I'm drawn to and attracted to.

KM: You have been heavily involved with Idle No More, and I'm wondering if you see that as connected to this work that you're doing with healing and suicide prevention. Do you see them as related projects?

GL: Absolutely. It wasn't even planned. I got here, and then all this stuff was happening. Last March, actually, some of the chiefs were at Mayfield Inn talking about these bills that were coming up. Then the first teach-in was happening in Louis Bull, and I went to that. I saw you guys there. And then you saw how fast that grew. It wasn't even meant to be called Idle No More as a movement; it was going to be teach-ins—let's go to reserves and talk to these people about what they're going to have to deal with. So it was just all about education—a platform to create that. But it ignited into this movement overnight.

There's definitely a spirit; it's part of a prophecy that was already talked about—that there was going to be a rise in spirit and energy, and there was going to be a global unity happening. It just caught on fire, and because of the Internet and Facebook and social networking, the world was awoken. When people are losing their lives because of [industry or resource development]—look at how many people are dying of cancer at Fort Chip, or women who don't even have breasts to feed their babies, when they do have babies, because their breasts were removed in Manitoba. Wherever there's extraction, there's death.

So when they removed the protection from water … that is a dark, dark, dark spirit right there. How could we do that? Water is sacred. If we run out of water, we're done. We need it for this planet to live. So for our prime minister to remove that, it's just unbelievable. But when you see the unity that can happen—people in Russia, people in Ukraine, people all over the world were putting up Idle No More signs and getting involved in this movement—that was healing in itself. Because I always felt like we were alone. First Nations people—Indian people—we've never had a voice. John Trudell burned a flag upside

down because of what was happening over there, and his family was burnt to death. We are continuously told to shut up, or, "Don't speak unless you're spoken to," just like in residential school.

So today, having that kind of protection—that kind of solidarity with the world—that was so healing, and it just gave me hope. I shot some of the Idle No More events before *Path to Freedom* was even written, so now it will contain a chronology of what happened—crucial things that happened to shape who we are today. History is happening right now. And seeing these little kids coming out to events—you know, like the round dance we had at West Edmonton Mall ... we saw families, and people at every age, from newborns in diapers right up to the ninety-year-old kohkums. It was just beautiful! And the mall supported us, gave security; it was just wonderful. I'll never forget those experiences. It's just feeling that pure love, you know, because something's happening, and it's magic. This is history, man, and you're living it. It's beautiful. It happened because of something bad, but the unity and solidarity is gorgeous.

KM: And it seems to offer kind of a different model of healing somehow. What you said about Indian Affairs offering you fourteen sessions of therapy—that's so consistent with all the other government policies around healing, which have been geared toward ending the "Indian problem" all over again.

GL: Absolutely!

KM: For instance, residential school survivors can no longer apply for the Independent Assessment Process. The deadline is past; that's closed, finished, and they're trying to turn the page. They've paid their settlements; they're no longer funding the Aboriginal Healing Foundation; NAHO [the National Aboriginal Health Organization] is shut down. It's as if the burden is placed on Indigenous people to heal themselves according to a *deadline*.

GL: Yes.

KM: And then we're all supposed to collectively "move on." But, I think what you're talking about is kind of a politicized model of healing, which requires a lot more from the rest of the country—from the government and from the mainstream. So instead of suggesting that reconciliation will happen when Indigenous people just decide to heal themselves, we turn that around and ask, what is the responsibility of the government—or of the rest of Canada—in supporting this kind of healing, which isn't just a healing of individual trauma, but of the *land*, and of ...

GL: Everything! And everyone has to be involved in the healing process. The educators have to understand that these children who are coming to school are dealing with the results of residential school and also with also systemic racism. It starts there—with bullying in the playground—and then it continues to grow and grow and grow, and then we've got our judicial system and incarceration. The highest growing statistic now is women in jail! But that's connected to the high rates of sexual violence. You've got young girls being sexually violated and then getting enraged and going into the "red zone," as I call it. And then they end up in jail, because they were victims at six years old, and nobody's dealing with the trauma that they experienced. One of the young women that I met at the U of A when you brought some students to the *Older Than America* screening, she said that when she used to talk about it on the school bus, they'd say, "Leave your problems at home!" So she just learned how to keep it inside.

School should be someplace where you're going to get educated, but you're also growing as an individual, and you're learning social skills and all these other skills. I really do think that the implementation of a "Feelings and Emotional Expression Class" should be mandatory. "How are you feeling today?" How do you process emotions? How do you deal with feelings? Because depression is the number one epidemic around the world. Everything's going to escalate, unless there's some catastrophic change in the way things are being done. Depression causes addiction, causes bad behaviour. The root of all these behaviours—suicidal behaviours—is depression.

And depression is caused from trauma. If you're six years old, and you're exposed to domestic violence, a chemical process happens in your brain. It's called "fight or flight." The adrenaline rushes, and it's a really important thing to have, because it can keep you safe. But when you're in that all the time, that constant adrenaline becomes damaging to your brain—especially to the serotonin release. So over time, you become impaired. And then that gets passed on from generation to generation, unless there's a reversal. So that's part of what this healing journey is: it's really to watch and see how we can transform our brain. How we can transform the energy and the patterns that are happening because of the damage that was done in violent situations. So we'll aim to prove that with this medicine wheel healing philosophy, if we truly commit to it, and if we have all the support systems, we can actually transform with healing.

KM: So you'll be there at the TRC in Edmonton next year?

GL: Yes, absolutely. I can't wait for that event. So many people need healing; this is one of the most racist cities that I've ever experienced. I've travelled all over the world, and the racism here is so unbelievable. It's awful. People need healing. And something like that could bring people to a solidarity, even if it's just for a weekend.

Look at what happened here with Idle No More—you know, when you got people jumping in and going, "Huh. Indians are dancing. We don't know why." And they start asking and it's like, "Oh! That affects me too?" "Yeah! This is about all of us, man." So, you know, now that Idle No More woke everybody up, it's the perfect time for that. We need that in this in here, in this city. I can't wait for it to come.

Note

This chapter is based on a conversation recorded on April 9, 2013, at Georgina Lightning's home in Edmonton. It was transcribed by Daniel Nikpayuk.

CHAPTER 11

Resisting Containment: The Long Reach of Song at the Truth and Reconciliation Commission on Indian Residential Schools

Beverley Diamond

Preface

I first heard about Indian residential schools when doing research in the Canadian North on Inuit drum dance songs for a doctoral dissertation in the 1970s. A number of families shared their distress about separation from their children and the loss of language rendering the younger generation unable to communicate with their grandparents (in particular) when they returned to the community. At that time, they did not share stories of suffering and abuse in the schools. I was concerned and empathetic but I know I was ineffective. It seemed that this was a big issue for government and the Christian churches that ran the schools, but I did not see a role that I could usefully play. I realize now that I might at least have written to MPs or clergy, could have learned more about the history of the residential schools, and should have acknowledged the grave concerns of Inuit families in my dissertation. I failed to do any of those things.

The honour of witnessing the testimony of survivors who have come forward to speak to the Truth and Reconciliation Commission and of working with fellow authors in this anthology engaged my heart and mind more fully. I struggle with my role as a settler, witness, and scholar. How can I listen with empathy without implicating the binary of settler/helpers and Indigenous/needy, reinforcing "benevolent imperialism," as Regan calls it (*Unsettling* 23)? How can I reciprocate the courageous gift of testimony? How can I use knowledge of the past to address structural inequities in the communities and institutions I inhabit? How can I work in solidarity with others who

resist the government's clear desire for closure, as if an inquiry in itself could resolve the problems caused by an unjust system of such proportion and longevity, when it is clearly a beginning at best?

Recognizing the long process of social transformation that lies ahead, I problematize "containment" in this paper as a polyvalent concept that often obstructs such transformation. The concept is most often used to refer to the obvious forms of exclusion, denial, and assimilation that underpinned colonialism and continue, as Simpson and Smith assert, in the ways contemporary institutions constrain or deny Indigenous subjectivity (*Theorizing ... Introduction* 9–12). Prime Minister Harper's articulated desire for "closure" of the "sad chapter" of IRS history in his 2008 apology is an example. Containment is, of course, "government speak" for many issues, at least since the Cold War when the United States overtly and officially sought to "contain" Soviet influence, or more recently in relation to such diverse things as nuclear arms proliferation, terrorism, and the spread of disease or urban sprawl, not to mention "cost containment" in response to urgent calls for equitable education, health, and housing in First Nations, Inuit, and Métis communities. In this paper, however, I focus on how the frameworks often used to discuss expressive culture, particularly attention to texts rather than processes, may also be problematic forms of containment. I reflect on how sonic culture, in particular, resists containment—spatially, temporally, and socially—and how it has, therefore, a particular role to play in vitalizing individuals and communities as well as enabling different perceptions of relationships.

In the rest of this paper, then, I will explore some of the broader social processes of which musical performance at the TRC events are part. I draw here on a series of interviews with both professional performers and survivors who played or sang at TRC national events.[1] I contacted Susan Aglukark and Andrea Menard as two of the most commercially successful of the "headliner" artists but equally because of their social engagement: Aglukark's song writing, public speaking, and fundraising initiatives focus on helping Arctic youth in particular; Menard's humour as an actress cuts through layers of hypocrisy, and her recent "Music Messenger" project indicates a commitment to the well-being of her people through music. I am grateful to these individuals for agreeing to discuss their work. Their performance processes and song trajectories challenge the view of some that the TRC concerts were simply "shows" that distracted from the "real" work of redress.

Then, focusing on Atlantic Canada, the region where I live, I will turn to Inuit and Mi'kmaw community members[2] whose uses of song at the TRC events play out of and back into specific community

practices and experiences. Within the Indigenous communities in my region, I am grateful to Inuit Patricia Kemuksigak, Sarah Anala, and Joan Dicker, as well as Sister Dorothy Moore (Mi'kmaq), as leaders in government, social services, and education. My interest in the work of Mi'kmaw survivor Alex Poulette was motivated by his courage in being one of the first Mi'kmaq in Cape Breton to speak and sing about abuse in residential schools and by his tireless commitment to educate youth about this history. Sadly, Alex Poulette passed away unexpectedly in February 2013. His cousin and co-writer, Richard Poulette, spoke with me about the song he performed at the TRC national event in Halifax, and Mike McGinnis about Poulette's participation in the Tunes and Talk program for survivors in Eskasoni.

My role in relation to these interviews is first and foremost as a witness, not an academic critic of texts. Just as we witnessed the testimony at TRC events, I choose to "witness" the stories of how sonic creation, mediation, and reception play a role in people's lives and how those often-hidden processes are shaped by intercultural attitudes and actions. The eclectic mix of repertoire discussed reflects the choices these artists made for their performances at TRC national events and, in a couple of cases, other songs they referenced in our conversations. I weave my own observations of sonic detail with the narratives of my interlocutors. In the final part of the paper I focus on some of the interconnections and divergences among their stories and consider the significance of the processes they describe.

Implicit in their words are views of healing that differ from the Western institutionalized medical model and align with a growing number of studies that explain Indigenous conceptions of wellness. As Audra Simpson has argued, "the Western therapeutic focus that manages mental health ... in individuated ways" misconstrues the fact that trauma is also "social and collective."

> Done in certain ways, Western therapeutic intervention can be a technique of power that creates certain subjects, both affectively and politically and then encourages certain forms of political engagement. To be a subject of pity, or sympathy, one might argue, is not an efficacious model of political subjectivity in an historical field of collective captivity, the condition that some indigenous critics might argue, is the correct approximation of current native "conditions." ("Commentary" 379)

The longer memories that song elicits demonstrate that health is an ongoing struggle for balance and social well-being and that the sonic continues to be integral to Indigenous healing. The 2012 report (see

L. Archibald) of the Aboriginal Healing Foundation on healing and the arts documents over one hundred healing initiatives that the AHF funded, only a handful of which did not include creative arts.[3]

The musicians also relate how the repertoire selected for TRC performance drew, at times, on community- or nation-specific protocols that played an important role in mediating and maintaining social relationships. I argue that these performative moments asserted "micro-sovereignties"[4] (local protocols that maintain social cohesion and facilitate both interpersonal and intercultural interaction) as alternative approaches to "reconciliation." Now that the final report of the Truth and Reconciliation Commissioners is published, it is apparent that they observed other such performative moments. In their summary report, they write:

> While Elders and Knowledge Keepers across the land have told us that there is no specific word for "reconciliation" in their own languages, there are many words, stories, and songs, as well as sacred objects such as wampum belts, peace pipes, eagle down, cedar boughs, drums, and regalia, that are used to establish relationships, repair conflicts, restore harmony, and make peace. The ceremonies and protocols of Indigenous law are still remembered and practised in many Aboriginal communities. (*Honouring the Truth* 16)

A Digression Concerning Sound

As a musician, I am drawn to the ways sound serves processes of intercultural mediation. What does it mean to survivors to finally give *voice* to their experience and for witnesses to hear that testimony? For what reasons have some survivors chosen to present something about their experience in song rather than speech, both in testimony at times and on stage in concerts or informal performances such as the talent shows? And how do professional musicians who are hired to perform in evening concerts decide what to sing or play at an event of such seriousness, scope, and potential significance?

To attempt to answer such questions it is useful to think about how sound differs from visual (or other sensory) expression. In conversations with Indigenous musicians I have repeatedly encountered two distinctions. Regardless of whether the music is very old or very new, whether it is First Nation specific or shared widely across com-

munities, many emphasize that creating and performing songs and dances are parts of larger and longer social processes such as healing, enlivening, restoring balance, or strengthening relationships (to human, non-human, and spirit beings). Such processes have an impact on both personal life and relationships. To consider a song or tune or single performance as simply a sort of "text," then, is already containing it in a way that ignores the ongoing process that some describe as the journey of a song. Talking with songwriters and performers about their intentions in creating or selecting songs; about factors they did not control in the creative process; about the intergenerational relationships that inspired many songs; about the ways the song's energy shifts with each performance; about various spatial, social, and technological mediations are some of the ways one can better understand music as process.

Second, while all forms of expression are subject to multiple interpretations, of course, the sonic "means" differently from the verbal and visual in several regards. Musical sound rarely denotes anything the way a word or a realistic image does,[5] but, rather, it evokes: individual and shared memories of specific times and places, thoughts of someone who shares the love of that song, or activities that accompany specific acts of listening. The San Carlos Apache singers who worked with anthropological linguist David Samuels conveyed many layers of community history by simply naming a song. The timbres or vocal qualities of voices have particularly powerful associations; babies recognize voices they hear in the womb. Certain timbres might be associated with specific families (as described by one of the interviewees discussed below) or particular First Nations. Although communities share musical styles and some connotations of melodic, rhythmic, or timbral elements become conventionalized in specific times and places, there are many individual variations in the way meaning is assigned to sound. And beyond those times and places, the same sonic patterns trigger quite different memories of other contexts and relationships.

Another distinction is the way sound, like movement, is experienced as vibration. Sound enters our body, enlivening and energizing. It is not surprising that First Nations drum sound is so often described as a heartbeat, partly in recognition of the interior quality of sound. Singing and dancing enliven the earth.

How one learns to listen, on the other hand, reflects contrasting attitudes about sound and the relationality that sound invariably enacts. I have attempted to learn to listen with the precision and environmental awareness that many Indigenous teachers and friends over

many decades have demonstrated. I recall the Mohawk instructor who showed me how to make a cowhorn shaker, explaining that twenty-five BBs is the right sound. I recall my astonishment when told of an Anishinaabe instrument maker who created an instrument with a handle that turned in each of the four directions so that the sound world could change with each turn. I recall a discussion with a Haudenosaunee singer who explained how the people in her group positioned themselves when they sang to balance both the air currents and one another's vocal energy. I think of the Elder who taught how the sound of a specific metal alloy might resemble a rare sound in nature that was needed in ceremony. I think of a Creek student who, for a class assignment to make a visual "transcription"[6] of an Inuit *katajjaq* (throat song) that imitated a goose, made a piece of beadwork—an image of a goose flying behind a cloud since she heard something of the way clouds inflect bird song in the performance. I think also of Isabel Knockwood's description in *Out of the Depths* of how her mother taught her to keep safe by "listen[ing] to my footsteps as I went along so when I retraced my steps back home I would recognize the different sounds and realize if I was going the wrong way before going too far" (21). Of course, there are also many Indigenous stories and a growing number of academic studies that reflect how humans, birds, animals, spirits, and other sensate parts of the environment listen back.[7] All of these lessons point to a keen awareness of space, a very discriminating ear for timbral difference, and a recognition that the aural is inevitably about relationship.

Students in professional music schools, on the other hand, are still most often taught to hear (and label) those elements of music that can be notated easily, reflecting a colonial association between what the institution deems "proper sound" and literacy. In a detailed study of the colonial roots of such ways of listening, Ana Maria Ochoa Gautier describes how elites in colonial Colombia distinguished different sorts of voices as a mechanism of governance. "Orality,"[8] she writes, "was not what, in the late nineteenth century, named the multiplicity and singularity of different vocalities but rather what disciplined the production and perception of the human voice" (167). She studies nineteenth-century Colombian intellectuals who deemed it particularly important to distinguish human from non-human sound and were quick to judge sounds unlike their own: "vocalities that seemed out of tune, difficult to classify as either language or song, improper Spanish accents that did not conform to a supposed Spanish alphabet, an abundance of noises or 'voices' coming from natural entities that seemed to overwhelm the senses" (4). Phenomenologist Harris Berger

attends to similar distinctions in studying how cultural conditioning predisposes our listening to be shaped by the "stance" we assume. The stance of listeners can be problematic in relation to TRC testimony, as Roger Simon identifies: "Hearing the stories of former residential school students as narratives of victimhood … increases the likelihood of a dissociative splitting off in which listening accords no need to take on a sense of responsibility for a social future that would include those whose stories one is listening to" ("Towards a Hopeful Practice" 132). He points to a problematic rigid binary that maps victim/ non-victim and roles of helper and helpless onto the way we hear others. Divergences among the stance of different listeners can be contentious but might also be potentially productive moments where dialogue might begin.[9] Aware of these complexities of sonic communication, I now turn to the individual stories of some of the professional artists and community performers.

Professional Artists at TRC National Events

An evening at each national event featured a concert showcasing musicians from the region and beyond. From iconic folk music to country to a rendition of "Ave Maria" in the Mi'kmaw language, from hoop dancing to peyote chants, these were stylistically diverse.[10] Some performers chose repertoire that spoke directly to Indian residential school experiences, to intergenerational trauma or other colonial inequities, or to Indigenous resurgence. These evenings were also times to relax in the company of other survivors, and so some sang familiar country hits, traditional dance music, or pop songs—songs to renew the spirit after the intensity of the daytime testimony. It is curious that hip hop, a genre popular with Indigenous youth and associated globally with political resistance, was rarely programmed for the concerts.[11] There was a "showcase" vibe to the evening performances, an attempt to present a range of arts that "represented" the region. Some criticize the fact that the concert organization was generally sub-contracted to organizations that did "entertainment" and were inclined to big-ticket intercultural performances (e.g., the excerpt of the four hundredth anniversary of Membertou's conversion, or *Fatty Legs* in Halifax). As cultural theorist George Yúdice argues, however, "rather than view certain social movements' collaboration with the media and markets as simply a form of co-optation, it is also accurate to see this as the strategic management of the use that these groups make of these venues and vice versa" (53). Individual performers at the TRC

events had the liberty to select repertoire that, in their view, would speak meaningfully to the survivors in attendance, fully aware that each listener brings different memories and experiences to create multivalent interpretations.

Susan Aglukark, the renowned Inuk musician from Arviat, is well known as both a popular songwriter and a social activist. "Music has been a way for me to give voice to the silent struggles," she explains. I asked how she decided what she would sing at the initial TRC national event in Winnipeg (June 2010). She replied,

> "Hina na no" and "O Siem" are celebratory songs; for me, they represent a celebration of small victories, of small steps taken towards personal healing on personal journeys. The third song was "Bridge of Dreams." This is about my mother's childhood experience with "school" and her telling of it impacted me even to this day. This song and her story is evidence of the generational hold residential school can have on our people.

Both "Hina na no" and "O Siem" make prominent use of an Inuit frame drum, with its distinctive sound produced by hitting the wooden frame to resonate the membrane, but in both songs there is a drum conversation with different percussive timbres arrayed opposite one another (one left and one right in the sound spectrum): an energetic djembe pattern in the first song and a dry percussive sound in the second. She and her team of arrangers, recordists, and sound mixers include Inuit cultural references while arguably making the dialogue cross-cultural. These, of course, are markers of what the industry calls "world music," an industry-defined genre established in the late 1980s that feeds on Otherness and homogenizes cultural specificity. Ethnomusicologist Steven Feld has described traditional elements in world music arrangements as "safe genre statements of authenticity" (270). His perspective resembles that of Indigenous educators (Hermes; Lomawaima and McArty; Richardson) who suggest that the selective incorporation of Indigenous materials (those considered "benign enough to be allowed, even welcomed within American life")[12] are "safety zones" that constitute problematic form of containment. Alternatively, one can listen for the distinctive energy and unique knowledge that each sound offers. While the industry category of world music is only about twenty-five years old, First Peoples have a much longer history of creating hybrid style mixes. Philip Deloria has suggested that such sonic juxtapositions can be instances of the "unexpected" that assert an Indigenous presence and invite us to listen differently. Musical compositions that use hybrid elements, then, raise questions about how we listen.

She also chose to perform "Bridge of Dreams" (see Figure 11.1), a song that refers to her mother's residential school experience[13] ("At the age of just eleven a child should be a child / She was taken from her haven, a river running wild"). Only in the final chorus is the child identified as her mother: "I wonder if you hear me, mother." In earlier choruses, the generations "meet" sonically at the "bridge" where male voices—far back in the mix—say *"umajunga"* ("I am alive"). She responds, "I'm standing at the river / I'm waiting at your door. I'll be your battle raging / Here for evermore / On the bridge of dreams." The bridge, then, is a point of connection with the spirit world. The pop style and Aglukark's gentle voice belie the strong images of a child wrested from her home or the "battle raging" at the metaphorical bridge where her mother helps in the struggles she faces.

Emphasizing that her use of song to engage with residential school issues began well before the TRC, Aglukark discussed one other song she wrote prior to the TRC's establishment to urge survivors to share their residential school experiences. "Circle of the Old" was created because of the "particularly heart-breaking realization of the deep deep fear entrenched in our Elders to speak out, just simply to speak out....[14] I wrote the song 'Circle of the Old' as my contribution to rebuilding that safe place that is special to Elders and to allow my own spirit a safe place so that in the future when I am old, I will share that safe place with my children and grandchildren."[15] As in "Bridge of Dreams," the song switches, for one phrase, to Inuktitut, in a line where she addresses the Elders directly: *"Kappiasungilanga, Ilirasungilanga, Ijirasungilanga, Kappiasungilanga"* ("May I not be afraid. May I not feel afraid or manipulated. I am not hiding. May I not be afraid").[16] The language shift, break from stanzaic form, and change to chromatic harmonic accompaniment mark this line as different, arguably outside the pop "genre world"[17] and its mainstream expectations. At the same time, Aglukark's songs often illustrate that a song's purpose and meaning is not singular (see Cruikshank, *Social Life* 35–40 for further illustrations), because context changes meaning.[18] In this case the shift from English to Inuktitut, from more public to more intimate address, allows her to speak to different audiences in the same song.

Aglukark wrote compellingly about the emotional shift from fear to the courage to speak that she felt at the Winnipeg national event. "All of my time in Winnipeg was emotional, from walking the grounds to meeting people I knew personally who were or had told their stories; knowing that we are allowing ourselves that emotional shift was significant." She believes that the TRC is "a huge step in the right direction in setting a healing path," while emphasizing that it is one step among many.

Figure 11.1: "Bridge of Dreams," written by Susan Aglukark and Chad Irschik. Reproduced with permission. Transcription by Beverley Diamond.

Like Aglukark, Saskatchewan Métis songwriter Andrea Menard,[19] who performed at the Saskatoon national event in 2012, is committed to use her arts to name social injustice and inspire Indigenous resurgence. Multi-faceted as a film actor and writer for television, Menard spoke to me about her vision for people coming together, people opening their hearts, and compassion replacing conflict.

That is my vision and it's [for] all people. I am interested in the healing of Métis people and Indigenous people for sure, but I'm also interested in the healing of all people because it's time that Aboriginal people stand equally among non-Aboriginal people. And in order for that to happen, compassion has to live within our hearts. We must no longer accept victimhood as our way of life, no longer feeling *less than* or having someone else feel *more than*. And others must widen their concept of, and embrace the beauty of, their Aboriginal brothers and sisters.... So that is my social justice.... It's a loving way of changing the world. But it also encourages self-responsibility.

Her grandparents, like many of their generation, decided to stop speaking their language and encourage English use within their household, in hopes of enabling a better life for their children and grandchildren. Andrea's response to that was, "Why did they do that? You know, it's like swallowing the oppression," but she has come to understand their rationale.

Andrea described herself as a vessel for spirit who brought her the songs years ago but intended them, among other things, for the TRC event:

With spirit writing these songs through us, I truly believe that while we are here in our human form, suffering as humans— you know we have a very linear way of looking at things but when we invite spirit in, exponential ideas, and growth and love can occur. That song, "My Neighbourhood," is a song that we wrote maybe now ten years [ago].... It's like it was always written for that event.... I've been praying to be used as a vessel that way.

Past, present, and future circle over one another.[20] Menard's version of history is not a linear one.

She emphasized song trajectories when I asked her what message she wanted to present at the Saskatoon concert. She opened with "100 Years," a reference to cultural resurgence in an oft-quoted statement by Métis leader Louis Riel: "My people will go to sleep for one hundred years and it will be the artists who will wake them."[21]

"100 Years"—me saying "listen"[;] "listen to spirit" hopefully inspired the question, "How do we listen?" by the attendees. And of all words to be sung over and over again at a TRC event—"Listen, listen listen" [*she sings*]—That word was

repeated over and over and over for this audience. There's nothing more important than listening. You know. So these songs were written a long time ago but they were meant for today.

In "100 Years" (see Figure 11.2) the tiered descent of the refrain "listen, listen, listen" is reminiscent of the contour of powwow songs. The stanzas spill beyond the expected four-bar phrase lengths as she struggles to articulate her social role: "I've been given this heart and a voice, a sense of history and choice, but I'm not sure what I'm supposed to do." Jazz guitar inflections and a rhythmically free delivery of the text create fluid lines, but the refrain is more on-the-beat commanding. Every line has space at the end—space to listen, perhaps. But in the refrain (as in Aglukark's "Bridge of Dreams") others join the conversation: "We are rising" echoes in the back-up chorus that asks, "What would you have me do?" Riel's spirit whispers, "*Écoutez*" and "*Je vous écoute*."[22] The question and Riel's response invite all listeners. She explained that before the performance, she and two bandmates prayed for their ancestors to walk with them and knew that happened when audience members told them, "Your songs and your words, they hit me in the heart."

Andrea then sang "My Neighbourhood"[23] depicting a scene of crying children alone with no parental love or care, an abusive exchange on a bus, a prostitute standing in the cold. It is implicitly any distressed "neighbourhood" that survivors and settlers alike might read themselves into, relative to their own situations of distress. The melody mostly follows speech contours—a vehicle for the seemingly dispassionate telling of the story, until a single striking melodic line in the refrain, "who's gonna lead them to their glory" with an ascending octave leap on "glory." The non-specific "neighbourhood" in Menard's song, like Aglukark's "bridge," makes space for different listeners, facilitating different readings. Ethnomusicologist Joshua Pilzer has described the value of such song texts in relation to trauma victims elsewhere.[24] He argues that the "opaqueness" of song is the very attribute that enables the long process of reckoning that inevitably follows trauma, allowing listening experiences to be simultaneously very public and very intimate, "both precise and unclear at the same time." Such qualities allow listeners to "slot themselves into these positions [referenced in the song lyrics] at will and modify them" (8–9). His opaqueness argument is not unlike Anishinaabe theorist Gerald Vizenor's promotion of "shadows" as part of an Indigenous practice of "survivance." Without a direct object or referent, argues Vizenor, shadows counter the materialist, object-oriented tendencies of many Euro-American and English-language interpreters, allowing for an active engagement with unstable memories.[25]

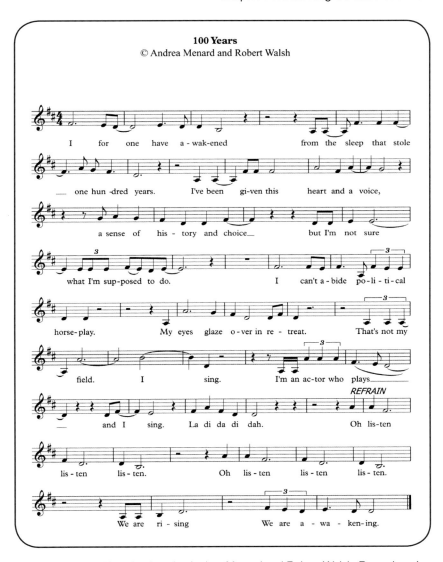

Figure 11.2: "100 Years," written by Andrea Menard and Robert Walsh. Reproduced with permission. Transcription by Beverley Diamond.

Community Songs and Their Stories

In the Atlantic Canadian region where I live, I spoke with or visited survivors from the Labrador Inuit and Cape Breton Mi'kmaw communities. Labradorians kindly took time to help me understand their specific struggle for recognition as survivors since they have thus far been

excluded from the Settlement Agreement[26] because their schools were run by the International Grenfell Association or by Moravian clergy, rather than mainstream Christian denominations. This exclusion left Inuit survivors feeling that their suffering did not count. When she first spoke with me, Inuk Elder Sarah Anala described how the Harper apology was "like a spear went in my heart or in my soul somewhere. I felt a lot of pain as an excluded person." Others made interventions in the Learning Place at the TRC, writing names of their "Non-Agreement Schools" and homes on maps that documented the schools and communities of students (see Figure 11.3). Led by Nunatsiavut Inuit,[27] Indigenous Labradorians made compelling individual and group presentations[28] to the TRC in Inuvik and Halifax.[29]

Figure 11.3: Map of Indian residential schools in the Learning Centre at the Halifax National Event, with the insertions of "Non-Agreement Schools" by Inuit from Nunatsiavut. Photo by Pauline Wakeham. Used with permission.

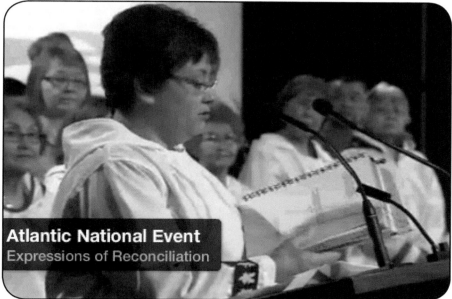

Atlantic National Event
Expressions of Reconciliation

Figure 11.4: Labrador delegation performing "Till We Meet Again" in Halifax.

Sarah's early life was happy in a family and community who "lived spirituality at home and out on the land," offered unconditional love, and taught her that her language was "so strong it could never be broken." That changed abruptly when her father died unexpectedly and her mother—a very capable parent—was forced to send her to residential school, a dictum that would not have been inflicted on a non-Indigenous parent. "The attitude still exists from some corners that Inuit can't do as well as Kallunât ... that's racism," Sarah observed. She shared a poem, "The Invisible Wounds of Long Ago," that she had read as testimony at the TRC, powerfully describing the despair of separation from family and community.

Anala was part of a group that performed a Moravian hymn, "God Be with You till We Meet Again,"[30] as an "expression of reconciliation" at the Halifax event (see Figure 11.4), before they placed legal documents (prepared for their class-action suit) in the bentwood box.[31] I first heard the hymn as a political gesture: twenty-five people crowding the small stage, singingly tentatively at first but gathering strength with each verse. To me, they embodied solidarity, a determined pursuit of justice, and an intention to continue to press for recognition as survivors. They explained the meaning differently, focusing, like most survivors, on relations within their families and communities.

This hymn is now both a sacred and a civic protocol for parting in contexts ranging from Nunatsiavut government gatherings to funerals. Each person emphasized different aspects of its significance. Sarah Anala remembers genealogy, hearing traces of generations of families of song carriers in the vocal timbres: "As a Nunatsiavumiut Inuk … it's part of the Moravian influence, I suppose, the wonderful singing that has been passed down from family member to family member." Nain teacher Joan Dicker stressed the many contexts for singing it and the hope that everyone will be okay after departing from the TRC event: "It is a very powerful song … especially when it's sung in Inuktitut. Throughout my growing-up years I've heard that song all the time … when there's different events going on. For example, when they have big gatherings or meetings and there's people coming from different places, like from along the coast and other places … they would always end off the meeting with this song…. So you're singing and hoping that everbody's going to be okay until you meet again. It's almost like a farewell song." Patricia Kemuksigak emphasized the emotional power of the hymn. "I don't know if you noticed but we starts to cry. It's sad on different levels, I guess, because you felt the connection with people and then you go your separate ways, but also because you think of people who have passed on. [Memories] of loss. Innocence of childhood. Layers." She switched to the pluralized verb ("We starts to cry") that often signals intimacy in Newfoundland and Labrador, when she began to talk about the hymn.[32] Both in Inuvik (in the talent show) and in Halifax, by gently asserting their protocol, using an adopted Moravian hymn, they interjected their framework for processing the emotion of separation. They demonstrated, as a number of others have observed, that Christian hymns have long mediated relationships, "infusing them with the emotion and power necessary to bridge a chasm between worlds" (Hamill 42). As a micro-sovereign protocol for closing, for departing with a commitment to ongoing relationality, their act was political but also multi-valent in ways I had not, at first, perceived.

Another Labrador Inuit performance had a shorter history but significant community impact. At the Inuvik talent show,[33] singers from Nain, Labrador—Keri Obed and Joan Dicker—performed "Farther Along," a country gospel hit penned by an Indian agent grieving the loss of his own child.[34] Joan situates the TRC performance in a longer trajectory of healing, finding solace and recovering balance.[35] She thought it a happy coincidence that she had already translated the song a few months before funding was secured to take them to the Inuvik national event. The familiar melody, waltz metre that often

bears nostalgic emotion in country music, and sorrowful lyrics garnered strong response. Because of the TRC performance, Joan suggests that the song had added impact back in Nain, where it is now a frequent radio request, speaking in particular to Inuit families who have lost a child through suicide or violence. The Inuktitut language is part of the impact: "It helps them when you sing it in your [our] language," Joan explained. "Because the Inuktitut words fit the tune differently from English words, it's almost like they never heard the tune even in English before." Joan turned the song in a new direction, and through the use of Inuktitut and the local relevance for grieving families, she enabled what Roger Simon describes as "the eruptive force of remembering otherwise" (*Touch of the Past* 4).

Like Inuit, Mi'kmaq and other members of the Wabanaki Confederacy[36] in the Atlantic provinces (and across the U.S. border) have a long relationship with Christianity—in their case with Roman Catholicism,[37] part of what Rollings describes as "a complex terrain of religious and cultural exchange" (123). Their experiences in the Shubenacadie residential school, however, are intransigent nightmares for many, such as Mi'kmaw songwriter and survivor Alex "Pikun" Poulette, who spent two years at Shubenacadie. The most frightening of the abuse he suffered there were repeated attempts to drown him.[38] I met Alex at a circle on research ethics (at the TRC's Atlantic National Event), where he offered that it had taken him fifty years to be able to forgive his abusers. At both the talent show and on the concert stage, he again referenced "forgiveness" in a song by that name.[39] It is a song he performed frequently at wide-ranging events, including the Halifax powwow, the East Coast Music Awards, and presentations at schools across the province where he frequently spoke about Indian residential schools.

The song's title and history, however, has more complicated dimensions. The song title on the CD[40] that circulated widely is the only newly composed song[41] with both an English and Mi'kmaw title: "*Apiksiktuaqn.*" Inspired by Métis artist David Garneau's search for the manner in which "reconciliation" is expressed in Cree,[42] I listened again to Grand Keptin Andeli Denny's welcome speech at the Atlantic National Event. He described one word in Mi'kmaq for intention (*aniapsit*) and one for the action (*apiksiktuak'n*), indicating that the latter was more widely used since restitution and positive action were clearly needed to move forward. Sister Dorothy Moore and Michael R. Denny both described how *apiksiktuak'n* was enacted as an annual protocol for renewing social relationships. Sister Dorothy described how, in Membertou on New Year's Eve, the community gathers in a

circle (in the Catholic church these days), and each individual moves around the circle, shaking hands with one another and saying "*apiksik-tadult'nk*"—"we forgive one another." She emphasized that the action was two-way. Anger over old injustice is put aside, the year starts in peace, and future alliances are enabled. It's the only Mi'kmaw word in Alex's song and it's an action, not an intention, a reference to the local protocol for conflict resolution even as his personal struggle to forgive was not easily resolved. Like the Inuit hymn that has become a protocol for parting, the Mi'kmaw protocol asserts a micro-sovereign tradition as an alternative to "reconciliation."

The song's trajectory further reflects how the mediation of music is a space for intercultural negotiation. Alex's cousin and musical partner, Richard, helped write the original lyrics that described a hand emerging from blackness—"a nun's habit," he explained. The Halifax producer argued that this evocative image of a boy's terror would not be understood, and so the line was rewritten. I note that it became more explicit in terms of action but vaguer in terms of the perpetrator: "They held my head under water until I almost died."[43] The producer hired the Halifax-based African-Canadian female quartet Four the Moment to sing backup; they were widely known for the song "Africville," a ballad that condemned the razing of a historic Black community in Halifax. While the decision to combine the Mi'kmaw duo and African-Canadian quartet was probably driven by the popularity of Four the Moment at the time of recording and by the fact that both groups suffered racist oppression, the fusion might be read as a conflation of very different histories in an attempt to create a "multicultural" product. It raises questions addressed earlier about how we listen to and "read" stylistic divergences. In the new arrangement, the quartet sang a cheery refrain that arguably trivialized the song's dark message. For the TRC performance, Alex left the refrain out and replaced the angriest phrase—"I learned how to hate. I learned how to fight"—with an intense arc of vocables that I read as a space of emotional reflection instead of recrimination.

Challenging Discourses of Containment

As indicated early in this chapter, I unfold song trajectories as indicators of larger social processes that spill beyond the tunes and rhythms and lyrics in themselves. In every case, it is not simply a song but its whole journey, including its many performances, receptions, and

mediations, that defies the containment that a "text" alone might imply. The stories that musicians shared with me cast light on several intra- and intercultural dimensions.

The musicians' stories as well as some of my reflections on TRC events point to the importance of listening as active and agentive, not passive or neutral. The problematics of hearing victimhood, the divergent audio responses to hearing "This Little Light of Mine" (see note 9) and the solace of hearing a song in one's own language were important indicators of this. Some survivors stressed that the hearing, not the voicing, of their testimony was crucial for social transformation. "They wanted people to listen and they felt they were listened to for the most part," explained Labradorian Patricia Kemuksigak. Elder Sarah Anala made a related distinction: "the Euro-Western world hears with their ears. The Inuit world hears with their spirit and their heart." Listening, then, is a diagnostic of diverse values and experiences, an act of commitment and respect (or not), and an ethics of response ability. Unlike the testimony, which was quite specific, the song texts often allowed individual and divergent interpretations that met specific emotional needs. Andrea Menard's "neighbourhood" of song was resonant with survivors and settlers alike, and Joan Dicker's Inuit version of "Farther Along" continues to be embraced by residents of Nain for the solace it offers them on a daily basis.

A significant contrast between song and writing was offered by Inuk Sarah Anala, who is involved in healing programs as the Elder for the correctional system in New Brunswick. In dealing with trauma, she described how she sees the importance of expressive culture, for her primarily creative writing:

> When you see your own hand-writing on paper, in black and white, you realize that it no longer owns you. It's outside of your core. It's come away from your centre and it's no longer an internal part of who you operate as, as a person throughout the day. And when you hear, when you hear with your own heart with your own spirit, hear with your own voice and ears, it validates and makes it real, what you have gone through. And gives an avenue to begin to heal because you are no longer keeping it inside of yourself, to yourself, and suffering alone.

While writing enabled her to externalize her suffering, hearing had different effects. It "validated" her experience. When she spoke of the Inuit performance of "Till We Meet Again," she heard history, the

lineages of Nain families conveyed in vocal timbres that again made them "real." Aural validation is a concept that settlers, by and large, must work to understand.

Validating was also an important reason for drawing on aural protocols for resolving relationships. Singing "Till We Meet Again" secures the realness of futures together. As coastal Labradorians explained, the mediating of loss needs a song, whether that loss be separation through death or simply parting after a meeting. They enact the sadness of parting over and over and use a hymn as a commitment to meet again. Similarly, for Cape Breton Mi'kmaq, including Alex Poulette, "*apiksiktuak'n*" must be voiced each year in a process of regular renewal.

I have described both the Labrador Inuit protocol for parting and the Membertou Mi'kmaw protocol for *apiksiktuak'n* as micro-sovereignties because there is a political dimension to their use at TRC events as alternative models for maintaining relationality and social responsibility. In both cases, the commitment to action on their part is what is important and what is expected in return.

These and other expressions at the TRC events emphasized healing more often than critique. They seem in stark contrast with the naming of abuse that is the main part of TRC testimony, and they raise questions about the opportunities for giving voice to anger or pressing for justice in the TRC context. There is a long history of Indigenous songs that draw attention to colonial abuse in Canada, but we heard fewer of these than I expected. In this regard, the Canadian TRC differs from TRCs in other countries[44] where songs were, in many cases, actively used in public spaces to insist on justice[45] or to share information about violence by using media that circulated below the radar of authorities.[46] While, in the context of the TRC, music was occasionally offered that voiced more direct critique,[47] the framing of TRC events in terms of healing arguably contained the artistic and emotional range of expressive culture seen there. Of the individuals whose performances I have considered here, Alex Poulette is the one who courageously used song to describe violence directly. Here, however, there is the further irony that, in its mediated form, the image that epitomized his fear was rewritten to be more obscure. The stark image of terror associated with the black-clad figure who hovered over him was written out. And the specificities of Indigenous and African–Nova Scotian histories were elided in a "multicultural" production.[48] On stage in Halifax, Poulette stated that he "didn't want to record this song, but he did." The song trajectory, then, arguably says

more about intercultural relationships than its text. On the other hand, by telling his story through this song at schools and powwows across the province in recent years, Poulette reclaimed the right to sing about the violence he suffered, even in a song that he titled *"Apiksiktuak'n"* ("Forgiveness").

Two issues, signalled by the trajectory of the Poulette song, emerged in other conversations I had with Indigenous musicians for this project: genres and mediation. As vehicles for intercultural dialogue, I argue that both are double-edged. Many Native American scholars and ethnomusicologists (see, for example, Deloria; Hamill; Diamond) have written extensively about the capacity of Indigenous artists to "turn" colonial genres to reorient the sound for new purposes (as the marching-band drum can be turned to be a powwow drum; as a Moravian hymn translated to Inuktitut can be turned into a protocol for parting; as a country waltz can be re-nuanced in translation with both a subtly altered message and a new "feel"). Many have also written about the Indigenizing of popular music, perhaps most importantly by disrupting listeners' expectations of genre. Genres have been critiqued as systems of "purification" (Ochoa) that define and contain ideas about how certain beings and bodies are expected to sound. Indigenous artists and academics (among them, Bissett Perea, Perea, Aplin, and Avery, all in an issue on the theme of Indigenous Modernities of the journal *MUSICultures*) emphasize how Indigenous music has challenged these systems in myriad creative ways. One socially productive challenge to the genre categories is simply that Indigenous music is so immensely varied, drawing on a huge array of styles and materials, including some that were encountered in residential schools.[49] Another is the insertion of elements that don't fit genre expectations in specific songs. In "Circle of the Old," Aglukark's disruption of a pop song with an Inuktitut message that changes the audience address along with the rhythms, harmonies, and phrase structures is a good example. Equally so in Poulette's "Forgiveness" is the phrase of vocables that breaks the mould of a country song. There are, of course, more widely known instances, perhaps most notably A Tribe Called Red, whose digital remixes often juxtapose, recolour, and overlay old media that depict blatant stereotypes of Indigenous people. Or Digging Roots' "Memego,"[50] a hard-hitting critique of the residential school system that juxtaposes spoken word with a traditional vocable melodic response over a slow reggae beat. While, as Philip Deloria eloquently argues with reference to the American context, expectations reflect "the colonial and imperial relations of power and

domination existing between Indian people and the United States," the unexpected "resists categorization and, thereby, questions expectation itself" (11). After Deloria, I argue that genre disruptions, then, are an effective decolonizing tool used by Indigenous artists. In music, such sonic disruptions sharpen our listening and raise questions about stereotypes as well as new strategies of representation.

The situation is made more complex by the intercultural processes that govern media production in particular.[51] The use of hybrid elements that have come to define "world music" in the last few decades, for instance, may weaken the capacity of unexpected elements to question power relations. Does one hear an Inuit *qilaut* and the other drums used in a conversational manner in Aglukark's "O Siem" as expected references to authenticity (benign inclusions) within the genre of "world music," or as unexpected? I argue that listeners have a political role to play by insisting that such subtle differentiation be heard and recognized with a precision akin to that of the Indigenous teachers whose lessons in listening I mentioned earlier, but equally with keen attention to the appropriation and mass marketing of digital "samples" of "tribal sound." The trajectories of song may, of course, be beyond the control of the creators in other regards, as Menard recognized when she described herself as a vessel for song given through prayer. In her case, the trajectories of "Listen" and "My Neighbourhood" served to increase the power of the song.

While the broader systems of colonial abuse are receiving more public attention through initiatives such as Idle No More and the pressure for action on missing and murdered Indigenous women, the quieter processes described in this paper are rarely acknowledged. I suggest that revealing narratives about the longer processes by which sonic expression is created, modified, mediated, translated, reinterpreted, and repositioned in individual and social life are significant for several reasons. Sonic trajectories reveal and validate the long work of recovery for both Indigenous and settler allies. They reinforce work on Indigenous health that point to the ongoingness of the struggle for individual wellness and social well-being. The intercultural aspects of borrowing, translation, arrangement, and media production speak to implicit views of how the "oral" and the "local" should sound and to power relations that are often hidden. Some of the work discussed here uses unexpected sonic and structural elements that not only break dominant patterns but create potential spaces for dialogue. By combining languages and stylistic elements they imply a dialogicism that is at the heart of building an intercultural future. By challenging

the linearity of history, they narrate generational and cultural difference as a dynamic process. The ways in which local protocols are put forward as models that are alternative to reconciliation teach us all not only to think critically about the very concept of reconciliation, but also to respect the sovereign right of local Indigenous communities to define the process in their territory. By asserting micro-sovereignties, by enacting or referencing protocols, they offer alternative models for intra- and intercultural healing. By acknowledging the trajectories of song, they challenge closure and insist on the ongoing community work of vitalization, repair, and healing. In the end, the political import of Indigenous song may simply lie in the fact that performances exceed containment by happening over and over and over—but never quite the same, always attune to new environments, sounding new issues, contexts, and models of relationship.

Notes

1 All quotes from my conversation with Susan Aglukark are from her email responses to a series of questions I sent her in January 2013. She preferred to prepare written responses rather than record a conversation. Quotes from Andrea Menard are from a Skype interview in October 2012.

2 All quotes are from interviews conducted in October 2012 unless otherwise indicated.

3 Linda Archibald observes the irony of releasing the report at the time when the Aboriginal Healing Foundation, which had funded over four hundred healing programs in total, was being closed down owing to federal budget cuts (4).

4 While I was unaware of other uses of "micro-sovereignty" when I chose to use the concept in this chapter, it is important to note that it has different connotations in different spheres. It is used in international law as complementary to self-determination, to refer to individual or group rights (Kornhauser). My usage differs in that I seek to connect protocols to sovereignty struggles. In this paper, the performances I describe as acts of micro-sovereignty are local protocols—sometimes pertaining to a specific community, at other times to a region—for ensuring productive relationships in the future.

5 There are extra-musical exceptions to this statement in human, non-human, natural, and industrial contexts where sound is used as a signal or where it conveys detailed practical information that may be essential for survival. There are other rarer exceptions in some music cultures where certain sonic gestures convey hidden texts to those in the know. Of course speech and song are texted and hence denotative, but such dimensions as the vocal timbre, the loudness, or the rhythm exceed textuality. Linguists study such "paralinguistic" elements and determine

widely shared patterns that one can say have meaning. Musicologists may do the same sort of structural analyses. But the results do little to enable us to understand the polysemic aspects, or such things as irony and indirection that are frequently employed in live performance.

6 The assignment was designed primarily to ask students to think about the limitations of music notation and about other possible visual analogies for sound.

7 See, for instance, Cruikshank's *Do Glaciers Listen?*

8 She distinguishes between aurality and orality.

9 Consider, for example, how different listeners respond very differently to music associated with Christianity. At the Montreal TRC, an African-Canadian United Church choir took the stage at the end of a "Talent Show" featuring a wide range of First Nations, Inuit, and Métis performers. The choir was a rocking gospel ensemble, and while most admired their skill and spirit, their final rendition of "This Little Light of Mine" elicited strong but varied responses. Many audience members joined in with enthusiasm. A few parodied hand-waving believers, and one person laughed with his friends before falling to his knees in the aisle with his hands uplifted in a gesture of mock conversion. I responded guardedly, hearing the simple Sunday School song as one of the kinds of "simple songs" with "tunes bright and cheerful" (Knockwood 49–50) used in the residential schools themselves as a mode of assimilation; for me, the benignly intended invitation to join the performance felt coercive. This performance, then, was overtly a contested site where listening was politically and socially charged by assumptions we each had about the church's role in residential schools and by our own spiritual practices.

10 John Troutman explores how the experiences of boarding and residential schools fostered skill in mastering diverse styles and expressive languages: in relation to American boarding schools, he notes that Native Americans have been exceptionally good at "creatively appropriat[ing] and mak[ing] their own a multitude of musical styles" (254).

11 Exceptions include the following: The Muskokay rap artist Eekwol, known for her socially conscious lyrics (Marsh), performed at an outdoor and family-oriented noon-hour concert in Saskatoon. Biz from the Québécois sovereigntist group Loco Locass performed his rap "Genocide" at the Montreal concert. He was introduced as a "spoken word" artist rather than a rapper.

12 Lomawaima 6. In the same way, areas on the grounds of boarding schools had tipis that were part of the domesticated training of female students. See photographs in Lomawaima 3–4.

13 Aglukark is one of many intergenerational survivors who have chosen to honour older survivors in their families, among them Stó:lō composer Russell Wallace ("Gathering Song" on *Tzokam*), Métis songwriter Fara Palmer ("Bring Back Yesterday" on *Pretty Brown*), and Métis jazz and blues musician Jani Lauzon ("Stolen" on *Mixed Blessings*).

14 Of course, at the TRC event, Elders were speaking out and so Aglukark did not perform this song there.

15 Leela Gilday also wrote about the silences surrounding IRS experiences in "Secrets."

16 Thanks to Jean Briggs and Susan Aglukark for correcting my transcription and translation of this Inuktitut line.

17 "Genre world" is a phrase coined by popular music scholar Keith Negus to organize the codes and conventions of popular music production and distribution into categories or "genres" as marketing tools, shaping the expectations of listeners. Of course, both musicians and listeners frequently resist such conventions.

18 Cruikshank discusses a song that she calls "Pete's Song," explaining how one performance was a gift of the song to Pete from his mother, Angela Sidney; another was an assertion of territorial rights; and another was commemoration (*Social Life*). In addition, she speaks of the fact that, like many oral traditions, the text was fixed only when it was written down.

19 Menard was not aware, prior to coming to the national event in Saskatoon, that many Métis in the province were not included in the Indian Residential Schools Settlement Agreement.

20 The plasticity of history has been theorized by Nabokov and demonstrated most fully by anthropologist Julie Cruikshank, whose work with Yukon Elders illustrates the way life and storytelling are interwoven and the way stories and songs are strategically reworked since "narrator and audience both change with time and circumstances, giving any one story the potential range of meanings that all good stories have" (*Social Life* 28).

21 Justice Sinclair has quoted this statement in TRC speeches.

22 Other artists have similarly used multiple languages to address different publics and invite the spirits of ancestors. In Northern Tutchone and English, Jerry Alfred's "Residential School Song," for example, demonstrates that he still speaks language in spite of punishment for using it.

23 Included on the TRC's compilation CD, *Songs from the Indian Residential School Legacy* (2015).

24 He has written music-rich biographies of several "comfort women" of Korea (women forced into prostitution to serve the Japanese army), whose responses to the trauma of their lives is hardly commensurable but sometimes resonant with struggles of IRS survivors.

25 I would suggest further that because both images (the opaque and the shadow) are visual, it will be useful to consider their sonic counterparts, a topic to which I return below.

26 In 2015, their class-action suit has been delayed in response to a request from the churches to have more time to prepare documents. Other groups who were similarly excluded include Métis day-school attendees in Saskatchewan.

27 Meanwhile, they await response to their class-action suit challenging their exclusion.

28 Inuit children who were Moravian (from Hebron, Nutak, Makkovik, Postville, Nain, and Hopedale) attended schools in the communities of Makkovik and Nain before confederation with Canada in 1949. Rigolet

had an Anglican church and children went to North West River Dormitory. The Moravian schools in Makkovik and Nain were called boarding schools, and even if pupils were from the community they had to stay in the boarding school and were allowed to visit their family for only two hours a week on Sunday afternoons. After confederation most young people went to North West River to the International Grenfell Association (IGA) Dormitory. A few went to Lockwood School in Cartwright, St. Anthony Orphanage, and Muddy Bay School, also run by IGA.

29 In its *Interim Report*, the TRC supported action "to address legitimate concerns of former students who feel unfairly left out of the Settlement Agreement, in order to diminish obstacles to healing within Aboriginal communities and reconciliation within Canadian society" (recommendation 12).

30 The hymn was composed in the late nineteenth century by a Moravian composer, William G. Tomer.

31 The contributions to this box are intended in many different ways. In this case, the offering indicates a situation that requires restitution before reconciliation can be achieved.

32 Its ubiquity is readily evident: it was used recently at the opening of a new headquarters for the Inuit-run Nunatsiavut government in Hopedale and selected as the title of a documentary film (2012) about Labrador Inuit culture (producer Nigel Markham).

33 While today, people may associate the term "talent show" with TV reality shows such as *American Idol*, the rubric and the related one, "amateur hours," developed with early radio in the 1930s, first in Britain but quickly spreading to other countries and many Indigenous communities in Canada. Relative to the concerts, the "talent shows" at TRC national events are less scripted and hence, although the audience for the formal concerts and talent shows is largely the same, there is more intimacy and openness to widely divergent presentations by all ages in multiple languages. Some chose to present local culture: the *kojua* dances of the Mi'kmaq, Inuit throat singing, Métis fiddling, or Moravian hymns. Some performed a piece of particular individual importance, e.g., Sister Dorothy Moore's performance of Schubert's "Ave Maria" in Mi'kmaq.

34 The lyrics were penned by Rev. W.A. Fletcher, itinerant preacher in the Indian Territories in 1911. He sold the lyrics for two dollars to J.R. Baxter, who had them set to music and published what would be a hit that has been covered by hundreds of country artists.

35 Joan has often used song to help with life's challenges, including co-writing "I Want to Go to Nain" with her friend Beatrice Hope to give voice to their loneliness while they were residential school students in North West River in the 1970s. Beatrice recorded the song on her album *Daughter of Labrador* (n.d.).

36 A confederacy of Mi'kmaq, Maliseet/Passamaquoddy, Abenaki, and Penobscot First Nations created in the late eighteenth century.

37 The relationship between Indigenous leaders and priests was generous, wary, and often strategic. The 1610 "baptism" of Chief Membertou was locally regarded as a recognition of sovereignty that "symbolizes an

international alliance with one of the most influential powers in European history" (Battiste 4). Grand Keptin Andeli Denny emphasizes that "[Membertou] did not give up or replace Mi'kmaq spirituality and its spiritual teachings" but affirmed "the profound truth of a new humanity based on the Creator's teachings to the Mi'kmaq" (qtd. in Battiste 1); he acknowledges that for some families there is a split between the two ways of being.

38 Both he and his brother Thomas documented their IRS experience in several songs (see Alstrup) at a time when it was not widely accepted to speak out. Stories of abuse appeared in the *Micmac News* in 1978, but according to a note in the Beaton Institute archives, the magazine had to find a new printer since the usual one refused to print the stories.

39 More recently, Poulette composed the song "Frozen Child" for the *Learning to Heal* CD produced with Mike Mcginnis's Tales and Tunes group.

40 As a duo, Alex and Richard Poulette performed as Morning Star. The CD, *A Little More Understanding,* was produced and arranged by Ralph Dillon.

41 There are two traditional songs in Mi'kmaq on the CD.

42 He learned that it is possible in Cree to translate "reconciliation" as "I regret something" (*nimihta tân*), but more often a word that means "we wear it" (*is ê-kiskakwêyehk*) is used ("Imaginary Spaces" 36).

43 Attempted drownings were described in multiple testimonies in Halifax.

44 The context of transitional governance, which does not pertain in Canada, may be one of the reasons for the difference.

45 The "freedom songs" and dances performed at the trials of high-profile figures such as Nelson Mandela and Stephen Biko in South Africa, for instance, as described by Cole (56).

46 The "testimonial songs" that described violence during the Shining Path years in Peru, as described by Ritter, circulated via pirate radio and continue to be sung in the post-TRC era.

47 Among the concert performances was Loc Locass's spoken-word piece "Genocide," as well as more general "protest" songs such as Buffy Sainte-Marie's "Universal Soldier" and "My Country 'Tis of Thy People They're Dying." There is also more direct description of violent abuse in songs by John Wort Hannam ("Man of God") and Stephen Kakfwi ("In the Walls and Halls of His Mind") and more vehement critique by Digging Roots ("Menego"), Murray Porter ("Is Sorry Enough?"), and Aaron Peters ("Perfect Crime") on the compilation CD produced by the TRC and distributed at the gathering in Ottawa for the presentation of the final report in June 2015. As mentioned earlier, rap—a genre of enormous significance for young Indigenous people (and youth worldwide) as a vehicle of resistance—was curiously missing from most staged TRC performances, although the aforementioned Los Locass performance is sometimes identified as rap.

48 As they also were in the performance of an excerpt from the dramatic piece *Membertou* during the same concert.

49 Ironically, Indigenous music is often marketed as "new age" with little regard for this immense stylistic variety.

50 Track 2 on *Songs from the Indian Residential School Legacy* (Truth and Reconciliation Commission of Canada).
51 Robinson ("'A Spoonful of Sugar'") also demonstrates how the politics of intercultural live production often replicate social inequities or colonized attitudes about how sound should be shaped and controlled.

CHAPTER 12

Song, Participation, and Intimacy at Truth and Reconciliation Gatherings

Byron Dueck

The Truth and Reconciliation Commission's national event in Montreal, held in April 2013, opened and closed with song, as did each day of the gathering. On the afternoon of the first day, participants met around a sacred fire in a small park near the hotel where the rest of the events were to be held. Don Waboose, an Ojibwe singer, sang in the park, accompanying himself on a hand-held drum, and then began to march toward the hotel, singing again, followed by distinguished participants, including the TRC commissioners and residential school survivors. Once at the hotel, attendees filed into the large convention hall, led again by Waboose. He sang in a manner reminiscent of northern-style powwow singing, in a high register and with tensed vocal chords, and in watching him again as I write this chapter,[1] I hear the effort involved in singing through the long phrases of the songs, and notice how Waboose's brow was wet with perspiration when he finished.

Afterward, emcee Charles Bender explained that Waboose had sung a "traditional spiritual song" in which he spoke "to the Creator to welcome you into this room." He went on to say a few words about Waboose's biography before announcing that Waboose would sing a grand entry song for the procession of residential school survivors, and asking us to stand. Waboose greeted us in Mohawk and Wendat, the languages of the territory, and said,

> The song I'm going to be singing is a spiritual song to the Creator, talking to our ancestors in the spirit world to be with us here today and through the whole duration of this time of being together and listening to our brothers and sisters [who] are going to be speaking later.... [My] mother ... came from the residential schools, so I'm one of the survivors from that. So it really gives me great honour to sing this song. It will be in our language, the language that the Creator has given us, original tongue that we speak. So those of you, at this time, I

would like to ask you, each one of you, for your help: through the duration of the song, to say a small prayer in your mind as the song's going. Sit back, and really feel our people.

He sang two songs for those of us who were in the room, then exited to lead a procession of dignitaries to the platform at the front of the hall, singing another.[2]

When Waboose had finished, John Cree, a Mohawk Elder from Kahnawake, was called to the microphone to welcome us to the traditional territory of the Mohawks and to pray.[3] Before doing so, he passed a smudging bowl among those assembled on the platform. Then he proceeded to give a long address in both English and Mohawk. It soon became apparent that the opening ceremonies would go well beyond their initially allotted hour. Nor was this unusual at this national event or others: it often happened that certain people, and certain protocols, took however much time they took (see McNally 7–8, 221).

Song as Sacred, Participatory, Circulating, and Emplaced

The foregoing account highlights some of the kinds of work that Indigenous song accomplished at the Québec National Event and other TRC gatherings I witnessed in Halifax and Saskatoon.[4] Perhaps most importantly, song acknowledged relationships between attendees and spiritual beings—including between co-present "brothers and sisters" and "ancestors in the spirit world." It also coordinated collective action, for example, by leading participants into the spaces where testimony was to be given. Music thus played a significant part in orienting to one another the persons, seen and unseen, who would together be occupying the time and space of the TRC gatherings.

Song addressed not only those who came to bear witness, their supporters, and their ancestors, however, but a wider, mass-mediated audience as well. (Accordingly, I was able to observe Don Waboose's singing performance several times after the event, via a streaming video recording on the TRC's website.) Music was thus enrolled in the broader intervention enacted by the TRC events, which sought to educate the settler public about Indian residential schooling and its ongoing consequences for Indigenous people. The chapter that follows expands on these ideas, considering how song at TRC events connected attendees and their spiritual relations, facilitated participation, and prioritized intimacy, even as it hailed much wider national and international audiences.

I came to the TRC events in part as an ethnographer who studies Indigenous music, but also as a member of the non-Indigenous settler public those gatherings hailed and held to account. That position informed my observations in many ways, including through a perhaps exaggerated awareness of aspects of social interaction and musical performance that might have seemed remarkable to a settler audience, but that were nevertheless accommodated or even prioritized at TRC events. If I focus from time to time in this chapter on moments of performance that some readers might regard as infelicitous, the point is not to find Indigenous musicians lacking against ostensibly universal standards. It is rather to locate moments that, for the very reasons they might seem marked to other settler observers, shed light on the kinds of participation that event organizers consistently honoured and made room for. It is also to insist that the aesthetic expectations of a settler audience need to be understood as particular and parochial, however powerful they are. Thus, for instance, in mentioning that the opening ceremonies in Montreal extended well past the time allotted for them, my aim was not to suggest that the singers and speakers had failed to uphold some global standard of timekeeping, but rather to point to the way the event made room for certain protocols, however much time they took. In drawing attention to such moments, the purpose is not to hold them up as examples of failure, but instead to point out instances when alternative priorities were being affirmed.

Returning to an earlier point, although TRC events were oriented outward via the media to a generalized Canadian public, they were simultaneously gatherings in specific places and times. Attending to the musical dynamics of these events thus means considering how music undertakes not only work oriented to a mass public, but also more emplaced and particular tasks—and it means considering the multiple, sometimes complementary and sometimes exclusive, aims of song. In discussing these differing aims and orientations, I will frequently distinguish between music that engages intimate, co-present contexts and music that hails audiences of strangers; I will use the terms "publics" and "imaginaries" to designate the latter, unknown audiences, addressed by means of radio, television, print, and other forms of mass mediation (see Warner 65–124).

Spiritual Song

The TRC national events I witnessed in Halifax and Saskatoon, like the one in Montreal, opened and closed with ceremonies in which song played an important role. Ceremony and song are widespread in Indigenous public culture, but they seemed especially appropriate at

the TRC gatherings. Giving testimony required strength and bravery from residential school survivors and others whose lives had been affected by the crushing intergenerational effects of residential schooling. The commission, too, faced challenges, including struggles with the federal government to gain access to a more complete set of historical documents relating to residential schooling.[5] More broadly, the commission was concerned that its events receive national attention. In short, there was a great deal at stake for all involved.

In these contexts, song oriented participants to one another, to unseen relations, and to the difficult work to be undertaken together within the space they shared. Consider again how Don Waboose, before singing, drew attention to the testimony attendees would shortly hear from "our brothers and sisters," and pointed to the presence of "our ancestors with us here today."

Not only drum song but Christian song addressed itself to the coordination of relationships between singers, hearers, and persons or beings unseen. For example, at the national event in Halifax, the delegation of Labrador Inuit bid farewell to other attendees by singing the hymn "God Be with You till We Meet Again" (see Beverley Diamond's discussion of this performance in her chapter in this volume, 253–54). In singing the hymn, the Inuit performers activated relationships with the others in the room and with the sacred, asking God to be with their hearers when they went their separate ways.[6] That they imparted this blessing immediately after a plea had been made for their residential school experiences to be addressed by the federal government was especially important, since the people they sang to included a number who would be taking that plea forward.

Participation

A second important aspect of song at the TRC's national events, and one often intertwined with its sacred aspect, was its participatory character. This was in evidence during the survivors' walks that opened the gatherings in Halifax, Saskatoon, and Montreal, as well as the moment during the opening ceremonies in Montreal when Don Waboose requested that we help him by saying a prayer as he sang. The national events were participatory undertakings more generally: people came to give testimony, to make "Gestures of Reconciliation," and to witness and support others as they did so. Song almost always played a role in the plenary parts of the gatherings, when attendees came together in the same room.

Musical participation was also an important aspect of the activities organized during the evenings at the national events, for instance, the talent shows I observed at the Halifax and Montreal gatherings. A wide range of musicians, professional and amateur, got involved in these shows, and many musical styles were represented, including drum song, traditional dance, Christian devotional song, light classical music, fiddling, country, rock, rap, and R&B.[7]

Notable was a sense that anyone could contribute, whatever a settler audience might have thought of their musical abilities.[8] Notable, too, was a lack of shyness on the part of both "strong" and "weak" performers. These characteristics point in part to the intimate character of the talent shows (see Beverley Diamond's chapter in this volume): event organizers had created spaces where music was made by and for those giving and hearing testimony. They had also created spaces that welcomed the participatory performance of musical distinctiveness,[9] often manifest as a nonchalant, even charismatic disregard for dominant musical conventions. While this could make for uncertainty or unevenness in performance, it often contributed a real sense of excitement to the proceedings.[10] Algonquin singer Jimmy Hunter's raucous set of country and rock standards—all over the place rhythmically but bursting with energy—brought an enthusiastic crowd of dancers up to the stage at the talent show in Montreal. Similarly, audiences—and, in Halifax, the judges awarding the prizes—showed appreciation for not only professional-sounding performers but also musicians whose intonation was unsteady or who performed in a rhythmically irregular style.

Only a small number of TRC attendees had an opportunity to take part in the talent shows, but the evening musical events offered additional opportunities for broader forms of participation. After the contestants had performed at the talent show in Montreal, Don Waboose taught the audience some drum songs and had us sing along with him. At a number of points earlier that evening, members of the audience had got up to take part: to dance during Jimmy Hunter's aforementioned set; to jig during a performance of the "Orange Blossom Special" by the Algonquin Pesendawatch Family; and to dance to traditional drum song sung by Innu singer Réal Mckenzie. The following night, there was a moment during Innu singer Florent Vollant's performance when it seemed that nearly the entire audience was on its feet, with many of them dancing through the room in a long, winding line.

The evening events made use of a format (the talent show) and musical materials (e.g., gospel songs and popular music) associated with non-Indigenous origins, but this should not obscure the ways

in which they facilitated expressions of Indigenous personhood and collectivity. As remarked earlier, they presented opportunities for distinctive performances of musical selfhood; they also enacted a particular understanding of music making, in which expertise was welcome but, in the end, less important than participation. As this suggests, in attending to the aesthetics of reconciliation, it may be important to listen to all of the music that fills the spaces of assembly, and not simply what sounds professional and polished.

My argument is not that poor music accomplished good things. Nor is my aim to mobilize the kinds of aesthetic criticism that would frequently be brought to bear by the settler public (except by way of pointing out the power of these forms of criticism). It is rather to show how TRC events prioritized musical participation and opened up spaces for performances of Indigenous personhood and community. What from some aesthetic perspectives might appear to be musical infelicities should in these contexts be understood as evidence of an insistence on inclusivity and on acknowledging the full range of Indigenous expressive performance. "Mistakes" from the perspective of one evaluative regime were in fact evidence of other kinds of success.[11]

Intimacy and Imagining

Music at TRC events was not only concerned with articulating relationships between attendees, or opening spaces for the performance of selfhood and community; it also addressed a broader public. This was especially true of a number of songs, performed at TRC talent shows and concerts, on the subject of residential schooling and its intergenerational consequences. Many of these songs had circulated in the form of recordings and live performances well before the TRC events, and they often undertook a similar kind of political work: enrolling, through appeal to painful stories of individuals, families, and communities, support for those affected by residential schooling.

This political work frequently involved orienting narratives concerning particular persons to wider national or international audiences of strangers—what I have elsewhere described as articulations between intimacies and social imaginaries.[12] Such an articulation is exemplified in the following account, from a 2010 presentation to the Senate Committee on Aboriginal Peoples by the Honourable Justice Murray Sinclair, which describes how the songs of the late Cree singer and songwriter Edward Gamblin came to be presented to the Truth and Reconciliation Commission:

Florence Kaefer told us ... that in 1957, as a young teacher she went to work at a residential school in Norway House, Manitoba. There she met Edward Gamblin; five years old when he entered the school. She worked at the school only a short time and eventually moved on. Once proud of her teaching career, by 1990 she said she had stopped talking about her work in residential schools, as revelations about abuse began to surface. In 2006 she discovered a country music CD by a singer named Edward Gamblin and wondered if it was the child she knew. Kaefer purchased the CD and was devastated by what she heard—songs about pain and torment and loneliness suffered in the school. She reached out to Gamblin, who remembered his teacher, and her classroom as a place of refuge. She travelled from her home in Courtenay, BC, to visit him and the two became friends. Kaefer visited several times, and she and Edward went through their own reconciliation process.

Edward Gamblin was in Winnipeg during the TRC's National Event, but not at the Forks historic site with us. Instead he was in hospital with a heart condition. Kaefer flew to his side and remained with him on what would be the final leg of his earthly journey. As he lay in the hospital, at Edward's request, she came to the National Event to present Edward's gift of music to the Commission and to share their story with those in attendance. (TRC, *Presentation* 5)

The account does not specify which songs Kaefer heard or presented to the commission, but very likely among them was "A Survivor's Voice," released on Gamblin's album *Cree Road* in 2006. That song describes the alienation of an Indigenous child from his culture at residential school, as well as a subsequent distance from his own children later in life.

Sinclair's account suggests two moments when intimacy was oriented to a social imaginary. First, Gamblin's narrative of a particular boy, his experiences in a residential school, and their consequences for his emotional life as an adult was recorded and released to the public as "A Survivor's Voice" (that public is explicitly hailed in the song's refrain, which exhorts the nation, "Canada, heal with me"). Second, the account of the personal reconciliation between Gamblin and Kaefer was presented by the latter to the TRC, and then by the TRC to the Senate Committee on Aboriginal Peoples and to a broader national public.[13] In both cases, specific experiences and interactions between particular people became the basis for narratives addressing much broader audiences.[14]

It is not only recordings and narratives that connect intimacy and imagining, but musical performances as well. Performances frequently engage specific groups of co-present participants even as they address broader, unknown publics, as was particularly apparent when I watched the opening ceremonies of the Saskatoon National Event via streaming video. As part of those ceremonies, a group of young singers from the Kihew Waciston (Eagle's Nest) Cree Immersion School at Onion Lake First Nation gathered on the stage to sing. All told, there were perhaps thirty schoolchildren, aged around six to nine, accompanied by a number of adult chaperones, one of whom led the group with a frame drum. Many of the children wore shirts or dresses in a traditional or neo-traditional style: there were girls in dresses and blouses with colourfully fringed and beaded collars and boys in ribbon shirts. The drummer came to the microphone before the second song, announcing that it was a prayer song and asking the assembly to stand for it. Together, attendees and singers faced east, south, west, and north, changing position at the beginning of each of the song's four strophes.

In the announcer's introduction, the children's presence represented hope for the next generation of Indigenous people, but it also seemed to signify a number of things implicitly. In part, it was a reminder of the age at which many of the older attendees had been taken away to residential schools. It additionally pointed to a dramatic inversion: whereas students at residential schools had often been removed to environments where they were forbidden to speak Indigenous languages and separated from the traditional practices of their communities, these children were attendees at a school where they learned the Cree language and drum song. The performance asked a co-present audience, as well as a more general public, to reflect on what it would have been like for children of this age to be separated from their families and communities, and it invited them to think about the implications of the past for the futures of those children.

Prioritizing Intimacy

At the same time, there was a specific and emplaced aspect to the Saskatoon performance that did not lend itself to mass mediation, epitomized by the way attendees moved through the four directions in prayer. As at the opening ceremonies in Montreal, song set participants in relationships to one another, to the spiritual world, and to the immediate physical context. Certainly, aspects of these connections were available to the mass-mediated audience, but as someone who watched the proceedings at a distance, it was all too evident that I was

engaging with them in a different way. I could have stood up in my study while watching the webcast, and turned in the four directions, and indeed I could do so now, as I view the archived broadcast, but something is missing. What is lost in part is a sense of being implicated and accountable to co-present others.

Significantly, TRC events and people at them regularly prioritized Indigenous intimacies, even when this meant curtailing the public circulation of songs and ceremonies (without necessarily rendering these "private"). So, for instance, at one of the national events, I spoke informally to a residential school survivor whom I had heard sing a moving piece of music she described in her testimony as a healing song. I asked her whether she had recorded it and she told me she had not, and in our subsequent discussion she explained that this was because she liked to know whom she was helping. One way to interpret her position is that, in orienting a song to a public of strangers, the dynamics of intimate interaction disappear, and one no longer sees what one is doing and for whom.[15]

The relaxed relationship many talent-show performers had to hegemonic stylistic expectations similarly suggests an orientation that prioritizes immediate social circumstances. Certainly, many participants in these shows made use of songs and styles that circulate in mass-mediated form, and in doing so demonstrated affiliations to broader social and stylistic formations.[16] At the same time, their performances did not always suggest an overriding concern to calibrate what they were doing to the conventions that govern those styles. Music making was not first and foremost a contribution to a field of mass-mediated performances, but rather something that was done for the people assembled in a particular place—something that would help others to understand, heal, or laugh. Again, this is not to say that performers did not want a broader public to hear their music or message, but rather to identify how aspects of music making prioritized intimacy.[17]

Family and Nation

Musicians and other participants at TRC gatherings privileged not only intimacies between people present at those events, but also relationships to family and community. Among the final performers at one TRC talent show were an older First Nations man and woman who sang together, the man accompanying on guitar. They performed two Christian devotional songs, the man dedicating the second to the memory of his grandniece and niece and explaining that they had

just buried his niece the previous day. It was late in the evening, the program was running behind schedule, and competitors had been performing one piece each. When the couple finished their second song, stagehands rushed to move their microphones and the emcees quickly announced the next performers, a reaction that suggested the singers had misjudged the appropriateness of their contribution. Yet it is also possible to understand their performance as a fitting response to a difficult situation. Even though grieving the loss of a relative, the two singers had come to participate in the national meeting, and in this way demonstrated their commitment to both the truth and reconciliation project and their family.

The importance of intimacy was not only evident in song. A panel entitled "It Matters to Me: A Call to Action on Reconciliation" at the national event in Montreal considered the issue of reconciliation between Indigenous and non-Indigenous people and explored, among other questions, how the sense of culpability or shame on the part of non-Indigenous Canadians might be mobilized nationally. One speaker reframed this political idea of reconciliation in a strikingly personal way: for her, reconciliation meant mending the relationship with her daughter through prayer and ceremonies. When asked what implications this might have for Indigenous people more broadly ("for all of us, for the broader community"), she replied that what she did for her children she also did for the future, seven generations away. Notable was an insistence upon the relational specificity of reconciliation in which even "the broader community" was framed in terms of descent.

Both of these moments were notable for their drift from certain of the concerns emphasized at TRC events: the singers described a recent grief that they did not associate with residential schooling or its intergenerational effects (subjects many of the performers at the talent show had focused on), while the speaker redirected a conversation about national reconciliation to a discussion of reconciliation within her own family. These were particularly acute examples of a persistent prioritization, in music and testimony, of family and community.

Residential schooling was a national project in a number of senses: it was implemented across Canada, and it sought to make Indigenous children into Canadians by disrupting the intergenerational transmission of language and other aspects of culture.[18] Underwriting the attempt to assimilate Indigenous children was a prioritization of potential relationships between those children and the nation, and a discrediting of actual relationships between the children, their kin, and their communities.

Because the scope of residential schooling was national, so too was that of the TRC. This had a potentially serious consequence in that it continued to centralize relationships between Indigenous groups and the nation. Hopeful stakeholders understand these relationships to be undergoing a potential transformation: consider, for instance, Commissioner Murray Sinclair's address to the audience during the opening ceremonies of the national event in Saskatoon:

> [All] of you who are here ... are being asked to bear witness to what it is that will be said and spoken about during these next four days, but at the same time we ask you to take the message forward to all of Canada that we all must embrace the solution, and we all must work together to ensure that not only those who were affected by the schools are helped in their healing, but that this country becomes the truly great country that it can be by overcoming the shame of this particular portion of our history and at the same time building a better place for all of us. (TRC, "Live Show [Procaster] Thu Jun 21 2012")

Yet in these remarks, the relationship between Indigenous people and the nation seems as central as ever. Given the importance of nation in the truth and reconciliation project, it seems significant that musical performances at TRC events often focused on the immediate context, more so than the national one, and on relationships with kin and community. In prioritizing these relationships, song was perhaps enacting a compensatory politics of emplacedness and particularity.

Conclusions
Intimacies and Intimate Publics

The singer who preferred to know whom she was helping with her song is a reminder that certain kinds of singing are deployed in specific contexts and address particular persons. Not all singing is primarily oriented to publics or markets of strangers, and singers may even take measures to prevent it from circulating in this way. Accordingly, the preceding accounts have shown how some musical performances privilege intimacy, prioritizing relationships between co-present persons, beings, and places.

Recent scholarship in the humanities has emphasized the role intimacy plays in song (and writing, film, etc.) oriented to publics or markets. Perhaps most notably, Lauren Berlant has explored how work oriented to a public presumes audiences whose members share certain affective sympathies (Berlant, *Female Complaint*; see also Stokes). This is certainly true of the TRC's national events and publications, which seek to appeal to the hearts of the public they address. Nevertheless, an important distinction is relevant here: intimacies between particular persons, beings, and places are not the same as the generalized intimacies one presumes to share with the members of a stranger-public.

Both kinds of intimacy were evident in the music performed at TRC events, in ways that were sometimes complementary and sometimes exclusive. But while the music performed at the events may have been heard by national and international audiences, it was often concerned with aspects specific to the events and those present at them: preparing attendees for (and releasing them from) the emotionally and spiritually difficult work of giving and witnessing testimony; bringing them into relationships with co-present others, seen and unseen; undertaking to comfort or heal; and performing both solidarity and personal distinctiveness.

Participatory Music Making

Thomas Turino distinguishes "presentational" music, in which there is a strict division of roles between those who make music or dance and those who observe it, from "participatory" music, in which everyone is involved in some way in the collective production of sound and movement. As I have suggested, many instances of music making at the TRC's national events were participatory, perhaps most dramatically the movements of attendees into and out of the spaces where testimony was to be given, to the sound of drum song.[19] The categories "presentational" and "participatory" hinge on a difference in orientation that seems especially salient in the case of music making at these events. As Turino argues, in presentational interactions, it is the quality of the music and of the performance that matters, whereas in participatory interactions it is the quality of the mutual engagement: "participatory music and dance is more about the social relations being realized through the performance than about producing art that can somehow be abstracted from those social relations" (35). This, too, suggests that it is significant that, while music making

at TRC events may have been disseminated to a wider public, it was so often concerned with negotiating and realizing relations between co-present intimates.

* * *

To sum up, music performed in and around the TRC's national events attempted a number of kinds of work, sometimes simultaneously. Some music undertook clearly political tasks, addressing national and international audiences, calling attention to historical wrongs, and pointing to ongoing injustices. Other music was deeply intertwined with interactions at the events themselves, organizing relationships between attendees (e.g., through dance and other coordinated movement through space) and between attendees and spiritual beings. The work of song, like that of testimony, was in many instances an affective labour that sought to move an *intimate public* through narratives that appealed to presumed fellow-feeling in its hearers. But song also organized *intimate assembly*, coordinating relationships between participants at particular events. It was in this regard that certain aspects of Indigenous interaction were especially evident, including the importance of sacred observance and participatory inclusiveness. The TRC's national events made room for sacred song (both traditional and Christian); for dance and symbolically participatory musical forums like talent shows; for performances of personhood and acknowledgements of the specificities of Indigenous groups and communities. Not all of the song performed at TRC events made an immediate or obvious political argument, but such music, too, merits consideration as a part of the undertaking, not least because it prioritized the very intimacies residential schooling attacked.

Notes

1 This account is based on field notes taken at the Montreal gathering and a subsequent review of the TRC's online recording of the streamed broadcast of the event (TRC, "Live Show [Procaster] Wed Apr 24 2013"). The video can no longer be accessed.
2 All the songs alternated non-verbal syllables and sung text and were accompanied by the drum, but Waboose sang different kinds of songs for the different parts of the opening ceremonies. The song he identified as a spiritual song had a straightforward musical form (a repeated strophe with slight variations), while the song that accompanied the grand entry of residential school survivors had, appropriately enough, the

asymmetrical structure associated with powwow songs (powwows open with a grand entry; on the asymmetrical structure of powwow songs, see Levine and Nettl).

3　On the second day of the event, Cree explained that he wasn't so much praying as saying a "few chosen words in our way of life" (TRC, "Live Show [Procaster] Thu Apr 25 2013").

4　As will become apparent, I observed the Saskatoon National Event from a distance, via streamed broadcast.

5　For a summary of these struggles, see TRC, *Honouring the Truth* 27–29 or various accounts in the press, for instance, Perkel, "Truth Inquiry."

6　Patricia Kemuksigak's remark (reported in Diamond's chapter in this volume) that "God Be with You till We Meet Again" summoned the memory of departed loved ones suggests that Christian songs, like traditional ones, also acknowledge relationships between the living and the deceased.

7　Many of the performers at the talent shows were figures of some prominence, including well-known members of Indigenous communities, TRC commissioners, and members of the TRC Survivor Committee, but they had a participatory and egalitarian ethos all the same. I was struck by how similar the talent shows were to others I had attended while doing fieldwork in Manitoba, where coffee houses, talent shows, and jam sessions are frequent and valued forms of Indigenous pubic assembly, and where a similar participatory ethos prevails.

8　My reference to the standards of the settler public needs some nuancing. On the one hand, a participatory openness similar to that at the talent shows can also be found at certain events where non-Indigenous people are in the majority. On the other hand, there are events organized by Indigenous people that hold performers strictly to hegemonic standards of musical or choreographic competence. The point is that TRC events consistently created spaces that were open to participants who possessed (by those hegemonic standards) very disparate levels of skill.

9　The mid-twentieth-century ethnographic literature on Cree and Ojibwe communities (see Hallowell, "Culture," "Ojibwa"; Jenness; Landes; and Mason) places considerable emphasis on social individuation. Michael McNally has criticized this literature for its overemphasis on individuation and its relative lack of attention to community; nonetheless, the older literature identifies something significant about (what today might be called) the performance of selfhood. I suggest elsewhere that individuation remains an important element of Cree and Ojibwe musical performance, but that it is best understood to exist in a complex relationship with Indigenous forms of collectivity (see Dueck).

10　Relevant here is Charles Keil's argument that musical discrepancies—for instance, of timing, tuning, or timbre—invite social participation (see Keil, esp. p. 277).

11　This argument is indebted to elements of Thomas Turino's concept of "presentational" and "participatory" performance (*Music as Social Life*), discussed at greater length at the end of this chapter.

12 See Dueck. This idea of intimacies oriented to imaginaries is informed
 by Lauren Berlant's concept of the "intimate public" (*Female Complaint*)
 and to the work of Berlant and Michael Warner on intimacy and publics
 more generally (Berlant and Warner; Berlant, *Intimacy*; Warner), as well
 as writing on music by Martin Stokes and Georgina Born.

13 The same story was also disseminated by CBC News Manitoba ("Teach-
 ers Seek Healing") and again by the TRC in its summary report (*Hon-
 ouring the Truth* 274).

14 The two intimacies described here are not strictly parallel: Kaefer repre-
 sented herself and Gamblin and their interactions in her public state-
 ments (see especially "Teachers Seek Healing"), but it is difficult to say
 whether Gamblin's lyrics are strictly autobiographical or more broadly
 representative. All the same, in both cases, the accounts draw their force
 from the representation of intimacies, whether the brutal intimacies of
 residential schooling or the much happier one in the narrative of recon-
 ciliation.

15 That she sang that song while giving testimony that was streamed over
 the Internet complicates this account.

16 A number of performers at the TRC's evening musical events playfully
 mimicked the styles of famous musicians. In this way and others, they
 performed their positionality with respect to certain songs, genres, and
 publics (affection, approval, ironic distance, and so on; see Warner 102).
 Nonetheless, it was the immediate social context that mattered espe-
 cially.

17 During a discussion in Montreal in 2013 of research to be included in
 this volume, David Garneau advocated an Indigenous aesthetic of art
 that placed artist, artwork, and audience together in the same space—an
 aesthetic that, in another way, might be understood to privilege intimacy.

18 As observed at TRC gatherings and in the summary of the commission's
 final report, such disruption constitutes cultural genocide (see TRC,
 Honouring the Truth 1–2).

19 The talent shows at TRC events involved collective involvement of a
 somewhat different kind: a sequential form of participation (see Turino
 48–51) in which many were encouraged take part, but one or a few at a
 time rather than simultaneously.

CHAPTER 13

CHAPTER 13

Gesture of Reconciliation: The TRC *Medicine Box* as Communicative Thing

Elizabeth Kalbfleisch

"There are no art things. The aim of something has always been communication. There are only communicative things."

—Esther Pasztory, *Thinking with Things: Toward a New Vision of Art*

Introduction: The Importance of Things

Words and actions, not things, drive the work of the Truth and Reconciliation Commission.[1] This is especially true of the public gatherings organized by the TRC between 2010 and 2015. In addition to meticulously collecting records and testimony from Indian residential school (IRS) survivors so as to amass a public historical record, part of the TRC's mandate was to host this series of national events. The TRC commissioners, survivors and their families, special guests identified as honorary witnesses, and the local public congregated at large hotels, convention centres, and fairgrounds for several days at a time for activities both solemn and celebratory. These multi-faceted events provided the opportunity for survivors to speak publicly about their residential school experiences, as well as for school staff, clergy, or other officials to make oral "Statements of Reconciliation." The gatherings, it was hoped, would facilitate the challenging process of reconciliation between survivors, their families, and communities, and, moreover, with church representatives, government officials, and a settler public who may feel that IRS history has little to do with them.

These events also provided a window onto the TRC for the many scholars who attended—Indigenous scholars and those of settler backgrounds, like myself. As an art historian interested in Indigenous–settler relations and their impact on the visual arts, my own experience

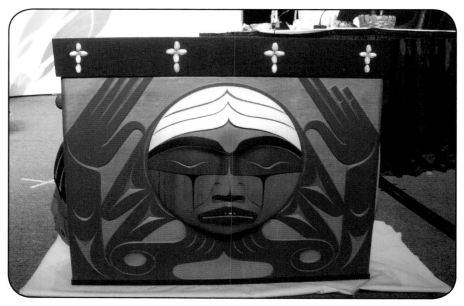

Figure 13.1: View of Luke Marston's *Medicine Box* at the Saskatoon TRC national event, June 23, 2012. Photograph by Elizabeth Kalbfleisch. Reproduced with permission of the Truth and Reconciliation Commission and the artist.

of the TRC events was shaped by the emotional force of the proceedings enmeshed with the task of listening, observing, asking questions, and seeking knowledge; identifying the role of the notionally "static" art object in this charged atmosphere became all the more pressing. Much of what will come to constitute the public memory of the TRC's work in this setting will be driven by words: stories, memories, the articulation of presence and of responsibility. What was said and how it was delivered are key to this undertaking. And yet objects shadow the process, communicating feeling and meaning in the manner Esther Pasztory suggests in the quotation that opens this essay. The presence and work of material things are evocative, set as they are within this larger setting focused on orality.

A Bentwood Box for the TRC

Early in its mandate, the TRC commissioned a bentwood box from Coast Salish carver Luke Marston. Formally, the box is titled *Medicine Box*, though it is more often referred to as the bentwood box or, sim-

ply, as the TRC box (Figure 13.1). The box travelled across Canada with the three commissioners, Murray Sinclair, Wilton Littlechild, and Marie Wilson, as they carried out their work and was present at the TRC national events that are the focus of this essay. The *Medicine Box*'s materiality is all the more pronounced given the events' dual emphasis on orality and action. Orality includes the aforementioned statement making, truth sharing, and official addresses, while examples of action involve opening and closing processions, ceremony (such as tending to the sacred fire that burns nearby for each event's duration, burning sweetgrass, and lighting a *qulliq* [an Inuit oil lamp]), and the singing and dancing that occurs during the evening entertainment programs.

During the TRC proceedings, the *Medicine Box* serves as both a functional and a symbolic vessel. The *Medicine Box* sits centre stage at the sharing panels during which the commissioners listen to hour upon hour of testimony. As survivors from all regions of the country recount their experiences, they share a space with this bentwood box, often the sole object upon which the eye can rest during these arduous minutes of testimony, much of it detailing abuse, deprivation, loss, and loneliness. It also serves as a repository for material offerings made by speakers: handwritten notes, photographs, archival mementos, and newly made or procured gifts have all been ceremonially committed. The *Medicine Box* remains in place throughout the day and as events unfold. So placed, it assumes the role of an object witness to the more officious aspects of reconciliation such as speeches by dignitaries and honorary witnesses. But this presence continues through the lighter aspects as well, such as the dancing that accompanied a performance of Elvis Presley's "Hound Dog" during a talent night in Montreal.

The *Medicine Box* is intractably connected to the work of the TRC in the context of these events. As an object, it derives its thingness—its object identity—from the unique status it holds as a Northwest Coast object made for the TRC: a highly specific pan-Indian body with cultural, political, and social dimensions. This thingness is also informed by the communicative power the box holds within a transcultural Canadian landscape, for these TRC events are open to a settler public, a public encouraged to attend and participate in the process of reconciliation. Parsing this complex context is key to understanding the uniqueness of the *Medicine Box*. Thus, I will present some of the *Medicine Box*'s imagery as it reflects the artist's Coast Salish viewpoint, but also how it reflects and serves IRS history and the TRC project. To this end, I will also discuss the function of the *Medicine Box* at the TRC, including the ways in which it serves as a mnemonic device. Finally,

I will argue that it acts as a surrogate for the complicated processes of intercultural reconciliation invited by the TRC in this setting. The box prompts a discussion of the ways in which it speaks to the various communities party to the TRC's work and further, how different meanings might together contribute to the *Medicine Box*'s complex object status, its *thingness* to use Bill Brown's term for the stuff that prefigures and exceeds an object (5).

The *Medicine Box* remains an object of significance within the Coast Salish culture of Marston, its maker, based on its material, social, and aesthetic attributes as a bentwood box, crafted from red cedar. Yet over and above the specific imagery that decorates it, the commission of a bentwood box is highly suggestive from a pan-Indian and a transnational (meaning Indigenous/settler) perspective. Its use by the TRC informs its unique object status as a pan-Indian tool of reconciliation. The TRC could have chosen any number of culturally specific receptacles: an Abenaki woven basket or a stitched Inuit skin bag could have served the same purpose. Surely, the familiarity of a bentwood box and its iconographic style to those beyond the Northwest Coast region influenced its selection.[2] Moreover, its imagery and design prompt an intercultural recognition by a settler population, a recognition necessary for the TRC to maintain the momentum of its mission.

For settler Canadians, Northwest Coast art has long been, arguably, the most familiar, respected, and valuable style of Indigenous art. Though this has not been confirmed by the TRC, this recognizability may well have played into the TRC's decision to select and use Marston's *Medicine Box* so as to draw as many Canadians as possible—Indigenous and settler—into the reconciliation process. The box complements and carries the TRC directive to, as expressed by TRC Chair Justice Murray Sinclair, "ensure that the whole world hears [survivors'] truths and the truth about residential schools, so that future generations of Aboriginal and non-Aboriginal Canadians will be able to hold to the statement that resonates with all of us: This must never happen again" ("Address to the Assembly of First Nations").

Medicine Box as Coast Salish Object

Marston (b. 1976) is a member of the Stz'uminus First Nation and part of a family of respected carvers that includes his parents, Jane Marston and David Marston, and his brother, John Marston. Marston trained under master carver Simon Charlie (1920–2005), a Cowichan artist

venerated for his dedication to maintaining and disseminating a Coast Salish aesthetic but who also advocated for the artist's imperative to experiment with design. Marston's participation as a young man in the celebrated carving program at the Royal British Columbia Museum's Thunderbird Park exposed him to carvers working in a variety of Northwest Coast Indigenous styles. While Marston's work promotes a strong, contemporary Coast Salish aesthetic, he remains open to other influences, as his training might suggest.

The *Medicine Box* locates much of its Indigenous identity in the red cedar from which it is fabricated, a ubiquitous and sacred material in Northwest Coast cultures, one with a capacity to both "sustain and enrich" (Stewart 19). Northwest Coast peoples revere cedar, and accordingly, it figures in many stories. These stories address the power, wisdom, and energy associated with it. One story that is frequently repeated tells of cedar's origins, and connects the growth of cedar to the burial site of a good and generous man.[3] Thus unsurprisingly, given the association with munificence and abundance, cedar has multiple uses. Bark, roots, and wood from the trunk are variously purposed for shelter (longhouses and pit houses), transportation (canoes and paddles), storage, clothing, and objects connected to the everyday like utensils and tools, as well as those intended for ceremonial or sacred use. Cedar's healing properties lend themselves to ritual and medicinal practices. Cedar boughs are burned, in the manner of sage and sweetgrass, for spiritual cleansing.

Artists gravitate to cedar for its widespread availability throughout the region, as well as its flexibility and rot-resistant properties. In spite of these attributes, cedar presents challenges to the carver. The same softness that invites carving may also confound the carver as detail and definition may be hard to realize.[4] Thus the artist's vision must be sensitive toward and guided by the full spectrum of the material's properties.

Typically, the four sides of a bentwood box comprise a single piece of cedar steamed and bent into place along scored lines; wooden pegs affix the bottom and a separate lid is carved from another piece. Bentwood boxes serve as many purposes as the cedar from which they are crafted, having been designated as vessels for cooking, eating, or drinking, and for storing or transporting possessions. A box, too, may provide seating. Some specially designated bentwood boxes served as burial boxes, the slim seam line where the ends meet up allowing a crack through which the spirit of the deceased might escape. The surface of the box offers a canvas for the depiction of the crest associated with the

owner's lineage. This display is as much about declaring ownership as it is about connecting with the otherworldly, and in this sense, the crest figure depicted serves both as embellishment and as a guardian of the box's contents on the owner's behalf (Stewart 87).

Indisputably, this special commission allowed Marston to design a wholly original and unique box, one appropriate to his training and style, his Coast Salish cultural identity, and the distinctive visual imagery suggested by IRS history and the TRC mandate. That being said, the box still fits comfortably within a contemporary Coast Salish carving style that marries the more traditional imagery associated with pre-twentieth-century carving with the contemporary styles that emerge from the mid-twentieth-century aesthetic. Not surprisingly, Northwest Coast artists today embrace and blend both the contemporary and the "traditional." Yet as Gary Wyatt points out, "both the art and the culture [of the Northwest Coast] have always been concerned with themes of transformation and regeneration, and many of the myths document a world that is ever-changing" (15). These themes sit comfortably within the TRC's rhetoric of remembrance and record-keeping, but also within those TRC directives for healing and reconciliation.

The panels of a bentwood box offer an ideal canvas for storytelling; indeed, many boxes and chests present visual turns on culturally held stories or historical accounts. Marston's highly stylized designs fit within the spirit of box decoration. However, the nature of the very specific imagery with which he embellishes the *Medicine Box* speaks to the innovation of contemporary artists in reinterpreting older models and conventions. If bentwood boxes provide a medium for Coast Salish artists to interpret stories, Marston does so by looking to modern and contemporary history as a complement to the stories and themes that contribute to Coast Salish iconography. As befits its commission, the *Medicine Box* contains specific imagery that references IRS history—imagery intended to speak to Indigenous survivors from across Canada, respectively and collectively. However, he maintains a clear Coast Salish viewpoint. This balance is best articulated through a formal examination of each of the box's panels.

Northwest Coast Panel

Marston dedicates a panel to the peoples of the Northwest Coast, the North, and the Woodlands/Interior, respectively. These three panels, each depicting a human face, are more popularly—and taxonomically—understood to represent First Nations, Inuit, and Métis peoples.

The front panel, taken as representing First Nations peoples collectively, maintains for the artist a Coast Salish character and intention. A woman's face anchors the design. Her lids are downcast and each eye emits a stylized black tear. Her raised hands, palms forward in supplication or self-defence, frame her face. Marston's grandmother attended Kuper Island Residential School in British Columbia, and he honours her here as the "face" of the Northwest Coast. At Kuper, a school nun threw Marston's grandmother down a flight of stairs, a fall that broke her fingers. She received no medical treatment and her hand never healed properly.[5] The silence around IRS experiences, which pervades many Indigenous families, meant that for years Marston had no idea why his grandmother's fingers were crooked, as she never spoke of it: "I remember seeing that as a child but I never knew the reason why her hands were like that."[6] Details emerged as Marston began carving the box. During the process, his mother, who carved it with him, told him more of what she knew of his grandmother's experience. On the panel, the cropped fingers of the left hand break the design's symmetry. By depicting this physical scar, the artist recognizes his grandmother's trauma but also her survival and dignity.

Just as slippage occurs between "Northwest Coast" and "First Nations," it occurs between child and Elder and between individual and collective. In honouring his grandmother, the artist also pays tribute to Elders collectively: those like his grandmother who suffered as children, and those who suffered in having their children and grandchildren taken from them. Of the panel, Marston asserts: "In a way this symbolizes my grandmother, but it symbolizes more than just her. It symbolizes all of the elders that have lost their children, and that were persecuted or arrested for trying to stop these people that came to take the children away."[7]

Northern Panel

While the style remains Coast Salish, Marston moves to address Indigenous diversity in the faces depicted on the two narrower side panels. The panel on the left represents the people of northern regions or Inuit. A stylized, white parka hood frames this face and the black notch of a stylized beard marks the chin. Bold green stripes alluding to the northern lights cut diagonally across a black sky dotted with white stars. This dramatic and beautiful feature localizes the population and connects people to place. The northern lights, representing "our ancestors in the sky," also link survivors to those who came

before. Marston notes that an Inuk woman told him northern lights symbolize ancestors dancing in the sky or playing soccer. The note of levity this interjects into the imagery suggests hope and an element of joy that is not incompatible with the tenor of the TRC events at which the *Medicine Box* plays such a pivotal role.[8]

As is typical of the more embellished bentwood boxes produced for cross-cultural trade post-contact, the *Medicine Box* has an elaborate colour scheme, one that makes use of a palette more extensive than the more limited black, red, and white associated with earlier decoration. Concomitant with this development are inlay designs fashioned from opercula, abalone, or sea otter teeth to further embellish the surface. The four small crosses of inlaid opercula spanning the front lip of the *Medicine Box*'s black lid evidence this shift. Moreover, the crosses are an indelible reminder of the role that the Roman Catholic and Protestant Churches played in the IRS system and, analogously, the role they play in the process of reconciliation, and their conspicuous presence at the TRC events.

Woodlands Panel

The right side panel, representing the Woodlands/Interior or Métis, is the most colourful of the three. Here, the artist departs from the tricolour scheme of the other two panels—black, red, and white on the front and black, white and green on the left side—and uses eight colours. White, navy blue, red, green, yellow, light blue, black, and peach sections of the medicine wheel frame the face. Some of these colours are repeated elsewhere in the design, including the face paint, symbolizing the strength of youth.[9] The fact that Marston depicts a child is most clearly conveyed by the hair framing the face. The fringe draped across the child's forehead references the blunt haircut given to all children upon school entry. This haircut remains one of the most visible signs of the collective subjugation of Indigenous children to church and settler authority, its uniformity viscerally assimilationist as well as a cultural affront where long hair is an important marker of identity.

The infinity sign, the emblem of the Métis nation, tops the panel, pierced by one of the box's two handles. Marston has left the grain of the wood exposed here, painting the surrounding ground in yellow. The infinity symbol demarcates the Métis presence, a highly significant gesture given the Métis exclusion from the IRS Settlement Agreement.[10] Importantly, with regard to the context of the box, the Métis

nation originally selected this symbol to reflect their dual origins. The resonance of that entwining of the Indigenous with the European is not lost in the context of IRS and the TRC: just as both European and Indigenous peoples were party to the schools, both must participate in the healing and reconciliation that follows.

Marston is quick to point out that he did not attend residential school and he does not take the experiences of those who did as his own, nor attempt to speak for others. However, he, like other intergenerational survivors, continues to witness the effects of this history. In a radio interview, Marston notes that he does not speak Halkomelem, as his grandmother did not teach the language to his mother or aunts, a loss he mourns as a residual effect of the suppression of Indigenous languages within residential schools. The pain of this loss is apparent. Even within the panel depicting a child with eyes wide open and with a face defiantly marked with face paint, Marston has also depicted a hand covering the child's mouth, recalling the collective silencing of Indigenous voices and the denial of language.

The artist's style stretches the limits of Northwest Coast on this panel as well. Northwest Coast iconography informs the Eagle painted on the child's cheek.[11] As a figure associated with intelligence and power, it maintains an iconographic place among various peoples of the Northwest Coast. However, the manner in which the Eagle evokes exalted ideals and the pursuit of freedom transcends Indigenous and settler cultural lines: the use of the Eagle as an American national emblem renders these conceits ineffaceable. The appearance of the Eagle evokes a response in many, regardless of cultural background and knowledge; potentially, this is a response commensurate with the TRC's mission of social justice. The style of execution also represents a departure from Northwest Coast visual culture. The simple outline drawing of the Eagle (rather than a painted depiction or an unpainted low relief) is not particularly Northwest Coast in style. It evokes, rather, the outline drawings of Plains peoples, and perhaps this can be implicitly understood as a gesture of inclusion toward Métis traditions.

Back Panel: Whale and Thunderbird

The back panel departs from the other three both in style and subject. Unlike the others, the design remains unpainted and relatively unadorned and the imagery is without oblique references to residential schools. The imagery does, however, reinforce nuanced TRC rhetoric.

Thunderbird and Whale fill the space, with small details embellished by abalone shells. In Northwest Coast storytelling, Thunderbird possesses the greatest power of all the beings in Skyworld. His vast wingspan can darken the sky; clapping together, those same wings have the power to make thunder. The celestial being is here coupled with Whale, a strong and dignified animal that can feed an entire community. Both provide sustenance and nourishment, whether spiritual, cultural, or physical. This message of inter-relation and complement is conveyed subtly. More forceful is the Thunderbird's significance as a powerful entity. As Marston attests, the Thunderbird is a *unifying* symbol:

> I wanted something that would encompass all of the natives from all across Canada, North America, South America. The Thunderbird appears in legends and stories all of the way up and down the coast, so this also symbolizes a loud voice that our people have now, that we are going to step forth and tell the statements of what has happened.[12]

The Thunderbird's *recognizability* reinforces a pan-Indian iconography, where some local specificity is traded for the impact of collective identity and power. Thus the Thunderbird transcends the locality of a cedar bentwood box, appealing in a generalized way to strength and *survivance* of Indigenous people through not only the IRS era but also the TRC process itself.

This extended description of the box's cedar material and the artist's use of Northwest Coast designs and style is intended to highlight the object's rootedness in the Coast Salish culture of its maker. This emphasis is important because, as a Coast Salish object unintended for Coast Salish use, the status of the *Medicine Box* is ambiguous. The TRC also assumes authorship of the box because it was responsible for its commission and perpetuates its use. The *Medicine Box* is thus a conflicted signifier, a repository for, at times, competing intentions. Fairly, thus, the box's confused status is in line with the often conflicting interests of the TRC itself, a body trying to serve Indigenous people and survivors, the churches, and settler Canadians, in addition to remaining accountable to government and international observers.

The commission formally acquired the finished box on April 16, 2009, during a blanket ceremony held in Coast Salish territory. The ceremony marked the transfer of ownership to the TRC and also the *Medicine Box*'s departure from its home territory, as the box's next stop was the Ottawa offices of the commission on April 27. The transfer, and the box's first journey, symbolically denotes a shift from local to national. Not insignificantly, the blanket ceremony took place in

conjunction with the annual Cowichan International Aboriginal Film Festival. This festival maintains an international scope, screening films from around the world and attracting filmmakers from international locations to the Cowichan Valley. The festival evokes the dynamic, contemporary, and transnational identity of this object set within a local and culturally specific setting. Though an event wholly different in tenor from the TRC national events, it presciently signalled the intercultural journey the box was to embark on.

Gestures of Reconciliation and the Prayer Shawl

As mentioned at the outset, the *Medicine Box* served as a receptacle during event proceedings. Many times over the course of the day, speakers consigned objects to the box while an audience looked on, an action the TRC came to refer to as a "Gesture of Reconciliation." The number of objects deposited belies its relatively modest size as a container. These objects were discreetly removed at intervals so that more could be deposited: the effect is of a bottomless vessel, its accommodation boundless. Offerings are often as straightforward as the speaking notes turned over by the presenter following his or her statement. Other documents, while not insignificant in terms of content, are more perfunctory, such as a copy of British Columbia's "Reconciliation Week Proclamation" left by B.C.'s Minister of Aboriginal Relations and Reconciliation, John Rustad, at the Vancouver event or a document presented in Halifax detailing resolutions passed at a synod meeting regarding a self-determining ministry for Indigenous people within the Anglican Church. Copies of documentary films about IRS have been presented, as have numerous books, and more than one Indigenous-designed school curriculum or textbook. More personal offerings abounded, such as a reproduction of an album of photographs once belonging to an IRS teacher, a brick saved from a demolished school building, and a small suitcase that a young child carried with him when he first left home. Artistic offerings have included many paintings, multiple sets of beaded moccasins, a newly designed flag for the Mohawk nation, and a mixed-media artwork made from a 2006 IRS hearing transcript, torn up, wrapped with sweetgrass, and sealed with wax.

Whereas most offerings appear sincere, if not heartfelt, one of the more memorable and confounding moments occurred at the Halifax event, when then Minister of Indian Affairs and Northern Development John Duncan presented a printed copy of Prime Minister Stephen

Harper's 2008 apology to survivors, as well as some printed literature about Métis artist Christi Belcourt's IRS-memorializing stained-glass window, *Giniigaaniimenaaning*, at that point still to be installed in Ottawa's Parliament Buildings. Both documents were readily available and freely distributed by volunteers in the TRC's own on-site education centre. Many found Duncan's participation in the TRC event disingenuous; they were not dissuaded by his choice of offering. As a "Gesture of Reconciliation," these observers understood it as an anemic contribution in comparison with the more personal and emotionally charged dedications left by others.

In line with the heavy presence of the churches at the TRC events, church representatives and parish groups frequently offered "Statements of Reconciliation," followed by a "Gesture of Reconciliation" deposited in the *Medicine Box*. At the regional event held in Victoria in April 2012, Barbara Atleo and Nora Martin, both Nuu-chah-nulth, and Mary Parry, of settler heritage, made an offering to the *Medicine Box* on behalf of the Anglican Church of Canada that materially encapsulates the TRC objectives of intercultural reconciliation and process-based healing. Following a statement of apology read by Anglican Church representative Bishop Michael Ingham, the three women stepped forward and held up a prayer shawl, hand-knit with rusty, earth-tone yarn. A community outreach group composed of parishioners from St. Peter's and St. Paul's Anglican Parish in Esquimalt, B.C., and from other local churches made the shawl. Members of the Prayer Shawl Ministry, as they call themselves, knit during meetings but also hold discussions and pray together. The preparation of prayer shawls, or comfort shawls as they are sometimes known, is an initiative of the Anglican Church (as well as others) that pre-dates the TRC: most often, members of the diocese donate handmade articles that are put aside until there is a need for them. The intention of the knitted shawl is to provide comfort to the recipient during illness and periods of stress or bereavement, or in the context of other significant occasions.

Aboriginal Neighbours, an organization associated with the Anglican and United Churches, hosted a community event in 2010 attended by 150 survivors and 150 church members. Following discussions in a sharing circle at this and subsequent events geared at reconciliation, four women—two Indigenous and two settler, including Atleo and Parry—looked for further steps they could take toward healing and reconciliation.[13] Atleo noted the importance of having blankets with which to wrap individuals, particularly after giving testimony at the TRC hearings, as being a vital component of healing. For those within

the church already familiar with the crafting of knitted and crocheted prayer shawls, the link was apparent.[14] One of the dialogical effects of the prayer shawl initiative was greater cultural understanding. Specifically, after working on this project together with Indigenous participants, settler knitters expressed an increased knowledge of the importance of blankets in Coast Salish culture.[15]

The name of the individual maker of the prayer shawl chosen for the "Gesture of Reconciliation" remains publicly unknown: the shawl was one of many already assembled for the TRC. Some of these shawls were drawn from stockpiles in place at individual churches; others were made specifically for the TRC by individuals and by groups like the Prayer Shawl Ministry. Most of the shawls were knit in pastel shades of mauve, blue, and soft pink. Keeping in mind its place in the *Medicine Box*, a shawl knit in earth tones was deliberately chosen for the "Gesture of Reconciliation" offering; Ruth d'Hollander, an organizer and member of the Parish Council, was particularly pleased with how it looked against the cedar grain of the *Medicine Box*.[16] For d'Hollander, prayer shawls are a tangible, soft, "lovely symbol of reconciliation. [The initiative] was very successful."[17]

The *Medicine Box* as Numinous Object

The multitude of objects accommodated by the *Medicine Box*, prayer shawl among them, suggests the box is something of a time capsule of the TRC's national tour. Photographers take pictures of those making "Gestures of Reconciliation" together with the commissioners, hands clasping the object poised over the *Medicine Box*. Each offering more informally presented by a survivor making a statement is noted by the attending commissioner so that it can be properly identified, underscoring the archival imperative of the TRC and the box itself.

As the commissioners frequently reminded participants, their tenure was limited and the work of the TRC will wind down. The University of Manitoba houses the archival material collected by the TRC as part of a permanent National Research Centre. This collection will include the *Medicine Box*.[18] According to Ry Moran, the TRC's director of statement gathering and director of the National Research Centre, the centre will continue to accept statements from those who wish to make them on an ongoing basis, so it "is safe to assume that offerings will be a possibility unto the future."[19] If one thinks of the offerings presented as merely the flotsam and jetsam of the TRC between

2010 and 2015, then the time capsule metaphor is accurate. However, the possibility of the *Medicine Box* remaining an active repository for future offerings reinforces its dynamic nature as an object and, moreover, the responsibility that the stewardship of such an object entails. The *numinous* quality of the box—and indeed the objects entrusted to it—echoes this responsibility.

As Rachel P. Maines and James J. Glynn define them,

> numinous objects are examples of material culture that have acquired sufficient perceived significance by association to merit preservation in the public trust. They are the objects we collect and preserve not for what they may reveal to us as material documents, or for any visible aesthetic quality, but for their association, real or imagined, with some person, place, or event endowed with special sociocultural magic. (10)

In this sense, what makes the *Medicine Box* special as a bentwood box is not its unique imagery and beautiful craftsmanship, as praiseworthy as those elements may be; rather, its worth is amassed through use. The *Medicine Box* acquires its numinous quality over time, in the presence of words that are spoken and because of the objects placed within it, objects that themselves tell stories. At TRC events, intense, emotional experiences are framed by the *Medicine Box* and concretized through its materiality. Numinous objects are imbued with stories and, in this regard, bridge affective experience with material culture. Through the object, memory is validated and the link to the past strengthened. Given the TRC's goal of validating the experiences of IRS survivors, the *Medicine Box* implicitly works in tandem with the TRC in this mission.

Maines and Glynn present the numinous within the context of museum-based object preservation. The numen of the object in question will continue to exist for as long as there is at least one person who remembers the association that lent significance to the object; documentation can support this remembrance (10–11). The TRC, by virtue of its directive to create a public, historical record of IRS history and its effects, is necessarily concerned with documentation and evidence building. This legacy will support the *Medicine Box*'s numimous position into perpetuity, all the more so once it assumes a place in the National Research Centre, just as the *Medicine Box* will itself become an active memorial to the TRC's work. The role of the objects presented to the box, however, remains indeterminate. This ambiguity stems from the fact that each contribution adds to the *Medicine Box*'s

numinosity, but, in addition, the individual meaning of each suggests the specific objects are themselves numinous. The narrative described about the prayer shawl indicates both to be the case, insomuch as the prayer shawl is an object that enhances the richness of the *Medicine Box* while also, with the context of its making set out here, contributing to a grander narrative of reconciliation.

The *Medicine Box* embodies "a particular sensory mix" in the manner by which Constance Classen and David Howes understand artifacts, one that encompasses its production, its circulation, and its consumption. The sensory values of the *Medicine Box* include its rootedness to cedar and to Northwest Coast objects of prestige; the emotionally charged environment of the TRC events where it is present and where it implicitly mediates the presence (and sometimes competing interests) of those in attendance; and the way it is used as a receptacle, where it is consumed as it consumes. As Classen and Howes point out, the institutional environment of the museum privileges the visual above all other sensory experiences. With a mandate firmly in place since the nineteenth century to preserve artifacts, other forms of engagement, particularly tactile engagement, are strongly discouraged if not outright forbidden (208). It is interesting to note that while event attendees were not invited to touch the box, those who did so—openly, during breaks in the proceedings—were not asked to stop. It is too soon to speculate on the environment the *Medicine Box* will inhabit at the National Research Centre. However, the box's numinous nature—and the imperative to appropriately care for it—can be in part understood by underscoring its vitality as a Northwest Coast object.

At.óow and Objects of Prestige

While the origins of the *Medicine Box* are Coast Salish and not Tlingit, its nuance as a Northwest Coast object of prestige can be usefully analogized through the Tlingit concept of *at.óow*. Foundational to Tlingit cultural life, outlook, and social structure, an understanding of *at.óow* is helpful in determining and defining the *Medicine Box*'s objecthood from an Indigenous point of view and to add further dimensionality to a default settler means of studying objects.[20] On the topic of *at.óow*, Tlingit scholar Nora Dauenhauer relays that "[o]ur forefathers designed ... art pieces so that we'll be able to see what they were about. This is what I always heard. We should make these things so that our children will know what we're about, which means what we

have in our art pieces. The art pieces were made because they were a part of people's lives. In Tlingit they're called *at.óow"* (Dauenhauer and Dauenhauer, "Tlingit Speeches" 31).

Though its Tlingit application is broader, *at.óow* translates literally as "an owned or purchased thing or object," with equal emphasis on ownership and thingness (Dauenhauer 25).[21] As is customary in Northwest Coast cultures, the thing may manifest as tangible or intangible wealth and can be identified with names, crests, stories, and land features, just as it can be with tangible objects of prestige. Possessing, caring for, and using the thing is key to cultural and spiritual survival and carries great responsibility. In this sense, *at.óow* informs the *Medicine Box*, for just as context is key to establishing the *at.óow*'s thingness, so too does the *Medicine Box*'s wholly unique context inform its identity and place. While old objects are often passed down in this capacity, new ones too can become *at.óow* through dedication and ceremonial use (Dauenhauer 26). The newness of the *Medicine Box* does not discount its weight or significance as an object, nor do its para-cultural roots absolve its caretakers from the responsibility of honouring and maintaining it. If the *Medicine Box* in some way participates in the healing of survivors—provides medicine to the people—through an interaction, that interaction has to be honoured and the box's use continued.

Medicine Box as Mnemonic Device

Typically, Northwest Coast objects of prestige are connected to specific events: as illustrated through the Tlingit example of *at.óow*, to be used on ceremonial occasions to recall or reaffirm key political or social moments. Objects intended for use within specific ceremonies, for example, retain the conceptual link to those contexts, and importantly, to the events, stories, or songs associated with them. By this logic, specific objects serve as mnemonic devices to people present at those ceremonies or who recall the relationship. Jonathan Meuli elaborates on this concept, suggesting how objects can act as mnemonics in other, more abstract ways. He begins with an account by James Clifford of a group of Tlingit Elders gathered at a Portland museum, telling stories in the company of Tlingit objects. What Clifford remarked, and Meuli seized upon, was that the stories told and songs sung "were not predictable," nor were they obvious referents to the objects present. Rather, those objects served as *aides-mémoires* for further, often political elaborations by the Elders (117).

In a more classic dynamic, relationships between objects and stories (or memories) elicited may be quite direct. Visual representations of crests, for example, act as mnemonics of the clans they represent. But in Clifford's example of the Tlingit Elders, this was not the case: the narratives that followed the Elders' encounter with the objects could not have been anticipated by the specifics of the objects themselves. Rather, it was the *presence* of the objects—as Tlingit objects writ large, in this setting and at this time—that set the tone for those stories. The anecdote suggests that cultural things may provide strong relational prompts, and further, that an object may serve as a mnemonic for the *act* of telling stories and not merely for the stories themselves. By this logic, in the case of the TRC, the *Medicine Box* provides a prompt for the *act* of sharing truths and receiving truths by residential school survivors, intergenerational survivors, and others implicated in IRS history and reconciliation.

Another way of looking at this is by considering, as cultural theorist Tim Dant does, all objects as media, whereby all those communications between people transmitted by speech, gesture, touch, or facial expression can also be contained in an object. For Dant, the mediating object has an important role to play where individuals cannot communicate these messages directly to one another (esp. 153–175). Many accounts, like Marston's own, describe the silence of family members around their IRS experiences. Furthermore, for some, the public forum of the TRC was the *first* instance in which they heard from their relations details of just what occurred. Here, the *Medicine Box* provides a mediating presence between teller and listener, facilitating that connection with the promise to safely "store" these truths. Settler attendees of TRC events, more accustomed to encountering Indigenous cultural property in the museum, are exposed to a *live* object, perhaps for the first time. Here, the active role played by the *Medicine Box* may disrupt settler ocular privilege, a mode all too typical of the museum experience, as mentioned previously. Some, too, will more actively participate in the construction of the mnemonic status of the *Medicine Box* as statement providers or as witnesses, or in the case of the settler co-presenters of the prayer shawl, as contributors to the box through a "Gesture of Reconciliation."

Pan-Indianism at the TRC

The *Medicine Box* has become a visual symbol of the TRC's work. During the TRC's active tenure, its website featured a "three-dimensional" image of the box that slowly rotated 360 degrees so as to display its four

decorated surfaces. Event attendees often photographed the *Medicine Box* and every program reproduced its image. Several factors conspire to render the *Medicine Box* an effective *pan-Indian* mnemonic for the TRC itself. One, this bentwood box was crafted specifically for the TRC; Marston designed it to be used in this context. In this sense, without a previous history of cultural use, its capacity as an *aide-mémoire* is inorganic. Two, the TRC—and the *Medicine Box* by extension—addressed a broad Indigenous population, for whom the cultural relationship between cedar, box, and teller may be recognized but not intimately *known*. Therefore the potential for the *Medicine Box* to work as a mnemonic exists, even if indexically prompted cultural memories do not. Meuli suggests that there may indeed be circumstances in which a structural connection between object and meaning comes about that is not based on specific information and the (artistic) attributes of the object, but because of the relationship between a broader notion of "orality-as-praxis" and artistic style (173). To this end, Meuli finds that

> for a series of art works to function effectively as mnemonics they must have certain stylistic or aesthetic characteristics that will enable them to engage the attention of the viewer.... In other words, the stylistic repertoire needs to be able to contain wide variation (*new mnemonic content*) within recognizable canonic limits (*tradition*). (174)

Meuli's remark about the possibility of a mnemonic working in pointed but less directed ways is apt, even in the local context. The *Medicine Box's* function is in some capacity self-referential: it calls attention to its own Coast Salish objecthood, its nature as a cedar box, and the specific cultural style of its imagery. But as an object designed for and used by a wider public, it invites consideration of how a mnemonic might function otherwise, specifically to a pan-Indian constituency.

Pan-Indianism has fostered a greater familiarity with local customs by a wider Indigenous community, as well as the development of some common, collective expressions of Indigeneity. Both these actions were seen at TRC events, events that promoted collective culture even as they highlighted the local specificities of the host communities. At the Montreal event, Justice Sinclair presented each of the honorary witnesses with a small rock from Lake Superior painted by an Anishinaabe artist. These rocks were intended to help the honorary witnesses in the task of healing. Sinclair pointed out that the rocks, with the knowledge and wisdom stored within them, are grandfathers; they have been there since the beginning of time and have themselves been witnesses to everything that has occurred throughout history.[22]

As a gift, they reflect Sinclair's own identity as an Anishinaabe person and align with a pan-Indian message that reinforces Indigenous presence on the land since time immemorial. The rocks, however, do not specifically evoke the culture of the local Mohawk hosts of the Montreal event. Perhaps to compensate for this, and to reinforce the TRC's need to "call to gather" a range of Indigenous people under its banner, Sinclair presented each rock with a tobacco pouch, tea, and a pin, adding that the variety of tokens was intended to acknowledge that not all First Nations practise the same way.

Conclusion: *Medicine Box* as Communicating Thing

At the TRC events, the presence of the *Medicine Box* during public statements and performances invited the integration of the object into the memory of those tellings. The use of the box as a repository for offerings, and ultimately the archival nature of the box, reinforced this integral presence. While the *Medicine Box* is still in a state of becoming, of acquiring numen, eventually it will transition to a mnemonic in a more traditional sense for those who witnessed statements made, perhaps evoking the stories themselves that were shared. The potential for the *Medicine Box* to retain this active meaning post-TRC, and to retain a sensory mix, in the display setting of the National Research Centre, is great. As Tahltan artist Peter Morin suggested, the *Medicine Box* is strong enough to carry the gifts, histories, and emotions placed inside of it.[23] In the introductory essay to his influential 1986 work, *The Social Life of Things*, Arjun Appadurai argues that not only do human agents give meaning to things, but these same things shed light on humans and their social contexts (5). The *Medicine Box* is one small aspect of the TRC's formidable project of reconciliation. Yet by tracing its valences of meaning, the *Medicine Box*'s value as a unique cultural object comes more clearly into focus as one with the power to communicate the important histories brought to light by the TRC, as well as the distinctive social and cultural dynamics witnessed by the TRC events themselves.

Notes

1 The TRC was born out of the Indian Residential Schools Settlement Agreement, the 2006 agreement between the Canadian government and Indian residential school survivors. Funded by the government and

operated by Catholic and Protestant churches, 139 Indian residential schools operated in Canada from the 1880s to 1996, when the last school closed its doors.

2 TRC staff was unable to provide any information on why, specifically, Marston was chosen to make the bentwood box, or what factors informed the choice of object.

3 This story is attributed to Bertha Peters. See Stewart, 27; Naxaxalhts'I, 104.

4 Haida artist Robert Davidson, cited in Wyatt, 60.

5 Luke Marston, statement made to Opening Sharing Circle, Winnipeg National Event, July 16, 2010. Transcript made available by the TRC.

6 Luke Marston, cited in Narine, "Bent Box Will Gather the Gifts of Survivors."

7 Marston, statement made to Opening Sharing Circle, Winnipeg National Event, July 16, 2010.

8 Marston, statement made to Opening Sharing Circle, Winnipeg National Event, July 16, 2010.

9 Marston, cited in Narine, "Bent Box Will Gather the Gifts of Survivors."

10 For more on the exclusion of Métis people from the Settlement Agreement, see Flammand; Logan; and Chartrand, Logan, and Daniels.

11 I wish to acknowledge the very helpful comments with regard to Northwest Coast iconography made by art historian Megan Smetzer and by Katie Bunn-Marcuse, curator and assistant director at the Bill Holm Center, Burke Museum.

12 Marston, statement made to Opening Sharing Circle, Winnipeg National Event, July 16, 2010.

13 One of these initiatives is Return to Spirit, an intercultural, faith-based program during which Indigenous and settler people meet separately and then together in a series of intensive gatherings aimed at the expression of reconciliation.

14 Telephone conversation with Ruth d'Hollander, member of Parish Council, St. Peter's and St. Paul's Anglican Parish, Esquimalt, B.C., May 22, 2012.

15 Conversation with Ruth d'Hollander, May 22, 2012.

16 Conversation with Ruth d'Hollander, May 22, 2012.

17 The group presented the remaining shawls to the event's support workers to distribute privately to individuals as the need arose. At the end of the Victoria event, support workers reported that the prayer shawls were a wonderful addition and much appreciated. Conversation with Ruth d'Hollander, May 22, 2012.

18 The *Medicine Box* was also displayed at Winnipeg's Canadian Museum for Human Rights in 2014 and 2015.

19 Personal email correspondence from Ry Moran, Truth and Reconciliation Commission, January 10, 2014.

20 My intention is not to suggest that a Tlingit concept can entirely be appropriately used to describe a Coast Salish object, but rather to introduce a perspective that will further illuminate the importance of

Indigenous viewpoint and a nuanced array of meanings ascribable to this object.

21 See also Dauenhauer and Dauenhauer, *Haa Shuká*.

22 Justice Murray Sinclair in a public address at TRC event, Montreal, April 24, 2013.

23 Comment made by Morin to the author during Aesthetics of Reconciliation group workshop, Victoria, April 12, 2012.

CHAPTER 14

Imagining New Platforms for Public Engagement: A Conversation with Bracken Hanuse Corlett

Dylan Robinson

Dylan Robinson: Hey, Bracken, can we start with a quick introduction for readers who might not be familiar with you and your work?

Bracken Hanuse Corlett: Sure. My name is Bracken Hanuse Corlett; I come from the Wuikinuxv, Klahoose, and Gwa'sala-'Nakwaxda'xw people. I'm based out of Vancouver and the Sunshine Coast. And I'm a multimedia artist currently focused on media arts and animation, painting, sculpture, and performance. After a year and a half mainly spent on an animation titled *Mia' (Salmon),* I have gone back to some dedicated studio time in my visual arts practice, mainly painting, design, and wood sculpture. I have also been focusing on research into the historical styles, regalia, and ceremonial work of my people and have been working more to embed this within my new work.

DR: I thought it would be interesting to have a conversation about your piece *Giants Among Us,* used on the cover of this book and first produced as a bus shelter poster across Vancouver as part of Vancouver's "year of reconciliation." I'm interested to hear more about the conception of the piece, in relation to the wider context of residential school history. Had you done any work on residential schools or reconciliation prior to this piece?

BHC: I had avoided doing any work about residential schools mainly because of how angry it made me. I've never avoided making work that dealt with social justice issues, and in fact a lot of my work has focused on such issues. But the subject of residential schools really hit close to home because my mom went to residential school with thirteen other brothers and sisters. My grandparents went as well. And the negative impacts on my family still exist in the present day. When my mom was five she went to residential school, and during that time my

grandparents had their lives taken back in our home community. She actually had to stay in residential school and couldn't go back home. She was eventually adopted by my granny Donna, and she took five of my aunts and uncles into her home including my mom. That all is connected, you know? And that's actually a reason why I'm alive, because my mom was sent down to the Sechelt residential school. My family is actually from Wuikinuxv on the central coast, which is really far away from Sechelt, and after that they were kept down in Sechelt after my grandparents passed away, and they were adopted on the Sunshine Coast. My mom eventually met my dad when she was a teenager ... so I came out of that system in a way, experiencing extreme disconnection from actual home—

DR: There's been so much physical displacement because of the schools.

BHC: Yeah. As a kid I never really understood why I grew up on the Sunshine Coast—why I lived there. I didn't figure it out until I was in my late teens, how that all connected, how we all ended up down there.... Some of my aunties and uncles were adopted out in other places on the island and in the interior, too, by different families— some Native, some non-Native—and I always wondered why my family was spread all over the place and disconnected from each other. When we do come together it is so powerful, and you'd think a family like that would stay together if they could.

There are just so many emotions around how residential schools affected my family, which is why I avoided the topic in my practice. And then I think in 2011, Nlaka'pamux artist Chris Bose asked me about participating in a show called *Official Denial: The Art of the Apology* that dealt with Stephen Harper's apology. It was at the Arnica Artist Run Centre in Kamloops, and I actually declined it at first because of the emotions and thoughts I had about the apology and residential school. But then Chris just kept pressuring me, saying things like, "C'mon man, do something punk rock!" Something uncensored, right? "Make it fun! Do a triptych! Make it satanic!" He wanted something big and challenging. It took a couple months before I finally agreed that I would do it. I think I met with him, he came down to the city, and he kind of convinced me. And I had a hard time making that work. I did Dzunukwa figure—also known as the Atsi, or the wild woman of the woods, she's the person that kidnaps the kids. I wanted to think about our monster stories, and how they relate to the residential school legacy. I wanted to do something visceral. So I did a mask of her, and then I did a piece that was called *Wombspeaker* and it was basically a

self-portrait of myself in the womb and then being ripped away from that. So it was pretty black and white with the red cross, and kind of heavy. And then I did a piece of the wild woman actually beheading Stephen Harper. I actually painted it live—I painted his face in live during the show. That was meant to be a bit funny, but it was also this visceral, reactive kind of response that developed through anger. The mask took me about nine months to carve; there was a lot of time spent and learning that took place as I carved it. I wanted to learn how to do the carving properly, so I apprenticed. Carving the mask was part of reclaiming that tradition for me.

Then, about a year after the *Official Denial* show there was a show called *Net-eth: Going Out of the Darkness* at Malaspina Printmakers Gallery and Skwachàys Gallery.

DR: The hotel?

BHC: Yeah. There's a gallery in there. The same pieces I had in *Official Denial: The Art of the Apology.*

DR: Okay. I didn't know Skwachàys was involved in that.

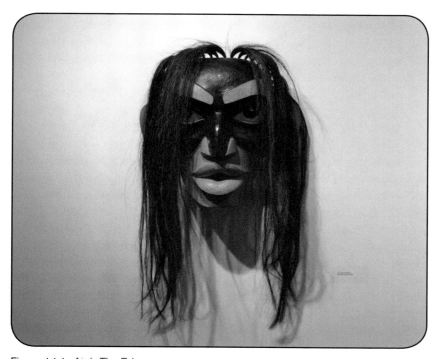

Figure 14.1: *Atsi—The Taker.*

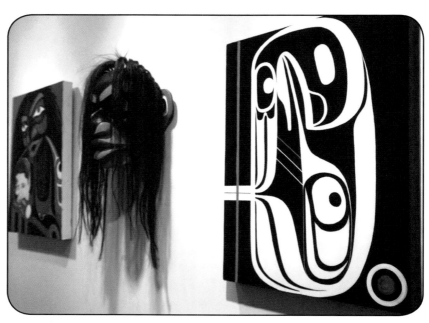

Figure 14.2: *Apology Triptych.*

BHC: I didn't make it to the opening that night because I had a different opening at Unit Pitt that I had to set up for. I had an opening there that night and the set-up for that show was really crazy. I didn't get to see that opening. I heard it was fairly emotional, as far as the welcome and the words that were said there. I wish I was able to make it there. The work I had at *Net-eth* was work I had already made. So I didn't have to go back down the rabbit hole. For the first show, *Official Denial*, my mom came. I think I spoke last, which felt strange because the other artists were a bit more senior than me. I wish I had gone first because it got my heart pounding just hearing the stories they had about their relationships with residential school. I've never really had a problem speaking about my work aside from usual nerves, which I usually get over fairly quickly. I just remember when I was speaking about that just feeling so overcome. And I didn't like that feeling; I didn't like feeling that vulnerable in front of people. I've never felt that before. You're in front of a bunch of people and you just want to burst out crying. That's probably what I would've done if I was alone. But I was trying to do justice to the work that was there and I was trying also to be strong for my mom. And after that I said to myself, "I'm not going down this route again."

So for my work for *Platforms: Art Marking Vancouver's Year of Reconciliation*, I felt that, because it was in public, it was an interesting opportunity to make something from a much different perspective and for the general public. I didn't have an idea full-fledged right off the bat—I just knew I wanted to explore the oral histories about monsters and explore how those connect to residential school history and its effects. I wanted to look into not just the bad but the good that those figures can teach us about our nature.

DR: The *Platforms* poster is a very different kind of work than the earlier works you've just described. What strikes me about *Giants Among Us* is how they try to engage the imagination of Native youth. As you've noted in our previous conversations, it's not just commuters

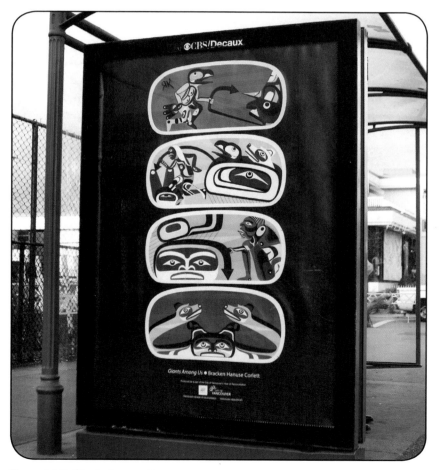

Figure 14.3: *Giants Among Us.*

who look at these transit signs, but kids. I think it's really important to think about this aspect of reclaiming the imagination, as part of not letting things be determined by this position of victimhood, and to think about ways forward, about our different teachings—how we carry those into the present and the future. And so I was thinking about your artist statement and how you describe these four scenes of your piece as visualizations of strategies, or teachings: "Protection" at the top, "Escape/Freedom" second from the top, "Rejection" third from the top, and "Balance" on the bottom. I wonder if you might if start by talking about each of the scenes in *Giants Among Us* individually.

BHC: Sure. I think I had about a month to really flesh out the idea. I already had a sketch, but after about a month I decided to think about it from a child's perspective. And so I tried to think of what I was like as a child, and I didn't have much awareness of my culture at a young age, but I tried to think of what I was interested in as a kid, and all my pictures were monsters, pretty much 100 percent. And my six-year-old son has continued this tradition into his own drawings. So that was the catalyst. I thought about my son seeing it, and other kids waiting for the bus seeing an image there, and I didn't want to make something that scared somebody, but I didn't want to make something that was just beautiful and didn't have any substance or intrigue. It's very easy to do, unfortunately; in Northwest Coast art it can be very easy to make that kind of work, based on the market for our work.

I had already been researching monster stories within Wuikinuxv and Kwakwaka'wakw oral traditions. And I wanted to depict four scenes, basically, because where I'm from four is a very sacred number. Four ancestors, four posts in our big house, good things come in four. Bad things come in three. So I wanted to make four scenes, and I started at the bottom with the Sisiutl, also known as Winalagalis, the double-headed sea serpent, which is one of my family's crests. I didn't know much about it before, but it always intrigued me as this kind of interesting-looking figure. It can be depicted in a lot of different ways that sometimes make it seem really scary, or other times make it seem more serene. What this represents is the balance between being a creator and being a destroyer, the balance between hatred and love, the balance between the dark and light that we possess, and the balance of all these characteristics within ourselves. And that it's basically a choice to determine which side you're going to be on. Deceit or truth? I think that in my own life I've been a hypocrite and chosen the darker path for various reasons…. I can blame my choices on this or that,

but everything I did was my own choice. I think that figure, to start at the bottom, was important for me, for myself, since I've become more politically and socially aware. And more emotionally aware, being a father. Whether it's 100 percent going to happen or not, just trying to choose that love, creation, light, whatever—trying to choose that over the darker things in life which are very easy to fall into, especially if you start thinking about … life!

DR: The things we have to deal with on a daily basis.

BHC: History, present-day stuff, it's all there. I do sometimes just fall into the negative. So the bottom was just about, you know, choosing that. Choosing that creator within, I guess. And then up from there was …

DR: Rejection.

BHC: Rejection. P'kvs, the wild man of the woods.

DR: Like a Sásq'ets?

BHC: Yeah, same guy. A lot of these monsters are up and down the coast, but they have different names and relatively similar stories. I've seen him depicted as a shady figure in the city before. Which I thought was pretty cool because I worked on the Downtown Eastside for about five years. And my own self, I had a brief couple years where I struggled with addiction, and just the ambivalence of drug use and the attraction to it and the actual … being horrified that I had done what I had done, with certain substances and just some of the people that you come across if you do go down that path, they do remind me of this P'kvs figure who seeks people out that are lone warriors, basically, lone hunters. People that are hungry and alone, which makes them vulnerable. And he'll offer them things that look very appealing, like salmon or berries. But once you eat his offering you turn into a ghost and are trapped in his world after that. My cousin Dean Hunt passed that teaching on to me as something that affected him. His own relationship with P'kvs too is not completely negative, because he's a teacher. I'm at this point in my life where I can look at addictions, whether chemical or something less tangible, and have a better understanding of the offering and its after-effects. That sweet smell that you think might be good for you or help you cope but ultimately will turn you into a ghost.

That's what I used to think of sometimes while I was working in the Downtown Eastside. How many spirits are down there. Before it was even a city, and then all the people who are down there struggling just have that ghost walk going on, or ghost talk. I've spent time with those people working down there but also being down there and dabbling when I was younger, and I thought it was … I was into writing and I wanted to go experience that and push myself into things and then crazy shit happens just out of nowhere. It didn't take long for me to realize that I didn't want to be down there in that regard, you know? But there is always that person who can try to entice you. I think those characters are everywhere in the city. And they can be related to a businessman, the Nestlé guy—

DR: Or even the context of reconciliation. The shiny object. The quick fix.

BHC: Friendship and peaceful relations and coexisting. I remember that's what I read about when I first looked at the word. I was like, "What is reconciliation?" I thought it was a Christian thing.

DR: It has that context.

BHC: I remember hearing it in a Christian hymn as a child.

> Hark the herald angels sing
> Glory to the newborn King!
> Peace on earth and mercy mild
> God and sinners reconciled.

I knew it meant coming to terms with something and trying to establish a peaceful, friendly existence with each other and I found that strange. But I didn't take that word into what I was doing as much. I considered more the residential school experience and how I was dealing with it, how my family was dealing with it. I think they asked us too, so I put it in my artist's statement, but I didn't want to use it the way maybe they were considering it. As I stated before, I didn't accept the residential school apology. If you look at the relationship between Canada and Indigenous people since then, I would say relations have gotten worse. It is hard to reconcile when one side is still exerting control over you.

DR: Thinking about the local context here in Vancouver, I wonder about whether this understanding—or feeling—of control is elided by the city's fairly constant repetition of how it has become more reconciled. In the space of a year, Vancouver changed from having a "year of reconciliation" to being a "city of reconciliation"—

BHC: An unceded city—

DR: I know that there is a great need to educate the non-Indigenous Canadian public about the unceded Indigenous history of Vancouver, but I also feel that the city declaring it's on unceded Coast Salish territory is a self-congratulatory gesture. "We're making this official announcement," they say, when in fact Tellhós (S̲kwx̲wú7mesh/Squamish), xwméthkwiyem (xʷməθkwəy̓əm/Musqueam), and Tsleil-Waututh (səl̓ílwəta) people have been saying it—*lived it*—since the city was founded! Calling Vancouver a "city of reconciliation" raises some important questions: What does a city of reconciliation look like? Who says we want or need a city of reconciliation? And how are city officials determining that Vancouver has become that? One of the city's initiatives tied to their "city of reconciliation" declaration was *Platforms: Art Marking Vancouver's Year of Reconciliation* project, which your work was part of. I'm interested to know what you think the social and political efficacy of the project was—how did it work and where did it fall short?

BHC: I felt like the bus stop platforms were a great opportunity for public dissemination, and to possibly educate more people about the impacts of residential schools, but I also didn't feel completely uncensored. As I mentioned earlier, I didn't want to go into overtly heavy visuals, but I thought, "What if I did?" There were some parts of the contract that stated the city had the right to reject the work and payment would not be made to the artist. I'm sure if I did the painting of Stephen Harper with his head in Dzunuk̓wa's hands that probably wouldn't have made it in.

DR: Probably not! [*laughs*] But perhaps that's part of what a city of reconciliation needs to support. Artists being able to put political statements up in public … or things that challenge the public to really consider what the phrase "unceded territories" means. These perspectives need to be integrated into the cityscape, encountered as part of our everyday travels across the city. The city had a number of initiatives as part of the year of reconciliation, and a few of the initiatives were not merely the feel-good joining hands initiatives I thought would predominate. A number of the public artworks in the *Platforms* project were thought-provoking.

BHC: And for me, getting my piece up really helped. I've gotten a lot of recognition from that. I'm not discounting it, but as far as that action and what it is … does it produce reconciliation? I don't know. It's a step for a few of us.

DR: Despite the recognition for the artists involved, I was a bit suspicious of the overall process. From the outside, it seemed very much to be business as usual, with the city determining what reconciliation involved and then asking our people here to fit into forms and events that the city organized, the things they thought were the most useful, rather than asking xwélmexw—the First Peoples whose territory this is—what should be done. I'm not sure that the city even thought about asking us basic questions: "What kinds of public art and forms of acknowledgements do you think are important? Where do you think it is important to situate these works, and make these acknowledgements? What kinds of social and political issues need to be addressed?" Instead they said: "We'd like bus shelter posters and a few video screens about 'reconciliation.'" This isn't to say that these formats aren't potentially useful, but from what I understand the decision to use these particular formats didn't emerge from conversations with the nations whose land this is.

BHC: I talked to some of the other artists too, and to them it felt like the power structures definitely remained intact. It felt like the power was in the hands of the city, and it was very bureaucratic. I know they have to do their jobs. They have to speak a certain way. But it didn't feel like a full collaboration. We were still going by their rules.

DR: It's perhaps appropriate that we're still talking about the fourth scene: rejection! [*laughs*]

BHC: Rejection for me was … part of a lot of residential school stuff. My mom was an addict and an alcoholic. And she was successful as a teacher and a counsellor and she was functioning, but aside from that, she ended her use of substances when she was around thirty-six. And some of my aunties and uncles still haven't. They're still going down that path and I think at this point I don't know if they will come out of it. But my uncle, who's the hereditary chief of our family, had been down the path of addictions. But now he's come out of it with sobriety and he had never talked about residential school until he was in his sixties. He was able to reach a point where he was able to talk about it and understand his life path, and basically the reasons for some of the dysfunction in our family…. He was a bit older when my grandparents died so he had more experience with the culture, which maybe even hurts more? Because my mom didn't have as much experience with the culture. And when you have that experience and get it taken away—

DR: You feel that absence more keenly, for sure.

BHC: He's come to that point where he's—only recently in the last five years—where he's like gone into this path of healing and so … just witnessing my family and knowing that there is that dynamic of being able to transcend those things and reject the negative things. Even when they can still have a grip and seem enticing.

DR: Shall we move on to the third scene: escape?

BHC: So this one was maybe not as literal on the actual scene, but it's based on the wild woman of the woods, Dzunuk̓wa, or Atsi, she's also known as—I forget what she's called down here.…

DR: Stó:lō people call her Th'ôwxiya.

BHC: I've been reading other Indigenous people, like in Australia, they have a similar figure. I'm sure other places too. My grandfather, Johnny Hanuse, called her Skwanee. This is a figure that my mom always told me about when I was younger, and in a lot of the stories, the kids get captured by her and they're put in her basket, and in stories that I have heard it is child who is the most ridiculed in the community, the one who is overlooked, that has the plan to get out of it. That kid figures out how to save everybody. I always found this inspiring. I think about some of my uncles and hearing about their experiences in residential school and being ridiculed by the nuns and the priests. My uncles were really handsome men … they turned into really handsome men, and I'm sure they were really good-looking boys and I'm sure they had a lot of confidence when they went into the schools. But they came out of there feeling completely tarnished and shamed. I think about carrying around shame and that feeling of being ridiculed and the impact it can have moving forward as an adult and the monsters that used these tactics to make the children submit. It's horrifying to think about.

DR: It's unfortunately a pretty common experience.

BHC: Which is humiliating. So I always think about a child like that— and what do they possess? And maybe in times that *are* a struggle that's the person you wouldn't expect. Something I've come across with non-Native people, when they see someone Native doing well in academics or something they see them as so special. It's like they're surprised by us as achievers.

DR: It's completely patronizing. "You're doing so well!"

BHC: Oh, you don't live on the reserve! Oh, you pay taxes! It's part of that story. Just the overlooked child and their ability to overcome that and help. And the Atsi figure, she's the monster that encapsulates the government and the nuns. Some of the stories my mom told me about sneaking around trying to get into the pantry and being just absolutely scared of being caught but taking that risk because …

DR: They're starving.

BHC: The nuns and priests. They would have all fresh fruit and they'd have turkey at Christmas and the students would be sitting there with gruel. That fear that was instilled. My mom has actually still not talked about her experiences that much with me, but I think the thing that I've gathered most is the constant fear that if you do something wrong you can get hit. And I think my mom's experience, from what I know, wasn't as bad as it was for some of my uncles. But she still won't talk to me about it. And she saw what happened to other people too. Witnessing that could be just as bad.

DR: Just as traumatic, for sure. It was such an everyday experience that it became internalized, and former students can still carry that shame or fear with them.

BHC: It's hard to get that out of your fabric. The reason I wanted to explore the scene of escaping from Atsi goes back to my experience as a youth and meeting an Elder who had spent two days in a residential school and then escaped on a log with his friend. He said he was on the log for two days and made it back. I used to work with him; he told me that story and I thought it was incredible. He said that because he had shown that he wouldn't go there they didn't make him go back. I've heard other stories of people escaping and getting away or being pulled back in. That feeling of being there, that feeling of just wanting to be free all the time. Just wanting to get out of there. Escape with a backpack and get back to the community. For my mom and her brothers and sisters, they weren't able to go back home at all after my grandparents passed away.

DR: It's quite a distance between Wuikinuxv and Sechelt.

BHC: You can only get there by boat or plane. So you have to go up to Port Hardy and fly over and take the boat over—it's quite a trip.

DR: That's one of the reasons why the policy was created: to prevent children from thinking that they could just leave and preventing parents from coming to see their children.

BHC: Geographically, there must have been residential schools closer, like Alert Bay. That would've been way closer than Sechelt. My mom said that created problems for her and my aunties and uncles because they were all Oweekeno kids and it was Sechelt kids there. I'm not sure if there were kids from other places. So not only were they taken away, but they were living with kids from that community. People sometimes still think she's from Sechelt. Sechelt residential school was burnt down by one of the former residential school survivors.

DR: A number on the West Coast were, including Coqaleetza Industrial School in Sardis and Alberni residential school.

BHC: I read something, by an Elder who said we should keep the residential schools around as monuments to remind us that this did happen. They're physical reminders. I can see that urge to want to just burn it all away. The residential school was the biggest building in Sechelt for a long time, and it kind of dominated the reserve.

DR: Shall we move on to discuss the first scene on the bottom of the picture: protection?

BHC: This was the first image that I made. It was similar to the rejection, but in a different way—a way of protecting yourself, medicine-wise. Something that I was taught is that when someone projects negativity onto you, you cover up. You visualize something that makes you feel protected, cedar boughs or something, so you can block a lot of that negativity. For myself I wish I had those techniques; I have them today, but I wish I had a bit more of that. Growing up in a predominantly non-Native town, there was a lot of racism and I could pass for something else. Some people didn't know I was Native, some people did; some people would bite their tongue around me, and some people wouldn't. Today when I hear racism I'm able to protect myself from it and respond to it, which I was never able to do as a kid. I remember this feeling of your face going hot and just wanting to hide. I used to just take it all in and it burned me. I worked on a fish farm when I was a teenager for about three or four years on Zeballos, which is on the island, which is really divided with maybe two hundred non-Natives and one hundred people who are Indigenous to that area. A resource town. That was definitely the most racist place that I've ever been in, and some of the things I heard daily … I just didn't know how to protect myself from it. I didn't have the tools for it. I was taught by an Elder about this technique of basically closing yourself in. To create a force field around you. I just didn't

have that back then. Youth have to deal with things like this all the time still. And so it would be good for youth to learn techniques like these of covering up.

DR: These techniques and teachings many of us didn't learn because our parents often didn't learn them. That was the awful success, in a way, of residential schools. Severing or weakening the connection to these important teachings and knowledge. I'm not sure we can consider academic institutions any less complicit by failing to employ Elders and Knowledge Keepers (in the plural, not just one!) who can provide this kind of mentorship to Indigenous youth.

BHC: I think just things I've heard with like medicine people, there's good medicine and bad medicine. There were always these techniques to block some of that negative out. I don't think that has been passed on as much as it would have been pre-contact. I was very lucky to meet Shirley Bear. She really helped me. She taught me how to smudge, and how to meditate. Tools I still use. She is Maliseet; she's from out east. So not where I'm from, but I think a lot of the stuff she taught me is universal in a way. She never said this is the one way you do things— she said this is the way I do things. And she passed that on to all of us youth. It was so powerful—we were all urban kids who hadn't experienced anything even close to that. We were all from different nations. Since then I've learned a lot more of what my people do. But some of those teachings she gave me I still use. They're really important, and I don't know if these teachings are being taught as much to youth in the city these days.

DR: I think it's something the city should be thinking about if it's making a commitment to address what it means to be a city of reconciliation. What about creating sovereign spaces in the city where Indigenous youth feel safe, supported, and can find guidance from Elders? There are some very basic things that need to happen.

BHC: Even just understanding of what traditional territory you're on. Ask ten people which traditional territory you're on here. Even after the Olympics, which repeated that the four nations—Squamish, Musqueam, Tsleil-Waututh, and Lil'wat—were hosting. But people still don't know.

DR: Well, I think it also comes back to the way in which the official acknowledgement of the city being unceded territory takes place. It's like a box to check.

BHC: It's a civic thing.

DR: It's *merely* an acknowledgement; it's not even—

BHC: It won't change any treaty negotiations, it won't change place names.

DR: I've been thinking about it kind of as the bureaucratization of acknowledgement. The city makes it "official" in a way that is more about risk management, covering their own asses, rather than doing what is necessary and really acknowledging the work that needs to be done here. The city feels that they can craft acknowledgement now, they're telling people how to acknowledge. Which is absolutely absurd! The art historian Mique'l Dangeli, who's Tsimshian, writes really cogently about this. When we come to each other's territories we have protocols and they're based on the relationships that we have. It's always a very context-specific thing rather than a "one size fits all" thing. If the city is going to commit to this work they need to do it in a completely different way, and work with people from here on what it actually *means* to say you're on unceded Coast Salish territory, rather than just say it.

Maybe this is a good segue. I was going to ask what kinds of things you think need to be addressed in the city, if we're going to think about the future role of Indigenous art in public spaces?

BHC: Place names are very important. Vancouver, Victoria, these colonial names are everywhere. With the name change from "Queen Charlotte Islands" to "Haida Gwaii," some people thought that wasn't that important, but for it to change, now even non-Native people are starting to call it that. To acknowledge the name is important. Where I'm from, "Ooweekeno" is how it's anglicized. And people call it River's Inlet. Where my grandmother is from, Cortes Island, is Klahoose territory. But people in my family call it Cortes. Because I've been an activist for a long time, it's important to recognize that Hernando Cortés is one of the worst criminals in history. When I go back there, because it's a big tourist spot, I'll go to the local swim holes—I'm not this kind of person, I don't try to get into conversations and teach people, but with some people I get into conversations to say this is not Cortes. And some people say, "Oh cool, I didn't know." Because the reserve is on the other end of the island a lot of people, and the tourists that visit, don't have much contact with Klahoose people.

DR: Well, the names of many of the places are either colonial—like Vancouver, Victoria, or Cortes that naturalize the history of colonization—or anglicized Indigenous names that most people don't even realize are anglicized Indigenous place names, like Toronto or Nanaimo.

BHC: And Canada is about to turn 150, right? That's so short ... that's nothing! People still cling to this identity. I haven't held on to any Canadian national identity since I was a teenager. I have a lot of friends who still do. When I was in my late teens I used to do these diminutive street collages with upside-down Canadian flags. I had a friend who questioned me about them; he thought they were funny but he was also really proud to be Canadian and had once done a graffiti piece with the Canadian flag interwoven within his letters. And he'd say, "Why do you hate on Canada so much?" And I said, "Okay, honestly? My mom was taken away when she was five and placed in a school with a bunch of sexually and physically abusive nuns and priests, and the people they hired were people who couldn't get jobs elsewhere, they were barely teachers—they were sadists. She was taken, placed in the school, had her language and culture forcibly beaten out of her, as was the case with her parents before her." I just told him that. And he had no idea. He was completely shocked, he was stunned that that actually happened. I'm just one generation removed from that history. My mom didn't get out of there until the early 1970s and I was born ten years later. I think she got out in 1970, but those schools still existed well beyond after that. We need to continue educating people about the impacts of these schools. Truth exists before reconciliation, whatever that really means.

Bibliography

Aboriginal Affairs and Northern Development Canada. "Indian Residential Schools—Key Milestones." *Canada.ca*, n.d. Web. 8 Aug. 2014. <https://www.aadnc-aandc.gc.ca/eng/1332939430258/1332939552554>.

"Aboriginal Sixties Scoop Class Action Lawsuit." Klein Lawyers. Klein Lawyers, 2016. Web. 13 Jan. 2016.

"About the LHF." *Where Are the Children? Healing the Legacy of the Residential Schools*. Legacy of Hope Foundation, 26 June 2009. Web. 3 Mar. 2014.

Alexie, Robert Arthur. *Porcupines and China Dolls*. Toronto: Stoddart, 2002. Print.

Alfred, Taiaiake. *Peace, Power, and Righteousness: An Indigenous Manifesto*. Oxford: Oxford UP, 2009. Print.

———. *Wasáse: Indigenous Pathways of Action and Freedom*. Peterborough: Broadview, 2005. Print.

Alstrup, Kevin. "'The Song—That's the Monument': Eskasoni Mi'kmaw Tribal Culture in the Music-Making of Rita Joe and Thomas George Poulette." Ph.D. diss. Brown U, 2004. Print.

Althusser, Louis. "Ideology and Ideological State Apparatuses." *Lenin and Philosophy and Other Essays*. Trans. Ben Brewster. New York: Monthly Review, 1970. 121–76. Print.

Anderson, Kim. *A Recognition of Being: Reconstructing Native Womanhood*. Toronto: CSPI, 2001. Print.

Angel, Naomi. "IRS TRC and an Aboriginal Principle of Witnessing." 2010. Web blog post. 11 Dec. 2015.

Aplin, Chris. "Expectation, Anomaly, and Ownership in Indigenous Christian Hip-Hop." *MUSICultures*. Ed. Beverley Diamond, Kati Szego, and Heather Sparling. Spec. issue of *Indigenous Modernities* 39.1 (2012): 42–69. Print.

Appadurai, Arjun. "Introduction: Commodities and the Politics of Value." *The Social Life of Things: Commodities in Cultural Perspective*. Ed. Appadurai. Cambridge: Cambridge UP, 1986. 3–63. Print.

———. *Modernity at Large: Cultural Dimensions of Globalization*. Minneapolis: U of Minnesota P, 1996. Print.

Archibald, Jo-Ann. *Indigenous Storywork: Educating the Heart, Mind, Body, and Spirit*. Vancouver: U of British Columbia P, 2008. Print.

Archibald, Linda. *Dancing, Singing, Painting, and Speaking the Healing Story: Healing through Creative Arts*. Ottawa: Aboriginal Healing Foundation, 2012. Print.

Armstrong, Jeannette C. "The Disempowerment of First North American Native Peoples and Empowerment Through Writing." *Gatherings of the En'owkin Journal of First North American Peoples* 1.1 (1990): 141–46. Print.

———. "Land Speaking." *Speaking for the Generations: Native Writers on Writing*. Ed. Simon J. Ortiz. Tucson: U of Arizona P, 1998. 174–94. Print.

———. *Slash*. Penticton: Theytus, 2007. Print.

Arthur, Paige. "How 'Transitions' Reshaped Human Rights: A Conceptual History of Transitional Justice." *Human Rights Quarterly* 31.2 (2009): 321–67. Print.

Assembly of First Nations. *Breaking the Silence: An Interpretive Study of Residential School Impact and Healing as Illustrated by the Stories of First Nation Individuals.* Ottawa: Assembly of First Nations, 1994. Print.

"At Least 3,000 Died in Residential Schools, Research Shows." *CBC News.* Canadian Broadcasting Corporation, 18 Feb. 2013. Web. 30 June 2014.

Atleo, Shawn. "First Nations." *Imagining Canada: A Century of Photographs Presented by* The New York Times. Ed. William Morassutti. Toronto: Doubleday, 2012. 28–45. Print.

———. "Re: Vancouver 2010 Indigenous Youth Gathering." Letter. N.d. *Treaty7.org.* Web. 8 Sept. 2014. <http://www.treaty7.org/files/Sean AtleoLetter-eng.pdf>.

Austin, J.L. *How to Do Things with Words.* Oxford: Clarendon, 1962. Print.

Avery, Dawn. "*Tékeni*—Two Worlds, Many Borders: A look at Classical Native Music through Indigenous Eyes." *MUSICultures.* Ed. Beverley Diamond, Kati Szego, and Heather Sparling. Spec. issue of *Indigenous Modernities* 39.1 (2012): 129–68. Print.

Azoulay, Ariella. "Ariella Azoulay: 'The Time Has Come.'" *Verso.* Verso Books, 7 Dec. 2012. Web. 13 Sept. 2015.

Barkan, Elazar. *The Guilt of Nations.* Baltimore: Johns Hopkins UP, 2001. Print.

Battiste, Jaime Youngmedicine. *Honoring 400 Years. Kepmite'tmnej.* N.p.: N.p., 2010. Print.

Bauman, Richard. 1996. "Transformations of the Word in the Production of Mexican Festival Drama." *Natural Histories of Discourse.* Ed. Michael Silverstein and Greg Urban. Chicago: U of Chicago P. 301–27. Print.

Beauvais, Wilhemina (Tewateronhiáhkwa). Letter to Jill Scott. 2 July 2013. TS.

Bederman, Gail. *Manliness and Civilization: A Cultural History of Gender and Race in the United States, 1880–1917.* Chicago: U of Chicago P, 1995. Print.

Belmore, Rebecca. *Apparition.* 2013. Video.

———. Artist statement. *Witnesses: Art and Canada's Indian Residential Schools.* Vancouver: Morris and Helen Belkin Art Gallery, 2013. 35. Print.

Bell, Catherine E., and Val Napoleon. *First Nations Cultural Heritage and Law: Case Studies, Voices, and Perspectives.* Vancouver: U of British Columbia P, 2008. Print.

Benjamin, Walter. *The Work of Art in the Age of Its Technological Reproducibility and Other Writings on Media.* Cambridge: Harvard UP, 2008. Print.

Benjoe, Kerry. Thomas More Keesick More Than Just a Face." *Regina Leader-Post.* Postmedia, 22 Dec. 2015. Web. 27 March 2016.

Bennett, Jill. *Empathic Vision: Affect, Trauma, and Contemporary Art.* Redwood City: Stanford UP, 2005. Print.

———. *Practical Aesthetics: Events, Affects and Art after 9/11.* London: Taurus, 2012. Print.

Berger, Harris M. *Stance: Ideas about Emotion, Style, and Meaning for the Study of Expressive Culture.* Middletown: Wesleyan UP, 2009. Print.

Berlant, Lauren. *The Female Complaint: The Unfinished Business of Senti-mentality in American Culture*. Durham: Duke UP, 2008. Print.

——, ed. *Intimacy: A Special Issue*. Chicago: U of Chicago P, 2000. Print. Rpt. of spec. issue of *Critical Inquiry* 24.2 (1998): 281–631.

Berlant, Lauren, and Michael Warner. 1998. "Sex in Public." *Critical Inquiry* 24.2: 547–66. Print.

Berleant, Arnold. *The Aesthetics of Environment*. Philadelphia: Temple UP, 1992. Print.

Bisset Perea, Jessica. "Pamyua's Akutaq: Traditions of Modern Inuit Modal-ities in Alaska." *MUSICultures*. Ed. Beverley Diamond, Kati Szego, and Heather Sparling. Spec. issue of *Indigenous Modernities* 39.1 (2012): 7–41. Print.

Blackburn, Carole. "Searching for Guarantees in the Midst of Uncertainty: Negotiating Aboriginal Rights and Title in British Columbia." *American Anthropologist* 107.4 (2005): 586–96. Print.

Blanchot, Maurice. *The Writing of the Disaster*. Lincoln: U of Nebraska P, 1995. Print.

Bonner, Michelle, and Matt James. "The Three R's of Seeking Transitional Jus-tice: Reparation, Responsibility, and Reframing in Canada and Argentina. *International Indigenous Policy Journal* 2.3 (2011): 1–29. Web. 20 Jan. 2014.

Born, Georgina. "Introduction—Music, Sound and Space: Transformations of Public and Private Experience." *Music, Sound, and Space: Transforma-tions of Public and Private Experience*. Ed. Born. Cambridge, Cambridge UP, 2013. 1–69. Print.

Borrows, John. *Canada's Indigenous Constitution*. Toronto: U of Toronto P, 2010. Print.

Bosum, John. Personal testimony. Commissioners' Sharing Panel. Truth and Reconciliation Commission of Canada Québec National Event, Fairmont Queen Elizabeth Hotel, Montreal. 25 Apr. 2013.

Brady, Miranda J. "The Flexible Heterotopia: Indian Residential Schools and the Canadian Museum of Civilization." *Peace and Conflict: Journal of Peace Psychology* 19.4 (2013): 408–20. Print.

Brant Castellano, Marlene. Personal interview with Jill Scott. 24 July 2013.

——. Message to Jill Scott. 24 July 2013. Email.

Brounéus, Karen. "The Trauma of Truth Telling: Effects of Witnessing in the Rwandan Gacaca Courts on Psychological Health." *Journal of Conflict Resolution* 54 (2010): 408–37. Print.

Brown, Bill. "Thing Theory." *Things*. Ed. Brown. Chicago: U of Chicago P, 2004. 1–22. Print.

Brownlie, Robert, and Me Kelm. "Desperately Seeking Absolution: Native Agency as Colonialist Alibi." *Canadian Historical Review* 75.4 (2001): 543–56. Print.

Buell, Hal. *Moments: The Pulitzer Prize Photographs—A Visual Chronicle of Our Time*. New York: Black Dog and Leventhal, 1999. Print.

Busby, Cathy. *We Are Sorry*. 2010. Inkjet print on fabric panel. Winnipeg Art Gallery, Winnipeg.

Butler, Judith, and Gayatri Spivak. *Who Sings the Nation State?* Oxford: Seagull, 2007. Print.

Byrd, Jodi, and Michael Rothberg. "Between Subalternity and Indigeneity: Critical Categories for Postcolonial Studies." *Interventions* 13.1 (2011): 1–12. Print.

Campbell, Maria. "Jacob." *Stories of the Road Allowance People.* Penticton: Theytus, 1995. 86–104. Print.

Canada. CAP. VI.: An Act for the Gradual Enfranchisement of Indians, the Better Management of Indian Affairs, and to Extend the Provisions of the Act 31st Victoria, Chapter 42. Aboriginal Affairs and Northern Development Canada. 22 June 1869. *Aboriginal Affairs and Northern Development Canada*, 15 Sept. 2010. Web. 4 Apr. 2010.

———. Dept. of Indian Affairs. *Annual Report of the Department of Indian Affairs for the Year Ended 30 June 1896.* Ottawa: S.E. Dawson, 1897. Print.

———. "House of Commons Debates." *Edited Hansard.* Canada. Parliament. House of Commons. 39th Parl., 2nd sess. Vol. 142, no. 110. 11 June 2008. Web. 18 Mar. 2010.

Carr, Geoffrey. "Bearing Witness: A Brief History of the Indian Residential Schools in Canada." *Witnesses: Art and Canada's Indian Residential Schools.* Vancouver: Morris and Helen Belkin Art Gallery, 2013. 9–21. Print.

Carter, Tom. "Pay-for-Pain, Indians Say." *Washington Times.* Washington Times, 12 Aug. 2009: n. pag. Web. 14 Sept. 2015.

"Catechism of the Catholic Church." *The Vatican.* Libreria Editrice Vaticana, 1993. Web. 13 Jan. 2016.

Chamberlin, J. Edward. "Doing Things with Words." *Talking on the Page.* Ed. Laura J. Murray and Keren Rice. Toronto: U of Toronto P, 1999. 69–90. Print.

Chartrand, Larry N., Tricia E. Logan, and Judy D. Daniels. *Métis History and Experience and Residential Schools in Canada.* Ottawa: Aboriginal Healing Foundation, 2006. Print.

Chrisjohn, Roland, et al. "Genocide and Indian Residential Schooling: The Past Is Present." *Canada and International Humanitarian Law: Peacekeeping and War Crimes in the Modern Era.* Ed. Richard D. Wiggers and Ann L. Griffiths. Halifax: Centre for Foreign Policy Studies, Dalhousie UP, 2002. 229–66. Print.

Chrisjohn, Roland, and Tanya Wasacase. "Half-Truths and Whole Lies: Rhetoric in the 'Apology' and the Truth and Reconciliation Commission." *Response, Responsibility, and Renewal: Canada's Truth and Reconciliation Journey.* Ed. Gregory Younging, Jonathan Dewar, and Mike DeGagné. Ottawa: Aboriginal Healing Foundation, 2009. 217–32. Print.

Chrisjohn, Roland, and Sherri Young, with Michael Maraun. *The Circle Game.* Penticton: Theytus, 1997. Print.

Clark, D.A.T., and Joane Nagel. "White Men, Red Masks: Appropriations of 'Indian' Manhood in Imagined Wests, 1876–1934." *Across the Great Divide: Cultures of Manhood in the American West.* Ed. Matthew Basso, Laura McCall, and Dee Garceau. New York: Routledge, 2001. 109–30. Print.

Classen, Constance, and David Howes. "The Museum as Sensescape: Western Sensibilities and Indigenous Artifacts." *Sensible Objects: Colonialism,*

Museums and Material Culture. Ed. Elizabeth Edwards, Chris Gosden, and Ruth B. Phillips. New York: Berg, 2006. 199–244. Print.

Cole, Catherine M. *Performing South Africa's Truth Commission: Stages of Transition.* Bloomington: Indiana UP, 2010. Print.

Colebrook, Claire. *Understanding Deleuze.* Crows Nest: Allen & Unwin, 2002. Print.

Colman, Andrew M. "Dissociation." *A Dictionary of Psychology.* 3rd ed. 2008. *Oxford Reference.* Oxford UP, 2012. Web. 28 May 2013.

Cook-Lynn, Elizabeth. "Why I Can't Read Wallace Stegner." *Why I Can't Read Wallace Stegner and Other Essays.* Madison: U of Wisconsin P, 1996. 29–40. Print.

Corntassel, Jeff, Chaw-win-is, and T'lakwadzi. "Indigenous Storytelling, Truth-Telling and Community Approaches to Reconciliation." *ESC: English Studies in Canada* 35.1 (March 2009): 137–59. Print.

Corntassel, Jeff, and Cindy Holder. "Who's Sorry Now? Government Apologies, Truth Commissions, and Indigenous Self-Determination in Australia, Canada, Guatemala, and Peru." *Human Rights Review* 9.4 (2008): 465–89. Print.

Coulthard, Glen Sean. *Red Skin, White Masks: Rejecting the Colonial Politics of Recognition.* Minneapolis: U of Minnesota P, 2014. Print.

Craps, Stef. "Wor(l)ds of Grief: Traumatic Memory and Literary Witnessing in Cross-Cultural Perspective." *Textual Practice* 24.1 (2010): 51–68. Print.

Cree, John. Opening address. Truth and Reconciliation Commission of Canada Québec National Event, Fairmont Queen Elizabeth Hotel, Montreal. 24 Apr. 2013. Address.

Cromley, Elizabeth. "Masculine/Indian." *Winterthur Portfolio* 31.4 (1996): 265–80. Print.

Cruikshank, Julie. *Do Glaciers Listen? Local Knowledge, Colonial Encounters, and Social Imagination.* Vancouver: U of British Columbia P, 2005. Print.

———. *The Social Life of Stories: Narrative and Knowledge in the Yukon Territory.* Lincoln: U of Nebraska P, 1998. Print.

CSSSPNQL. "Truth and Reconciliation Walkers Testimonies—Walker #1." *YouTube.* 8 Sept. 2011. Web. 22 May 2013.

Dant, Tim. *Material Culture in the Social World: Values, Activities, Lifestyles.* Buckingham: Open UP, 1999. Print.

Dauenhauer, Nora Marks. "Tlingit *At.óow*: Traditions and Concepts." *The Spirit Within: Northwest Coast Native Art from the John H. Hauberg Collection.* Ed. Steven Brown. New York: Rizzoli; Seattle: Seattle Art Museum, 1995. 21–29. Print.

Dauenhauer, Nora Marks, and Richard Dauenhauer, eds. *Haa Shuká, Our Ancestors: Tlingit Oral Narratives.* Seattle: U of Washington P; Juneau: Sealaska Institute, 1987. Print.

———. "Tlingit Speeches for the Removal of Grief." *Arctic Anthropology* 40.2 (2003): 30–39. Print.

Deerchild, Rosanna. "My Poem Is an Indian Woman." *Indigenous Poetics in Canada.* Ed. Neal McLeod. Waterloo: Wilfrid Laurier UP, 2014. 237–44. Print.

Deloria, Philip Joseph. *Indians in Unexpected Places.* Lawrence: UP of Kansas, 2004. Print. Culture America.

Denny, Antle. "Plenary Presentation." Truth and Reconciliation Commission of Canada Atlantic National Event, World Trade Convention Centre, Halifax. 26 Oct. 2011. Address.

Dewar, Jonathan, David Gaertner, Ayumi Goto, Ashok Mathur, and Sophie McCall. *Practicing Reconciliation: A Collaborative Study of Aboriginal Art, Resistance and Cultural Politics. A Report Commissioned by the Truth and Reconciliation Commission on Indian Residential Schools.* Kamloops and Sault Ste. Marie: CiCAC and the Shingwauk Residential Schools Centre, 2013. Web. 13 Oct. 2015.

Dewar, Jonathan, and Ayumi Goto, eds. *Reconcile This!* Spec. issue of *West Coast Line* 74 (2012). Print.

Diamond, Beverley. "Music of Modern Indigeneity: From Identity to Alliance Studies." *European Meetings in Ethnomusicology* 12 (2007): 169–90. Print.

———. "Native American Contemporary Music: The Women." *World of Music* 44.1 (2002): 11–39. Print.

Dorrell, Matthew. "From Reconciliation to Reconciling: Reading What 'We Now Recognize' in the Government of Canada's 2008 Residential Schools Apology." *English Studies in Canada* 35.1 (2009): 27–45. Print.

Dreamkeeper. Dir. Steve Barron. Hallmark Entertainment, 2003. Film.

Dueck, Byron. *Musical Intimacies and Indigenous Imaginaries: Aboriginal Music and Dance in Public Performance.* Oxford: Oxford UP, 2013. Print.

Ellis, Cath. "The Possessive Logic of Settler-Invader Nations in Olympic Ceremonies." *Journal of Tourism and Cultural Change* 10.2 (2012): 105–23. Print.

Elwes, Catherine. *Video Art: A Guided Tour.* London: Tauris, 2005. Print.

Etherington Jr., Patrick. "Residential School Walkers Panel." Indian Residential School Truth and Reconciliation Commission Atlantic National Event, World Trade Convention Centre, Halifax. 26 Oct. 2011. Panel.

"Exhibition." *Where Are the Children? Healing the Legacy of the Residential Schools.* Legacy of Hope Foundation, 26 June 2009. Web. 3 Mar. 2014.

Feld, Steven. "From Schizophonia to Schizmogenesis: On the Discourses and the Commodification Practices of 'World Music' and 'World Beat.'" *Music Grooves.* Ed. Steven and Charles Keil Feld. Chicago: U of Chicago P, 1994. 257–89. Print.

Feldman, Allan. "Memory Theatre, Virtual Witnessing, and the Trauma Aesthetic." *Biography* 27.1 (2004): 163–202. Print.

Felman, Shoshana, and Dori Laub. *Testimony: Crises of Witnessing in Literature, Psychoanalysis, and History.* New York: Routledge, 1992. Print.

"Find and Release the Documents." Editorial. *Winnipeg Free Press.* Winnipeg Free Press, 4 Dec. 2012: A10. Web. 27 Aug. 2013.

Flammand, Rita. "Truth about Residential Schools and Reconciling This History: A Michif View." *Response, Responsibility, and Renewal: Canada's Truth and Reconciliation Journey.* Ed. Gregory Younging, Jonathan Dewar, and Mike DeGagné. Ottawa: Aboriginal Healing Foundation, 2009. 73–81. Print.

Fonagy, Peter, and Mary Target. "Dissociation and Trauma." *Current Opinion in Psychiatry* 8.3 (1995): 161–66. Print.

"Former Patients Still Haunted by Memories of Nanaimo Indian Hospital." *Daily News (Nanaimo)*. Postmedia Network, 16 Dec. 2011. Web. 13 Jan. 2016.

Freud, Sigmund. «Screen Memories.» *The Uncanny*. New York: Penguin, 2003. 3–22. Print.

Frisbie, Charlotte Johnson. *Navajo Medicine Bundles or Jish: Acquisition, Transmission, and Disposition in the Past and Present*. Albuquerque: U of New Mexico P, 1987. Print.

Gaertner, David. "'The Climax of Reconciliation': Transgression, Apology, Forgiveness and the Body in Conflict Resolution." *Bioethical Enquiry* 8.3 (2011): 245–56. Print.

———. "Translating Reconciliation." *Translation Effects: The Shaping of Modern Canadian Culture*. Ed. Louise von Flotow, Sherry Simon, and Kathy Mezei. Montreal: McGill-Queen's UP, 2014. 444–57. Print.

Galley, Valerie. "Reconciliation and the Revitalization of Indigenous Languages." *Response, Responsibility, and Renewal: Canada's Truth and Reconciliation Journey*. Ed. Gregory Younging, Jonathan Dewar, and Mike DeGagné. Ottawa: Aboriginal Healing Foundation, 2009. 241–58. Print.

Garneau, David. "Imaginary Spaces of Reconciliation." *Reconcile This!* Spec. issue of *West Coast Line* 74 (2012): 28–39. Print.

———. "Indian to Indigenous: Temporary Pavilions to Sovereign Display Territories." *Revisioning the Indians of Canada Pavilion: Ahzhekewada [Let us look back]. A Colloquium for Aboriginal Curators, Artists, Critics, Historians and Scholars*. Aboriginal Curatorial Conference. Ontario College of Art and Design U, Toronto. 15 Oct. 2011. Keynote speech.

George-Kanentiio, Doug. "Atonement among the Haudenosaunee (Six Nations Iroquois)." *Indigenous Policy Journal* 20.3 (Fall 2009): 1–12. Print.

Giesbrecht, T., and H. Merckelbach. "The Causal Relationship between Dissociation and Trauma: A Critical Review." *Der Nervenarzt* 76.1 (2005): 20. Print.

Goeman, Mishuana. *Mark My Words: Native Women Mapping Our Nations*. Minneapolis: U of Minnesota P, 2013. Print.

Goffman, Erving. *Frame Analysis: An Essay on the Organization of Experience*. New York: Harper & Row, 1974. Print.

Goldie, Terry. *Fear and Temptation: The Image of the Indigene in Canadian, Australian, and New Zealand Literatures*. Montreal: McGill-Queen's UP, 1993. Print.

Goulet, Linda. Personal communication with Sam McKegney. 29 May 2012.

Govier, Trudy. *Forgiveness and Revenge*. New York: Routledge, 2002. Print.

Grand Council of the Haudenosaunee. *Polishing the Silver Covenant Chain: Building Relationships between Federal, State Agencies and the Haudenosaunee*. Ohsweken: Haudenosaunee Confederacy, 2002. Print.

Grant, Agnes. *Finding My Talk: How Fourteen Native Women Reclaimed Their Lives after Residential School*. Calgary: Fifth House, 2004. Print.

Grant, Larry. Personal correspondence with David Gaertner. 4 Nov. 2014.

Griffin, Kevin. "Witnesses: Bringing Residential Schools in the Present." *Vancouver Sun*. 17 Sept. 2013. Web. 12 Dec. 2015.

Griswold, Charles. *Forgiveness: A Philosophical Investigation*. Cambridge: Cambridge UP, 2007. Print.

Haig-Brown, Celia. *Resistance and Renewal: Surviving the Indian Residential School*. Vancouver: Arsenal Pulp, 1998. Print.

Hale, Alan S. "Justice Murray Sinclair Relates Commission's Findings on Residential School Legacy." *Kenora Daily Miner and News*. Kenora Daily Miner and News, 29 May 2014: n. pag. Web. 3 July 2014.

Halfe, Louise Bernice. *Bear Bones and Feathers*. Regina: Coteau, 1994. Print.

——. *Blue Marrow*. Regina: Coteau, 2004. Print.

——. "Nitotem." Halfe, *Bear* 75.

——. Personal interview with Sam McKegney. 2 Feb. 2011.

——. "Stones." Halfe, *Bear* 81.

——. "Valentine Dialogue." Halfe, *Bear* 52.

Hallowell, A.I. *Culture and Experience*. Philadelphia: Pennsylvania UP, 1955. Print.

——. *The Ojibwa of Berens River: Ethnography into History*. Ed. with a preface and afterword by Jennifer S.H. Brown. Fort Worth: Harcourt Bruce Jovanovich, 1992. Print.

Hamill, Chad. *Songs of Power and Prayer in the Columbia Plateau: The Jesuit, the Medicine Man, and the Indian Hymn Singer*. Corvallis: Oregon State UP, 2012. Print.

Harjo, Joy. "Threads of Blood and Spirit." *A Map to the Next World*. New York: Norton, 2001. 118–19. Print.

Hasty, Jennifer. 2005. "Sympathetic Magic/Contagious Corruption: Sociality, Democracy, and the Press in Ghana." *Public Culture* 17.3: 339–69. Print.

Hearne, Joanna. *Smoke Signals: Native Cinema Rising*. Lincoln: Nebraska UP, 2012. Print.

Henderson, Jennifer. "The Camp, the School, and the Child: Discursive Exchanges and (Neo)liberal Axioms in the Culture of Redress." Henderson and Wakeham, *Reconciling Canada* 63–84.

Henderson, Jennifer, and Pauline Wakeham, eds. *Aboriginal Redress*. Spec. issue of *ESC: English Studies in Canada* 35.1 (2009). Print.

——. "Colonial Reckoning, National Reconciliation? First Peoples and the Culture of Redress in Canada." *ESC: English Studies in Canada* 35.1 (2009): 1–26. Print.

——, eds. *Reconciling Canada: Critical Perspectives on the Culture of Redress*. Toronto: U of Toronto P, 2013. Print.

Hermes, Mary R. "White Teachers, Native Students; Rethinking Culture-Based Education." *Narrative and Experience in Multicultural Education*. Ed. JoAnn Phillion, Ming Fang He, and F. Michael Connelly. Thousand Oaks: Sage, 2005. 95–155. Print.

Highmore, Ben. "Bitter After Taste: Affect, Food and Social Aesthetics." *The Affect Theory Reader*. Ed. Melissa Gregg and Gregory Siegworth. Durham: Duke UP, 2010. Print.

——. "Social Aesthetics." *Handbook of Cultural Sociology*. Ed. John R. Hall, Laura Grindstaff, and Ming-Cheng Lo. London: Routledge, 2010. 151–63. Print.

Highway, Tomson. *Dry Lips Oughta Move to Kapuskasing*. Markham: Fifth House, 2010. Print.

——. *Kiss of the Fur Queen*. Toronto: Anchor, 1999. Print.

————. *The Rez Sisters*. Markham: Fifth House, 1988. Print.

Hill, Gabrielle L'Hirondelle, and Sophie McCall. *The Land We Are: Artists and Writers Unsettle the Politics of Reconciliation*. Winnipeg: Arbeiter Ring, 2015. Print.

Hirose, Tomio. *Origins of Predicates: Evidence from Plains Cree*. New York: Routledge, 2003. Print.

Hirsch, Marianne. "The Generation of Postmemory." *Poetics Today* 29.1 (2008): 103–28. Print.

Hirschkind, Charles. *The Ethical Soundscape: Cassette Sermons and Islamic Counterpublics*. New York: Columbia UP, 2006. Print.

Hokowhitu, Brendan. "Māori Rugby and Subversion: Creativity, Domestication, Oppression and Decolonization." *International Journal of the History of Sport* 26.16 (2009): 2314–34. Print.

hooks, bell. "Altars of Sacrifice: Re-membering Basquiat." 1993. *Art on My Mind: Visual Politics*. New York: New P, 1995. 35–48. Print.

Howes, David. "The Aesthetics of Mixing the Senses: Cross-Modal Aesthetics." *Relax Rainy Days Catalogue*. Luxembourg: Orchestre Philharmonie Luxembourg, 2008. 71–85. Print.

Hulan, Renée, and Renate Eigenbrod, eds. *Aboriginal Oral Traditions: Theory, Practice, Ethics*. Halifax: Fernwood, 2008. Print.

Igoliorte, Heather. "Inuit Artistic Expression as Cultural Resistance." *Dancing, Singing, Painting, and Speaking the Healing Story: Healing through Creative Arts*. Ed. Linda Archibald. Ottawa: Aboriginal Healing Foundation, 2012. Print.

Indian Residential Schools Adjudication Secretariat. "The IAP: What It Is and What You Need to Know." IRSAS, n.d. Web. 8 Aug. 2014. <http://www.iap-pei.ca/former-ancien/former-ancien-eng.php>.

International Center for Transitional Justice. "Canada's TRC: Special Challenges." Fact Sheet Series. ICTJ, 2008. Web. 29 Dec. 2009.

————. "What Is Transitional Justice?" Fact Sheet Series. ICTJ, 2009. Web. 4 Feb. 2014.

Inukpuk, Petah. Message to Pauline Wakeham. 26 Feb. 2014. Email.

Ironchild, Murray. Sidebar. *From Truth to Reconciliation: Transforming the Legacy of Residential Schools*. Ed. Marlene Brant Castellano, Linda Archibald, and Mike DeGagné. Ottawa: Aboriginal Healing Foundation, 2008. 408. Print.

Jacobs, Madelaine Christine. "Assimilation Through Incarceration: The Geographic Imposition of Canadian Law Over Indigenous Peoples." Diss. Queen's U, 2012. *Collections Canada*. Web. 13 Jan. 2016.

James, Matt. "Uncomfortable Comparisons: The Canadian Truth and Reconciliation Commission in International Context." *Ethics Forum* 5.2 (2010): 23–35. Print.

Janvier, Alex. *Blood Tears*. 2001. *From Truth to Reconciliation: Transforming the Legacy of Residential Schools*. Ed. Marlene Brant Castellano, Linda Archibald, and Mike DeGagné. Ottawa: Aboriginal Healing Foundation, 2008. Plate 1. Print.

Jenness, Diamond. *The Ojibwa Indians of Parry Island: Their Social and Religious Life*. Ottawa: National Museum of Canada, 1935. Print. Canada Department of Mines Bulletin No. 78.

Jennings, Francis, ed. *The History and Culture of Iroquois Diplomacy: An Interdisciplinary Guide to the Treaties of the Six Nations and Their League.* Syracuse: Syracuse UP, 1985. Print.

Joe, Rita. "I Lost My Talk." *Canadian Woman Studies* 10.2&3 (1989): 28. Print.

Johnston, Basil. *Indian School Days.* Norman: U of Oklahoma P, 1988. Print.

Justice, Daniel Heath. "'Go Away, Water!' Kinship Criticism and the Decolonization Imperative." *Reasoning Together: The Native Critics Collective.* Ed. Craig S. Womack, Daniel Heath Justice, and Christopher B. Teuton. Norman: U of Oklahoma P, 2007. 147–68. Print.

Kanehsatake: 270 Years of Resistance. Dir. Alanis Obomsawin. NFB, 1993. Film.

Katya, Mandoki. *Everyday Aesthetics: Prosaics, Social Identities and the Play of Culture.* Aldershot: Ashgate, 2007. Print.

Keil, Charles. "Participatory Discrepancies and the Power of Music." *Cultural Anthropology* 2.3 (1987): 275–83. Print.

Kennedy, Mark. "Attitudes of 'Coldness, Indifference' Behind Thousands of Residential School Deaths: TRC Report." *National Post.* National Post, 15 Dec. 2015. Web. 13 Jan. 2016.

Kindon, Sara. "Participatory Video in Geographic Research: A Feminist Practice of Looking?" *Area* 35.2 (2003): 142–53. Print.

Klopotek, Brian. "'I guess your warrior look doesn't work every time': Challenging Indian Masculinity in the Cinema." *Across the Great Divide: Cultures of Manhood in the American West.* Ed. Matthew Basso, Laura McCall, and Dee Garceau. New York: Routledge, 2001. 251–73. Print.

Knockwood, Isabelle, and Gillian Thomas. *Out of the Depths: The Experiences of Mi'kmaw Children at the Indian Residential School at Shubenacadie, Nova Scotia.* New extended ed. Black Point: Roseway, 2001. Print.

Koosees, Sammy. "Truth and Reconciliation Walk." *YouTube.* 4 Oct. 2011. Web. 22 May 2013.

Koptie, Steven W. "Indigenous Self Discovery: 'Being Called to Witness.'" *First Peoples Child & Family Review* 4.2 (2009): 114–25. Print.

Kornhauser, Sebastian. "Self Determination, Micro Sovereignty® and Human Rights in International Law: A Trinity of Categorical Imperative Norms through the Creation of the Doctrine of Micro Sovereignty." *Social Science Research Network.* SSRN, 10 May 2011. Web. 11 Jan. 2016.

Krog, Antjie, et al. *There Was This Goat: Investigating the Truth Commission Testimony of Notrose Nobomvu Konile.* Scottsville: U of KwaZulu-Natal P, 2009. Print.

Kupfer, Joseph H. *Experience as Art: Aesthetics in Everyday Life.* Albany: State U of New York P, 1983. Print.

LaCapra, Dominic. *Writing History, Writing Trauma.* Baltimore: Johns Hopkins UP, 2001. Print.

Lagaay, Alice. "Between Sound and Silence: Voice in the History of Psychoanalysis." *Episteme* 1.1 (2008): 53–62. Print.

Lalonde, Michelle. "Canadians 'Comfortably Blind' about Residential Schools' Damage." *Montreal Gazette.* Postmedia Network, 7 Feb. 2013: n. pag. Web. 4 Mar. 2013.

Landes, Ruth. *Ojibwa Religion and the Midéwiwin*. Madison: U of Wisconsin P, 1968. Print.

Latham, Alan. "The Power of Distraction: Distraction, Tactility, and Habit in the Work of Walter Benjamin." *Environment and Planning D: Society and Space* 17.4 (1999): 451–73. Print.

Lawrence, Bonita. "Gender, Race, and the Regulation of Native Identity in Canada and the United States: An Overview." *Hypatia* 18.2 (2003): 3–31. Print.

Leggatt, Judith. "Native Writing, Academic Theory: Postcolonialism Against the Cultural Divide." *Is Canada Postcolonial? Unsettling Canadian Literature*. Ed. Laura Moss. Waterloo: Wilfrid Laurier UP, 2009. 111–26. Print.

Levine, Victoria Lindsay, and Bruno Nettl. "Strophic Form and Asymmetrical Repetition in Four American Indian Songs." *Analytical and Cross-Cultural Studies in World Music*. Ed. Michael Tenzer and John Roeder. New York: Oxford UP, 2011. 288–315. Print.

Liffman, Paul. "Indigenous Territorialities in Mexico and Colombia." *Regional Worlds at the University of Chicago*, 1998. Web. 12 Jun. 2013.

Lightning, Georgina, dir. *Older Than America*. Perf. Adam Beach, Georgina Lightning, Bradley Cooper, and Wes Studi. Tribal Alliance Productions, 2008. Film.

Ljunggren, David. "Every G20 Nation Wants to Be Canada, Insists PM." *Reuters.com*. Reuters, 25 Sept. 2009: n. pag. Web. 13 Feb. 2014.

Llewellyn, Jennifer. "Bridging the Gap between Truth and Reconciliation: Restorative Justice and the Indian Residential Schools Truth and Reconciliation Agreement." *From Truth to Reconciliation: Transforming the Legacy of Residential Schools*. Ed. Marlene Brant Castellano, Linda Archibald, and Mike DeGagné. Ottawa: Aboriginal Healing Foundation, 2008. 183–204. Print.

Loft, Steven. "Reconciliation … Really? From Macdonald to Harper: A Legacy of Colonial Violence." *West Coast Line* (Summer 2012): 40–47. Print.

Logan, Tricia. "A Métis Perspective on Truth and Reconciliation." *From Truth to Reconciliation: Transforming the Legacy of Residential Schools*. Ed. Marlene Brant Castellano, Linda Archibald, and Mike DeGagné. Ottawa: Aboriginal Healing Foundation, 2008. 69–86. Print.

Lomawaima, K. Tsianina, and T.L. McCarty. *"To Remain an Indian": Lessons in Democracy from a Century of Native American Education*. New York: Teachers College, 2006. Print. Multicultural Education Series.

Loring, Kevin. *Where the Blood Mixes*. Vancouver: Talonbooks, 2009. Print.

Mackey, Eva. "The Apologizers Apology." Henderson and Wakeham, *Reconciling Canada* 47–62.

Maines, Rachel P., and James J. Glynn. "Numinous Objects." *The Public Historian* 15.1 (1993): 9–25. Print.

Maracle, Bonnie Jane (Iehnhotonkwas). Personal interview. 26 July 2013.

Marr, Tonaya. "City Committee Looking for Answers Regarding Industrial School Cemetery." *Regina Leader-Post*. Postmedia Network, 2 Aug. 2012: n. pag. Web. 3 Feb. 2014.

Marsh, Charity. "Bits and Pieces of Truth: Storytelling, Identity, and Hip Hop in Saskatchewan." *Aboriginal Music in Contemporary Canada: Echoes*

and Exchanges. Ed. Anna and Beverley Diamond Hoefnaels. Montreal: McGill-Queen's UP, 2012. 346–71. Print.

Marston, Luke. Interview by Gregor Craigie. *On the Island.* CBC British Columbia, 16 March 2012. Radio.

Martin, Karen. "Ways of Knowing, Being and Doing: A Theoretical Framework and Methods for Indigenous and Indigenist Re-Search." *Journal of Australian Studies* 27.76 (2003): 203–14. Print.

Martin, Keavy. *Stories in a New Skin: Approaches to Inuit Literature.* Winnipeg: U of Manitoba P, 2012. Print.

———. "Truth, Reconciliation, and Amnesia: *Porcupines and China Dolls* and the Canadian Conscience." *English Studies in Canada* 35.1 (2009): 47–65. Print.

Mason, Leonard. *The Swampy Cree: A Study in Acculturation.* Ottawa: Department of the Secretary of State, 1967. Print. Anthropology Papers, National Museum of Canada, No. 13.

Massumi, Brian. "Of Microperception and Micropolitics," *Inflexions: A Journal for Research Creation* 3 (Oct. 2009): n. pag. Web. 11 Jan. 2016.

McCall, Sophie. "1997: The Supreme Court of Canada Rules that the Laws of Evidence Must Be Adapted to Accommodate Aboriginal Oral Histories." *Translation Effects: The Shaping of Modern Canadian Culture.* Ed. Kathy Mezei, Sherry Simon, and Luise von Flotow. Montreal and Kingston: McGill-Queen's UP, 2014. 434–43. Print.

McCallum, Pamela. *Cultural Memories and Imagined Futures: The Art of Jane Ash Poitras.* Calgary: U of Calgary P, 2011. Print.

McKegney, Sam. *Magic Weapons: Aboriginal Writers Remaking Community after Residential School.* Winnipeg: U of Manitoba P, 2007. Print.

———. *Masculindians: Conversations about Indigenous Manhood.* Winnipeg: U of Manitoba P, 2014. Print.

———. "Warriors, Healers, Lovers, and Leaders: Colonial Impositions on Indigenous Male Roles and Responsibilities." *Canadian Perspectives on Men and Masculinities: An Interdisciplinary Reader.* Ed. Jason A. Laker. Toronto: Oxford UP, 2011. 241–68. Print.

McLeod, Neal. *Gabriel's Beach.* Regina: Hagios, 2008. Print.

McNally, Michael D. *Honoring Elders: Aging, Authority, and Ojibwe Religion.* New York: Columbia UP, 2009. Print.

Meuli, Jonathan. *Shadow House: Interpretations of Northwest Coast Art.* Amsterdam: Harwood Academic, 2001. Print.

Meyer, Manulani Aluli. *Ho'oulu: Our Time of Becoming: Hawaiian Epistemology and Early Writings.* Honolulu: Ai Pohaku, 2003. Print.

Miller, Jim R. "Reading Photographs, Reading Voices: Documenting the History of Native Residential Schools." *Reading Beyond Words: Contexts for Native History.* Ed. Jennifer S.H. Brown and Elizabeth Vibert. Peterborough: Broadview, 1996. 460–81. Print.

———. "Reconciliation with Residential School Survivors: A Progress Report." *A History of Treaties and Policies.* Vol. 7. Toronto: Thompson Educational, 2013. Print.

———. *Shingwauk's Vision: A History of Native Residential Schools.* Toronto: U of Toronto P, 1996. Print.

———. "Troubled Legacy: A History of Indian Residential Schools." *Saskatchewan Law Review* 66.2 (2003): 357–82. Print.

Million, Dian. "Trauma, Power, and the Psychotherapeutic: Speaking Psychotherapeutic Narratives in an Era of Indigenous Human Rights." Henderson and Wakeham, *Reconciling Canada* 159–77.

Milloy, John. *A National Crime: The Canadian Government and the Residential School System, 1879 to 1986.* Winnipeg: U of Manitoba P, 1999. Print.

Minister of Indian Affairs and Northern Development. *Gathering Strength: Canada's Aboriginal Action Plan.* Ottawa: Minister of Public Works and Government Services, 1997. Print.

Mitchell, Tony. *Global Noise: Rap and Hip-Hop Outside the USA.* Middletown: Wesleyan UP, 2001. Print. Music/Culture.

Mithun, Marianne. *The Languages of Native North America.* Cambridge: Cambridge UP, 2001. Print.

Morin, Peter. *Circle.* Diss. UBC Okanagan, 2010. Print.

———. *12 making objects A.K.A. First Nations DADA.* 2009. Performance. Open Space Artist-Run Centre, Victoria.

"Mortification." Def. n. *OED Online.* Oxford UP, June 2013. Web. 24 June 2013.

Nabokov, Peter. *A Forest of Time: American Indian Ways of History.* Cambridge; New York: Cambridge UP, 2002. Print.

Napoleon, Val. "*Delgamuukw*: A Legal Straightjacket for Oral Histories?" *Canadian Journal of Law and Society* 20.2 (2005): 123–55. Print.

Narine, Shari. "Bent Box Will Gather the Gifts of Survivors." *Windspeaker* 28.5 (2010): n. pag. *AMMSA.* Web. 21 March 2012.

———. "Creating Awareness during Walk to National Event." *Windspeaker* 29.7 (2011): n. pag. *AMMSA.* Web. 28 May 2013.

———. "Honorary Witnesses Promise to Spread the Word [TRC Event]." *Windspeaker* 30.5 (2012): n. pag. *AMMSA.* Web. 28 May 2013.

Naxaxalhts'I, Albert (Sonny) McHalsie. "We Have to Take Care of Everything That Belongs to Us." *Be of Good Mind: Essays on the Coast Salish.* Ed. Bruce Granville Miller. Vancouver: U of British Columbia P, 2007. 82–130. Print.

Negus, Keith. *Music Genres and Corporate Cultures.* New York: Routledge, 1999. Print.

Nock, David. *A Victorian Missionary and Canadian Indian Policy: Cultural Synthesis vs Cultural Replacement.* Waterloo: Wilfrid Laurier UP, 1988. Print.

Nock, Samantha. "Being a Witness: The Importance of Protecting Indigenous Women's Stories." *Rabble Blogs.* Rabble, 5 Sept. 2014. Web. 8 Sept. 2014.

Novak, Tim. Reference Services, Saskatchewan Archives Board. Message to Naomi Angel. 24 Sept. 2010. Email.

O'Bonsawin, Christine M. "'No Olympics on Stolen Native Land': Contesting Olympic Narratives and Asserting Indigenous Rights within the Discourse of the 2010 Vancouver Games." *Sport in Society: Cultures, Commerce, Media, Politics* 13.1: 143–56. Print.

Ochoa Gautier, Ana Maria. *Aurality: Listening and Knowledge in Nineteenth-Century Colombia.* Durham: Duke UP, 2014. Print.

———. "Sonic Transculturation, Epistemologies of Purification and the Aural Public Sphere in Latin America." *Social Identities* 12.6 (2006): 803–25. Print.

Oliver, Kelly. *Witnessing: Beyond Recognition*. Minneapolis: Minnesota UP, 2001. Print.

Panagia, Davide. *The Political Life of Sensation*. Durham: Duke UP, 2009. Print.

Pasztory, Esther. *Thinking with Things: Toward a New Vision of Art*. Austin: U of Texas P, 2005. Print.

Perea, John-Carlos. "The Unexpectedness of Jim Pepper." *MUSICultures*. Ed. Beverley Diamond, Kati Szego, and Heather Sparling. Spec. issue of *Indigenous Modernities* 39.1 (2012): 70–82. Print.

Perkel, Colin. "Truth Inquiry Seeks Help from Courts: Frustrated over Inability to Access Federal Papers." *Winnipeg Free Press*. Winnipeg Free Press, 3 Dec. 2012: n. pag. Web. 27 Aug. 2013.

"Phil Fontaine's Shocking Testimony of Sexual Abuse." *CBC Digital Archives*. Canadian Broadcasting Corporation, n.d. Web. 8 Aug. 2014.

Phu, Thy. *Picturing Model Citizens: Civility in Asian American Visual Culture*. Philadelphia: Temple UP, 2012. Print.

Pilzer, Joshua D. *Hearts of Pine: Songs in the Lives of Three Korean Survivors of the Japanese "Comfort Women."* New York: Oxford UP, 2012. Print.

Porter, Tom (Sakokweniónkwas). *And Grandma Said … Iroquois Teachings as Passed Down through the Oral Tradition*. N.p.: Xlibris, 2008. Print.

Pratt, Richard H. "The Advantages of Mingling Indians with Whites." *Americanizing the American Indians: Writings by the "Friends of the Indian" 1880–1900*. Ed. Francis Paul Prucha. Cambridge: Harvard UP, 1973. 260–71. Print.

Qureshi, Regula Burckhardt. "Musical Sound and Contextual Input: A Performance Model for Musical Analysis." *Ethnomusicology* 31.1 (1987): 56–86. Print.

Racette, Sherry Farrell. "Haunted: First Nations Children in Residential School Photography." *Depicting Canada's Children*. Ed. Loren Ruth Lerner. Waterloo: Wilfrid Laurier UP, 2009. 49–84. Print.

Radzik, Linda. *Making Amends: Atonement in Morality, Law, and Politics*. Oxford: Oxford UP, 2009. Print.

Rajan, Rajeswari Sunder. "Righting Wrongs, Rewriting History?" *Interventions* 2.2 (2000): 159–70. Print.

Ramos, Silvia, and Ana Maria Ochoa. "Music and Human Rights: The Afro-Reggae Cultural Group and the Youth from the Favelas as Responses to Violence in Brazil." *Music and Cultural Rights*. Ed. Andrew N. and Bell Yung Weintraub. Urbana: U of Illinois P, 2009. 219–40. Print.

Rancière, Jacques. *The Politics of Aesthetics*. Trans. Gabriel Rockhill. London: Continuum, 2004. Print.

"Raw Video: Survivors Testimony at TRC National Event in Vancouver." *APTN National News*. Aboriginal Peoples Television Network, 20 Sept. 2013. Web. 14 Sept. 2015.

Regan, Paulette. "An Apology Feast in Hazelton: Indian Residential Schools, Reconciliation, and Making Space for Indigenous Legal Traditions."

Indigenous Legal Traditions. Vancouver: U of British Columbia P, 2007. 40–76. Print.

———. *Unsettling the Settler Within: Indian Residential Schools, Truth Telling, and Reconciliation in Canada.* Vancouver: U of British Columbia P, 2010. Print.

"Residential School Survivor Says Compensation Process Failed Him." *CBC News.* Canadian Broadcasting Corporation, 14 Feb. 2013. Web. 30 June 2014.

Richardson, Troy. "Navigating the Problem of Inclusion as Enclosure in Native Culture-Based Education: Theorizing Shadow Curriculum." *Curriculum Inquiry* 41.3 (2011): 332–49. Print.

Ridington, Robin. *Trail to Heaven: Knowledge and Narrative in a Northern Native Community.* Iowa City: U of Iowa P, 1988. Print.

Rifkin, Mark. *When Did Indians Become Straight? Kinship, the History of Sexuality, and Native Sovereignty.* New York: Oxford UP, 2011. Print.

Ritter, Jonathan. "Complementary Discourses of Truth and Memory: The Peruvian Truth Commission and the Canción Social Ayacuchana." *Music, Politics and Violence.* Ed. Susan Fast and Kip Pegley. Middletown: Wesleyan UP, 2012. 197–222. Print.

Robinson, Dylan. "Feeling Reconciliation, Remaining Settled." *Theatres of Affect.* Ed. Erin Hurley. Toronto: Playwrights Canada, 2014. Print.

———. "Reconciliation Relations." *Canadian Theatre Review Journal* 161 (Winter 2015): 60–63. Print.

———. "'A Spoonful of Sugar': The Medicinal Redress of the Dakota Music Tour." *MUSICultures* 39.1 (2012): 11–128. Print.

Robinson, Dylan, and Keren Zaiontz. "Public Art in Vancouver and the Civic Infrastructure of Redress." *The Land We Are: Artists and Writers Unsettle the Politics of Reconciliation.* Ed. Sophie McCall and Gabrielle L'Hirondelle Hill. Winnipeg: Arbeiter Ring, 2015. 22–51. Print.

Rollings, Williard Hughes. "Indians and Christianity." *A Companion to American Indian History.* Ed. P. Deloria and N. Salisbury. Oxford: Blackwell, 2004. 121–38. Print.

Rosaldo, Renato. "Imperialist Nostalgia." *Representations* 26.2 (1989): 107–22. Print.

Royal Commission on Aboriginal Peoples. *Final Report of the Royal Commission on Aboriginal Peoples. Vol. 1: Looking Forward, Looking Back.* Ottawa: Canada Communication Group, 1996. Print.

Ruffo, Armand Garnet. *At Geronimo's Grave.* Regina: Coteau, 2002. Print.

———. *Grey Owl: The Mystery of Archie Belaney.* Regina: Coteau, 1997. Print.

———. *Norval Morrisseau: Man Changing into Thunderbird.* Vancouver: Douglas & McIntyre, 2014. Print.

———. *Opening in the Sky.* Penticton: Theytus, 1994. Print.

———. *The Thunderbird Poems.* Madeira Park: Harbour, 2015. Print.

———, dir. *A Windigo Tale.* Perf. Jani Lauzon, Andrea Menard, and Gary Farmer. Windigo Productions, 2010. Film.

Saito, Yuriko. *Everyday Aesthetics.* Oxford: Oxford UP, 2008. Print.

Saladin d'Anglure, Bernard. Message to Pauline Wakeham. 7 July 2014. Email.

Samuels, David William. *Putting a Song on Top of It: Expression and Identity*

on the San Carlos Apache Reservation. Tucson: U of Arizona P, 2004. Print.

―――. "Singing Indian Country." *Music of the First Nations: Tradition and Innovation in Native North America*. Ed. Tara Browner. Urbana: U of Illinois P, 2009. 141–59. Print.

Sarris, Greg. *Keeping Slug Woman Alive: A Holistic Approach to American Indian Texts*. Berkeley: U of California P, 1993. Print.

―――. *Mabel McKay: Weaving the Dream*. Berkeley: U of California P, 1994. Print.

Saunders, Doug. "Residential Schools, Reserves and Canada's Crime Against Humanity." *Globe and Mail*. Globe and Mail, 5 June 2015. Web. 13 Jan. 2016.

Sawtooth. Dir. Andreas Kidess. Perf. Adam Beach and Georgina Lightning. Tribal Alliance Productions, 2004. Film.

"Schedule N: Mandate for the Truth and Reconciliation Commission." *Indian Residential Schools Settlement Agreement*, 8 May 2006. Web. 17 July 2014. <http://www.trc.ca/websites/trcinstitution/File/pdfs/SCHEDULE_N_EN.pdf>.

Scott, Jill. Field notes from Québec National Event. Fairmont Queen Elizabeth Hotel, Montreal. 27 April 2013. TS.

―――. *A Poetics of Forgiveness: Cultural Responses to Loss and Wrongdoing*. New York: Palgrave, 2010. Print.

Seltzer, Mark. "Wound Culture: Trauma in the Pathological Public Sphere." *October* 80 (Spring 1997): 3–26. Print.

Shingwauk Residential Schools Centre. *The Spanish Indian Residential School: Photo Album, Boys*. Algoma University Archives, n.d. Web. 20 July 2014.

Silko, Leslie Marmon. "Language and Literature from a Pueblo Indian Perspective." *English Literature: Opening Up the Canon*. Ed. Leslie Fiedler. Baltimore: Johns Hopkins UP, 1981. 54–72. Print.

Silverstein, Michael. "'Cultural' Concepts and the Language-Culture Nexus." *Current Anthropology* 45.5 (2004): 621–52. Print.

―――. "The Improvisational Performance of Culture in Realtime Discursive Practice." *Creativity in Performance*. Ed. Keith R. Sawyer. Greenwich: Ablex, 1997. 265–312. Print.

Simon, Roger. *The Touch of the Past: Remembrance, Learning, and Ethics*. New York: Palgrave Macmillan, 2005. Print.

―――. "Towards a Hopeful Practice of Worrying: The Problematics of Listening and the Educative Responsibilities of Canada's Truth and Reconciliation Commission." Henderson and Wakeham, *Reconciling Canada* 129–42.

Simpson, Audra. "Commentary: The 'Problem' of Mental Health in Native North America: Liberalism, Multiculturalism, and the (Non)Efficacy of Tears." *Ethos* 36.3 (2008): 376–79. Print.

―――. "On Ethnographic Refusal: Indigeneity, 'Voice' and Colonial Citizenship." *Junctures* 9 (2007): 67–80. Print.

Simpson, Audra, and Andrea Smith. Introduction. *Theorising Native Studies*. Raleigh: Duke UP, 2014. 1–30. Print.

Sinclair, Murray. Address to the Assembly of First Nations annual general meeting, Calgary, July 22, 2009. *Truth and Reconciliation Commission of Canada.* TRC, n.d. Web. 5 March 2013.

———. "Closing Remarks." Truth and Reconciliation Commission of Canada. Vancouver Island Regional Event, Victoria. 14 Apr. 2012. Address.

———. "Presentation by the Honourable Mr. Justice Murray Sinclair on the Occasion of Receiving an Honorary Doctorate from the U of Winnipeg Fall Convocation." U of Winnipeg. 16 Oct. 2011. Address.

———. "Shared Perspectives, An Evening of Reconciliation." *Truth and Reconciliation Commission of Canada.* TRC, 14 Aug. 2012. Web. 13 Jan. 2016.

Sison, Marites N. "Anglican Exhibit Elicits Heartfelt Response." *Anglican Journal.* Anglican Church of Canada, 11 July 2011: n. pag. Web. 3 Feb. 2014.

———. "Moorby Collection Tells Tale of 1960s Inuvik Life." *Anglican Journal.* Anglican Church of Canada, 1 June 2011: n. pag. Web. 3 Feb. 2014.

———. "A Walk Unlike Any Other." *Anglican Journal.* Anglican Church of Canada, 27 Oct. 2011: n. pag. Web. 7 June 2013.

Sliwinski, Sharon. *Human Rights In Camera.* Chicago: U of Chicago P, 2011. Print.

Smith, Andrea. *Conquest: Sexual Violence and American Indian Genocide.* Cambridge: South End, 2005. Print.

Smith, Linda Tuhiwai. *Decolonizing Methodologies: Research and Indigenous Peoples.* London: Zed Books, 1999. Print.

Somerville, Margaret. *The Ethical Imagination: Journeys of the Human Spirit.* Toronto: Anansi, 2006. Print.

Sopinka, John, Sidney M. Lederman, and Alan W. Bryant. *The Law of Evidence in Canada.* Toronto: Butterworths, 1992. Print.

Spinney, Ann Morrison. *Passamaquoddy Ceremonial Songs: Aesthetics and Survival.* Amherst: U of Massachusetts P, 2009. Print. Native Americans of the Northeast: History, Culture, and the Contemporary.

"Statement of Apology to Former Students of Indian Residential Schools." The Right Honourable Stephen Harper, on behalf of the Government of Canada. House of Commons, Ottawa. 11 June 2008. Web. 2 Sept. 2012.

Stevenson, Lisa. "An Ethical Injunction to Remember: Memory, Cultural Survival and Ethics in Nunavut." *Critical Inuit Studies: An Anthology of Contemporary Arctic Ethnography.* Ed. Pamela R. Stern and Lisa Stevenson. Lincoln: U of Nebraska P, 2006. 167–84. Print.

Stewart, Hilary. *Cedar: Tree of Life to the Northwest Coast.* Vancouver: Douglas & McIntyre, 1995. Print.

Stokes, Martin. *The Republic of Love: Cultural Intimacy in Turkish Popular Music.* Chicago: U of Chicago P, 2010. Print.

Swan, Michael. "Aboriginals Try to Reconnect with a Stolen Past." *Catholic Register.* Catholic Register, 14 July 2011: n. pag. Web. 16 July 2014.

"Teachers Seek Healing through Truth Commission." *CBC.ca.* CBC News Manitoba, 18 June 2010. Web. 20 Aug. 2013.

Tengan, Ty P. Kāwika. *Native Men Remade: Gender and Nation in Contemporary Hawai'i.* Durham: Duke UP, 2008. Print.

Thrasher, Anthony Apakark. Unpublished manuscript. Calgary: Spy Hill Penitentiary, 1973. Print.

Thrift, Nigel. *Non-representational Theory: Space, Politics, Affect*. New York: Routledge, 2008. Print.

"Tk'emlups Day Scholars." *Tk'emlúps*. Tk'emlúps te Secwepemc, 2016. Web. 13 Jan. 2016.

Treasury Board of Canada Secretariat. "Minister's Message." *Treasury Board of Canada Secretariat*, 9 Nov. 2009. Web. 12 Dec. 2015. <http://www.tbs-sct.gc.ca/rpp/2010-2011/inst/irs/irs01-eng.asp>.

Troutman, John William. *Indian Blues: American Indians and the Politics of Music, 1879–1934*. Norman: U of Oklahoma P, 2009. Print. New Directions in Native American Studies.

Truth and Reconciliation Commission of Canada. *Canada's Residential Schools: Missing Children and Unmarked Burials*. Vol. 4 of *The Final Report of the Truth and Reconciliation Commission of Canada*. Montreal and Kingston: McGill-Queen's UP, 2015. National Centre for Truth and Reconciliation. Web. 29 March 2016.

———. *Canada's Residential Schools: Reconciliation*. Vol. 6 of *The Final Report of the Truth and Reconciliation Commission of Canada*. Montreal and Kingston: McGill-Queen's UP, 2015. *National Centre for Truth and Reconciliation*. Web. 29 March 2016.

———. *Canada's Residential Schools: The History, Part 1, Origins to 1939*. Vol. 1 of *The Final Report of the Truth and Reconciliation Commission of Canada*. Montreal and Kingston: McGill-Queen's UP, 2015. *National Centre for Truth and Reconciliation*. Web. 29 March 2016.

———. *Canada's Residential Schools: The History, Part 2, 1939 to 2000*. Vol. 1 of *The Final Report of the Truth and Reconciliation Commission of Canada*. Montreal and Kingston: McGill-Queen's UP, 2015. *National Centre for Truth and Reconciliation*. Web. 29 March 2016.

———. *Canada's Residential Schools: The Inuit and Northern Experience*. Vol. 2 of *The Final Report of the Truth and Reconciliation Commission of Canada*. Montreal and Kingston: McGill-Queen's UP, 2015. *National Centre for Truth and Reconciliation*. Web. 29 March 2016.

———. *Canada's Residential Schools: The Legacy*. Vol. 5 of *The Final Report of the Truth and Reconciliation Commission of Canada*. Montreal and Kingston: McGill-Queen's UP, 2015. *National Centre for Truth and Reconciliation*. Web. 29 March 2016.

———. *Canada's Residential Schools: The Métis Experience*. Vol. 3 of *The Final Report of the Truth and Reconciliation Commission of Canada*. Montreal and Kingston: McGill-Queen's UP, 2015. *National Centre for Truth and Reconciliation*. Web. 29 March 2016.

———. "Honorary Witness." *Truth and Reconciliation Commission of Canada*. TRC, n.d. Web. 8 Aug. 2014.

———. *Honouring the Truth, Reconciling for the Future: Summary of the Final Report of the Truth and Reconciliation Commission of Canada*. Winnipeg: TRC, 2015. Web.

———. "Live Show [Procaster] Wed Apr 24 2013 02:50:43 PM." Recording of streamed broadcast of segment of Truth and Reconciliation National Event in Montreal. 24 April 2013. Web. 16 Aug. 2013.

———. "Live Show [Procaster] Thu Apr 25 2013 09:18:13 AM." Recording of streamed broadcast of segment of Truth and Reconciliation National Event in Montreal. 25 April 2013. Web. 17 Aug. 2013.

———. "Live Show [Procaster] Thu Jun 21 2012 02:38:54 PM." Recording of streamed broadcast of segment of Truth and Reconciliation National Event in Saskatoon. 21 June 2012. Web. 17 Aug. 2013.

———. "Live Show [Procaster] Fri Apr 26 2013 08:35:54 AM." Recording of streamed broadcast of segment of Truth and Reconciliation National Event in Montreal. 26 April 2013. Web. 16 Aug. 2013.

———. "Our Mandate." *Truth and Reconciliation Commission of Canada.* TRC, n.d. Web. 21 Aug. 2013. <http://www.trc.ca/websites/trcinstitution/index.php?p=7#top0>.

———. "Open Calls for Artistic Submissions." *Truth and Reconciliation Commission of Canada.* TRC, n.d. Web. 13 Oct 2015. <http://www.trc.ca/websites/trcinstitution/File/pdfs/TRC_Art_Submissions_en_p6.pdf>.

———. *Presentation to the Senate Committee on Aboriginal Peoples by the Honourable Justice Murray Sinclair, September 28, 2010.* TRC, n.d. PDF. 20 Aug. 2013. <http://www.trc.ca/websites/trcinstitution/File/pdfs/sen ate%20speech_handout_copy_E_Final.pdf>.

———. *Québec National Event Program.* Montreal: TRC, 2013. Print.

———. *The Survivors Speak: A Report of the Truth and Reconciliation Commission of Canada.* Winnipeg: TRC, 2015. *National Centre for Truth and Reconciliation.* Web. 29 March 2016.

———. *They Came for the Children: Canada, Aboriginal Peoples, and Residential Schools.* Winnipeg: TRC, 2012. Print.

———. *Truth and Reconciliation Commission of Canada: Calls to Action.* Winnipeg: TRC, 2012. *Truth and Reconciliation Commission of Canada.* Web. 13 Oct 2015.

———. *Truth and Reconciliation Commission of Canada: Interim Report.* Winnipeg: TRC, 2012. Print.

———. *What We Have Learned: Principles of Truth and Reconciliation.* Winnipeg: TRC, 2015. Print.

Tsilhqot'in Nation v. British Columbia. 2014 SCC 44, [2014] 2 S.C.R. 256. Print.

Tuan, Yi–Fu. *Passing Strange and Wonderful: Aesthetics, Nature and Culture.* New York: Kodansha, 1995. Print.

Tuck, Eve, and K. Wayne Yang. "Decolonization Is Not a Metaphor." *Decolonization: Indigeneity, Education & Society* 1.1 (2012): 1–40. Print.

Tulk, Janice Esther. "'Our Strength Is Ourselves': Identity, Status, and Cultural Revitalization among the Mi'kmaq in Newfoundland." Ph.D. diss. Memorial U of Newfoundland, 2008. Print.

Turino, Thomas. *Music as Social Life: The Politics of Participation.* Chicago: U of Chicago P, 2008. Print.

———. "Signs of Imagination, Identity, and Experience: A Peircian Semiotic Theory for Music." *Ethnomusicology* 43.2 (1999): 221–55. Print.

Turner, Dale. "On the Idea of Reconciliation in Contemporary Aboriginal Politics." Henderson and Wakeham, *Reconciling Canada* 100–111.

———. *This Is Not a Peace Pipe: Towards a Critical Indigenous Philosophy.* Toronto: U of Toronto P, 2006. Print.

Turner, Michael. "Witnesses: Art and Canada's Indian Residential Schools." *Canadian Art.ca*. Canadian Art, 22 Nov. 2013: n. pag. Web. 8 Aug. 2014. <http://www.canadianart.ca/reviews/2013/11/22/witnesses-belkin/>.

Tutu, Desmond. *No Future without Forgiveness*. New York: Doubleday, 1999. Print.

"Two Row Wampum Treaty." *Wikipedia*. Wikimedia Foundation, n.d. Web. 2 April 2012.

United Church of Canada. "The Children Remembered" postcard. United Church of Canada Residential Schools Archive Project, n.d. Print.

United Church of Canada Archives. *The Children Remembered: Residential School Archive Project*. United Church of Canada, n.d. Web. 3 Feb. 2014.

United Nations. General Assembly. *Convention on the Prevention and Punishment of the Crime of Genocide*. New York: United Nations, 9 Dec. 1948. *United Nations Treaty Series*, Vol. 78, No. 1021. 278–322. Web. 2 July 2014.

Vizenor, Gerald. *Manifest Manners: Post-Indian Manners of Survivance*. Hanover: Wesleyan UP, 1994. Print.

Wakeham, Pauline. "The Cunning of Reconciliation: Reinventing White Civility in the 'Age of Apology.'" *Shifting the Ground of Canadian Literary Studies*. Ed. Smaro Kamboureli and Robert Zacharias. Waterloo: Wilfrid Laurier UP, 2012. 209–33. Print.

———. *Taxidermic Signs: Reconstructing Aboriginality*. Minneapolis: U of Minnesota P, 2008. Print.

"Walkers for Truth and Reconciliation." *Truth and Reconciliation Commission of Canada*. TRC, n.d. Web. 14 July 2012.

Warner, Michael. *Publics and Counterpublics*. New York: Zone, 2002. Print.

Warrior, Robert. "The Subaltern Can Dance, and So, Sometimes, Can the Intellectual." *Interventions* 13.1 (2011): 85–94.

Waugh, Earle H., ed. *Alberta Elders' Cree Dictionary/alperta ohci kehtehayak nehiyaw otwestamakewasinahikan*. Edmonton: U of Alberta P, 1998. Print.

Wiesel, Elie. *Night*. 1960. New York: Bantam, 1982. Print.

———. "Trivializing Memory." *From the Kingdom of Memory: Reminiscences*. New York: Schocken, 1995. 165–72. Print.

Wilson, M.T. "'Saturnalia of Blood': Masculine Self-Control and American Indians in the Frontier Novel." *Studies in American Fiction* 33 (2005): 131–46. Print.

Wise, Todd. "Speaking Through Others: Black Elk Speaks as Testimonial Literature." *The Black Elk Reader*. Ed. Clyde Holler. Syracuse: Syracuse UP, 2000. 19–39. Print.

"Witness Ceremony Conducted by Elder Larry Grant." *NationTalk.ca*. NationTalk, 28 July 2009. Web. 8 Aug. 2014.

Womack, Craig S. "Theorizing American Indian Experience." *Reasoning Together: The Native Critics Collective*. Ed. Craig S. Womack, Daniel Heath Justice, and Christopher B. Teuton. Norman: U of Oklahoma P, 2008. 353–410. Print.

Wright-McLeod, Brian. "Heartbeats: Native Music in Aboriginal and Canadian Life." *Hidden in Plain Sight: Contributions of Aboriginal Peoples to Canadian Identity and Culture.* Ed. Cora J. Voyageur, David R. Newhouse, and Dan Beavon. Toronto: U of Toronto P, 2011. 384–95. Print.

Wyatt, Gary. *Mythic Beings: Spirit Art of the Northwest Coast.* Vancouver: Douglas & McIntyre; Seattle: U of Washington P, 1999. Print.

Yúdice, George. "Afro Reggae: Parlaying Culture into Social Justice." *Social Text* 69 (2001): 53–65. Print.

Žižek, Slavoj. *The Parallax View.* Cambridge: MIT P, 2009. Print.

———. *How to Read Lacan.* New York: Norton, 2007. Print.

Discography

Aglukark, Susan. *Blood Red Earth*. Aglukark Entertainment under licence to Arbor Records, 2006.

———. *Unsung Heroes*. EMI Canada, 1999.

Alfred, Jerry. *Nendaä. Go Back*. Etsi Shon Productions/Caribou Records, 1996.

Bear, Cheryl. *The Good Road*. Independent, 2005.

Cline, Patsy. "Crazy." *Patsy Cline Showcase*. Decca, 1961.

Donovan, Mishi. *Journey Home*. Arbor Records, 2000.

Harris, Calvin. *Sweet Nothing, Remix featuring Florence Welch*. Deconstruction, Fly Eye, Columbia, 2012.

Hope, Beatrice. *Panik Labradorimiuk/Daughter of Labrador*. Independent, n.d.

Lauzon, Jani. *Mixed Blessings*. Ra Records, 2006.

Learning to Heal. Perf. participants in the Tunes and Talk group, Eskasoni, Nova Scotia. Prod. Jamie Foulds and Mike MacInnis. Independent, 2013.

Menard, Andrea. *Simple Steps*. Velvet and Hank Productions, 2005.

Morning Star. *A Little More Understanding*. Independent, n.d.

Palmer, Fara. *Pretty Brown*. New Hayden, 1999.

Simone, Nina. "Mississippi Goddam." *Nina Simone in Concert,* Phillips Records, 1964.

Songs from the Indian Residential School Legacy. Truth and Reconciliation Commission, 2015.

Tzo'kam. *Īt'em. "To sing."* Red Planet Records, 2000.

About the Contributors

Naomi Angel (1977–2014) completed her Ph.D. at the Department of Media, Culture, and Communication at New York University for which she received the Outstanding Dissertation Award. Her research focused on cultural memory, transitional justice, and processes of memorialization. From 2013 to 2014 she was an Andrew W. Mellon Postdoctoral Fellow at the Jackman Humanities Centre at the University of Toronto.

Jonathan Dewar is director of the Shingwauk Residential Schools Centre and special advisor to the president at Algoma University in Sault Ste. Marie, Ontario. From 2007 to 2012 he served as director of research at the Aboriginal Healing Foundation and is a past director of the Métis Centre at the National Aboriginal Health Organization. Jonathan is of mixed heritage, descended from Huron-Wendat, Scottish, and French-Canadian grandparents, and has an academic background in Aboriginal literatures and drama, Indigenous studies, and creative writing. Jonathan's research explores the role of art and artist in truth, healing, and reconciliation with regard to Indian residential schools and the Truth and Reconciliation Commission of Canada. He is completing a doctorate in Canadian studies at Carleton University.

Ethnomusicologist **Beverley Diamond** is an honorary research professor at Memorial University of Newfoundland, where she founded the Research Centre for the Study of Music, Media, and Place (MMaP). She has contributed to Canadian cultural historiography, to feminist music research, and to Indigenous studies. Her research on Indigenous expressive culture has explored constructs of technological mediation, transnationalism, and, most recently, concepts of reconciliation and healing. Publications include *Native American Music in Eastern North America* (Oxford University Press, 2008) and co-edited anthologies: Aboriginal Music in Contemporary Canada: *Echoes and Exchanges* (McGill-Queen's University Press, 2012) and *Music and Gender* (University of Illinois Press, 2000).

Byron Dueck is a lecturer in ethnomusicology at the Open University; he received his Ph.D. in ethnomusicology in 2005 from the University of Chicago. His research interests include North American Indigenous music and dance, musical publics, and the cultural study of rhythm

and metre. He is the author of *Musical Intimacies and Indigenous Imaginaries: Aboriginal Music and Dance in Public Performance* (Oxford University Press, 2013), the co-editor with Martin Clayton and Laura Leante of *Experience and Meaning in Music Performance* (Oxford University Press, 2013), and the co-editor with Jason Toynbee of *Migrating Music* (Routledge, 2011).

Alana Fletcher is adjunct professor in the département des lettres et communications at l'Université de Sherbrooke. Her recently completed dissertation examines the politically expedient yet problematic effects of adapting Indigenous oral histories concerning uranium contamination. Her work has appeared and is forthcoming in *Studies in Canadian Literature, Canadian Literature, Theatre Research in Canada, Papers of the Bibliographical Society of Canada*, and elsewhere.

David Gaertner is a settler scholar of German descent and an assistant professor in the First Nations and Indigenous Studies Program at the University of British Columbia. His research and teaching investigate new media and digital storytelling within a decolonial framework. He has also written and published articles on reconciliation, Indigenous literature, podcasting, and typeface. He blogs at novelalliances.com.

David Garneau (Métis) is associate professor of visual arts at the University of Regina, Saskatchewan. His practice includes painting, performance art, video, curation, and critical writing. He is interested in issues of nature and culture, metaphysics and materialism, and contemporary Indigenous identities and display. Garneau is currently working on curatorial and writing projects featuring contemporary Indigenous art in Canada and Australia, and is part of a five-year, SSHRC-funded curatorial research project, "Creative Conciliation." With Michelle LaVallee, he curated *Moving Forward, Never Forgetting*, an exhibition about aggressive assimilation, for the Mackenzie Art Gallery in Regina (2015). He is also touring *Dear John; Louis David Riel*, a performance piece featuring a living Riel sculpture interacting with John A. Macdonald statues across Canada.

Bracken Hanuse Corlett is an interdisciplinary artist hailing from the Wuikinuxv and Klahoose Nations. He is the co-founder of the Vancouver Indigenous Media Arts Festival, and over the last four years he has performed across the country as a member of the audio-visual collectives Skookum Sound System and the SEE Monsters. He

is a graduate of the En'owkin Centre of Indigenous Art and went to Emily Carr University of Art and Design for a B.F.A. in visual arts. He studied Northwest Coast art, carving, and design from acclaimed Heiltsuk artists Bradley Hunt, Shawn Hunt, and Dean Hunt. Some of his notable exhibitions, performances, and screenings have been at Grunt Gallery, Vancouver Art Gallery, Vancouver International Film Festival, Mackenzie Art Gallery, Urban Shaman, and Toronto International Film Festival.

Elizabeth Kalbfleisch is an independent art historian based in Toronto, Ontario. She writes and teaches about Indigenous visual culture, as well as craft, textiles, and contemporary art. She has held teaching appointments in art history, Canadian studies, and women and gender studies at several Canadian universities and was the 2011–2012 Research Fellow at the Canadian Museum of Civilization (now Canadian Museum of History). She holds a Ph.D. in visual and cultural studies from the University of Rochester.

Georgina Lightning (Cree) is a First Nations film director, screenwriter, and actor. Born in Edmonton, she moved to Los Angeles with her three young children in 1990. Since that time, her role in the film industry has evolved from actor and acting coach into producer, film director, screenwriter, and advocate for the involvement of women and Indigenous peoples in film. In 2008, she directed, wrote, and starred in the supernatural thriller film *Older Than America*, which won numerous awards and was featured at the TRC's Winnipeg National Event in 2010—the same year that Lightning received the White House Project Emerging Artists EPIC Award. A co-founder of Tribal Alliance Productions, Lightning is currently working on a trilogy of films dealing with suicide, trauma, and healing.

Keavy Martin is a settler scholar of Indigenous literatures at the University of Alberta, in Treaty 6 and Métis territory. Her 2012 monograph, *Stories in a New Skin: Approaches to Inuit Literature* (University of Manitoba Press), won the Gabrielle Roy Prize for literary criticism in English. Martin co-edited (with Julie Rak and Norma Dunning) the 2015 edition of Mini Aodla Freeman's classic autobiography, *Life Among the Qallunaat* (University of Manitoba Press). She is currently the principal investigator for a collaborative research project entitled "Creative Conciliations," which explores Indigenous artistic interventions into the problem of reconciliation following the TRC. She is the mother of a young son, Edzazii.

Sam McKegney is a settler scholar of Indigenous literatures. He grew up in Anishinaabe territory on the Saugeen Peninsula along the shores of Lake Huron and currently resides with his partner and their two daughters in traditional lands of the Haudenosaunee and Anishinaabe peoples, where he is an associate professor and graduate chair of the English Department at Queen's University. He has published a collection of interviews entitled *Masculindians: Conversations about Indigenous Manhood* (University of Manitoba Press, 2014), a monograph entitled *Magic Weapons: Aboriginal Writers Remaking Community after Residential School* (University of Manitoba Press, 2007), and articles on such topics as environmental kinship, masculinity theory, prison writing, Indigenous governance, and Canadian hockey mythologies.

Peter Morin is a Tahltan Nation artist, curator, writer, and assistant professor in the Visual and Aboriginal Arts Faculty at Brandon University. Morin studied art at Emily Carr University of Art and Design and completed an M.F.A. at the University of British Columbia Okanagan in 2011. In both his artistic practice and his curatorial work, Morin's research investigates impact sites between Indigenous cultural practices and Western settler colonialism. This work, defined by Tahltan Nation epistemological production, often takes on the form of performance interventions, object and picture making. Peter has participated in numerous exhibitions and performance events, including *Team Diversity Bannock* and the *World's Largest Bannock Attempt* (2005), *12 Making Objects A.K.A. First Nations DADA* (2009), *Peter Morin's Museum* (2011), and *Cultural Graffiti* in London, England (2013). Morin was longlisted for the 2014 Sobey Art Award.

A tawny mix of Ojibwe/Swampy Cree and English/Irish, **Lisa C. Ravensbergen** is an established, multi-hyphenate theatre artist based in Vancouver, British Columbia, on unceded Coast Salish territory. A playmaker, Jessie-nominated actor, dramaturge, writer, director, and sometimes dancer, she supplements her somewhat eclectic practice with the joys of motherhood and the challenges of self-produced works. She is an associate artist with Full Circle: First Nations Performance, a member of Literary Managers and Dramaturgs of the Americas, and a former associate playwright and dramaturg-in-residence at Playwrights Theatre Centre. She is a graduate of Trinity Western University and Simon Fraser University's School for the Contemporary Arts.

Dylan Robinson is a Stó:lō scholar who holds the Canada Research Chair in Indigenous Arts at Queen's University, located on the traditional lands of the Haudenosaunee and Anishinaabe peoples. His research focuses upon the sensory politics of Indigenous activism and the arts, and questions how Indigenous rights and settler colonialism are embodied and spatialized in public space. His current research considers the history of contemporary Indigenous public art and artistic interventions in public spaces across North America. His co-edited collection *Opera Indigene: Re/Presenting First Nations and Indigenous Cultures* (Ashgate, 2011) examines operatic representations of First Peoples and the lesser-known history of opera created by Indigenous composers and artists.

Armand Garnet Ruffo draws on his Ojibwe heritage for his writing. Born in Chapleau, northern Ontario, his roots extend to the Chapleau Fox Lake Cree First Nation and the Sagamok Ojibwe First Nation. In 2014, his creative biography *Norval Morrisseau: Man Changing into Thunderbird* was published by Douglas and McIntyre and was nominated for a Governor General's Literary Award. In 2015, *The Thunderbird Poems*, based on the paintings of the artist, was published by Harbour Publishing. In 2016, he co-edited with Heather Macfarlane the collection *Introduction to Indigenous Literary Criticism* (Broadview). He currently lives in Kingston and teaches at Queen's University.

Jill Scott is vice-provost (teaching and learning) and professor in the Department of Languages, Literatures and Cultures at Queen's University. She is the author of *Electra after Freud* (Cornell University Press, 2005), *A Poetics of Forgiveness* (Palgrave, 2010), and a co-edited volume (with Leo Riegert and Jack Shuler), *Thinking and Practicing Reconciliation: Teaching and Learning through Literary Responses to Conflict* (Cambridge Scholars, 2014). Her research is currently divided between Indigenous studies and educational research. She is currently engaged in projects exploring how the revitalization of Indigenous languages and cultures affects redress for Indigenous peoples in Canada.

Pauline Wakeham is a settler scholar of Indigenous literary and cultural studies. She is an associate professor in the Department of English at the University of Western Ontario, where she is also cross-appointed to the Centre for Transitional Justice and Post-Conflict Reconstruction and is an affiliate of the First Nations Studies Program. She is the author of *Taxidermic Signs: Reconstructing Aboriginality*

(University of Minnesota Press, 2008) and the co-editor of *Reconciling Canada: Critical Perspectives on the Culture of Redress* (University of Toronto Press, 2013). She is currently at work on a project regarding Indigenous reparations movements across Canada.

Copyright Acknowledgements

The publisher, the general editors, and the authors are grateful to the copyright holders who granted permission to reprint the following.

"Sweet Nothing" Words and music by Calvin Harris, Florence Welch, and Tom Hull. Copyright © 2012 TSJ Merlyn Licensing B.V, Florence and the Machine Ltd., and Universal Music Publishing Ltd. All rights for TSJ Merlyn Licensing B.V. in the U.S. and Canada controlled and administered by EMI April Music Inc. All rights for Florence and the Machine Ltd. and Universal Music Publishing Ltd. in the U.S. and Canada controlled and administered by Universal–Polygram International Publishing Inc. All rights reserved. International copyright secured. Used by permission. *Reprinted by permission of Hal Leonard Corporation.*

"Crazy" Words and music by Willie Nelson. Copyright © 1961 Sony/ATV Music Publishing LLC. Copyright renewed. All rights administered by Sony/ATV Music Publishing LLC, 424 Church Street, Suite 1200, Nashville, TN 37219. International copyright secured. All rights reserved. *Reprinted by permission of Hal Leonard Corporation.*

"Mississippi Goddam" Words and music by Nina Simone. Copyright © 1964 (Renewed) WB Music Corp. All rights reserved.

"'pain, pleasure, shame. Shame': Masculine Embodiment, Kinship, and Indigenous Reterritorialization," by Sam McKegney. *Canadian Literature* 216 (Spring 2013): 12–33. Copyright © 2015. Reprinted by permission of *Canadian Literature.*

An earlier version of David Garneau's chapter was published as "Imaginary Spaces of Reconciliation" in *West Coast Line* 74 (2012), a special edition titled *Reconcile This!* edited by Ayumi Goto and Jonathan Dewar. Reprinted with permission.

INDEX

Books in the Indigenous Studies Series
Published by Wilfrid Laurier University Press

Blockades and Resistance: Studies in Actions of Peace and the Temagami Blockades of 1988–89 / Bruce W. Hodgins, Ute Lischke, and David T. McNab, editors / 2003 / xi + 276 pp. / illus. / ISBN 0-88920-381-4

Indian Country: Essays on Contemporary Native Culture / Gail Guthrie Valaskakis / 2005 / x + 293 pp. / illus. / ISBN 0-88920-479-9

Walking a Tightrope: Aboriginal People and Their Representations / Ute Lischke and David T. McNab, editors / 2005 / xix + 377 pp. / illus. / ISBN 978-0-88920-484-3

The Long Journey of a Forgotten People: Métis Identities and Family Histories / Ute Lischke and David T. McNab, editors / 2007 / viii + 386 pp. / illus. / ISBN 978-0-88920-523-9

Words of the Huron / John L. Steckley / 2007 / xvii + 259 pp. / ISBN 978-0-88920-516-1

Essential Song: Three Decades of Northern Cree Music / Lynn Whidden / 2007 / xvi + 176 pp. / illus., musical examples, audio CD / ISBN 978-0-88920-459-1

From the Iron House: Imprisonment in First Nations Writing / Deena Rymhs / 2008 / ix + 147 pp. / ISBN 978-1-55458-021-7

Lines Drawn upon the Water: First Nations and the Great Lakes Borders and Borderlands / Karl S. Hele, editor / 2008 / xxiii + 351 pp. / illus. / ISBN 978-1-55458-004-0

Troubling Tricksters: Revisioning Critical Conversations / Linda M. Morra and Deanna Reder, editors / 2009 / xii+ 336 pp. / illus. / ISBN 978-1-55458-181-8

Aboriginal Peoples in Canadian Cities: Transformations and Continuities / Heather A. Howard and Craig Proulx, editors / 2011 / viii + 256 pp. / illus. / ISBN 978-1-055458-260-0

Bridging Two Peoples: Chief Peter E. Jones, 1843–1909 / Allan Sherwin / 2012 / xxiv + 246 pp. / illus. / ISBN 978-1-55458-633-2

The Nature of Empires and the Empires of Nature: Indigenous Peoples and the Great Lakes Environment / Karl S. Hele, editor / 2013 / xxii + 350 / illus. / ISBN 978-1-55458-328-7

The Eighteenth-Century Wyandot: A Clan-Based Study / John L. Steckley / 2014 / x + 306 / ISBN 978-1-55458-956-2

Indigenous Poetics in Canada / Neal McLeod, editor / 2014 / xii + 404 pp. / ISBN 978-1-55458-982-1

Literary Land Claims: The "Indian Land Question" from Pontiac's War to Attawapiskat / Margery Fee / 2015 / x + 318 pp. / illus. / ISBN 978-1-77112-119-4

Arts of Engagement: Taking Aesthetic Action In and Beyond the Truth and Reconciliation Commission of Canada / Dylan Robinson and Keavy Martin, editors / 2016 / viii + 376 pp. / illus. / ISBN 978-1-77112-169-9